FACE AND MASK

PRINCETON UNIVERSITY PRESS Princeton and Oxford

FACE AND MASK

A DOUBLE HISTORY

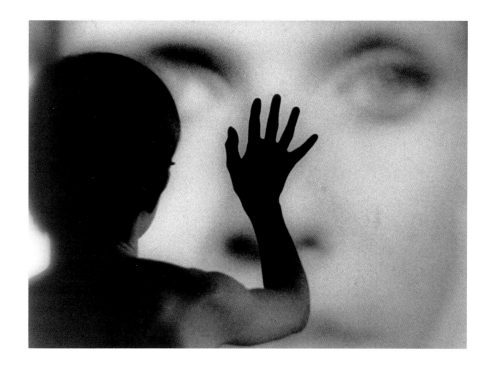

HANS BELTING

Translated by Thomas S. Hansen and Abby J. Hansen

First published in Germany under the title
Faces: Eine Geschichte des Gesichts
© Verlag C. H. Beck oHG, München 2013

Translation copyright © 2017 by Princeton
University Press
Published by Princeton University Press,
41 William Street, Princeton, New Jersey 08540
In the United Kingdom: Princeton University Press,
6 Oxford Street, Woodstock, Oxfordshire OX20 1TR

press.princeton.edu

Jacket illustration: *Ingmar Bergman, Persona: Collage
of Two Faces*, 1966 (film still and poster)
Frontispiece: Still from Ingmar Bergman's film
Persona, 1966
Front matter illustrations: pp. iv–v, details of
figs. 56, 69, 8, and 32
Part opening illustrations: p. 17, detail of fig. 10;
p. 91, detail of fig. 88a; p. 175, detail of fig. 126

Library of Congress Cataloging-in-Publication Data

Names: Belting, Hans, author. | Hansen, Thomas S.
(Thomas Stansfield), translator. | Hansen, Abby J.,
1945– translator.
Title: Face and mask : a double history / Hans Belt-
ing ; translated by Thomas S. Hansen and Abby J.
Hansen.
Other titles: Faces. English
Description: Princeton : Princeton University Press,
2017. | "First published in Germany under the title
Faces: Eine Geschichte des Gesichts." | Includes
bibliographical references and index.
Identifiers: LCCN 2016021495 | ISBN
9780691162355 (hardback : alk. paper)
Subjects: LCSH: Face in art. | Face. | Masks. |
Facial expression. | Facial expression in art. |
Face—Psychological aspects. | Masks—Psychologi-
cal aspects.

Classification: LCC N7573.3 .B45813 2017 | DDC
704.9/42—dc23 LC record available at https://lccn
.loc.gov/2016021495

British Library Cataloging-in-Publication Data is
available

Translation of this book has been supported by a
bequest from Charles Lacy Lockert (1888–1974)

Designed by Jo Ellen Ackerman / Bessas & Ackerman

This book has been composed in Chaparral Pro and
Avenir Next Pro

Printed on acid-free paper. ∞

Printed in China

10 9 8 7 6 5 4 3 2 1

CONTENTS

For us the most entertaining surface in the world
Is that of the human face.　　GEORG CHRISTOPH LICHTENBERG, *SUDELBÜCHER*, F. 88

INTRODUCTION: DEFINING THE SUBJECT

1

A history of the face? It is an audacious undertaking to tackle a subject that defies all categories and leads to the quintessential image with which all humans live. For what, actually, is "the face"? While it is the face that each of us has, it is also just one face among many. But it does not truly become a face until it interacts with other faces, seeing or being seen by them. This is evident in the expression "face to face," which designates the immediate, perhaps inescapable, interaction of a reciprocal glance in a moment of truth between two human beings. But a face comes to life in the most literal sense only through gaze and voice, and so it is with the play of human facial expressions. To exaggerate a facial expression is to "make a face" in order to convey a feeling or address someone without using words. To put it differently, it is to portray oneself using one's own face while observing conventions that help us understand each other. Language provides many ready examples of figures of speech that derive from facial animation. The metaphors we all automatically use about facial expressions are particularly revealing. "To save face" or "to lose face" are typical of these. They speak of control or threat to the face, but each also goes to the very core of the individual one is referring to. And yet we are not always in control

of our faces. Faces are tied to a lifetime during which they change and are stamped by experience. But they can also be inherited, learned by rote from another (as with mother and child), and recalled when one wishes to remember a person.

In the public sphere, by contrast, faces assume other roles, conform to conventions, or subordinate themselves to the ubiquitous official icons produced by the media. These icons dictate the faces of the majority instead of seeking true eye contact with them.[1] "The face is our social part; our body belongs to nature."[2] This idea immediately suggests the notion of the mask, into which we transform our own face when we wish to play a role. One can even speak of facial fashions. Thus we can see a "Face of the Age" popularized by the mass media as the homogenization of faces typical of an era. This phenomenon has existed throughout history, representing dominant, accepted types to which all have aspired.[3] One example would be an ideal of beauty generic to a period in which a preference for either "plain" or "strong" faces prevailed.

2

We cannot understand "the face" solely as an individual attribute, because it is clearly constrained by social forces. The domestication of faces in the nineteenth century is thus a historical phenomenon. To counter this development, August Sander records the upheavals in German society after World War I in a book of photographs titled *Face of the Times*.[4] This brings up the problem of how to talk about a "History of the Face." It is a different topic from the history of European portraiture, which began in the early modern period and encountered its first crisis with the invention of photography in the nineteenth century. What, then, does "history" mean in our case? What significance can it have within the framework of this book if it extends to all faces in general? Here we begin to discover a variety of possibilities for talking about a history of the face.

The life history of an individual face is familiar to everyone. That is not our topic here. A face changes with age when creases etch themselves into the sagging skin that gradually loosens from the skull; the creases become the expressive lines, wrinkles, and contours. These are what remain from the face's constant work of creating expression. They denote individual facial habits, which become fixed through a set repertoire of expressivity, and those habits are thus engraved in the face. In addition, a face can sometimes seem older or younger than the body that bears it, creating a sort of asymmetry that results from interplay during the course of a life.

Physiognomy is congenital and determined by skull structure. Yet the coherence in a face that we see after a long absence is sometimes made more obvious when we hear the voice, which recalls the face from the past even when it has

changed dramatically. Even though a face remains itself during the course of a life, it does not stay the same.

The "natural history of the face" (as Jonathan Cole has called it) is not my subject here, although it has been highly significant regarding the expressive powers of the face. The face that we have is just as much the expression that we give it as it is the result of evolution.

Charles Darwin, who based his findings on those of Charles Bell and Guillaume-Benjamin Duchenne de Boulogne, focuses on the idea of evolution in his *The Expression of the Emotions in Man and Animals*.[5] In medical patients loss of functionality in the facial muscles demonstrates that the interplay of many facial muscles generates the full spectrum of expression that makes faces readable. "The successful differentiation of consciousness and . . . emotional subtlety ran parallel to the evolution of the face," which increasingly separated expression from general body gestures and claimed it for itself. From the insights of primatology Cole deduced that the development of nuanced faces dates from the period before language and depends on "increasing complexity of social units."[6] The consciousness for which the face developed into a living mirror was central to the development of individuality. Facial movements that humans control are "partly primordial" and thus reflect a prehistory, but they are also partly a product of human evolution. "The more mobility and expressivity the face gained, the more refined its ability to convey feelings became."

This evolutionary process was completed before the emergence of the cultures now familiar to us. It was in these that the face first acquired those shades of meaning that expand upon nature and interpret it. Among these are faces that are painted or tattooed, groomed and styled, affective or secretive. The same is true of masks fabricated as artifacts representing faces and worn over faces. Prehistoric funerary cults invented the mask in order to replicate a lost face upon the corpse. Not until the advent of European culture and the social history of the modern era was the mask first understood not as a substitute but rather as a facsimile, a disguise and means of concealing the face. In self-representation with the real face, however, social norms have been at work, but shaped by cultural traditions. Cultures, furthermore, also differ in their interpretation of the face, but not in the same way that different races do.

3

The cultural history of the face is a broad topic that is difficult to reduce to a single concept. Sigrid Weigel reminds us of the historical significance of the human portrait, which is always an image and also the result of an interpretation of the face. "As the external view of a being imbued with affect and feeling, the face has become

a concentrated image of the *Humanum* in European cultural history." Precisely such an image is constantly deconstructed in the art and media of modernity. As the "emotional codes and cultural technologies" show, "the history of the face is first and foremost a history of media." This makes it worthwhile to examine the traditional and modern artifacts and to include "images of the face" when they lead beyond "the beaten path of physiognomy."[7] At the same time, the face is intrinsically "a medium of expression, self-representation, and communication." Conventions of living facial habits thus recur in the artifacts and ultimately lead back to the question of the mirroring relationship that exists between image and life.

We find a different model of the cultural history of the face in the work of Jean-Jacques Courtine and Claudine Haroche. They understand their history of the face (*histoire du visage*) as a social history of the emotions in the modern period in the West between the sixteenth and early nineteenth centuries.[8] During this period different varieties of individuality emerged in social life. In this process, self-expression (the will to show one's own emotions) collided with self-control (the desire or compulsion to regulate the emotions). Physiognomy provided the instructive material for a behavioral code of the face according to which the individual could go both "outside" and "inside" himself. Thus we can describe two "facial habits" that society demanded or tolerated.[9] This observation is supported by both texts and images, where even today it is still possible to read the facial habits of a past society.

Courtine and Haroche rely explicitly on the model of a "historical anthropology." Jacques Le Goff understood this phrase to mean a material as well as a moral history (*histoire morale*) of societies in which the living human body always represents a social reality.[10] The historian Jean-Claude Schmitt, Le Goff's successor at the École des Hauts Études, expanded the range of such an anthropology when he presented a first sketch for a "general history of the face, which has yet to be written."[11] In doing so he presented a threefold differentiation of the face—namely, as a sign of identity, as a vehicle of expression, and, finally, as a site of a representation (literally and figuratively): "If the face is a sign in its own right, then it stands for all that we attribute to it and ultimately for all that it conceals from us."[12]

A "historical anthropology" concerns itself with humans (and their faces) in general, but also gives us an inkling about how this topic has been incorporated into historical scholarship. Georges Didi-Huberman, by contrast, advocates the idea of an "anthropology of the face" that encompasses all eras and cultures. He warns against any "history of the face" restricted to a historical grammar of facial expression. He advises caution because in the form of a readable physiognomy, this soon turns into an ethnocentric argument.[13] On the other hand, an all-encompassing

"grammar of the face" swiftly strains its limits when it forsakes historical context. The difference between face and image recapitulates the difference between presence and representation, for representation implies that the face itself is absent.[14] And yet the living face produces an expressive or masklike representation in order to show or conceal the self. Human beings engage in the representation of their own faces. Thus, we all embody a role in life.

4

This work will discover the face in ever-changing historical contexts, although its history cannot be ordered in any linear chronology. This history is, rather, something that constantly changes and offers new insights into the subject each time. As a form of narrative, history thus presents the possibility of talking about the face and its social and cultural applications (praxis) without always resorting to generalities. In the realm of cultures there is no "history" in the singular. In this context one should really talk about "histories" in the plural, from which one can only make a selection—a selection that other histories may contradict. The focus of this study on an area of Europe has not been driven by an agenda, but is rather the product of compromise. This has been the only way to delimit the material, which is almost infinite, and to contain it within a scope that nonetheless remains barely manageable. Stepping beyond the European context leads us to confront completely new questions, which this introduction will nonetheless address with a few examples. When all is said and done, literature about the face is extremely diverse. In the area of cultural comparisons, only ethnology has provided a few models—for example, in the discourse about masks.

The concept of "history" is meant merely as a practical framework here, not as an authoritative prescription. The reader is, moreover, encouraged to notice that on the whole history remains forever elusive when one tries to pin down the topic of the face within it. In our framework we can only speak of history when we limit ourselves to a specific perspective; it changes as soon as that perspective changes. This is true, for example, of the history of the portrait. In the following pages, this topic will be viewed as a European (rather than a universal) subject and examined critically. It is also true of the history of contemporary mass media, in which faces seem to disappear and yet show stubborn persistence despite the almost constant innovations of most modern media. The history of the theater and acting also calls for a historical narrative. This is evident because in the modern age actors appear onstage without masks and must play roles from antiquity using their own faces. The history of scientific areas like physiognomy and neurology constitute subjects in their own right.

5

The history of the mask also belongs to the cultural history of the face. Nonetheless many studies of the mask never mention the face at all anymore. They seem to have a very different subject, and they even seem to contradict the history of the face. And yet the mask has always been used as a medium for the face. As such, it has accompanied the changing interpretations of the face or in some cases even caused them. This even applies to the oldest masks that we know. They did not merely replicate the face after death in clay and color but simultaneously produced an image that constituted a retrospective view of a life. In his book on masks, Richard Weihe examines the ambiguity between face and mask, calling it a "paradox."[15] In the duality of co-optation or contradiction between face and mask, "there emerges a dialectic of showing and concealing that is characteristic of the mask." In cult ritual and the theater of Greek antiquity, a "prosopic unity" was produced by equating mask and face (the mask is the face). According to Weihe the equation of mask and person, in the modern period, produces the *"homo duplex,"* to use Émile Durkheim's terminology: this is "the model of man who unites nature and culture within himself: *the self as a role.*"[16]

In a late lecture from 1938, Marcel Mauss described "the social person" (compared to the "self" [*Ich*; ego]) within the mask, which assumes a specific type or a role with which it must communicate in society. The person is a mask. By contrast, Erhard Schüttpelz reminds us that the mask is distinguished by a striking ambiguity in early societies. It can side with society (in other words, with roles and persons) against inimical nature, but can also take the side of a magically imbued nature in opposition to society. Within this framework it can either invite communication and narrow its distance from the public, or it can create a new distance.[17]

Considerations like these affirm a fundamental meaning of the mask, which establishes a close connection with the history of the face. The mask was predestined to interact with living faces and to address these in two ways. On the one hand we have an expression of excitement exaggerated to the point of inspiring fear, which transcends the expressive capacity of the human face. On the other hand, we find the utter peace of rapture, which calms the anxiety in the living faces of the cult audience. Both types of mask can be used in the same context, either simultaneously or sequentially. Interaction means that masks can be experienced here as faces, to which one reacts with one's own living face, as if in an exchange of glances—in other words, instinctively.[18]

The ambiguity of face and mask becomes immediately visible wherever the vivid interaction between gaze and facial expression is disturbed or interrupted. This can happen in two ways, both of which produce a similar effect on us. First, it

can happen when the wearer of a man-made mask—a mask of leather, wood, or plaster—peers through the holes in the mask and looks at us with his living eyes. At that point the gaze, which we can suddenly no longer interpret, acquires an uncanny force that renders us powerless. When we find ourselves restricted to such a gaze, disembodied from the face, we are no longer capable of exchanging glances, an action that belongs to the fundamental experience of our faces. But this disruption can also happen in a second way—namely, if someone approaches us with his living face but not his real eyes. The blind thus wear invisible masks on their real faces. And this fear can also arise when the eyes are covered by dark glasses or even with artificial eyes. This variation is familiar to us from Jean Cocteau's last film, *The Testament of Orpheus* (1960). In this film the actors portraying the gods appear with replicas of large, lifeless eyes covering their own. These do not change expression, and Cocteau himself similarly transforms his living presence into a (death) mask.[19] Facial expression is meaningless here; the true face is frozen into a mask when the living gaze is concealed from our own sight. We do not even need the assistance of artificial eyes, but rather, when we let our whole face become expressionless, we allow our face to become indecipherable and stiffen into a mask.

6

The man-made mask was used as a vehicle that possesses the permanence of all things, but which, in ritual, needed a living wearer with a voice and a gaze. Thus a dancer was required to bring the mask to life in performance. By contrast, the living face becomes stiff and rigid as a mask when it is portrayed; the very process of reproduction immediately yields a mask that can no longer change expression. In this second sense, the history of the face has come down to us in a tradition of masks, which represent faces but are not faces. Seen from both perspectives, this produces a type from which the face distances itself, because it exists only in life and is as multifaceted, ungraspable, fleeting, and transitory as life itself. In this book the face is the cynosure of all images, which are always subject to time and thus break down and lose the competition with the living face when confronted with the impossibility of representing it accurately.

A study that takes the face as its subject resembles a butterfly hunt and must often be content with duplicates or derivatives, which divulge very little information about the life and secret of the face. Thus, as the following arguments unfold they will not always do so systematically, but will often change course abruptly so as to include other aspects of the face. Such a process is suggested by the topic itself, if one does not want to sacrifice its many facets. Everything about the face that can be described or put into words is only a mirror for that which is not immediately there,

but which is flanked by scenery with which societies and cultures have surrounded the face. The frontispiece of this book, which comes from a film by Ingmar Bergman, depicts the search for the face as a reach into the void, for in this example the face has retreated into a distant image that the hand cannot grasp. A face is born anew with every human being. It ages and dies with that person no matter what the circumstances of life may have been at the time. All competing designs and deconstructions of the face are only episodes in its social activities; these are always survived by the face and subsequently laid to rest. Thus, the invisible center of this book—the face—can only be encountered at its societal and cultural periphery. It is the raw material of life and thus nature in its social praxis.

The chapters in this book each stand alone and discuss a particular aspect of the face in order to present a view of its manifold aspects in chronological order. They are also related thematically, in the sense that they reflect one another. This is true especially for the second part, which is devoted to the portrait as a mask and which traces this kind of mask, including photography, up to the present. It is also true for the third part, where the age of electronic media provides the context. Such connections are not immediately evident in the first part, but the context will emerge little by little through trial and error. This section begins by demanding that the reader accept face and mask as a single theme in the organizing principle of a "history of the face" and not view these concepts in sharp contrast to one another. For this reason, the masks of the self and the roles of the face are viewed from a common vantage point in part I. There then follows a break where the man-made mask is introduced as it is worn in two very different contexts. One such context is the genealogy of the mask ritual in cults, which introduces the cultural history of the face in early prehistoric times. This stands as a counterpoint to the reencounter with the mask—now as an exotic object in museums of the colonial period. After we have passed through the modern period, the mask is suddenly experienced as something foreign and unintelligible.

The performance of the mask in the theater presents the face in a dual context that is introduced in the classical use of masks and is something that remains familiar to us from the modern theater, where it undergoes an unanticipated change. In the modern age the mask per se has not returned to the theater, but rather the actors' faces have taken over the stage roles of the mask. The actor's face thus becomes the model of the original social mask at court and later in civil society. The revival of the ancient study of physiognomy as a potentially reliable science of the face reached its high point in the writings in Lavater, but ultimately left disappointment in its wake. These studies nonetheless paved the way for their scientific successors—first phrenology, then neurology. The focus thus turned away from the

face as an organ that was the subject of research rather than the communicator of a human being's character. Ultimately, the face had been overlooked for so long that a new cult of the death mask as true face introduced a modern nostalgia for the face. As a prelude to this sentiment, Rilke went so far as to write a farewell to the face after he experienced the metropolis of Paris.

The second part begins with the potentially unexpected thesis that, where other cultures use the mask, Europeans have developed the portrait in its place. The representation of the face, whether as proxy or memento, was delegated to a silent image, which outlived the face but never recaptured its life. Such a concept of the portrait contradicts the enthusiastic acceptance of the depicted face as an authentic facsimile of life—an opinion repeated like a leitmotif throughout all critical appraisals of portraiture. But this likeness was restricted to an inert surface, against which artists rebelled in the self-portrait. They suddenly realized, with horror, that by using their own face they could not portray the self they possessed in life. As a result, issues concerning the mask become highly focused in the self-portrait. Even in portrayals of his friends and models, the painter Francis Bacon engaged in a life-long struggle to free the voiceless mask and violently recapture the vivid life of the face instead of producing a mere likeness.

In his major work on the European portrait, Andreas Beyer pursued the topic to the furthest limits of art. But even he was forced to conclude that no theory of the portrait did the concept justice.[20] Georges Didi-Huberman further changes the theme by analyzing the intrinsically contradictory "portraits" of anonymous sitters, even of crowds, that portray the common people and thus defy representation.[21] But even those people are forced to put their faces on view—faces that either disappear in the next moment or are about to be lost forever at the threshold of death. This ambiguity of appearance and disappearance applies to a series of pictures of very old faces that the photographer Philippe Bazin took in the 1980s. Such faces clearly have their histories behind them. In the case of newborns, however, whom Bazin photographed in a later series, their histories had not even begun and cannot be deciphered from their faces. It is only in the image that the future and former face remain fixed.[22]

The asymmetry between the face and its representations is evident from the fact that faces in portraits cannot age, yet they do age with the medium: a painting collects dust, and a photograph fades. Even when an image is taken or photographed from a living face, it does not begin to live; rather, the image robs it of time, since in retrospect the face can only be viewed at the moment when it is reproduced. Oscar Wilde evoked this relationship between image and life in the unforgettable parable of his tale, *The Picture of Dorian Gray*. There, by reversing

image and life, Wilde revealed the paradox that exists between the two. Through a diabolical bargain concerning Dorian Gray's immortality, it comes to pass that only his image ages over time; the face retains its youthfulness throughout life. For this reason, the libertine must conceal his portrait because it has become an undesirable mask that portrays the truth, while his own face has been transformed into a mask that denies the true span of his years on earth. In his literary history of the human face, Peter von Matt inserted an excursus on the "basic indescribability of the human face," which naturally applies to literature and verbal description. His thoughts also apply to images, although these seem to possess a closer relationship to the face.

Even photography, which seemed to fulfill the long-sought guarantee of similitude, soon disappointed expectations because it could only preserve the moment in time at which the photograph was produced. For that reason, the technologies for reproducing moving images, whether in movies, television, or private video, promised an escape from photography as mask. Yet these introduced a new obstacle, for the images captured with the camera only become fully realized once they are projected on a screen. Moreover, the life span of new technologies—compared with older photography—is dramatically shorter, and new methods of preserving images are constantly needed to extend their useful life. Accordingly, there has arisen an internal cycle between reproduction and continuous technological innovations aimed at saving the fleeting face in pictures.

The age of mass media—our topic in the third part—has unleashed an unlimited production of faces, and through the printing of pictures and the Hollywood film, has established a new cult of the face. Thomas Macho calls these public faces "exemplars" (*Vorbilder*), not in an ethical or social sense, but rather in the way we always encounter them without really meaning to.[23] "Prominent faces" have now become products of the media. Instead of addressing a single viewer, they are aimed at the anonymous masses, which strive to find their own collective face in them. At the same time the modern metropolis has made the compilation of an "archive" of facial records necessary for law enforcement agencies, lest faces disappear too quickly into the crowd. The celebrity face, on the other hand, has deteriorated into a stereotype, and despite this—or because of it—has been able to revel in its public triumph. An example of this is the illustrated magazine *Life*, which offered its readers all of the faces that were enjoying their moment in the limelight in the 1930s.

The cinematic face has its own checkered history, which is the subject of numerous studies.[24] In these the large portrait photograph takes center stage and is allied with the cinematic technique of montage. This context has provided new insights about the readability or opacity of facial expression. The so-called Kuleshov

effect shows how the expression of a face can remain the same and yet be interpreted quite differently depending on the context in which it appears. In Ingmar Bergman's film *Persona*, the title of which evokes an old concept of the mask, the face is not only motif and technique but also the actual subject that unfolds in the dialogue between two "similar faces," one speaking and one silent.

Mao's face provides the mirror for two quintessentially different societies that are major players on the world scene today. In China, Mao's image was politicized on several levels as the only official face. This agenda was enforced so rigorously that it became the symbol for the people and the Party as it provided a collective identity for the faceless masses. In the United States it appeared somewhat belatedly among the colorful celebrity faces in circulation in the media. The marketing of Mao's face in the art scene launched a new career as a high-priced investment opportunity. In both cases the same face provided a template onto which two systems projected their worldviews. Today, paradoxically, it has emerged in a third stage of its history, in which it is penetrating the contemporary art scene in China as an American pop icon that confronts the state-sanctioned image still being produced there.

7

We now digress somewhat from the content of this book to cast a wider net while remaining true to our subject as we take a cursory look at this topic in other cultures. To reiterate: a cultural history of the face cannot be restricted to Europe, even though the main body of discourse applies to that geographical area and to the modern period. Nothing but a comparative analysis, such as one I have attempted elsewhere, permits us to transcend a focus limited to one's own culture.[25] Only then can one achieve an outsider's gaze, which makes it possible to recognize the local idiosyncrasies of one's own culture. It was ethnological research on masks that pointed the way toward research on faces. The scope of this book only permits a few examples to convey some main points about how a transcultural history of the face might look.

In countries where the religion of Islam is dominant, the veil testifies to a culture of the face completely different from that of the West. Nonetheless, the memory of the Taliban regime in Afghanistan is still fresh in our minds. They tried to force the burka, the full body veil, upon all women. This situation dominated the press photos of the period, as one example taken by Santiago Lyon demonstrates. It was taken in Kabul on November 13, 1996, in front of a Red Cross station as relief supplies were being distributed (fig. 1). In this photo the face of a girl emerges from among a crowd of burka-clad women whose faces remain invisible to us, while she alone—either not yet forced to wear the veil or having neglected to do so in an

unguarded moment—looks out at the viewer with a terrified expression. It is only the hands of the burka-clad women who clutch their veils to their bodies that reveal their presence behind their viewing grids.

The photograph elicits a shocked comparison between the free face and those locked away from sight behind full veils. In reality the veil—especially after the discussion surrounding its prohibition in France—has become a political issue. For one side it is a symbol of oppression, and for the other a symbol of identity. A third path presents itself in the descriptive labels accompanying a London exhibition devoted to the theme of the veil.[26] In the catalog the film theorist Hamid Naficy reminds us that regulation imposed on gazes between the sexes was not confined to the veil, but in Iranian postrevolutionary film also applies to the woman's indirect or direct gaze.[27] The veil also immediately brings the face into play in a double sense—on the one hand, regarding the gaze *at* the female face, which the veil is meant to protect from threats by potentially abusive men; and on the other hand, regarding the gaze *of* the female face, which is liberated by its vantage point behind the veil. The veil, in its varying strictures concealing and revealing is just like a mask or makeup in that it helps to tell the story of the staging of the face.

The search for personal identity in a world crippled by cultural strictures brings another work into the mix: Pakistani artist Nusra Latif Qureshi created this work for the 2009 Venice Biennale (fig. 2).[28] As a symbol of her official identity, she superimposed her own passport photo onto a transparent film strip of digital prints almost nine meters long, placing her own likeness over approximately twenty colored profiles of the Mogul period taken from Indic book illustrations. She alternated these with her image superimposed upon portrait paintings of the Venetian Renaissance representing the locale of the exhibition. The title of the work offers the key to the logic of this dual dramatization. It challenges the viewer with the question, "Did You Come Here to Find History?" The work embodies the postcolonial suspicion that viewers seek only stereotypes of cultural differences, given that they themselves in no way wish to be identified with Renaissance portraits.

In this work the layering of faces resembles a palimpsest, and history disintegrates into a dubious local construct that has itself become historicized. The portraits reproduce a twofold art history, and in so doing they emerge as collective patterns of a culture of the face, which replicates its own indigenous canon. For the viewer every so-called history of the face is also, as it were, a gallery of ancestral portraits from which one catches a glimpse of other, foreign cultures. In this study a remarkable metamorphosis of the gaze develops when the artist secretly looks at us with the eyes of a Venetian portrait, thereby breaking down cultural barriers. In this

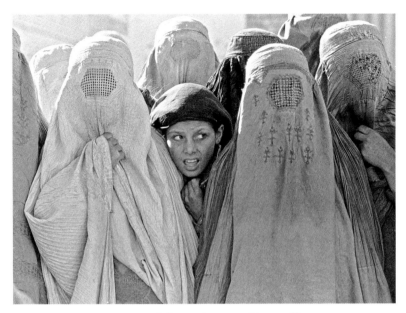

FIGURE 1 Santiago Lyon, Frauen in Kabul, November 13, 1996 (photograph)

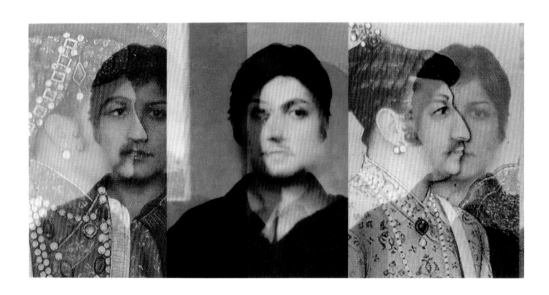

FIGURE 2 Nusra Latif Qureshi, Did You Come Here to Find History? (2009)

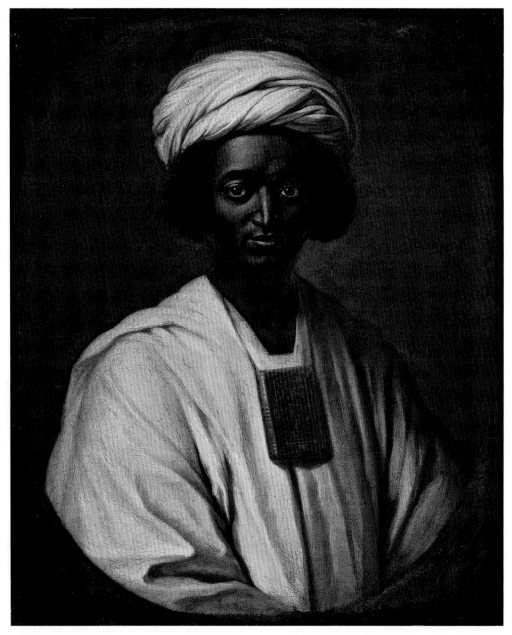

FIGURE 3 William Hoare of Bath, Portrait of the Freed Slave Ayuba Suleiman Diallo, 1773 (Qatar Museum)

act history suddenly becomes transparent. In a new, cosmopolitan present those cultural clichés that we have inherited as images hold each other in check when they reveal the gaze of the living artist in the background.

A third and last example, which again leads us back into the past, provides eloquent testimony to the complexity of cultural interaction via the face. This painting appeared on the art market only recently and may be designated the oldest (and for a long while to come, probably the only) portrait of an emancipated slave from Africa (fig. 3).[29] The object under consideration is the portrait of Ayuba Suleiman Diallo (1701–1773), painted in London in 1733 and all but forced upon the model against his bitter objections. The corresponding piece is the biography of the "African gentleman" written by Thomas Bluett (the author called the sitter Job Ben Solomon). It was his objective to give Suleiman Diallo an appropriate identity as a person in both word and image, which the period of the Enlightenment deemed essential.[30] From this biographical description there emerges a life of adventure that can only be considered unique in the history of slavery.

Suleiman Diallo, who was of aristocratic lineage, was born in the former kingdom of Bonda, site of present-day Senegal in West Africa, where, as a good Moslem, he had been educated in the Arabic text of the Koran. In 1730 during a trip to an English ship that lay at anchor in the River Gambia, he was kidnapped by members of the enemy tribe of the Mandingo. His head was shaved and he was sold to the same English captain with whom he himself had wanted to trade slaves for paper. He eventually ended up on a plantation near Annapolis, Maryland, to which his later biographer tracked him after an escape attempt. After numerous complications all related to his ransom, he was brought to England and introduced to polite society. There he was marveled at as an exotic sensation and even made the acquaintance of Sir Hans Sloane, one of the founders of the British Museum. Once a public collection had raised enough money for his ransom, he was able to gain his freedom in 1734, and he returned to his homeland. The Royal African Company, which expected better trade relations from this gesture, mediated the transaction.

The biographer also gives an account of the portrait painted by William Hoare and commissioned by one of Job/Suleiman Diallo's sponsors.[31] As a good Moslem the sitter was an avowed enemy of all images and thus also of his own portrait. He finally acquiesced after it was explained to him that a painting was the only way in which a memory of him might be preserved. Once the face was finished the painter asked the sitter about the costume he wished to wear, and he insisted on his indigenous garb. When the painter said he was not familiar with such attire, Suleiman Diallo replied that Hoare would probably also paint a likeness of God, whom no one has ever seen. In the portrait he seems to be wearing his native cos-

tume of silk, which he had made to his specifications by a London tailor. For him it may have symbolized a combined sign of his social and religious identity, in a way that his mere face could not have done. In accordance with this desire, he also seems to be wearing a Koran amulet around his neck, for it was ultimately not only his religion but also his literacy that had helped obtain his freedom. In the final analysis the portrait did not bring about his cultural assimilation, for it represented him only as an exotic subject with all those attributes that we now describe as "otherness" or "alterity."

I

FACE AND MASK: Changing Views

1
FACIAL EXPRESSION, MASKS OF THE SELF, AND ROLES OF THE FACE

The expressive achievement of the living face lies as much in its ability to show and proclaim as in its ability to conceal and deceive. The same face expresses truth and falsehood: at times someone can vividly reveal his "inner self" to us; at other times he conceals himself with an impassive face as though from behind a lifeless mask. In life, expressions change the face we *have* into the face we *make*. This dynamic triggers a *perpetuum mobile* of many faces, which may all be understood as masks once we expand our concept of the mask. The concept of "the face as a mask" is ambiguous in this sense because it is not merely a face that resembles a mask but also a face that creates its own masks when we react to, or engage with, other faces. We therefore can speak of the expressive drama of masks.

The *face mask* is an artificial, man-made mask that shows only a single fixed expression. Its paradoxical superiority over our changeable and erratic faces lies precisely in this deficiency. It fascinates and annoys us at the same time because it does not participate in the social exchange with other faces. The *face mask*, which merely depicts a face, transforms its image into a symbolic face. An example of this was apparent in 1995 in a stage production of the novella *Averroës's Search* by Jorge Luis Borges, in which Edith Clever appeared alone onstage at the Berliner

Schaubühne changing masks for a full hour. When she finally appeared without a mask, the pathos of distance—which every man-made mask creates—was diminished. Her own expressively dynamic face elicited disappointment.

In this study "face" and "mask" are used only as operative concepts, which means that they do not possess any fixed definitions but rather stand for the indistinct boundary between face and mask. Any attempt to find a common theme in them creates a contradiction almost reflexively. This comes from a tradition of modern thought that has idealized the "real face" and purports to see only deception and inauthentic expression in the mask. The tendency to differentiate between face and mask as true and false is an option we have reinforced through cultural norms.[1] In all this the remoteness from the body figures in our concept of the image, for here imagery is attributed solely to the mask, and the images that originate in the face are ignored.[2] The etymology of the German word *Gesicht* (face) reveals that a *Gesicht* involves sight, that is, it is *seen* by a viewer. This recalls the ancient Greek concept of *prosopon*, which designated both the face and the mask. The history of the word began with the face that others see.[3] When people see a face, they want to "make an image" of it by "reading" its expression, although they know that images can deceive.

Our faces can transform or lock themselves into masks at any time. This transformation is a natural capacity rooted in our expressive abilities and our voices. For that very reason face and mask cannot be reduced to antitheses. It is the lack of distinctness that exists between them that quickly becomes evident in a history of the face. It is only the face that transforms the body into an image, and it does this quite differently from the way that a mask does. This body is then perceived as an image through face and gesture. Our faces immediately awaken to images when we gaze and speak. We make our entrance with the face; we communicate and represent ourselves through our faces. This is more than a body part, for it acts as a proxy or *pars pro toto* for the entire body.

Face and mask can each be understood as an image that appears on a surface, whether that surface be natural skin or an imitation made from some inert material. Faces are the body's witness to the primeval sense of the image. Through the face our bodies achieve an iconic quality. The use of the man-made mask, in contrast to the face, is inseparable from the concept of a foreign body, because the natural body functions as its bearer. The face that wears the mask must become invisible in order to give the mask physical integrity. Face and mask stand in for each other. To repeat the point, the *mask upon the face* and the *face on the body* do not ultimately stand in contradiction to each other. On the contrary, they have the same relationship that unites nature and culture. As images they are both subject to inescapable forces that apply to all representation.

A man-made mask appears in cult ceremonies in place of the real face. In doing so it immobilizes changeable facial expressions and transforms them into a single, absolute expression. The half mask, which leaves a portion of the face visible, demonstrates the fluid transition between face and mask. The ritual mask simply amplifies the exclusive role that the face possesses for the body. When this appeared in the place of a real face—namely, by covering it—it gave the wearer a new face, which represented someone else who had taken possession of the wearer's body. Even when we can see through this pretense, we still sense the fascination derived from such a symbiosis of body and man-made face. The man-made mask, is, of course, the image, but it is not a *copy* of the real face; it is a symbolic one.

One might call it an *excarnation* of the face, in the sense that it "disembodies" a face in order to "embody" someone else. By contrast, one may speak of an *incarnation* of changing masks, which our face constantly produces in expressive gestures.

We do not have access to an artificial second face, but rather produce masks with our own face by making it expressionless or by grimacing. We then speak of a mask in the metaphorical sense. In this use of language, we can see the pictorial character shared by image and mask: one image transforms itself into the other. Since the Enlightenment we have become accustomed to denying this common pictorial character and to seeing face and mask as antitheses: the face as *image of the self* and the mask as *counterfeit self*. When we talk about a "bare face," however, we prove that it is possible to tear invisible masks from the face. These are then masks of disguise rather than masks of self-expression. When a person "loses face," he has forfeited credibility and lost control of his face. Even the face has roles that it is expected to play. A face that projects character is a mask that defines a role.

Nietzsche once championed the mask of the face and the mask of the voice when he postulated the necessity of retreating behind a mask so as not to betray oneself. Someone "who instinctively uses speech to keep silent and be secretive . . . *desires* and promotes the fact that a mask that represents him lives in the hearts and heads of his friends instead of his true self. And, assuming that this is not his intention, then one day his eyes will be opened to the fact that there is nonetheless a mask of himself there—and that is as it should be. Every profound intellect needs a mask: what is more, a mask is constantly forming around every profound mind, thanks to the continuous false (namely, shallow) interpretation of every word, every step, every sign of life that he gives (about himself)."[4] This is a modern rejection of role play that Nietzsche paradoxically considers necessary in order to remain oneself and preserve one's own subjectivity. Seen from this perspective the face is destined not only to wear a mask, but also to be one.

The portrait offers a special case that lets us examine this interrelationship between face and mask. The central portion of this book is thus dedicated to that subject. The portrait is an image of an image, for it depicts a face that is itself an image of our self. *Likeness* is a concept that applies to the face (*image*) as well as to a thing: the picture of a face. In portraiture of the modern period European culture invented a mask that is unique across cultures. Portraits inevitably transform the face that they represent into a mask that always stands at a remove from the real face; indeed, it is a substitute for the face. In modern European culture, portraits have taken the place that masks occupied in ancient cultures. Their importance lies in memorializing real persons and real faces, yet to this end they use conventions that change over time. The portrait, however, is not merely a *face*, but also a *medium for the face*. An example is a votive image, which is a movable object and therefore like a body. It is thus well suited to representing a person in a legal sense, which we can see from photographs in government offices. In a paradoxical way painted portraits live as memorial faces, because the person whose presence they recall is actually absent. Thus they are a prime example of reification, which represents a central characteristic of the European culture of memory. Not until the age of photography did portraits reach the broader public and become reproducible. Nonetheless, the analogous reproduction remained an act of reification, which produces an object, the photographic copy, instead of living experience and perception.

In his study on "Mask and Face," Ernst H. Gombrich was interested only in physiognomic perception. When he writes that we "first see a mask before we recognize the face," he means an individual face, in the sense of its physiognomy, and not the mask, which produces a face of its own. He goes on to say that similarity is only possible when a painter's gaze is capable of empathy, for that is the quality that makes it possible to experience physiognomy.[5] The mask Gombrich is talking about is not the expressive face that is our subject here. That concept means a face that is constantly producing masks and is thus almost impossible to reduce to a "true face." A further difference lies in the fact that Gombrich seeks the true face behind the mask, whereas in the portrait as *genre* the inevitable mask emerges, which can never become a living face.

Gombrich's search for perception begins, however, with the question of how similarity exists or comes into being in a face. By now we know that a particular region of the brain is responsible for facial recognition. This capacity can be absent in some patients. Yet the problem of similarity is not restricted simply to mere recognizability, which is greater with the voice than the face anyway. When we hear a voice on the telephone or in a recording, we recognize a person with greater certainty and clarity than by the face, which changes over the individual's lifetime. It is

not for nothing that we reassure acquaintances whom we have seen after a long absence by saying that they haven't changed a bit (in their faces), because we are surprised by the fact that their faces have changed so little in life.

The expressive (or "mimic") mask, which is our topic in this section, ends in death once it freezes into a lifeless mask. We experience this as "empty" because there is no longer anyone there to inhabit it. For that reason, we honor the so-called death mask made of plaster or clay, not as an image of a corpse from which these may have been taken, but rather as an image of the "true" face. In our perception it gathers together the sum of all the different faces of a life in a single expression, which does not materialize until all expressive activity has ceased. The "death mask" could thus become an object to be exhibited and summon up nostalgia for the face, for it bears an expression that we no longer attribute to life. Like so much else in our culture, it is objectified and immobilized for observation. It challenges us to honor the face in a mask that is a memorial to that which once was.

When the face is animated by expression, gaze, or language, it becomes the locus of many images. It follows that the face is not merely an image but also *produces images*. Its appearance changes rapidly between active and passive, between image and bearer of images. In the facial expression and the work of the face there lies a socially learned code of conduct in which cultures differ significantly. The ambiguity of presence and absence is inherent in the concept of image, for images show something that is not there. This ambiguity has been revealed in the drama of the face, which is twofold. The face is always present as a vehicle, yet the expression changes so that in it we can find the presence of a person and, in the next moment, experience that person's absence when he more or less retreats from the face.

Visibility in the face is by no means as unequivocal as it seems, but is manipulated by the will of the person whose face is before us. That person is the actor of his own face. We perceive body and face either in harmony or opposition, especially whenever the face takes command. Both of these effects arise because the spatial distance (distance or nearness of the person gazed at) determines the perception. Our gaze itself has the capacity to extend or contract the distance from which we perceive someone. With our gaze we invite another body closer to us or, conversely, keep it at a distance. The viewing distance thus participates in how we perceive a face—and how intensely we do so. From a distance the face appears as part of a whole body. Up close, the same face is separated from that totality and monopolizes the body, thereby conveying the impression of a whole body, even when we are actually seeing only the face. In experimental psychology, such as in the work of Michael Argyle, such perception is described as the *gaze-distance effect*.[6] When we view a face up close, it becomes more independent (of the body) the nearer we get.

Thus the affect with which we view a face becomes more important than the expression that we experience in the face of the other. A transference takes place in the sense that we invest another face with our own expression. For this reason, Gilles Deleuze describes the *close-up*, or *gros plan* in the cinema as the epitome of the expressive potential of an "affection image" (*Affektbild*). And yet the situation is different here. In the darkness of a movie theater where we encounter such a face, the viewer is overwhelmed and robbed of perception in which he himself can determine the appropriate distance for his gaze.

In the case of actors, face and mask belong in a special category. We are used to viewing action onstage as situations in which we recognize both an actor and a character being played. But we view this ambiguity as an either/or situation by directing our attention to the real face or the one being simulated, in other words either at face or mask (or the mask as face). It is as if we could simply "focus" our eye at our own discretion. Yet it is the same face that can play this double role at one and the same time with its own resources. We are not willing to acknowledge that the actor actually appears onstage with two faces, with which he then undertakes to change masks—except when he wears a man-made mask that is not his own face. This he would hold in his hands so that we could glimpse the "unacted" face behind it, as it were.

In the year 1938, Ruth Wilhelmi set up a series of experimental images in which she photographed the face of an actor while also photographing the mask he held in front of his face (fig. 4). This separation of face and mask lets the photographer show us the possibility of viewing both elements as they interact. The photograph shows the actor Albin Skoda as the spirit Ariel in Shakespeare's *The Tempest*. At one particular moment, in the scene when he is not only Ariel but also playing the role of the goddess Iris at Prospero's command, he thus enacts a play within a play.[7] Consequently, he is playing two roles—one with his own face, as Ariel, and the other as Iris with the mask, an object that was no longer in general use in the theater of Shakespeare's time. Behind the mask with its blank expression, the photograph catches the actor at the moment of transition from the mask's expression, withdrawing into his own "unacted" oblivious face. The unusual view arises from the fact that he does not form the mask with his own face but rather holds it as an artifact in front of his body, as did the actor Gabrielli in an old engraving by Carracci. This effectively creates a concrete metaphor for the face that plays a role as well as one that embodies a role.

In his cycle of poems *Les Fleurs du Mal*, Baudelaire dedicates a poem titled "The Mask" to the sculptor Ernest Christophe, whose "statue in Renaissance taste" he admired. In Baudelaire's essay "The Salon of 1859," he described this statue as an allegory whose frontal view showed a "sweet, cheerful face," but whose reverse pre-

sented a painful grimace. The moral of the story is that the beautiful face was just a theatrical mask: "the universal mask, your mask, my mask, a handsome fan used by a skilled hand to veil one's pain and guilt from the eyes of the world."[8] We find ourselves on the threshold of the modern era, in which Rilke will soon publish his farewell to the face.

THE ROLE When one tries to deal categorically with the face, a conversation about masks soon emerges. Facial expressions and the gaze provide an infinite repository of masks. Even the voice becomes a mask by participating in the work of the face. Faces often behave as role masks in order to be socially acceptable when they play the part that society expects of the wearer. Expression is thus also an action that we perform. The natural face is always ready to behave like a mask, for a face playing a role offers the wearer a social identity under the protection of a mask.[9] Because the mask must also have the effect of an "authentic" face, however, one encounters the paradox that faces conceal their dissemblance. In the early modern period the theory of roles interpreted society as a theater in which everyone had a role to play. These roles are masks that serve to negotiate social situations, especially when people lack any free choice of their role.[10] Nonetheless, the debate about the face and the mask constantly veers toward notions of a moral nature. As we have seen, the differentiation of the natural face from a man-made mask evokes ethical principles of truth and deception. But these premises do not stand up to experience.

The anthropologist Helmuth Plessner hesitated for a long time before equating facial expression with true action because it merely seemed to "resemble" action. In an early work he wrote that our facial expressions behave "like symbols of an action."[11] But where does the difference lie? The "mimic image," as Plessner correctly labels it, is clearly guided by the intention of producing expression. Facial expression is action performed by the face, for the face produces masks when it "goes into action" or when it conceals itself from the person opposite. Plessner tried to address the question of expression in his essay on actors.[12] Of course in life the face cannot

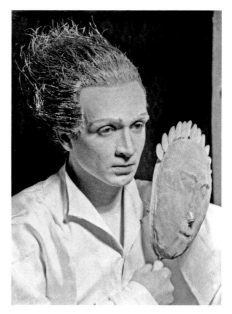

FIGURE 4 Ruth Wilhelmi, *Albin Skoda as Ariel in Shakespeare's "The Tempest"* (Berlin, 1938). Photograph (Deutsches Theatermuseum Munich, Archiv Ruth Wilhelmi)

be as conclusively interpreted as in drama, for which there exists a script. Plessner speaks of a "double role" that one plays with the face when portraying a character and simultaneously oneself.[13] Yet this leaves the question of the "self" (as *Ich*, or ego) unanswered—a question that in the modern period has supplanted questions about the soul.[14] In psychoanalysis the ego and its mask were posited in opposition to the mask-less unconscious, the id. But even concepts are masks for the things they label. The game is always more transparent than the players.

The roles of the ego were bound to behavioral norms of a society; in the modern period these persist in front of the mirror. This mirror served as a medium of social adaptation and also as a vehicle for the secret wish that one might here encounter the self. To quote Sabine Melchior-Bonnet, this "tension between both" produces the experience of the self.[15] Even in front of the mirror the self is not alone, but feels itself observed by society's gaze. "The right to gaze upon oneself was subject to moral controls." Here observers were subject to censorship, which they had already internalized. Adherents of Descartes utterly rejected the notion of relegating the search for the individual to its mechanical reflection. It was, however, impossible to shake off the fetters of the subject in front of the looking glass.

After his abdication, Shakespeare's Richard II flings away "the flattering glass," disappointed that it has never shown him anything but the face he had so unquestioningly accepted as the image of his royal self:

> Was this the face
> That, like the sun, did make beholders wink?
> Was this the face that faced so many follies,
> And was at last out-faced by Bolingbroke?[16]

Jean-Jacques Rousseau invoked nature to oppose the artificiality of court life, thereby articulating the transition from the courtly to the bourgeois face. "I hate the masks," one of his characters says. "One no longer dares to appear as one is," but rather stands "in this herd that they call society," always under pressure to conform or dissemble. One becomes alienated from oneself when involved in the games that determine courtly life.[17] Thus there arose "inequality among men," as Rousseau's famous book title states—and this is contrary to nature. But what is the real face? It was not enough simply to discard the mask and become completely human. The face needed a new kind of nurturing in order to express that which is natural. But the dream of the true nature of man was not to be fulfilled. For a time, the desire to express oneself resisted the pressure to play a part that was dictated by court life. One was not allowed to assume a role outside of court circles. The martial call for

the natural, real face served the cause of liberation from the mask that the courtly face had demanded.

Rousseau's contemporary, Louis-Sébastien Mercier, did not see his role as that of an accuser, but rather as a chronicler who described the court with ironic distance. He writes that everyone there had practiced and learned his own face, and "the women alter their physiognomy even more than the men. And yet all these faces, despite their masks (*malgré leur masques*)," do not conceal the passions that consume them. Mercier was not able to describe everything because he was never granted entrance to the innermost chambers. "Yet one may be sure that one only sees surfaces there and that all these personalities are mere figures in a tapestry. The work of the face is concealed behind the fabric (*le travail caché derrière la toile*)."[18] This commentary was written a few years before the French Revolution, when the whole phantasm would disappear only to be replaced by faces imbued with republican passion. The era of the Enlightenment saw the proclamation of universal human rights that transcended the existing social order. We can understand the studies in physiognomy, like those produced by the Swiss pastor Lavater, as a campaign against the courtly role of the face, for a goal of physiognomy was to graphically convey the greatness of man without a mask. Yet the euphoria lasted only as long as bourgeois society existed. Once the modern mass media had homogenized the faces of the masses, it became clear that we had not escaped the mask forever.

The concept of mimic gesture or facial expression, which has its roots in ancient mime, was not applied to the face until quite late. In 1785 Johann Jacob Engel, the tutor of the Humboldt brothers, published a book about acting under the title *Ideas on the Mimic Art* (*Ideen zu einer Mimik*). For him mimic art was a general concept applied to theatrical craft without being restricted to the face in particular. For the concept *Mimik* his French translator substituted the words *geste* and *action* to better capture the contents of the book, yet the use of the word *Mimik* demonstrates how close he considered the connection between drama and face to be. If we carry this idea even further, then mimic gesture would be the drama that someone produces with the face.

The concept of the character mask—actually a contradiction per se—harks back to a tradition of equating characters with their roles in society. In Rousseau's day the debate about the true character of a human being had become a major topic. The goal of physiognomy was to determine character from the face without identifying it with individual facial expressions. Jean Paul characterized "the face, or a person's exterior" as "the character mask of the concealed self."[19] For Diderot, "in comedy character was the primary focus and social class [*état*] merely something incidental." But he wanted that to change, for he believed that one enacted primarily one's own social class and "could not possibly fail to recognize one's duties."[20]

Marx took up the concept of the character mask in order to describe roles such as feudal lord and vassal in the social production process. These he called "economic character masks."[21] In the works of Kant the concept is sometimes used descriptively and sometimes normatively—for example, when a lady of rank is excluded as a representative of a "particular character."[22] A "particular character" was consequently seen as a male privilege.

The debate over gender has reinvigorated the question of roles that are played out in masks. There has been a penchant for describing gender roles in which being and seeming alternate in the face as "masks" with which the sexes arm themselves. But they also exert pressure against which the wearers rebel. Gender theory proceeds from the differentiation between that which is biologically determined and that which is socially constructed.[23] In modern society transvestites engender particular rejection because of their infringement upon accepted social rules. As early as 1929 Joan Riviere presented arguments that were then extrapolated in the gender debate. If the "gender role" is a mask, then who inhabits that role? Riviere did not wish to recognize any subject who stood behind the mask and used it.[24] She speaks of a "mask of womanliness" as well as one of "femininity." If, however, no female subject acts behind the mask, then the difference between femininity and mask collapses. Genuine womanliness and the mask, according to Riviere, "are then the same."[25]

It was precisely this assertion that created controversy in the gender debate. Subsequent to this, Judith Butler (in *Cultural Studies*) found the formula for a multiple and variable *identity*. When a gender role is played with changing masks, there is no true contrast between the self and the mask.[26] Sexual difference, according to Ina Schabert, is a cultural construct that consists of an interplay between roles and masks. The gender masquerade has access to gestures of power as well as those of anxiety, but also permits acts of liberation. If no unchangeable gender exists, then the "mask and that which is behind it cannot be clearly and permanently divided." Gender is only "culturally predetermined and recalled" through disguise.[27]

MASKS OF THE SELF The antithesis of the concept of the role is that of the self, but this in its own right is subject to the pressure of roles. The right to our own self brings up the question of what the self is, and that leads to the further question of the trustworthiness of its expression on the face. The ego is directed by the impulse to express a self, which is unable to show itself "by itself." The face belongs to someone who is unknowable without a face. From the face we can read collective attributes such as age and sex, but does the self also find expression in these? It is hard to penetrate the relationship between expression and face. The expression of a face is created by the work the face does, during which expressive gestures, gaze, and voice alternate, each dominating in turn.[28] The face is thus more stage than mir-

ror. When the expressive work stops, nothing remains but an empty stage. Only in death does a single mask triumph over the many that come and go on the face.

The impulse to represent the self produces many masks on the same face. These are related to the effect we produce on others. The world sees us by our faces. But the play of facial gestures transforms the face into masks. Even the act of speech is always supported by facial gestures and by the gaze. This fact can be easily observed with users of mobile telephones who run through their entire repertoire of expressive gestures without being able to see their conversational partners. Without pausing, we change from one and the same mask by retreating into some and showing ourselves in others. Yet who are "we"? And what, or whom, are we representing when we represent a self? There is no stable relationship between the face and the self and no reliable likeness. In fact, we are always practicing self-expression anew with our gaze, voice, and expressive gestures.

We have to pose the disquieting question *of whether or not we create a self only in order to express ourselves*. In particular, our will and our compulsion are especially visible in representing the self—or conversely in concealing it. This cannot really be depicted on a face, because one's self (no matter how we describe it) cannot ultimately be portrayed. And yet it only forms itself when it is depicted. Is it, then, only the mimetic impulse to represent ourselves to others that produces the self? Erving Goffman suggested the concept of *face-work* for a behavioral pattern that is coordinated with the face or that aims to preserve the face. But is "the face an image of the self," as he writes? And does a self exist that is not already an image when it *expresses* itself? That is a tricky problem of images, which leaves unanswered the question of whether a self only comes into being through the work of the face or exists in the sheer will to self-expression.[29]

If we follow this thought a bit further, we must entertain the possibility that self-expression (in contrast to self-consciousness) is primarily calculation and mask. One cannot pin the self to the images that it produces on the face. Nothing is visible but the fact that a relationship of intention develops between the expression and the bearer who wishes to display it. Even the ego—a drive that begins when the child first says "I"—is therefore willful and mercurial. The self differentiates itself from the ego just as the understanding of the self does from the sense of ego. The self does not express itself in a spontaneous situation, but rather in the biographical history that is reflected again and again, and always differently, in a face. It is not in the single face, but rather in a series of faces beginning with practice in childhood, that there emerges a coherence that is difficult to analyze. It is this coherence that we usually accept as a self, which both changes and coalesces as one ages. The traces of age, which are engraved in the face, are testimony to the self in the unity of

its life history. Only the presence of the "past" in the "present" provides the coherence of a life context. And the expressive-mimetic effort to produce a self leaves behind "mimic lines" (wrinkles, folds, and lines produced by the expression of emotion) as traces in the face.

In the case of the mentally ill who lack facility of expression and the ability to read the facial expressions of others, a lacuna opens up in the self. They have no access to the presentation of a self because they lack a way to express it. This became evident in experiments on such patients when they were asked to interpret faces and masks in Rorschach tests. Roland Kuhn, who led the experiments, had been the assistant to Ludwig Binswanger, a psychiatrist who had treated Aby Warburg. The subjects in the experiment demonstrated their incapacity to express themselves with their faces by the way they experienced other people's faces. They perceived nothing but lifeless masks everywhere. The blankness of the face was not intentional on their part; it was rather an inhibition of expression that they could not produce consciously.[30]

We are certainly engaging in a Western discourse when we talk about a "self" that has been equated with the independent subject in the course of its history. By contrast, when one speaks of self-expression, one means something different. In that instance we are controlled by rules that society has designated as communicative behavior. Like every social act, self-expression is part of a particular culture and reflects a position in the society that has formed it. This can be demonstrated in Europe through the example of courtly society, which was explicitly a society of masks.

In his *Meditationes de Prima Philosophia*, Descartes postulated an ego behind the face without actually correlating the face to the expression of this ego. "I do not know precisely who I (*moi*) am, but I am certain that I am." He thus refused "to consider anything else to be my 'I'" (II.5) even though his own body attempted to deceive him about that (II.7). "The 'I' has a face," but this merely belongs to the "machine of flesh and bones such as one finds upon a corpse and which I call body" (II.6).[31] In the same century Thomas Hobbes shed new light upon the relationship between person and mask. He claimed that even a specific individual could take over the leadership within the commonwealth. The first part of *Leviathan* thus ends with a chapter about the person and one's rights to representation. "Person in Latin means *disguise* or the external appearance of a human being played upon the stage." All those who give a speech or appear in public have been actors, although they were not acting upon the stage but rather in public life.[32]

For Hobbes the differentiation of person and actor lay in the fact that a person represents himself and is thus a "natural person." Hobbes distinguishes this from an "artificial person," whether or not this is an actor or someone who publicly repre-

sents a group with voice and body ("by fiction"). A multitude of people therefore becomes one person when represented by a single person. For this to happen it is necessary to have a contract similar to that between author and actor in the theater; only then can a representative embody the multitude and speak in its name. The argument is expressed in the frontispiece of *Leviathan* by the famous figure of the state. It is an "artificial person" whose design embodies the many who have contracted with it to do so.[33] This is first and foremost political iconography, especially because the state embodies an accumulation of its citizens. But Hobbes also visualized a personalization of the state—namely, through a living representative and thus through an "artificial person" who represents a plurality just as a "natural person" represents his individual identity.

THE CULTURAL HISTORY OF THE FACE The mass media make the semiotic character inherent in faces legible in the same way that masks did in earlier ages. They confront us in television as disembodied surfaces that no longer permit an exchange of glances with the viewer and, in this respect, also correspond to the former dynamic of the mask. The so-called facial society (to use Thomas Macho's term) has usurped the mass media of the face and produced a new type of "prominent face."[34] "We live in a facial society that continually produces faces."[35] "No one dares to appear on a billboard without a face anymore." "Facial politics and advertising aesthetics" have not only politicized the face, they have also commodified it. "Faciality," consequently, is no longer derived from the natural face, but rather usurps our screens with a blank facial formula. With his own now-anonymous face the viewer consumes faces on the screen; these show projections of the power structures of society. The public face has produced its own mask.

Such facial masks also arise in public life when a speaker stands in front of a screen that shows his face enlarged to gigantic proportions. He has become a speaker of his own mask in order to offer the public an encounter via television. Even in the theater it has become customary to show the face of an actor in close-up on video. By bringing his face near us in this way, the face unintentionally becomes transformed into a mask through the process of magnification. In our everyday life the transformation of our own face seems to be limited to coiffure and makeup. Hairdressers have more business than mask makers. In the case of the public face, even coloring one's hair is significant. In spring 2002, Gerhard Schröder, the German chancellor at the time, instituted legal proceedings in response to the accusation that he had dyed his hair—a claim that his barber, Udo Walz, strenuously denied. Schröder won the court case. The public considered coloring his hair to be a deception about his appearance. Yet the debate about the chancellor's "real face" overlooked the fact that he nonetheless employed a media face in order to win over the electorate. According to one news

agency, it was a female image consultant, of all people, who had noted that Schröder would lose credibility if he were to cover the gray at his temples.[36]

In private life the mask is always present, whenever one tries to restore one's own skin (and what is the mask if not a second skin?) by using makeup and creams. In doing so one can only achieve a kind of contrived beauty. In the most extreme case a cosmetic mask is a borrowed face that depersonalizes the original one. This applies all the more to the wish to have one's face operated upon for the sake of beauty, at the cost of losing similarity to the face one was born with. A special case in cosmetic surgery addresses the desire to have one's own face transformed to resemble a famous face. Some people prefer to walk around as copies rather than wear and tolerate their own, unloved, everyday faces. This is not mimesis of one's own self but rather of an alien ego and its mask. In 2004 the American MTV series *I Want a Famous Face* presented people circa age twenty who had undergone "drastic plastic surgery to remodel their faces to resemble their favorite celebrities.[37]

There is some justification for speaking of "facial masks." But haven't masks always represented or resembled faces? Why else would they have been invented? Yet today the situation is made different by the fact that the mass media create only disembodied masks, which are all produced, observed, and broadcast as faces. These either deny their masklike character or lose it completely through over-familiarity. Faciality has become the branding of masks, which have replaced faces. In the event of the death of a prominent person, pictures from their lives are published because the media can broadcast only living faces. Faces can only be consumed when their image displays life. But it is precisely this life that is the life of the mask.

Despite this assertion, the argument about mask and face is not tautological. Mask and face cannot offset each other, even though their relation to our media society has become opaque. *Face-to-face* contact has retreated from the Internet, where the name Facebook evokes the private face, despite its faceless texts. Mass media rob the face of its corporeal presence by disembodying the habits of our perception. The "public" or "prominent" face—the omnipresent *face*—is no longer the expression of a particular social stratum because fame is created only by the media. In this age of globalization, the face has also been globalized and is no longer restricted by local physiognomies. This process, which inundates us with facial masks in our media age, does not follow a linear or inevitable progression like that of the unstoppable trajectory of the media. Natural faces are still being born, and the development of the media is still reversible in many parts of the world.

The continuity of the history of the face can thus be postulated if we understand it, not as *natural history*, but rather as *cultural history*. Seen from the perspective of natural history, the human face has developed a very specific set of mimic

gestures in incremental steps that probably preceded the means of communication through language as we know it. The face possesses its own capacity for expression, just as the gaze controls the capacity to recognize expression in other faces. The lack of these abilities has become an area of clinical research today.[38] Culture, on the other hand, always tends to control expression, thereby socializing it and emphasizing collective standards, expectations, and taboos. Even the mask is an invention of culture, whether it originates as the living face or is worn as a man-made object.

Thomas Macho traces the "proliferation of faces" back to modern techniques for reproducing portrait images.[39] With the portrait there began a new history of the face, which the icon inherited and which represented an individual's role in society. On the eve of the age of mass media this was accelerated and democratized by photography. Now there was no stopping the face, which became ever more dominant and simultaneously disembodied in the frenzy of reproduction. Modern consumption of the face caused a backlash of nostalgia for the true face, to which the aesthetic of Georg Simmel and the ontology of Emmanuel Levinas belong.[40] In modern art "the slogans of facial politics and advertising aesthetics" (to quote Macho again) are subverted in order to reclaim the face from ever-present consumption. The history of the face ultimately proves to be a history of society, which imposes itself on the face and finds itself reflected there.

A further explanation for the omnipresence of the face, which can also be seen as the crisis of the face, is offered by Gilles Deleuze and the psychiatrist Félix Guattari in *A Thousand Plateaus*, a book that has become a classic. Their argument can only be understood if one realizes that they are trying to come to terms with the colonial history of the white man. In what was formerly Christian Europe, the authors find that there was always "an abstract machine" at work, projecting its claim to power onto the face, as though upon a "perforated screen." In their chapter about signs they write, "the mask does not conceal the face, it is the face. The priest uses the face of the god. Everything public is only so via the face."[41] And in the chapter "Year Zero: Faciality," they state apodictically, "what counts is not the individuality of the face," but rather the schematization by a single standard to which it is subject. "Certain power structures have the need to produce a face, and others do not . . . the face is the typical European." The authors, therefore, see salvation in a deconstruction of the face in order to liberate themselves from the fetters of the colonial period.[42]

One could, however, imagine a different solution and cite the history of the face in other cultures as an alternative. Deleuze and Guattari have also traced this line of reasoning, but set themselves a new barrier at the outset, in order to defend their argument about modern "facialization" (*visagéité*).[43] Their premise is that "primitive peoples have no face and do not need one." But when one examines the

history of the mask in sacred ceremonies, as we shall be doing in this study, one reaches different conclusions. The ceremonial mask clearly dominated the body of the wearer because one needed more face than the body was able to provide. Deleuze expanded the argument from *A Thousand Plateaus* in his book on the painter Francis Bacon, when he claimed that Bacon was "a painter of heads, not of faces."[44] Some critical caution is appropriate here, because Bacon did not oppose the face per se, but rather portraiture, in order to liberate it from its conventions. In doing so, his goal was to make it expressive in the scream, which finally and ultimately destroys the mask and strips it of representational conventions.

For Deleuze and Guattari the concept of an absolute distinction between head and face is definitive. They designate the head as part of the body, whereas they separate the face from the body, because the face serves as a carrier of expression and thereby dominates the body. This thesis is far from astonishing. In cultural history we also find many examples to show that the face was often disputed and, one might say, abused. The problem arises when one begins to search history for those guilty of imposing power with the face. In this case both authors make the face of Christ responsible for the authority of the face over the body. In Christianity, however, there was never any "Zero Hour" for this image. Christianity distanced itself radically from the Orient and its imageless origins in later centuries once it had elevated the icon of Christ to a cult image.[45]

In 1992, approximately ten years after the first appearance of the book by Deleuze and Guattari, the Fondation Cartier in Paris dedicated an exhibition to the face (*À Visage Découvert*), which represented a position contrary to that of the two authors. The exhibition presented a broad panorama of global cultures in which the face was revealed not as a stiff template, but as an open form, which constantly crossed the boundaries between presence and representation (or absence), between near and far.[46] In this panorama the face is either veiled or surrounded by images that open up a multiplicity of associations and reveal the face as a focal point of mythical, religious, official, and intimate imagination. The face is thus an image that is transformed through other images and also transforms images in and of itself. The cultural history of the face is image history that has its origins in religious ceremony.

2

THE CULT ORIGIN OF THE MASK

The history of the human face begins in the Neolithic period with masks that represented or replicated faces. Masks are evidence of the oldest human concept of the face.[1] The beliefs of early, preliterate cultures about the face were expressed in ceremo-

nial masks that gave faces to spirits and ancestors so that they might appear in religious rituals. Such masks also contain statements about the living face, which was understood as a vehicle for social codes controlled by society. Masks that transformed the face could be painted on or placed over it as artifacts. The production of masks was intended to make them correspond with one expression, over which society could claim the right of disposition. They served as official proxy faces for spirits of the dead, who had lost their bodies. There thus developed a universe of masks that encompasses almost all known cultures. The variety of forms and interpretations is virtually inexhaustible. And yet it is always the face—whether as foil or model—to which it corresponds. Even when a mask concealed the face or was presented by an anonymous wearer, it nonetheless brought a new face into view. The meaning of this face was agreed upon by social norms or comprehensible only to initiates.

In Europe the mask suffered the loss of such significance very early; today it often survives only in folklore or during carnival season. Yet it remained a memory in the theater, which in antiquity had secularized the cult of masks and introduced them to the stage in order to identify various dramatic parts. This was the role mask. The object of the following remarks is not only to view the mask as a subject for ethnology but also to restore its privileged place in the cultural genealogy of the face. This means that one must understand the face along with the masks that represent or dramatize a face. When one contemplates the cult of masks in general, one becomes aware of two structures that invite interpretation. First, there is the complicated and often dramatic relationship between mask and wearer, a relationship that was often surrounded with taboos if the wearer had to remain anonymous to avoid endangering the presence in the mask. Second, the dramatic presentation of the mask is often represented by the oversimplified shorthand notion of "the dance." In this context dance is really a collective term for the performative presence of the mask when it appears along with the ritually prescribed movements of a dancer who functions primarily as an actor onstage. In doing so, the man-made mask imbues itself with a life that it lacked when it was a mere object. In contrast to the face with its mimic expressions, the man-made mask possesses a stiff, blank surface until it is used in performance by a living wearer who gives it his gaze and his voice. At that point the rigid surface seems to erupt into movement, which is augmented by physical gesture during the performance. The mask ritual transfers the expressive drama of the face to the gestural drama of a wearer, who "embodies" the mask in the truest sense of the word by lending it the body with which it appears to awaken to life. When observers ask who is appearing in the mask, they are certainly not wondering who is acting behind the mask, but who the figure is that is being performed via the mask. The presence of the mask demands the

absence of its interchangeable wearer. Masks take command of the body more decisively than the face can, and they dominate the body that wears them. By transforming the body, they imbue it with a symbolic power that allows the expression to take on a life of its own. Roger Caillois called the mask "a medium of metamorphosis" and an "instrument of political power."[2]

The mask is simultaneously surface and image, which may also be said of the face, which offers itself as an image when revealed as the bearer of expression, and which can also be painted. The word *surface* contains the concept of face. Etymologically, a surface is a plane that lies over or upon a face. Similarly, the mask of a face is also placed upon the face. It consists of an outside, which we see, and an inside, which is not revealed to our gaze. And yet the openings that connect inside and outside make the mask permeable to the face it conceals. The mask was invented for a face, which it fits like a second face.

There is much evidence that the cult of the dead predates all other cults and religions. Masks affixed to corpses can be found as early as prehistoric cultures. In such cases the ancestors were not presented as part of a mask ritual, but rather represented by a likeness. It goes without saying that masks were appropriate for the dead after their faces had been lost. If one wanted to restore a face to them it could only be in the form of a mask, which took the place of a living face. In this we can see the roots of the human habit of producing images in general. From the ritual practice that employed masks, we may conclude that faces were also understood as images in life—namely, ones that could be reconstituted upon the dead without sacrificing visibility. The origin of ancestor cults and cults of the gods may also be reflected in the history of the mask. Yet there is a fundamental difference between a mask that covered the faceless corpse with a replica of the dead person's face and one that was presented dramatically in ritual.

Through the vehicle of the mask, the ancestors returned to the living in whose social framework their death had left a void. In doing so, masks reproduced the social characteristics of the living face, and possibly represented the local norms that a society practiced with the face. We find the epoch-making invention of the mask around 7000 BC in the Neolithic culture of the Near East.[3] These masks already show openings for the eyes and mouth, and one example in the Israel Museum in Jerusalem even has teeth formed in the opening of the mouth, as if the mask were beginning to speak (fig. 5).[4] The surviving examples show a smoothly polished surface and betray traces of lifelike coloration, which means that these masks were meant to portray authentic faces.[5] For whom and for what purpose were these masks intended? The heavy stone material eliminates the possibility of use by living wearers or dancers. The masks, for the most part, have holes around

FIGURE 5 Stone Mask from the area around Hebron, ca. 7000 BC (Jerusalem, the Israel Museum)

their edges, which served to affix them to something. It is possible that they were tied upon corpses during the process of decomposition. A further detail points to this explanation—namely, that there is evidence of a cult of the skull at the same archaeological site, which represents a different stage in this process. If one follows this argument, then the openings in the masks have no practical function but were rather symbolic in nature, for they could only have been intended for the dead. Millennia later masks returned to the Egyptian mummy where the only thing that was represented pictorially was the face, whereas the rest of the body disappeared under layers of linen strips.

The same Neolithic site complex also contains evidence of a second practice in the cult of the dead. This consists of real skulls covered with a thin layer of fired lime and clay fused together; the empty eye sockets are filled with seashells (fig. 6). In this

case the mask does not lie upon the face, but rather it is the face, for it is modeled directly onto the skull, to which it has restored the face that it once wore. In other words, in place of its living face, the skull has received a new, permanent one, which may then be understood as an image. In some cases, the skulls were mounted on small structures such as pedestals. This produced a composite entity consisting of skull (corpse) and image. The skull alone retained its complete form in order to carry a likeness. In addition to these skull statues, this archaeological site has also yielded face masks, which were separated from the corpse and buried face down.[6] A third group of artifacts consists of statues or dolls, which were probably only used briefly during the burial. An example from Ain Ghazal conveys an impression of how the skulls with the implanted eyes looked. (fig. 7).[7] The excavators concluded that the ritual practices regarding the skulls attested to an ancestor cult of an agrarian society. Nowadays, however, many details suggest a privileged treatment of the dead who enjoyed a particular social function and whose skulls were then used as cult objects.[8]

To interpret these finds, one must view the masks and their sculpted overlay together. The everyday experience of people with their dead was probably the most decisive factor here. They began with the impure corpse and ended with its purification in the faceless skull, which permitted culture to intrude upon nature.[9] Since that moment the question of the face in the mask has never been posed so profoundly, nor the answer framed so radically. This earliest practice introduces the dualism between visibility and invisibility, between displaying and concealing the image on one and the same wearer—on the body itself. The face has been exchanged for a mask once death has destroyed it. From the Stone Age masks we can discern how early the connection between face and mask entered the consciousness of human cultures. They suggest that the mask was understood as a copy of the face that one wanted to reproduce as a substitute for that face.

The practice of making death masks has continued into the modern era in ever-newer forms and has not only produced modern portraits but also stimulated spec-

FIGURE 7 Statuette from Ain Ghazal, 7000 BC (Paris, Musée du Louvre)

ulation on the part of intellectuals. It thus makes sense to recall that these are the origin and root of representation of the human face. The history of the face has always been one of the human image. The best known and most significant continuation of the prehistoric death mask was the death cult in the first high culture that developed in Egypt. The rich repertoire of image-making techniques appears in finished form as early as the third century BC. All forms, from the portrait to the complete statues in the round, have their origins in the mummy, which had withdrawn from human sight when inside the tomb, but was represented outside by images of the dead. During the mummification with wrappings that concealed rather than depicted the body, the practice was to emphasize the face through the use of a mask, which was fitted to the skull and seemed to gaze with the eyes of the dead. An especially early example from the third millennium BC (now in the Kunsthistorisches Museum [Museum of Art History] in Vienna) still bears traces of skull bandages on the inside of the mask (fig. 8). In this case the plaster mask sits directly upon the skull and thus reconstructs the face on the corpse as in prehistoric finds.[10] In such a second face, which could also be gilded in order to suggest eternal existence, the embodiment of the dead found its visual center.[11] An image substitutes for the face. The mask is the *new face*.

In the late period of Egyptian culture, when the country was under Roman occupation, the three-dimensional mask was replaced by a hybrid form, which

FIGURE 8 Skull of a mummy, overlaid with plaster, ca. 2300 BC (Vienna, Kunsthistorisches Museum)

FIGURE 9 Mummy portrait from Fayum, detail (Paris, Musée du Louvre)

brought panel painting out of dwelling spaces and into the tomb. The so-called mummy portrait (fig. 9) does not represent a mummy, but is actually a life study that was attached directly to the mummy in place of a mask. The young woman from Fayum, who looks at us from such a panel painting in the Louvre, presents a time-bound likeness from life, especially with her personal jewelry. This portrait presents a stark contrast to the timeless mask whose place it took.[12] This contradiction can be explained by very different attitudes toward death. With their funeral rites, the Romans introduced a procession of ancestors into public life. The wax portraits, of which a rare example from the necropolis at Cumae remains, were molds of the head, the realism of which emphasized elements of character or of family resemblance (fig. 10).[13] These paved the way for the portrait busts of marble and bronze that were objects of public veneration.

The ritual performed by the living has been of greater significance in the death cults of many cultures than either the grave cult itself or the preparation of the corpse. In this connection, the ceremonial mask was less an object than a prop for the role of an actor who embodied and summoned the ancestors. This brings up the question of image per se, which we encountered with the corpse in quite a different way.[14] Here it is not a question of how the mask looks; when and how it appears are the deciding factors. In such rituals the mask is the performance itself. We remain prisoners of a modern concept of the image when we think of dance and mask as

separate entities. The specialized disciplines that focus on either the performing or the visual arts are responsible for this dichotomy. Such a differentiation, however, falls short of accounting for image praxis in most cultures. A mask cannot be explained by its form alone, but rather through the cult ceremony in which it gains its significance before an audience of initiates. The cult ceremony endows the mask with life—life that the carved surface lacks—and imbues it with voice, gaze, and movement. The cult ritual transforms the mask into a face among faces—a foreign and often secretive one, but nonetheless a face to which the physical gestures of the dancer can give the impression of expressivity. For this reason, most research does not treat types of masks but rather customs surrounding masks, which express themselves in the various types formed by the mask carver.

In his book *The Way of the Masks*, Claude Lévi-Strauss describes transregional distribution and influence of masks among the Indians of the American Northwest. For them masks play a central role in creation myths because they illustrate narratives. "A

FIGURE 10 Wax death mask from the Necropolis of Cumae (Naples, National Museum of Archaeology)

mask never exists for itself alone, but rather refers to other masks, real and potential, which could have been chosen to replace any one of them. It is not merely that which it portrays, but rather participates with all that it simultaneously excludes. Like myth, a mask thus denies the existence of other masks by reacting to them, transforming competition or opposing it. For this reason the native peoples used masks as a means of communication in the service of diplomatic relations with distant relatives by expressing family relationship through symbolic and collective faces."[15]

In an interview given in 1960 to promote the exhibition *Masques* in the Musée Guimet in Paris, Lévi-Strauss emphasized the incredible variety of masks that this exhibition documented.[16] He noted that it was useless to seek "morphological similarities" among masks because their meaning only becomes apparent in the context of the local cult. He notes that communication took place via a different means than the everyday face. Masks that concealed and those that revealed could not be distinguished from each other: "each mask is both one and the other . . . the function of the mask is almost opposite to that of the word," which serves the purpose of direct communication between two people. "The mask interrupts this communication to create one of a completely different nature. It creates participation or correspondence, not exchange." What then do masks mean in different cultures? He further maintains that they fulfilled "a social function," and their assignment to "religion, secular society, or festival" expressed itself in different choices of style. Ultimately every ritual function produces its own mask. The mask is like "a woman wearing makeup, or a public person monitoring his own expression." Commenting on the modern culture of the commodification of the face, the ethnologist added thoughtfully, "in the moment of its defeat the mask celebrates its actual triumph."

We owe art historian Robert F. Thompson a debt for his contribution to the understanding of masks in particular African societies. He discovered a puzzling similarity between the fixed expressions of people in the throes of possession and the faces of various masks. Here the face of the person who was possessed resembled a mask when it was in the grip of an unnatural frozen expression.[17] The individuality of the one who is transformed is extinguished in the trance and through the wearing of the mask. The concept of trance is related to *transitus*, in the sense of transition, change, or transformation. Possession, as a condition in the mask, refers to the "possessed" body as being "occupied" by another being, which uses the host body as a mask. Strong taboos protect the anonymity of the wearer in the mask ritual. The protocols of the cult regulate the secret relationship between wearer and mask, but they also avoid the danger that spirits and ancestors within the mask would be surprised by the presence of spectators. Such taboos are basically an admission that the mask is a cultural construct whose security is strictly guarded by a community.

The mask as a "medium" gave indigenous cults a face in the literal sense. Fritz Kramer described a narrowly defined geographical region in Africa that has the most differentiated and contradictory mask forms and customs regarding the mask.[18] When creating thier ancestor masks, the Pende tribe chose an abstract type. Characters from the actual community, on the other hand, were represented by a realistic mask type. In the Katundu tribe "each mask received its own personal face," which makes it possible to identify portrait masks. The Afikpo people used a mask in which men could play the role of women and also people from other tribes. A mask called *beke*—meaning "whiteness"—had the explicit function of representing foreigners.[19] In this way the wide variety of masks was able to depict both social reality and religious experience in one local cosmology.

FIGURE 11 Anthropomorphic portrait mask from Vancouver Island, eighteenth century (Herrnhut, Museum of Ethnology)

Without even knowing much about the particular cult of the Nootka Indians on Vancouver Island, we can label as *portrait masks* some curious finds brought home by English sailors in 1778.[20] These are life-size masks with human hair that show individual facial features, sometimes including the entire head. Even the teeth are represented, but the eyes are closed to mere slits (fig. 11). These masks would be very difficult for living wearers to use in any ritual, and their massive wooden bulk suggests that they were probably meant for the tribe's dead, who were being prepared for cult purposes. Masks thus record the face as document and memento, like the European portrait. In contrast to the European portrait, however, most masks were not objects of contemplation, but rather vehicles of transformation and objects required for cult ceremonies. For that reason, they either were, or had to be, continually refashioned, whereas outworn or damaged masks that had served their purpose were withdrawn from use in order to protect them from curious gazes, a practice that is the complete opposite of exhibition.

Michel Leiris has provided a vivid description of mask customs from the Dogon people of the central Malian plateau in Africa. He wrote his report upon returning from the famous expedition from Dakar to Djibouti when Marcel Griaule

led a colorful group of surrealists and ethnologists through Africa in 1931–32.[21] He had been able to observe the "procession of the masks" (*sortie des masques*), which took place on the occasion of an important burial. The masks had been stored in particular caves, on the walls of which the elders had renewed the symbols of the masks in order to make sure that their forms could be copied correctly. During the dance of the masks the "wearers became the object of a great number of taboos. For example, one is not allowed to utter their names, for a mask wearer may not be recognized." If he were caught removing a mask, it would have to be destroyed immediately, for it was now contaminated and threatened its wearer. At the same time the wearer had to "speak only in a secret language." The Dogon also used their caves as places where termites could destroy their discarded masks.

3
MASKS IN COLONIAL MUSEUMS

The report by Michel Leiris was published in a special edition of the surrealist journal *Minotaure*. The connection with surrealism aligns this report with modern reception history in which the masks of colonized peoples figured. The foreignness of the mask, which holds fascination as an exotic object, was the motive for its colonial appropriation in the modern era. The mask was the absolute embodiment of the other in our Western understanding of the face, which otherwise simply viewed masks as deceptions. As a non-face it became a fetish easily subject to all kinds of misinterpretation. Anthropological interest became so crucial that every analogy to a real face was ignored. The collection and exhibition of masks in museums especially designed for them was a logical consequence. In such museums masks that had fallen into disuse or been removed from use became objects of study to satisfy ethnological curiosity.

Countless masks collected by colonial civil servants on their expeditions found their way into the archives of colonial museums where it was almost impossible to determine the provenance of the object. "Mask" quickly became a collective concept for all artifacts that came from the colonies. Yet for indigenous peoples, masks in African colonial museums were no longer masks, for they had been deprived of all meaning. Without the body language of a living wearer, they had fallen silent and mutated into objects with dead surfaces. The double separation of the mask—from the person who had worn it and the one it represented—turned it into an object for exhibition, which was not its original purpose. African languages do not have a specific lexeme for mask—for the mask was nothing more or less than the face it showed. Here the colonial masters were separated from the producers of the masks by an insurmountable cultural barrier.

This incongruity in dealing with the mask is vividly demonstrated in the making of life masks of racial types of so-called primitive peoples to exhibit in anthropological collections. Examples of these may be found in the collection of the Berlin Society for Anthropology, Ethnology, and Ancient History. These colorful molds date from around 1890 from the sculpture studio Castan's Panopticum, a Berlin waxworks museum (fig. 12). They were taken from plaster casts made by the Königsberg doctor Otto Schellong of natives of Papua New Guinea, which was a German colony at that time.[1] Once one had celebrated the unity of the whole human race, the new idea of evolution was used to draw new boundaries. The practice of making plaster casts—which was soon to be supplanted by photography and film—created a lifelike documentation of the variations among ethnic types.

Indigenous peoples were thus subject to a procedure that transformed their faces into objects for scholarship. Europeans turned the mask forms into display objects, whereas the masks the indigenous peoples had created themselves were sent to a different department in the museum. It is surprising that the same concept of "mask" appears in both cases. But the analogy lay in the fact that the living faces, like the cult masks, were exotic objects that satisfied Western curiosity and could be curated and exhibited.

Interpretations of African and Oceanic masks in the West went through several stages in which collectors, ethnologists, and artists have all played their parts. In this process a single mask, as an object for the Western gaze, could change dramatically without its appearance being altered. Rarely was any attempt made to give masks their place in a cultural history of the face. There remained a blind spot in the theoretical literature about the face that consistently compared it to the physiognomy of Caucasians. In addition, the face was always seen in the context of Western media history, from painting to film. New concepts of the face, as mirrored in masks, were relegated to the ethnologists and therefore marginalized. Ethnology, however, has seldom been able to provide a survey of the social praxis of faces and masks in one and the same place.[2]

The concept of fetishism enjoyed such currency in the nineteenth century that it became an obstacle to viewing the mask as a representation of the face. The colonial use of the word *fetish* originally meant nothing more than an alien, incomprehensible man-made object. It could not be encompassed by any European concept, not even the concept of the image. Fetishes were often understood as witnesses to a primitive worldview in which inanimate objects could acquire magical significance.[3] As trophies for collectors, masks lost their original function purely through their tangible characteristics. When he developed the thesis of commodity fetishism, Karl Marx was familiar with the anthropological writings of Charles de Brosses.[4]

EIN MEDIUM WIRD BESICHTIGT

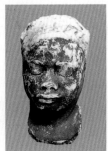

*Auf Papua-Neuguinea 1886/88
entstandene, in Castan's Panopticum
1890/94 gefertigte Gesichtsmasken,
die in unterschiedlicher Qualität
überliefert sind*
[Anthropologische Rudolf-Virchow-Sammlung
der Berliner Gesellschaft für Anthropologie,
Ethnologie und Urgeschichte am Medizinhisto-
rischen Museum der Charité Berlin]

Lebendmasken aus Papua-Neuguinea

D2-1

FIGURE 12 Life masks from Papua New Guinea made ca. 1890 by Louis Kastan (title page of "Castan's Panopticum," no. 6, Berlin 2009)

The analogy lay in the fetishizing of goods, which was determined by a buyer or collector and not intrinsically by the object itself. The now voiceless fetish was compared to the practice of its "primitive" origin without recognizing the fetishism inherent in this Western appropriation.

This is not the place to follow the direction in the avant-garde that reassigned the mask to the body of "Negro art," a concept later labeled "primitivism." It will suffice to cite a text from the classic book by Karl Einstein, which appeared in 1915 under the title *Negerplastik* (Negro sculpture).[5] "The mask only has meaning when it is impersonal, free from the experience of the individual. . . . I would like to call the mask frozen ecstasy . . . the strangely blank expression means nothing more than ultimate intensity of expression, freed from every psychological origin. . . . In masks there speaks the power of the Cubist gaze." Here the mask has been reduced to an aesthetic experience dominated by the awareness of cubism. There is no talk of the face here, and the mask's distance from any kind of portraiture is interpreted as midwifery for greater abstraction in which Einstein celebrates the birth of Modernism. In November 1914 the photographer Alfred Stieglitz mounted an exhibition in his New York gallery titled *Statuary in Wood by African Savages: The Root of Modern Art*.[6]

In 1926 the Parisian Gallerie Surréaliste opened with *Objects from the Islands* (*Objets des Iles*), which were then contrasted with works by Man Ray. The cover of the catalog showed a photo by Man Ray, which he claimed depicted the full moon over the island of Nias behind an Oceanic statue that was on display in the show and originated on that island (fig. 13). What we have here is a literary-artistic movement, which James Clifford aptly characterized as "ethnographic surrealism."[7] In contrast to ethnology, people carried on their own cult of masks and rare *objets*, upon which the literati imposed their interpretive authority. All barriers of time and origin had fallen, for the *objets* were simply "surreal" and could thus no longer be categorized with certainty. The page had turned in the interpretation of the mask, which was now relegated to the shorthand category of the "erotic, exotic, and the unconscious," as Clifford wrote about the entire movement.

The same year, 1926, saw the exhibition of Man Ray's arguably most famous photograph, *Noir et Blanche* (Black and White) (fig. 14). The black-and-white photograph has a double subject: mask and face. Kiki, Man Ray's model from Montparnasse, lays her face upon a table like an object while holding up a mask from the Baule tribe of the Ivory Coast right beside her own face. The difference between face and mask is consciously subverted in order to force a comparison between two fetishes. The Parisian model's face is entirely a mask here; the African mask is entirely a face. Whitney Chadwick reminds us that Man Ray did not first publish the photograph in a fine arts journal but rather chose the fashion magazine *Vogue* instead.[8] The

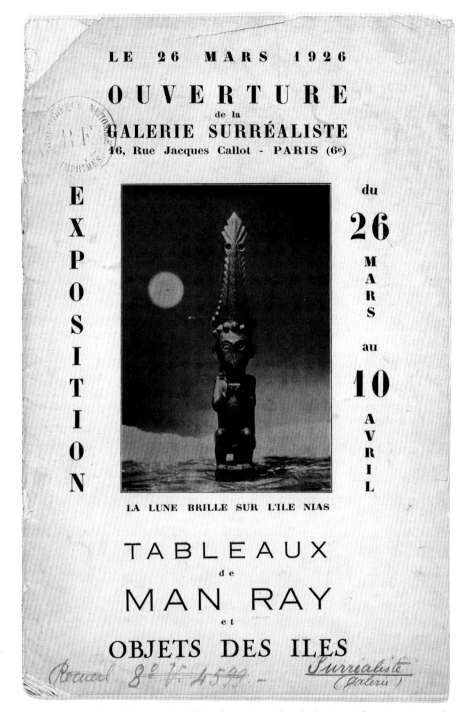

LE 26 MARS 1926

OUVERTURE

de la

GALERIE SURRÉALISTE

16, Rue Jacques Callot - PARIS (6e)

E
X
P
O
S
I
T
I
O
N

du

26

MARS

au

10

AVRIL

LA LUNE BRILLE SUR L'ILE NIAS

TABLEAUX

de

MAN RAY

et

OBJETS DES ILES

Recueil 8° V. 4599 — *Surréaliste*
 (galerie)

FIGURE 13 Cover of the exhibition catalog, *Tableaux de Man Ray et Objets des Iles* (Paris, Gallerie Surréaliste, 1926). © Man Ray Trust / Artists Rights Society (ARS), NY / ADAGP, Paris 2016

accompanying text spoke of the "face of woman" (*visage de la femme*), which is still connected to primitive nature and which therefore—through her sex and her foreignness—engenders both dread and fascination. The passive and smooth face of the woman oscillates between the primitive mask (an object or mercantile commodity) and nature. This establishes the colonial contact with the mask in a dual way, imbuing it with arbitrary meaning without any reference to its origins. When the photo was taken, "*Negrophilie*" was very popular in Paris. In the *Revue Nègre* in the Théâtre des Champs-Élysées, Josephine Baker was the celebrated star

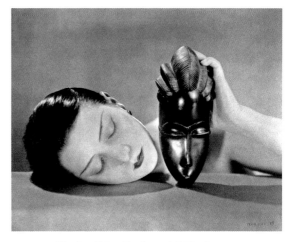

FIGURE 14 Man Ray, *Noir et Blanche*, 1926. © Man Ray Trust / Artists Rights Society (ARS), NY / ADAGP, Paris 2016

as well as the embodiment of the mask that was familiar as a collector's item. Man Ray's photograph fascinates by virtue of its forced analogy between a face that, like an African mask, actually is an object and beside it, a face with closed eyes that *functions* as a beautiful object of desire. Through this coexistence the dual staging eludes any statement about the mask, which is subject to the collector's gaze, as well as any statement about the face, reduced to a fetish of consumerism.

At the time, the surrealists were fascinated by rare objects that coalesced to become "poetic objects." They collected ethnographic curiosities in order to re-create them with their own gaze and endow them with an existence in their world. In the 1920s André Breton, the so-called founder of the surrealist school, surrounded himself in his studio with a collection whose unity existed only in his own mind and whose heterogeneity he emphatically denied.[9] He consistently had himself photographed among his works and masks. His collection reflected his inner world. He encouraged his artist friends to hang their works beside masks and fetishes. When the Musée Guimet opened its exhibition *Masques* in 1960 (which has already been mentioned in the context of Lévi-Strauss), Breton wrote a manifesto of his worldview, which made history at the time.

Breton's text "Phénix du Masque" alludes to the mask as the mythical bird that rises from the ashes.[10] The author claims authority from a book of masks from 1948 in which the anthropologist Georges Buraud traced the mask back to the face of the Sphinx. The mask, according to this book, does not seem to belong to the body that wears it. Rather, it is born from it and, in its own way, expresses its secret. "The

Sphinx is a mask," just as "women wear masks some days." Breton reminds us also of death masks, such as "The Beautiful Anonymous Girl from the Seine," which confronts us with images from our own memory. "The mask—for primitives, an instrument of participation in the world of occult powers—has not yet reached the end of its career. Nothing about it is obsolete." Anyone who views the mask, however, without the emotional "bonds" that touch "our deepest drives" will always fall short of understanding the true problem. Yet what is "the true problem?" Contrasting this poetic essay with the ethnological explanation of Lévi-Strauss, both of which arguments derive from the same exhibition, shows that interpretations, be they poetic or scholarly, belong to a given discourse, which reflects itself. The question of the history of the face—evident in the various mask cultures—was, however, not posed.

4
FACE AND MASK IN THE THEATER

Since the origin of the theater, the mask has been inseparable from its history. Throughout this evolution the mask has been subject to changing interpretations. On the stage ancient customs of the mask from cult ceremonies developed from those that once invoked gods and ancestors.

The age-old mask ritual returned as a representation of living people who, as figures in a drama, were made recognizable through masks. The choice of a recognizable mask was the choice of a role. In modern times, however, the mask of antiquity has vanished from drama. This change introduced a "facial presence" in the theater in the course of which natural faces took over the role of expressive masks. Even in the Commedia dell'Arte, Harlequin, who is more a type than a person, wore a half mask. The placement of this on his face made his role transparent to the audience. During the baroque period, the tragedies of antiquity were recast in new guises, which demanded of their character actors deepest expressions of feeling, thereby forcing the actors to use their own faces.[1] "The mask fell, and gradually the actor entered into the transformation with his own body," as Helmuth Plessner stated in his essay on actors.[2]

The lack of distinction between face and mask requires us to look more carefully at the process in which the mask became united with the face and then returned as a face. Roger Caillois spoke of the "gradual disappearance of the mask as a medium of transformation," whereas the face itself, instead of the mask, became the medium of transformation that was performed as a mask.[3] In modern times the mask is a role that is played with the whole body. For the most part we have forgotten this when we speak of a mask of deception and lies. And yet the training of the

face was not possible without the memory of the art mask. The search for the legibility of the face in the study of physiognomy appeared at the same time as the performance of the face upon the stage. With that, the interaction between theater and life proceeded in two directions at once. This process was expedited by the fact that modern theater was a product of courtly culture and its rules of conduct. One performed onstage as one was meant to behave at court.

Since art masks are no longer worn onstage, the actor has embodied the character or the role to be played with the expressions and speaking style of his own face, which he employs like a mask. The public has become accustomed to perceiving face and mask on one and the same surface. We thus applaud an actor who has performed a role so well that his own face has become a mask. Even the voice of the actor participates in this transformation because it is used as an acoustical mask, which simplifies the differentiation between face and mask. The *drama* has remained a memory of the old "*masquerade*," for it derives its life from the masks that denoted specific roles.

Helmuth Plessner spoke of the delineation of an image (*Bildentwurf*) when the actor transforms himself during the performance of his role.[4] But the image, which was so important to Plessner, is inadequate unless it also includes the face, which transformed itself into a living mask upon the modern stage. The mask is the role, but it is played with the real face. It is precisely in the face that the human being's dissociation from himself shows most clearly. That is to say, he can represent himself as someone else using his own face and, as a result, behave eccentrically. In the figure of the actor Plessner recognized how much human nature, which consists of imitation and play, relies upon images. This is also true for the audience members when they recognize the actor in the role and know that his face is real.

The masked drama of antiquity developed firm rules that made rigid types of masks and plots transparent to the audience. The wearers performed their masks as readable signs. In the modern period the same semantic expectation is in force in the theater, as well as in public life. A new relationship has developed between these two. In life the face surrendered to a society that read character in it and measured the wearer according to social norms—norms that were rendered powerless onstage. As a hostage to public attention, the face could not hide in public, but only disguise itself—in other words, use a mask. In the neo-Stoicism of the seventeenth century we encounter the paradoxical formulation of an "honorable or permissible disguise" (*dissimulazione onesta*), which is the title of a work published in 1641.[5] This was understood to mean the legitimate resistance to the infringement of public life upon one's own face.[6] For the Dutch philosopher Justus Lipsius it would have "displeased a beautiful soul when she cried out: *Banished*

are deception and concealment from human existence. In private life certainly, but not exactly in public life, for this would be impossible, even for one who held the whole Republic in his hands."[7] In the theater the goal was either the expression of feelings, which had to be intelligible and thus playable without masks, or else excesses that could only be performed in disguise.

In order to survey the further life of the mask in the modern period, we need to look back to antiquity. When we consult the use of language in the ancient world we encounter two idioms regarding mask and face, which diametrically oppose each other. In Greek the concepts for mask and face were one and the same, whereas Latin speakers separated the two conceptually. This difference reveals two completely distinct modes of thought that relate to the theater. The Greek word *prosopon* meant the face as it is seen—in other words "before our eyes." The face is defined as that which reveals itself to the gaze of another.[8] To some extent, the concept for the face as an object to be gazed at exists in the accusative case. Sight (*Sicht*) and face (*Gesicht*) became inseparable. The mask, however, became the face of the actor who wore it. It was, of course, with his real eyes that the mask gazed outward. The death mask is absent from Greek culture, for the Greeks were a people who hastily removed the gazes of their dead and cremated them. The face created a crisis of the gaze when it was disfigured. Late Greek literature clearly shows a reaction against Roman theater and its concepts as when, for example, it speaks of an artificial mask (*prosopeion*), which is differentiated from the "real face" (*autoprosopos*) or from the "naked" (*gymnos*) face. Yet these linguistic formulations all converge in the same concept. The church father Gregory of Nyssa railed against immoral theatrical masks, which in his words, "obscured God's creation with unnatural colors." He claimed that, instead of wearing masks (*prosopeia*), one should show one's own face (*prosopon*), which is in the image of God.[9] We now find ourselves in an era when the theater is already encountering philosophical misgivings.

Peter Hall, the founder of the Royal Shakespeare Company, chose *Exposed by the Mask* for the title of his Clark Lectures.[10] The word "exposed" represents a paradox for masks, which conceal. For Hall, however, the mask expressed a "quintessence of emotions." It served as a medium for expression, and not only in the powerful transcendence of nature, as in the translation of life into art. "By hiding, we reveal." The Greeks, according to Hall, introduced the mask in order to separate theater from life. Through its strict control of a single expression the mask had more authority than the uncontrolled face, and thus it became a tool of the imagination as long as a play lasted. It was only deployed in frontal view because it confronted the public directly. "The mask is therefore always presented to the audience, telling the story of the character."[11] According to Hall, the mask is nowadays worn

invisibly, in contrast with the modern era. The actor uses his text (or, in the case of Shakespeare, the verse form) as a mask. He brings this text so completely to life that he becomes the mask: "the mask becomes him."[12] For this reason Hall ruthlessly attacks the practices of contemporary theater direction, which do violence to the text and tear off the mask. "In reality contemporary theater has not given up the symbolic character of representation, but has begun to deny it."[13]

It is generally true for the Greek mask that it does not conceal, but rather shows the face that presents a figure first created in the theater. The entrance of Dionysos was an exception. He was played in the mask of a Lydian foreigner who visits Thebes. Dionysos, in whose name the Athenians produced theater, was honored in the cult with a mask, a *prosopon*—a mask that hung from a column wreathed in ivy. In the theater this was used in a linen replica, as Erika Simon has described.[14] Jean-Pierre Vernant, anthropologist at the Collège de France, described the mask of Dionysos using the example of the *Bacchae*, the last play by Euripides. Here the foreigner embodies the god with his laughing mask in a tragic context. For Vernant the unity of wearer and mask was suspended in this special case. "Dionysos reveals himself in concealment and is recognized by the fact that he disguises himself (*en se dissimulant*)."[15]

Because Greek masks were made of fragile materials, only a few are extant. The best example comes from an archaeological site from the period around 500 BC, the time of the birth of the theater in Athens (fig. 15). The mask, which is made of fired clay and is in the collection of the museum in Syracuse, comes from Megara Hyblaea, one of the oldest Greek colonies in Sicily.[16] Everything in this face is concentrated on the wide open mouth and penetrating eyes, in other words, on the openings behind which the concealed player acted. The speech of the large-lipped mouth, which is thrust forward like a megaphone funnel, is thus amplified, as is the powerful gaze of the sharply cut-out eye openings, which act like fathomless pupils. The mask represents a face in action and does not relate directly to archaic faces designed according to rules permitting only a rigid, stylized smile. Rather, it was invented for the performance, and without it, it remains silent. It is difficult to assign this mask to a particular stage genre because the actor gave it expression. This mask liberates itself from the distance imposed by the masks of god and ancestor cults and for the first time onstage gives precedence to the living human face. It is in the truest sense of the word anthropomorphic, as was the birth of the theater from cult ritual when the fate of humans in conflict with gods was seen upon the stage. And yet it is so very much a face and nothing else that the equation of face and mask in the Greek language becomes evident in this artifact.

Peter Hall has nothing but harsh words for Roman theater masks. Whereas the Greek mask had been supported by the emotion of the actor, the Romans

FIGURE 15 Theater Mask from Megara Hyblaea, Fifth Century BC (Syracuse: Archaeological Museum)

demanded fixed types, masks for good and evil, tragic or comic (figs. 16 and 17).[17] And yet we have the legal-minded Romans to thank for the subtle differentiation of mask and face. The Roman mask was called a *persona*, which refers to its speech act.[18] For in order to permit the voice to "sound through" (*per sonare*), the actor used the mask like a megaphone. The explanation for this origin is disputed, not among the ancient Romans but among modern philologists. The Romans possessed two concepts for the face, neither of which was applicable to the mask. The *facies*, which still appears in the modern word *face*, designates the natural face, which belongs inseparably to its wearer. By contrast, the word *vultus* belongs to the face with its changeable play of expressions.[19] The mask was thus a single facial expression without the natural face (*facies*) and its range of expressivity. When the Romans depicted masks in their art they let the eyes and mouth of the actor be visible behind the openings, which presented the mask as seeming to rest upon a face.[20]

The Roman *orator*, who addressed his listeners in the Forum, stood before them with his own face and his own speech, whereas the actor upon the stage "imitated" speech and, in doing so, falsified reality. The face of the orator was supposed to show deep emotion and character.[21] Death masks, which were unknown among the Greeks, represent a special case in Roman culture; they are designated neither as face nor mask, but rather as *imago*.[22] These were also worn by actors, although not in the theater, but rather at funerals. The death mask re-created the natural face (*facies*) of the dead as an impression (*forma*) and was thereby essentially different from the living face, of which it represented *a double*, and from the theater mask (*persona*), because it was a memento.

Persona could also designate a person in the legal sense. Cicero established its correlation with a person's role when in the spirit of Stoic philosophy he demanded that one had to choose a role in life and then act within its framework. It was the theologians who later made sure that *persona*, as a concept of role, became detached from the theater in late antiquity. This theological episode is worthy of mention

FIGURE 16 Mask relief, second century AD (Vienna, Kunsthistorisches Museum)

FIGURE 17 Mask depicting a type of the "Handsome Young Man," second century BC (Lipari, Archaeological Museum)

because with it, the meaning of the theater mask that derived from the word *persona* disappeared, and its whole field of meaning shifted. *Persona* became a professional secret in Christology. The Latin Church fathers agreed to define the Son of God as a "mask" (*persona*) or a role of the divine nature, a role that Jesus played as a human being just as an actor plays his own mask or part.[23] Christ was not a person in the common sense of the word, but rather a role for two natures, divine and the human.

Whereas the Greeks operated within the concept of *hypostasis*, Latin thinkers solved the theological problem using the mask in its function of role, a concept that had by then lost its currency in the theater.[24] The classical theaters were soon to be closed anyway, relinquishing their significance to ecclesiastical rites. As a result, the continuity of classical theater practice was also disrupted in language.

The theologians established the basis for our concept of the individual person.[25] The classical word for mask survives today when we speak of the person, and yet this concept is as remote as it could possibly be from the classical meaning of "mask." Only in the English language does the word *persona* still echo this original meaning. When theater was finally produced again, the word mask was replaced by a newly introduced concept from the Arabic, namely "*mashara*," which appears in Italian as *maschera* (and thence, in English, as *mascara*). The question is not why an Arabic concept was chosen, but rather (as Richard Weihe correctly notes) why a substitute was needed for the classical concept.[26] The answer is obvious: the Latin concept was no longer available to us because it had been imbued with new meanings that no longer corresponded to the theater. Only the equivalent Latin word *larve*, which appears in German in the verb *entlarven* (to reveal, unmask), survives today, but without commanding the authority of the mask as a designation of the face.[27] This fact shows that the modern period had to start from scratch in its discourse on the face and the mask. The ritual mask had been utterly forgotten, so much so that when it was encountered again during the period of colonization, the response was astonishment at this exotic artifact. This contributed to the development of a negative relationship to the art mask, which Goldoni had banned even in the Commedia dell'Arte in favor of "true characters." As if in retaliation, the face came to the fore in the theater as a communicator of social roles and natural affects. Masks were thereafter considered false and deceptive, for they were merely a betrayal of the face.

The theater of the Middle Ages developed in the shadow of ecclesiastical rites and was often a variation on the liturgy, into which it was sometimes inserted. By the Renaissance the theater had evolved to its modern state of secularized spectacle, which had its roots in antiquity—roots that were only known from texts. At the time of this historical transition, the mask of antiquity did not return to the stage. It grafted itself instead onto the living face, which in its own way became the

surface for any imaginable mask. Instead of being a separate attribute, the mask was now internalized in the face where it could be changed according to desire or necessity. In modern European culture the face was now able to take on a distinctive type, which was transferred in other cultures to man-made masks. This transformation into a mask forced the actor to gain control over the mimic expressivity of his own face. Expression now *is* the mask, which is why the face can produce it. What, then, was the status of faces in life? The study of physiognomy soon sought a reliable method to allow one to distinguish between expression and wearer on one and the same surface. Insight into human nature now required that one not be deceived by the masks that the face produced.

The humanists reached back to the Roman concept of the mask when they began to play with the idea of an autonomous self that could not be lived in society, or probably not lived at all. They brought into play the mask of antiquity in the sense of a lived role, which served the purpose of self-fashioning, as Stephen Greenblatt has called it.[28] The self lay concealed as role behavior in the contrast between *self-being* and *self-revelation*. The true self could only be concealed, and the face, for its part, became a mask that protected the self. In courtly society the mask, as expression and language, was a mode of conformity to social norms.

Erasmus of Rotterdam expands on this thought in his satirical work, *The Praise of Folly*, in which he compares human life to a sort of comedy (*fabula*). He suggests that if one were to try to snatch the masks (*personas*) off the actors on stage and reveal their true faces (*facies*), then no face would ever again fit any role. In life as well, he goes on, one acts under the protection of masks (*personis*), which permit us to look the part that we wish to play. This will always remain so until we exit from the stage of life.[29]

Erasmus is speaking of the theater of antiquity, but without knowing it he is adumbrating the theater of modernity where no one could snatch the masks off actors' faces because they no longer wore any. "Their living faces," to quote Erasmus again, now had to "fit the mask," meaning that they became invisible masks in their transformation into the visible face. This opened up a new game with the mask, which demanded new attention and participation from the audience with every change in expressivity. It was more difficult and exciting *to play a mask* than it was *to wear a mask*. This role had its prelude in courtly society, where Erasmus recognized the play of masks that made the wearer into an actor portraying himself. This play had no text and no specific duration, but rather ended when life did. The self, however much it was praised, could only be lived socially through the mask.

The *masque* was a theatrical genre in the era of the Stuart dynasty, but as a theatrical form it did not include the wearing of masks. This short-lived genre consisted of

sumptuous staging at a time when music and dance almost eclipsed the spoken word. The *masquers* identified themselves through costume and attribute when they appeared as "living images" or danced to music. A Frenchman of this period remarked that this theatrical genre "was made almost entirely for the eyes alone."[30] At the same time the courtly *masques* also had diplomatic significance. This explained the appearance of the monarch upon the stage, which offered a festive context for courtly representation. The Banqueting House, Whitehall, in London, designed by Inigo Jones for James I in 1619, was both throne room and performance space for such *masques*. A frieze of masks running above the windows all the way around the interior space alludes to this function. Inigo Jones also designed the stage sets and the costumes of the *personages*. Numerous drawings of these survive,[31] leaving no doubt that the *masquers* stood upon the stage without face masks, even when they appeared in roles personifying allegories, ideals, or different races in exotic costumes. The drawings for the performance of *Temple of Love* (1635) provide an example. They show Queen Indamora and her magicians (fig. 18a and b).[32] In *The Tempest* Shakespeare alludes to the genre when he has the spirits under Prospero's direction appear as a play within a play, in a courtly masque celebrating the engagement of his daughter. In Shakespeare's time, costume change and a different way of speaking were enough to convey their transformation into Ceres, Juno, and Iris.[33]

In the French dramas of the seventeenth century the heroes or mythical characters wore the mask of their roles upon their real faces. In a famous essay about "paradox," Diderot refers to the fact that actors upon the stage did not need to become angry when they portrayed anger. When they "remove their masks and put them on again (*déposer et reprendre*)" onstage, they do it with their real face every time.[34] For the "mask of their various faces" they need only *art*, for which *nature* "gave them their own faces." Diderot was, as Richard Sennett writes, "the first man to understand performance as an autonomous art form, independent of that which was being represented."[35] He is referring to the pathos of distance, for on the stage emotions were only one function of the role. In their expressivity, actors had to "behave *unnaturally*" in order to master the form that we call the role, and to do this they had to employ their *natural* face as a virtuoso mask.

In his treatise on theater technique (published in 1657) the Abbé D'Aubignac asserts that the main goal of theater is illusion (*tromperie*). This "ingenious magic of the theater," he postulates, robs the audience members (who are imagined as absent) of their natural powers of perception. An audience's experience of a comedy is nothing more than the process of *alienation méntale*, as though one were not really in the theater. The curtain was introduced in Paris in 1640; it immediately created the condition that, when open, reality and fiction were no longer distinguishable from each

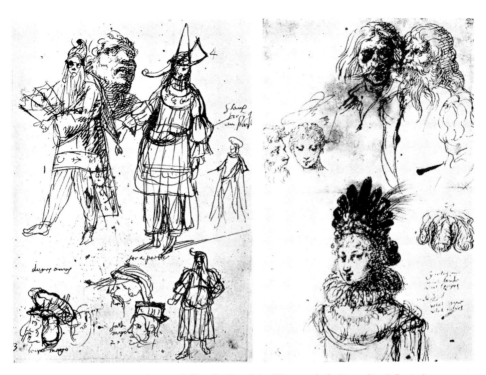

FIGURES 18A AND B Inigo Jones, *Actors in the "Temple of Love,"* 1635 (Chatsworth, the Devonshire Collection)

other. Comedy helped one to awaken from the preceding tragedy as from a dream, thereby liberating oneself through laughter from one's own participation in the play.[36]

Even when the texts of the great dramas of this period recast models and material from antiquity, they still contain frequent references to the significance of the face and its expression. In 1677 Jean Racine added a foreword to his play *Phèdre*, where he wrote that he had found the material for his tragedy in Euripides. Yet his conception of the actor is quite a modern one. The actors constantly change their expression and try to deceive one another or to dissemble by what they say and how they say it. A permanent tension thus opens up between their speech and their facial expression. In Act I, Hippolytus speaks of not wanting to show his stepmother his face any longer, which she despises—*un visage odieux*. Phèdre, who is in love with him without being able to show it, complains to her nurse that her face is flushed, and that "my eyes fill with tears against my will. Whenever I saw him I blushed or grew pale at his gaze (*Je rougis, je pâlis*)."[37] Blushing and blanching could only be achieved using one's own face.

Peter Hall recognizes a kind of score at work in Shakespeare's theater, for he sees the text as having been precisely scored to serve as the mask of "natural speech."[38] It

fell to the actors, who wore no artificial masks, to coordinate their faces with the spoken and active word.[39] The painted face, by contrast, already carried a negative significance on the stage of Shakespeare's time. Makeup provoked moral outrage as the varnish of evil and ugliness—such as in the case of the devil's white-painted face. Makeup also served as a deception of the secondary players onstage. In Shakespeare's *Timon of Athens*, the painted faces of the audience betray the false game of Timon's friends. In Ophelia's made-up face, Hamlet sees a deceptive mask instead of her God-given face.[40] The painting of the face was seen as a new type of mask, which replaced the authentic face with deception. "In masks the times proceed," says the steward in *Timon of Athens*, and Lady Macbeth charges her husband to "look timely if he wants to cheat time," which he understands to be a challenge for a false face.[41]

Even in the half masks of the Commedia dell'Arte, the good actors were cheered for what they did with their roles, which were stock characters in every play. They made their careers by competing with their masks. The triumph over the mask consisted of transforming oneself from a type into a person. In Goldoni's works the mask falls away completely in order to present human beings through their true faces.[42] Even Molière developed characters for his comedies who differed from the stereotypes of the masked roles and of the pantomime. To do so he wrote speaking roles of a new sort for the real face. The audience was thus astonished at the great variety that could be expressed or concealed with the face, for here a living mask could be changed in the blink of an eye. In this era it was said of an actor that one had never seen "anyone dismantle his face so well," for "in a single play he changed it more than twenty times."[43]

In portraiture the mask became the paradoxical attribute of the professional actor who no longer wore a mask onstage. Portraits of actors were a paradox anyway, for how should one capture a face that was able to play infinitely many roles and look different each time? In Rome in 1611, Domenico Fetti, a member of the actors' troupe from Mantua, represented Francesco Andreini with a black three-quarter-length mask.[44] Similarly, around 1599, Agostino Carracci represented the actor Giovanni Gabrielli with a mask in his hands—an actor who was able to play different roles in one and the same play. Carracci's portrait identifies him as "comicus, called Sivello" (fig. 19).[45] The inscription mentions that Sivello played all the roles alone (*solus*). His gaze from the picture seems to ask the viewer: who am I then? Do I even exist without a role? In a later text we read that the actor, who may have worn half masks in the Commedia dell'Arte, could mimic voices and that he perfected such imitation, for he "made the words and sentences fit the languages and the voices."[46] Imitation—an ambiguous term—here refers to the visual arts. In a trial print (fig. 20) Carracci first works on the face alone, while simply sketching the rest. In this version the mask in the picture merely looks as if the actor had just removed it for the portrait. In the final

FIGURES 19 AND 20 Agostino Carracci,
Comicus, detto Sivello (the actor Giovanni
Gabrielli), ca. 1599. *Above*: copper plate
(Vienna, Albertina). *Right*: Trial strike with
drawing (Chatsworth, the Devonshire
Collection)

version, however, the comedian points the mask at himself, as though challenging us to compare his face with the mask, or to differentiate him from it. Metaphorically, the mask represents the face with which the actor went onstage.

Rembrandt rejected the mask as a professional attribute when he produced a series of drawings of the actor Willem Bartolsz Ruyter in Amsterdam. He represented him onstage in different roles, for which the actor had to change only his costume in order to play a farmer or a sultan. Each role is played with his own face. The actor must have allowed Rembrandt to draw him during rehearsals. But he also sat for him as a model for a portrait drawing (fig. 21). In this case Ruyter is still playing a character part, but no longer onstage. In doing so he is leaning over a wall, as if declaiming to an invisible audience.[47] In a different drawing Rembrandt observes Ruyter in his dressing room during an intermission while studying his script (fig. 22). A bishop's costume hangs on a wall hook, suggesting that Ruyter is preparing to play the part of a bishop in the popular patriotic play *Gysbrecht van Aemstel*, which was written by Joost van den Vondel in 1638, the year the first local theater, the Schouwburg, was founded in Amsterdam.[48] Even earlier, in 1617, in Haarlem and Leiden, performances are documented in the Akadamie (the seat of the Chamber of Rhetoricians). French and English troupes of players performed their versions of modern, foreign, and classical dramas.

FIGURE 21 Rembrandt, *Drawing of Willem Bartolsz Ruyter in His Dressing Room*, ca. 1638 (Amsterdam, Rijksmuseum)

FIGURE 22 Rembrandt, *Drawing of Willem Bartolsz Ruyter*, ca. 1638 (Amsterdam, Rijksmuseum)

FIGURE 23 Willem Willemsz van der Vliet, *Gespräch über Masken*, 1627 (Privatsammlung)

A remarkable painting from this early period of Dutch theater from 1627 by the Delft artist Willem Willemsz van der Vliet (1584–1642), was auctioned by Sotheby's in 2011 (fig. 23). It represents an unmistakable lesson about the theater, as demonstrated by the four mask wearers, and yet the argument that the picture makes is still unclear.[49] The contrast between the scholar and members of the acting troupe is made more vivid by the fact that the scholar, with his toga and long beard, is a figure of classical antiquity, whereas the actress before him is resolutely Dutch in her period dress. The classical author—for he could be nothing else—raises his index finger to instruct the actress about what he has written in the open book before him. But the actress, who has removed her mask as a useless relic, is apparently bringing counter-arguments with her speech gestures. Since the rest of the figures are wearing masks, this debate is obviously about the mask as a metaphor of the classical and the modern theater.

With a slightly hesitant smile, a youth in classical costume behind the bearded author holds up a mustached mask for the viewer. On the other side are two figures—

one is a man in a turban—who wear close-fitting face masks that would be useless on the stage, for although they have eye openings, they lack ones for the mouth.

This picture reveals allegorical allusions to dissemblance and masking. Yet the mask may refer symbolically to the theater in Calvinist Holland, where the introduction of French or English troupes of players was controversial. This suggests an actual event of contemporary importance at the time the picture was painted. The key to understanding the problem lies in the person of the author, about whom we can only say that he lived in the classical period and in this painting is carrying on an argument with a young actress. Cicero, Seneca, and Quintilian were the authorities who figured in contemporary debates about the drama. Yet the treatise that comes down to us from Aristotle on the subject of "Poetry" still contains the most important theory about the nature of tragedy. In this text, Aristotle defends the mimetic arts against the epic and against the claim that the genre of *historia* held a monopoly on realism. This argument was much nearer to the hearts of Dutch theologians. Aristotle's thesis holds that tragedy should represent elevated characters of high social standing who were thus examples of ethical conduct. The portion about comedy has not come down to us, but Aristotle does mention the fact that it is not known who introduced masks (*prosopa*) into comedy.[50] Aristotle was also the authority for Daniel Heinsius (1580–1655) who taught at the University of Leiden and in 1611 republished Aristotle's *Poetics* with his own treatise on the genre of tragedy.[51] It is therefore significant that this painting is already documented in Leiden in the 1670s, which permits us to interpret the work as an argument about classical theater and its contemporary reinterpretation. Patriotic material in popular dramas of the age was meant to be played with the true face and not with the mask, in order to do justice to moral standards.

By inviting us into the studio, seventeenth-century painters use the real face to pose the question of performance practice. They behave like actors when they depict themselves, and in so doing practice expression and character in the mirror before an imaginary audience. Without imitating the drama of his time, Rembrandt gives an idea of the way actors changed their faces using expression. He would dress himself in exotic costumes, which he purchased at high prices at auctions, in order to act out an imaginary drama in front of the easel and in the painting. In the mirror he practiced the face that he wanted to paint. His pupil, Samuel van Hoogstraten, advised his own pupils to "transform themselves as if in a play" before the mirror in order to observe themselves in a role. In the introduction to his treatise on art we read that the representation of passions happens best "in front of the mirror where one is simultaneously both actor and observer." He states that a poetic spirit is necessary "in order to present oneself as someone else."[52] The actors in

Shakespeare's day probably also practiced in front of the mirror before appearing before the public, which was their true mirror.

The texts often ignore the fact that the baroque drama was a game of masks with the "living portrait" (*portrait vivant*), as one can read in the dedication to Corneille's *Cid*.[53] In the theater one acted with the same face that one wore in life. It was specific to a role and, therefore, a mask. In the "mask society" that characterizes the courts of the time,[54] faces were worn like masks. Both theater and life in their own ways acted as mirrors in the baroque era. This prompted Calderón to speak of a "theater of the world." In that period, it was only in the theater that parts could be chosen; there one also rehearsed the role of one's own ego. No guidelines for this existed. Hamlet and King Lear, who each appear at a court, are typical ego roles through which their bearers come into contact with all other roles. They play a mask within a mask and thus a double role.

Once the stage had become a school for emotion, the Enlightenment raised the cry for a natural face. In conventional society of the modern era, however, the mask returned with different significance, as Roger Caillois has shown. Evidence for this is the black half mask, which in French is called a *loup*, in other words, wolf.[55] Just as in repressive Venetian society,[56] masks served the purpose of escaping from a role instead of playing one. Wearers of masks seek anonymity, for their goal is to transgress, commit forbidden acts, or flout convention. The mask represents the wish to remain unrecognized, thereby signaling less a change of role than a rejection of one. Anyone who wears a mask suspends his social identity.[57]

5
FROM THE STUDY OF THE FACE TO BRAIN RESEARCH

The study of physiognomy was primarily concerned with the problem of images. It proceeded from the assumption that the face provides a reliable image of man. Yet as early as the Enlightenment, attention was turned to the brain, which displaced questions of physiognomy. The Viennese anatomist Franz Joseph Gall examined skulls in order to discover the form of the brain within them and ascertain an aspect of the individual not revealed by the face. Phrenology became an interim state of inquiry between the science of the face and the science of the brain. Once it was possible to examine the brain itself, scientists had to make do with the "morphological brain image," a provisional representation of the cerebral cortex. The physical and neurological functions of the brain could not be represented until one had obtained a "functional brain image."[1] With that, the traditional concept of the image had become outmoded. The brain possesses no images of itself, but can only be

comprehended by using schematic models derived from quantifiable data. The process that separates the old study of physiognomy from the modern use of imaging provides reason enough to talk about a paradigm shift. Yet it was the face that was once the point of departure for those questions brain research now poses. A fundamental premise of physiognomy stated that it was possible to discern the character of a human being from the face and to extrapolate the existence of a similar character from similar faces.[2] It was hoped that anatomy revealed a particular human type in the concrete characteristics of a face. The logical fallacy here, however, was subjecting the anatomy of the face to a general taxonomy, thereby ignoring all activity of facial expression that humans use to express themselves. Later people would label this activity as a "language for the eyes,"[3] which turned matters upside down developmentally. In the natural history of the human race, as Darwin described it, facial expressivity preceded language. It was prelinguistic language, so to speak, as evidenced in the primate behavior of baring the teeth.[4]

When popular physiognomy became fashionable, authorities called for a reliable science of the face in order to gain control over human beings. Shakespeare gives expression to this trend when King Duncan complains in Macbeth that there is "no art to find the mind's construction in the face" (Act I, iv). He had just ordered the execution of an opponent who possessed exceptional control over his facial features, but Duncan did not suspect that he himself was surrounded by traitors whose faces he could not penetrate. In 1659 Cureau de la Chambre praised the "art of insight into human nature" (*l'art de connaître les hommes*) as a method suited to revealing hidden motivations and secret actions.[5] In courtly society there emerged a need for surveillance, which has become the purview of the police since the nineteenth century. But such surveillance suffers from an inadequate understanding of what actually makes up the character of a human being. Thus the "art of spying into people's inner lives"—as Kant labeled the study of physiognomy—soon reached its limits. Kant criticized physiognomy because one could still have a "dissemblance of the ego." He noted with satisfaction that "demand had decreased" for Lavater's attempts to discern a person's inner life from his face.[6]

It is no accident that physiognomy in antiquity was founded by the same society that produced masked theater. The Romans, however, developed an art of the likeness that was predominantly *pathognomic* rather than *physiognomic*, in other words, determined more from pathos—expressivity—than from physical form.[7] With the term *pathognomic*, Lichtenberg wanted to emphasize the changing expression of affects that we use to communicate. Roman authors emphasized that rhetorical expression depended on common rules. Roman portraits were created to represent roles through expression, even though the anatomical gestures had to be

literally frozen (in stone). When physiognomy was rediscovered in the sixteenth century it found a champion in Giambattista della Porta (1535–1615), who was familiar with the theater in Naples and in his comedies describes how a face is transformed into a mask when one casts a spell on it.[8] In his illustrations he works with animal faces in order to designate human characters as leonine or feline. At the same time, he encompasses a total system of the body that represents both humans and animals. His diagnostic considerations were aimed at the goal of reading the state of the body's health in the face.[9]

In 1603, della Porta followed his "human physiognomy" with a "celestial physiognomy" in an effort to prove that facial forms predicted human fate. The face, we learn in this work, is determined "not only by the stars, but also by the humors," and facial beauty denotes beauty of the internal organs. The face is an "image (*pictura*) drawn by nature." Man wears "a transparent mask inseparable from the real face" as a second face. In this context he speaks of *maschera*, but in the Latin text he still uses the word *persona*. The concept of the "transparent mask" contains an apparent contradiction, which will continue to dominate the study of the face henceforth. The dual character of the mask both displays and conceals, as it transfers to the face itself.[10]

The next round went to the Parisian painter Charles Le Brun (1619–1690), who attempted to devise a universal grammar for the expression of passions. He put his faith in the competence of painters to provide the instructional material for the sciences. But he also wanted to give them some practical guidance about the way one could reproduce human actions with the feelings appropriate to them. Following Cartesian mechanics, he discerned in eyebrows a type of pointer that conveyed an emotional state.[11] His schematic aesthetic would soon elicit a critique and require a set of instructions.[12] The English painter William Hogarth (1697–1764) praised the work of Le Brun for collecting "all the known forms of expression," even though these were only "incomplete copies" of real faces. Le Brun, he said, presented "the passions in very ordered fashion" and drew faces "with lines alone, so that they did not show any shading." Admittedly, the drawing could only capture faces as schematic types.

The Swiss pastor Johann Caspar Lavater (1741–1801) struggled with relevant pictorial material in order to present physiognomy as groundbreaking science. Beginning in 1775 he began to publish the fascicles of his major work, *Physiognomische Fragmente zur Beförderung der Menschenkenntnis und Menschenliebe* (Physiognomic fragments for the promotion of human understanding and human kindness). He planned to compile a catalog of all the facial types that he considered universally valid. He took advantage of all sources in order to reproduce the likenesses of illustrious dead people, as though this material, which was never actually

meant for the study of physiognomy, granted him access to all faces. He defended himself against the empirical spirit in the emerging natural sciences with the argument that he possessed an infallible feeling for the truth of a character as expressed in the face. Virtue was mirrored in physical beauty, he argued, whereas vices "twist the visage into a Satanic mask."[13] When Lavater spoke of a "primeval image" (*Urbild*), he meant not only the "primeval form" (*Urgestalt*) of the human being per se but also the true reflection of an individual.[14]

In his preface Lavater declared that physiognomy possessed "the power to recognize the inner state of a person through the external appearance and to perceive that which is not immediately apparent to the senses through varieties of natural expression." As a science it had the ability to analyze "all direct human expressions" with which a person presents himself. In the narrower sense Lavater understands physiognomy as facial formation, specifically of the "most important essence that reveals itself to our observation." He differentiates among various types of physiognomy, including moral physiognomy, which explores one's state of mind based on external signs, whereas cognitive physiognomy concerns itself "with the intellectual powers of man." But only someone who can judge immediately upon a first impression "is a natural physiognomist."

Because the face is essentially an image, it had to be suitably represented in pictures. The "similarity" that connected a face with a character would also be transmitted to the representation. Lavater used copper engravings to represent his models wherever he found them. For him such models were a message from a human being and served to "preserve his image."[15] In the nine profile heads of Socrates, "drawn from copies of antique gems" (fig. 24), he noted a "striking resemblance" that buttressed his trust in ancient portraits, even when they showed "noticeable differences of expression."[16] In his own drawings he sought to "observe and describe directly from nature." In so doing he would pose the same people in contrasting positions, both as "pictures" and as "silhouettes." He did not seem disturbed by the lack of congruence between the drawing of a profile and a silhouette.[17] Both young gentlemen depicted here were "the first people who sat and stood for me in the service of physiognomic description" (fig. 25). Lavater describes them completely in accordance with the spirit of the age, as examples of "a good person in whom there is so much humanity." In this system it is the silhouette that permits an authentic reproduction of the face through methodical measurement, thereby predicting the authenticity that photography would later provide. In a "not quite precise silhouette" of a famous man, Lavater divided the profile into nine segments and noted that he "wished his successors luck," should a "mathematical genius ever tread this path and apply his powers to the curves of humanity."[18]

FIGURE 24 Socrates, *Nine Profile Heads*, from Johann Caspar Lavater, *Physiognomische Fragmente*, 1775–78

FIGURE 25 *Profile Portrait and Silhouette of Two Young Gentlemen*, from Johann Caspar Lavater, *Physiognomische Fragmente*, 1775–78

In his own research Lavater included human skulls, which would soon replace the face as an object of scrutiny, for he considered himself a better observer than the pedantic "dissectors." He comments on a plate depicting four skulls, of which the two lower views are of an old man who had been executed. About these he remarks that the skulls showed evidence of weakness or strength of character (fig. 26).[19] He describes them using the words of Winckelmann, "which are especially fitting for a work on physiognomy," and continues that he had added "a tiny contribution of his own perception." Lavater drew the head twice "in silhouette" and could not stop gazing at its outline.[20]

The quasi-religious belief in the face as an emblem of man became bound up with the pseudoscientific belief in the readability of the face. In the cult of physiognomy, a secularized religion sought a substitute for its former icons. Following the familiar biblical formulation that God had created man in His own image, Lavater interpreted man as a divine likeness, which he rhapsodizes about in his first volume. The Romantic poet Novalis spoke of a "religious essence" in physiognomy, which seemed to exist in the service of "sacred hieroglyphs."[21] Lavater himself could not resist the temptation to apply the study of physiognomy to the face of Christ. He thought it "a deficiency of physiognomic sense that at one time people had not believed in Christ." He also bemoaned the fact that traditional representations of Christ "missed the human, or divine, or Israelite, or his messianic traits."[22] The qualities that he would have so loved to study in the quintessential face, he now had to seek in the physiognomy of his contemporaries (fig. 27).

In October 1789 Wilhelm von Humboldt visited Lavater and had the expert interpret his face for him. Lavater explained that "such physiognomies" represented an easily deciphered character. When the guest expressed his misgivings, Lavater insisted that in future "all physiognomic rules will be proven mathematically." Yet Humboldt objected that physiognomy could not achieve its goal "as long as our knowledge of character is still so incomplete," especially since "our language has no expression for the finer nuances." Humboldt felt that one would search for "all these in vain among the rigid unvarying traits." Then he added, "there is probably a good deal of deception in all this."[23]

The sharpest criticism of physiognomy came from the Göttingen physicist Georg Christoph Lichtenberg. In his essay "Über Physiognomik; Wider die Physiognomien" (On physiognomy; against physiognomies) (1778) he pours scorn upon the physiognomists' illusion that it is possible to deduce character from faces. "The resting face . . . far from defines a person. What does this is primarily the series of changes that no portrait, and far less an abstract silhouette, can represent.[24] Changes in the face, he notes, are caused by affective movements. The author calls

FIGURE 26 *Four Skulls*, from Johann Caspar Lavater, *Physiognomische Fragmente*, 1775–78

FIGURE 27 Apollo Belvedere, in Johann Caspar Lavater, *Physiognomische Fragmente*, 1775–78

for a "semiotics of affects" and of the "knowledge of the natural signs of affective movements," which leads him to find a corrective for physiognomy in pathognomy. He states that it is not the "rigid and immobile parts, especially not bone structures," but rather the "spontaneous movements" of expression and the language of gestures, as well as "the spontaneous [gestures] of concealment," that must be studied.[25] Lichtenberg considered it significant that our language possesses many concepts for facial expression yet no words for facial properties. He also states that there is no such thing as a "physiognomy valid from one people to another, one tribe to another, and one century to another."[26]

In their quest to understand the human race with empirical criteria, researchers soon abandoned the physiognomic approach in disappointment. The Viennese neuroanatomist Franz Joseph Gall caused a stir in 1800 with his study of skulls, or phrenology. This approach was thought to reveal by touch the form of the brain from the exterior features of the skull with all its depressions and contours.[27] This new science ushered in a gradual departure from the study of the face, and yet its way had been prepared by physiognomy, which sought in vain to discern the inner workings of man from his face. The skeletal structure of the skull supplanted the skeletal structure of the face as an object of study. Even so, the organ of the soul,

the expression of which was so uncertain in the face, could not be found anywhere in the brain, for the brain was, and remained, an organ of the body. In a "physiognomy of the convolutions of the brain"[28] it no longer made any sense to talk about pictures or images in the old sense. Here ended any thought of similarity between the interior and exterior, criteria that people had hoped to find by studying faces. The skull as well as the brain mass were no longer a place of representation. Phrenology introduced a new stage in a process that changed the concept of man by stimulating a controversy about the human "mind" (Geist) and its functions. Lichtenberg, however, scoffed that one should not "deduce a brain from its enclosure," although this had been the original goal of phrenology. He had witnessed approximately eight dissections of the human brain and seen that "incorrect conclusions had been drawn from at least five of these."[29]

The inspection of the skull had introduced the search for man in the brain, but the search was still dominated by the competition between brain research and character study. Skulls—the guise in which death had always appeared—were now being drawn and studied more fervently than the living face had ever been. The faceless skull promised more insights into human character. People were exhilarated by the feeling that they had penetrated further into the long-sought "interior," but they were not yet in agreement about what they were seeking there. A simple representation of a skull had little use. Data first had to be gathered and transferred to drawings or charts. But natural philosophy remained at odds with the study of organs. The controversy ignited over the question of the relationship between mind and brain.

Carl Gustav Carus (1789–1869) was a physiologist and painter of the Romantic school from Dresden. He both embodied and was burdened by the conflict between these two epistemological systems. He had begun his career as an anatomist and physiologist and immediately won wide admiration for the brilliance of his drawings of skulls. His second career as a painter offered him an enormous advantage.[30] This was still a period when the skull promised more insight than the gray matter would later. It seemed to offer more information about individuality. In his later work, under the influence of Goethe's natural philosophy, Carus turned away from contemporary brain research in order to attempt a personal synthesis in the "symbolism of the human form," as he called the work of his later years. Even his *Atlas der Cranioskopie* (Atlas of cranioscopy), published in 1843, was in a way a retreat from the contemplation of the mind. It opens with a drawing of Schiller's skull in profile. This artifact had been in Goethe's house in Weimar before it was reburied (fig. 28). The drawing appears as a new kind of portrait, for it illustrates not the face but rather the venerable skull of the poet.[31] Carus made the drawing from a plaster

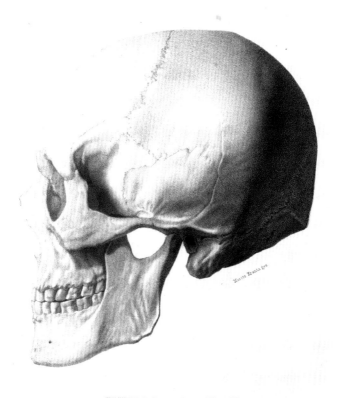

FRIEDRICH VON SCHILLER.

F. A. Brockhaus Geogr-artist. Anstalt, Leipzig

FIGURE 28 Carl Gustav Carus, *Drawing of Schiller's Skull*, from *Atlas der Cranioskopie* (1843)

cast of the skull, which was a technique formerly applied only to faces. Thus one can speak here of a portrait of a skull, or of a true portrait of Schiller in his skull.

In his book *Symbolik der menschlichen Gestalt* (Symbolism of the human form) (1858), Carus confidently states that a description of a person will in future remain only fragmentary "without the description of the skull formation." He continues, "the casting of the cranial structure" will be more important than that of facial features. To a certain extent the skull had already been anatomically prepared as a scientific object. It contains "the highest organ of life, the brain." But Carus is not yet ready to abandon the face completely, for it is there "that the great organs of the senses reside,

and it is through them that the intimations of the soul—with which the brain develops the higher manifestations of conscious life—are channeled." And yet he says a "scientific physiognomy of the face alone is forever doomed to fail."[32]

The philosopher Hegel was unwilling to let the matter of the development of brain research rest. He settles the score with the old study of physiognomy when he writes that "the reality of man" is not his face, but rather "his deed; therein lies true individuality."[33] Language alone, he continues, is "the visible invisibility" of the mind. For this reason, the philosopher found the new cult of skulls highly suspect, for the skull as a visible artifact was nothing more than "the *caput mortuum*," in other words, a death's head. At this stage the spirit has left the brain anyway. He is most disturbed by the localization of brain activities, which he fears limits the mind to inborn predispositions or misses the point completely. For Hegel the skull was just a "bony attribute of the mind." In an oracular tone, Hegel says that the "essence of the mind [*Geist*] can no more be measured by the [physical] essence of the skull than by the convolutions of the cerebrum."[34] Hegel is resisting not only the methods but also the goals of the new brain research, because in it he senses the loss of the image of humanity that is central to his own philosophy.

In this period the brain had already become "a more important object for epistemology than the skull."[35] A feverish investigation of the convolutions and furrows of the brain was sparked by the sensational discovery of the neurological locus of speech production. These investigations had been made possible by breaking with the taboo of examining not just the brains of criminals but also those of geniuses. Naturally, there were always rear guard skirmishes concerning threatened idealism, which found their expression in a certain enthusiasm for the "physiognomic characteristics" of the brain. Yet the trend toward a more soberly rational knowledge (to paraphrase Michael Hagner) accorded central significance to pathology in the field of knowledge of the brain's functionality. Researchers continued to be stymied by morphological questions. There were efforts to gain insights from the surface of the brain, from its size and its mass, instead of searches for neural paths and synapses, because the necessary technology simply did not yet exist.

The dispute with neurologists about degenerate brains ushered in a period in which social politics of the brain flourished. The Leipzig anatomist Paul Flechsig featured prominently in this controversy (fig. 29). He confidently had himself photographed in his laboratory with a large, iconic photograph of the brain behind him. This represented the area of his expertise. The "true" image of man had become faceless and thus all the more suited to the laboratory.[36] In its *Transactions* of 1907 the American Philosophical Society in Philadelphia published illustrations of the brains of "six prominent scientists of the nineteenth century from Philadelphia," of

FIGURE 29 Paul Flechsig in his laboratory

whom three had been members of the society. The object was to demonstrate "the special anatomical characteristics" of gifted men. The author would have gladly included the brain of Walt Whitman in his study, but "a careless assistant had dropped it on the laboratory floor" (fig. 30).[37]

It is possible to present only a brief overview here of the unstoppable ascent of brain research to its prominence in twentieth-century science. A conflict with psychology was present from the outset, but psychology ultimately lost the battle. In the field of brain anatomy, the "anti-physiognomic tendency" triumphed. New imaging techniques do not actually produce a picture of the brain, but rather produce diagrams of brain functions, which disembody the brain as much as possible.[38] Scientific interest is no longer directed at individual characteristics of the brain, but rather toward normal and abnormal brain activity. Thus the paradigm that worked with images had to give way to new methods. This led to a virtual "dream of a physiognomy of the mind"[39]—an area from which the face as the means of communication and expression had already been eliminated.

A particular developmental thread dating from this period after the heyday of physiognomy has been lost. This thread of reasoning arose in the work of the physiologist Charles Bell in his *Essays on the Anatomy of Expression in Painting*, published in 1806, and reached its temporary apex in Darwin's theory of evolution. Here the face is the center of attention again, not by virtue of its individuality, but rather because of the activity of its muscles. In the introduction to his famous work, *The Expression of the Emotions in Man and Animals* (1872), Charles

FIGURE 30 Cover of *News from Philosophical Hall* (2007) with an illustration from the "Transactions" of the American Philosophical Society, April 21, 1907: "The Brains of Six Prominent Nineteenth Century Philadelphia Scientists"

Darwin states that he has no interest in reading character from the "permanent form of the features."[40] He shifted the emphasis from physiognomy, which differentiated men from animals, to expressive and vocal characteristics that relate man to animals. In facial activity Darwin found the expression of stereotypical emotions that had emerged by evolution, through adaptation and inheritance, to ensure survival. Interest shifted from the face to its muscular activities, movements that reflected the process of the evolution of species. These muscles are labeled with letters on a diagram, which Darwin based on one by Charles Bell (fig. 31). The muscles produce reflexes stimulated by feelings like anxiety, sadness, and pain. These feelings are as innate as their mode of expression and are rarely voluntary, although they can be produced through human volition.[41]

Fig. 1.—Diagram of the muscles of the face, from Sir C. Bell.

Fig. 2.—Diagram from Henle.

FIGURE 31 Two diagrams of facial muscles from *The Expression of the Emotions in Man and Animals* (1872)

For Darwin "expression" was social "action" sending out signals that have evolved and been preserved in the lives of species. As Darwin writes in his introduction, Charles Bell had shown him the way with his work, *Essays on the Anatomy and Philosophy of Expression* (1824). In his use of photographic reproductions, Darwin followed the neurologist Guillaume-Benjamin Duchenne de Boulogne, whose work, *Mécanisme de la physionomie humaine* had appeared in 1862.[42] Duchenne had performed experiments on patients in which he applied electrical current to their faces. These caused mechanical contractions of various facial muscles and created facial expressions that he

2

FIGURE 32 Guillaume-Benjamin Duchenne de Boulogne, *Experiment on a Patient, A Study for Mécanisme de la physionomie humaine . . .* 1862 (Paris, École Nationale Supérieure des Beaux-Arts)

could document photographically, as in the case of his example showing fear, which Darwin reproduces in his work (fig. 32). The facial activity expressed itself even better the more severely the face was impaired by sickness or birth defects. These new methods were explicit evidence of the departure from Lavater's physi-

ognomy. Once photography had been invented, the mechanics of facial motor expression could finally be documented.

The reason for Darwin's interest in Duchenne's experiments is clear. By isolating muscles so that they could be studied individually, Duchenne had shined the spotlight on the developmental history of man as deciphered in the face. He was able to categorize the muscles based on their particular expression and function and show that these muscles governed facial expressivity and social interaction with other members of the species. For example, there was a muscle for sadness, one for pain and aggression, and also muscles for joy and fear. The face proved itself to be a showcase of phylogenetic history, upon which expression became ever more complex over time. There was certainly confirmation here of similarity, which allowed people to recognize each other in the throng. But more important, these muscles are evidence of interaction with others without the use of voice and gaze. It was more the case that every muscle in the face communicated a message that a partner could interpret because his own face functioned similarly. What one did with the face was definable only because every face had access to the same repertoire of expressions. Natural selection has obviously continued in dissimilar cultures to the present day, even though each one regulates facial expressions differently. The pictures that captured a face in a single expression (in contrast to Duchenne's series of photographs) could therefore not reproduce the facial work that was the whole focus of the research.

Darwin introduced a development that led to a new paradigm. Laboratory experimentation replaced icons. Man proved to have a kind of species-determined expression in his emotions and was thus nothing more than a creature of nature like all others. Emotions that reacted to situations were examined, whereas feelings of another sort remained unexamined. Darwin's conclusion was that man "descends from a lower life form."[43] In his feelings and his facial expressions he recapitulates an evolution in which all races have their roots. "The language of emotions, as it is sometimes called, is of great significance for the welfare of humanity" and its survival. Darwin concluded that the various expressions, which hourly play across the human face, merit the interest of the scientific researcher. He recognized this as a collective characteristic applicable to all human beings. Anything that can be observed on an individual face has also been seen on every face. Expression forms itself in the young child before the child can account for the phenomenon. Anthropology naturally takes a different direction here, and henceforth the face is examined only for its functions rather than as an expression of the unity of man, as had previously been the case. For modernity the consequence is a lament, not for the loss of the face itself, but for each individual concept of the face and its perception.

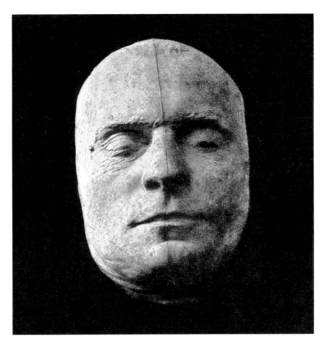

FIGURE 33 Death mask of Gotthold Ephraim Lessing, 1781 (Wolfenbüttel, Herzog August Bibliothek)

6

NOSTALGIA FOR THE FACE AND THE DEATH MASK IN MODERNITY

In the late nineteenth century the death mask had become "the secret center of the physiognomic domain."[1] Here contemporary physiognomy found its true place long after science had turned away from it and here we encounter a mask in the most literal and physical sense of the word. In it a face is turned toward us that has been swept clean, a face that a dead person has left behind. "This uncanny fact distinguishes it from every other mask: that it has separated itself from the face of a human being, never to return to that person again." Durs Grünbein speaks of this "violent break, *Facies interrupta*."[2] But the memory of the former wearer of the mask was not always the meaning behind its modern cult. More often it was the presence of a face, which, beyond life and death, had been reduced to the concept of itself.

Only a few years after Lavater had ended his work on physiognomy, a death mask of a new sort emerged. This was the death mask of the dramatist and critic Gotthold Ephraim Lessing, which his friends had made in 1781 in order to keep the memory of such a friend and example alive (fig. 33). The objective was not to produce a portrait—no longer a means to an end—but rather a symbol of an intimate

gaze beyond death into the hereafter. At the time, the Duke of Braunschweig-Wolfenbüttel had honored Lessing, as the foremost literary figure in the land with an official burial ceremony in the "enlightened consciousness of the dignity of a person graced by God."[3] The mask also embodied the new authority of intellectual greatness without reference to social barriers. The message was not one of a man who had died, but rather of his true face, as had been the case with the true icon of Christ.[4] Death, as the visible completion of life, now stimulated new fascination. In the mask the viewer perceived a face in which the actual nature of an individual was irrevocably expressed. Lavater had praised "the true and enduring plaster casts" for their ability to display "characteristics much more sharply than on living or sleeping people. Whatever made them falter in their lives is forever fixed in death."[5] Lavater speaks of a physiognomy that has been frozen in time, in which the true visage of man shows itself in the mirror of eternity. One could speak of a mask of physiognomy in order to drive home the point of this paradoxical conclusion.

Ultimately, we have here the phenomenon that the face becomes an image in the death mask (in the literal sense). Only when the face is transformed into its own mask can it become—and remain—entirely an image. This image is fascinating because it creates an insoluble puzzle: it represents a presence that can only emerge through the absence of that which it represents. A death mask is thus the mask taken of a face that, in death, had become a mask in its own right, in other words, the mask of a mask. It is cast from a face no longer capable of any expressive activity, which rather possesses an expression that transcends all possible facial expressions. It thus casts a spell on us, even though we know that mask makers may have actively tampered with the corpse and conjured the peace of sleep from the face of the departed.

The modern cult of the dead was not focused on the grave, but rather came into being in an archival context, such as in a collection of death masks like the one owned by the Museum of the City of Vienna, a collection that has meaning only when it is on display (fig. 34). In reality this is an exaggerated cult of life, which seems to proceed from the mirror of a timeless face. In physiognomy people have sought a character, which in death has become an eternal appearance. The closed eyes retreat from the viewer into the distance, yet they leave behind an unobstructed close-up view. Such masks have presented themselves as perfect surfaces onto which one may project all expectations that have been directed toward the human face, as if the idea of the face itself were threatened. Unequivocal clarity has finally been reached, albeit in a macabre way—a stability that was missing in the expressively active face of the living with its impermanent countenance. The death mask became a totemic object that permitted the creation of a nostalgic cult of the timeless, authentic face.

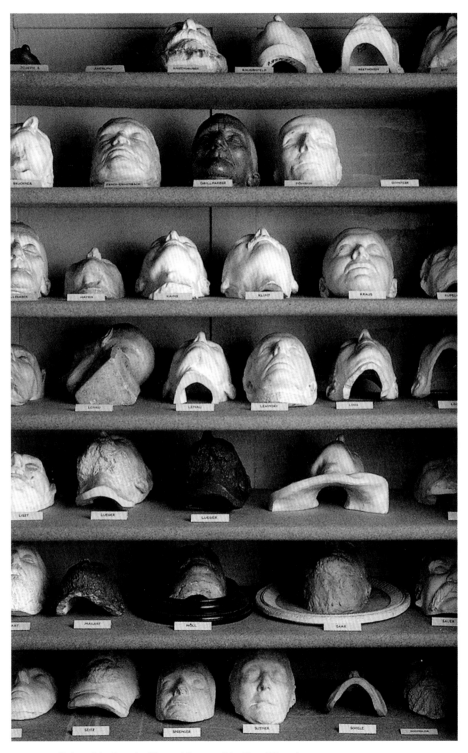

FIGURE 34 Shelves of death masks (Vienna, Museum of the City of Vienna)

A further example of this phenomenon is the so-called *Inconnue de la Seine* (Unknown Woman of the Seine). After someone took her death mask in the Paris morgue, she was marketed in countless plaster casts and photographs around 1900. The woman was nameless and therefore did not leave behind a mask that made it possible to ascertain the usual similarities; she was nothing but image representing not a dead person but rather death per se as timeless beauty. The poet Rainer Maria Rilke wrote in his poem "Face of a Young Drowned Woman" that the cast of the face had been taken "because it was beautiful, because it smiled so deceptively, as though it knew."[6] Maurice Blanchot wrote his essay "L'Arrêt de mort" about the same mask, "with its closed eyes, but with the life of such a fine and rich (but secret) smile, so that one could think that she had drowned at a moment of greatest happiness."[7] An exchange has taken place here between life, which has departed, and the image, which has come into existence as a result of that departure. In the words of Blanchot, "in the otherness of the corpse one could also see that of the image, which produces a new kind of similarity, by referring to nothing more than itself." In an era that had begun to doubt the truth and authenticity of the face, this pure and immutable image of one face offered a new refuge.

When a new cult of the death mask arose after World War I, the nostalgia for the face merged with the nineteenth-century farewell to the face; the old idea of the individual had been painfully destroyed by the war. The new cult of masks enjoyed great popularity in elaborate picture books with misleading titles, such as *Das letzte Gesicht* (The final face) by Egon Friedell and *Das ewige Antlitz* (The eternal countenance) by Ernst Benkard. In his text, Benkard views the death mask "far from breath and pulse, erected as a monument at the crossroads between reason and faith . . . it is the last image of man, his eternal countenance." He confidently recognizes in this visage "the face of man finally released from the grimace of the day."[8] Like a magnet, the mute face attracted all disappointed gazes of the modern age to itself. The casts of the mask that had been made of the real face of a dead person through contact with the body had the effect of copies of an original. During the casting of the mask, the source face had retreated into its final image, which was then honored like an artifact from a vanished age.

Ernst Benkard expressed his amazement that it had taken so long "for the death mask to become that which it means to us today." He himself produced the reasons for this in which are also to be found a crisis of modernity. When people look backward longingly for man in a permanent sense, man is not defined by his social role, but by the respect he enjoys as an individual: someone who embodies the essence of being human. Even the photography books fashionable at the time participated in this new cult of the death mask. In the guise of a kind of devotional

book, they offered a complete collection of intellectual greats, whose personalities people thought they saw reflected in their death masks. Photography was the technical medium of reproduction that had supplanted earlier forms of mask making and brought the mask back to a new kind of view in the literal sense of the word. In the black-and-white photograph, the difference between face and mask receded and restored the face to its proper place, beyond the medium of casting.

The "archive of faces" in the Schiller-Nationalmuseum in Marbach in southern Germany preserves the death masks of great Germans. These masks were collected for a cult of memory and reproduced in a catalog written especially about this collection. Writing in the catalog, Durs Grünbein objects to the genre by stating that in death the face was "finished with the business of reflection and expression. It finds itself in the same tangible condition as that of a door that has been slammed shut. Whatever can be read from the face of a dead person is now left up to the meditations of the viewer."[9] But these meditations were precisely the goal of this collection, for after the catastrophe of World War I, with its innumerable anonymous dead, the search for a lost ideal of man became popular. People felt they could contemplate this ideal in the death masks of poets and philosophers unimpeded by fashions and trends. It was a paradoxical exercise to wish to rescue a timeless face from the disasters of the age. People paid homage to it as if to a precious relic that was all that remained of the face. In so doing, the famous face served as a guarantee of the *human image* in the highest sense.

Once this had been established, a new connection was revealed between such dissimilar subjects as the death mask and the faces considered typical of German regional ethnicities, which became a popular theme in the period between the two world wars. In this so-called face of the common man (*Volksgesicht*)—whatever its varied message may have been—we find the fundamentals of the same nostalgia for the face. In this case, however, people were searching among the rural population for a timeless face so urgently that it was as if it had been lost in the cities. These faces became enshrined in photographs as if they had come from another age. Here, too, the face sprang from the mirror of a thoroughly modern photographic art and was staged by lighting for the viewer's gaze. It is difficult to draw a clear line between the aura of a photograph or representation and that of the face it represents, which—through this medium of transformation—is hallowed for eternity. The relevant photography books, which were heavily promoted in the market as bibles of the human image, revealed—behind the death mask or behind the faces of common folk, in their various ways—an ur-image, or ideal image, of the "authentic" face. This was a face that transcended the limits of individual portraiture. The death mask had been sustained by the wish to idealize the face, and the photogra-

phy books of the period thus show different varieties of a common cult of the face that had been nourished by a feeling of loss. The death mask was just as much a symbolic face as the "folkish," or regionally defined face was in its own way. Both genres are the result of a crisis of the face suggesting different solutions depending on one's point of view: either the meditation on a timeless face as stark contrast to the rapid tempo of a journalistic candid shot, or the return to the "simple" face of the rural populace as a mirror of a collective ethnic character.

In the final analysis, conflicts about the face that raged during this period were linked to a threatened and controversial image of man, which on the conservative side found its emblem in the timeless death mask or in the ethnic "icon." Karl Jaspers scrutinized the dominant images of the era, which were the basis of our modern icons, and saw everywhere at work a "love of the noble human image and hatred of the ignoble."[10] "Aspects of man expressed in dominant images and counter-images are emerging." He noted that a typology was becoming evident that seemed to be nourished everywhere by "secret love and aversion." Jaspers was referring to voices such as those raised by the writer Ernst Jünger, who took it as a threat that in the face of urban dwellers "the tremendously homogeneous and typical aspects" of facial expression were gaining the upper hand. The writer Alfred Döblin expressed himself similarly when he saw remnants of "a few original types," but also noted the spread of "new types."[11] Such remarks are evidence of a criticism of modern culture dominant during the Weimar period before the racial ideology of the Third Reich brought a violent end to such debates.

This conservative position elicited an opposing point of view. Axel Eggebrecht, for whom portrait photography had ended by the end of World War I, discovered in the photographer Erich Retzlaff, the "proletarian face" as the new alternative.[12] In his project on people in the twentieth century, August Sander turned away from the predominant close-up photography of faces. He gave his work the polemical title, *Antlitz der Zeit* (Face of the Times) instead of "Timeless Face." He concentrated on social types and classes in their collective roles, as when he portrayed an industrialist or a master mason, as types (figs. 35, 36).[13] Rather than seeking the physiognomy of his age in the faces of individuals, he looked for it in society where conservative and "modern" types mingled.

At the other end of the spectrum Erna Lendvai-Dircksen agitated in favor of the face of the common people. During the Third Reich she attained some dubious distinction by embracing the tenets of folkish racism.[14] She also produced images that exemplified collective types. Yet her so-called timeless face of members of rural German welfare and cultural associations presented an opposing view to that of August Sander.[15] In the peasant face she found a contrast to the "inauthentic mask" worn by

FIGURE 35 August Sander, *Master Mason*, 1926–32. © 2016 Die Photographische Sammlung / SK Stiftung Kultur—August Sander Archiv, Cologne / ARS, NY

FIGURE 36 August Sander, *Industrialist*, ca. 1920. © 2016 Die Photographische Sammlung / SK Stiftung Kultur—August Sander Archiv, Cologne / ARS, NY

urban man. After 1916, when she was guided by a nostalgic form of cultural criticism, she assembled a collection of faces that she then published in 1932 under the title *Das Deutsche Volksgesicht* (The Face of the German People). In the rural populace she recognized the surrogate for a face that no longer existed in the cities. The lament about the "general homogenization of the *facies*" was at the center of the contemporary debate.

The faces in Erna Lendvai-Dircksen's work are presented as the results of regional influences and were thus meant to seem as timeless as the landscape they mirror (fig. 37). She was convinced that the face of the landscape is imprinted in "the landscape of the face." When she referred to the contemporary talk of a landscape of the face, she was using a pun, but one she meant quite differently. For her the face was not a landscape in the sense of a three-dimensional surface, but rather a mirror of the landscape in which its wearer lives. Origin myths and affective anthropology came into play when she spoke of the faces that she wanted to rescue from the "characterless

FIGURE 37 Erna Lendvai-Dircksen, *Das Gesicht des Ostens: Mädchen aus der Lausitz* (The Face of the East: Girl from the Lausitz Region) (Berlin, Berlinische Galerie)

masks" of the degenerate modern age. Her "great love" was directed at the "grandeur and timelessness of the face of the people [*Volksgesicht*]." In her text we read assertions such as the idea that many women who lived in the countryside appeared like "figures from Shakespeare who seemed to be quite impersonal yet nonetheless generalized." This nostalgia could be quickly co-opted by the racial ideology of the Third Reich, which is what happened to Erna Lendvai-Dircksen, yet it was a nostalgia that initially was neither imposed nor directed from above.

A feeling of loss is discernible here, just as it was in the cult of the death mask—a feeling not rooted in any particular antimodernist strain of thought but encountered in various groups. Nor is it identical to a renewal of any bourgeois cult of the subject, which found its ideals represented in individualism. Veneration was no longer reserved for the strong individual who used his face as a weapon; rather, it sought the human being in a timeless, primitive form, which was no longer to be found in one's own age. This cult of the face necessarily encouraged the creation of masks, and photographic collections produced them with great success, but they were masks that nobody wore anymore, especially not the dead, nor urban dwellers, for they could only be found among the rural populace where a former age remained intact and provided the source of family history. These books of photographs either represented actual masks—namely, of the dead in whom one tried to perceive the real face—or they froze the faces in photographs like rigid masks and reduced them to a formal frontality, through which they step out of time. Here the legacy of physiognomy survived, for it was a legacy with an idealistic twist that had made the contemplation of a facial icon its agenda.

7

EULOGY FOR THE FACE: Rilke and Artaud

Nowhere, and at no earlier time, is the crisis of the face lamented with greater poignancy than in the works of the young poet Rainer Maria Rilke (1875–1926), who

worked on his *Notebooks of Malte Laurids Brigge* in Paris. As his young German protagonist roams the metropolis like a latter-day flaneur, questions of individuality and identity fill him with fear as he recalls a personal loss through death. He remembers this drama in a flashback to his own childhood in the countryside, and he rediscovers the experience in the newly constituted urban crowd. In the hospitals people are dying as if on an assembly line. "With such production numbers that a single death doesn't get the same attention; however, that isn't what matters. Quantity is what matters. Who even cares today whether or not a death has been well constructed?" Not even the rich care about that. "The desire to have a death all one's own is becoming ever more rare. In just a while it will become as rare as a life of one's own. It will be a finished article, something you just have to slip into. People will die just as it comes. They will die the death that belongs to the sickness they have." Death, which formerly had a privileged place in the life plan of an individual, or even represented a goal, has become "banal" and is no cause for fuss and bother anymore.[1]

One cannot lose one's face in death. The face and death appear in tandem in Rilke's works, and we thus encounter a sarcastic description of all those faces in the crowd that have an expiration date. Identity in the face has become a lost memory. "There are a lot of people, but there are a lot more faces, because everyone has several. There are some people who wear one face for years; naturally it gets worn away," and it "stretches like gloves that one has worn while traveling. The question, of course, is—because they have several faces—what do they do with the others? They save them so that their children may wear them." But maybe the dog runs away with one of them. "And why not? A face is a face. Other people put on their faces amazingly quickly, one after the other, and wear them out." They have barely reached the age of forty, and they're using their last one. "They aren't used to going easy on their faces, they've worn through their last one in eight days, it gets holes in it . . . and then, after a while, the bottom layer, the non-face, comes out and then they walk around with that."[2]

One has the impression that Rilke is talking about man-made masks that one can put on and take off, but he always says *face* when he means *mask*. The difference seems to have become irrelevant, for the face itself has become a cheap mask that wears out rapidly in life. Everyone is given a set number of faces to use. They are rationed like ready-to-wear garments. Modernity is casting a disappointed glance at an old ideal of mankind, but perhaps there have always been privileged faces as exceptions. Could anyone have one of those? There certainly were roles, and those one could learn. For them, one also needed masks. But when there were no longer any roles, the masks themselves had become superfluous. Was individuality a role as well? And could one have simply removed it, like the mask of a role? Even though

the face turned out to be a mask in the meantime, it still could not be removed, for there was nothing more under it (other than the bare skull). Only a sculptor could take a mask *off* the face. But to do so, he first had to find a face. Rilke's pessimism finds an early expression in the play by the dramatist Georg Büchner, *Dantons Tod* (*Danton's Death*, 1835). There, somebody in the Jacobin Club says about those who betray the Revolution: "It is time to tear off the masks." When this sentence is reported to Danton—the man who has already lost the game—he answers curtly and emphatically, "and the faces will go with them."

The non-face seems to be borne out in the nightmares of Rilke's young protagonist Malte most horribly when he meets "the woman" on a corner of the Rue Nôtre-Dame-des-Champs. She "had completely fallen into herself, bent over, with her face in her hands." His own footsteps in the empty street frighten her so much that she jerks upward, "out of herself," so violently, "that her face remained there in her two hands. I could see it, its hollow form lying there." It costs him some effort not to look at the thing that had "torn off in her hands. I was terrified to see a face from the inside, but I was far more afraid of seeing the bare, raw head without a face." By comparison, it is almost comforting to think that one may die anonymously in a hospital.

Rilke could have observed the hollow form of a mask in the atelier of the sculptor Auguste Rodin, where he often watched plaster casts being made. Here, however, he is talking about a face on which there is no reverse side other than its own concavity. For Rilke's art, things were quite different, because here the face retained a form, which it always lost in life. Faces in art were a memento of that which they had once been in life, or they preserved the hope that they might still have a future. In his texts about Rodin, Rilke describes the way Rodin worked. Everything that the sculptor created was a mask, even when it was a bust of the sitter. They were all masks, meaning that none of them was a real face. In Rilke's first essay on Rodin from 1902, he praises "the mask of the *Man with the Broken Nose*," one of the early works from 1863–64, as the first portrait Rodin ever created (fig. 38).

"When Rodin made this mask he had a person in front of him, sitting quietly with a peaceful face. But it was the face of the living human being" and thus "full of restlessness and motion." Art that wishes to represent life (and in so doing, capture it) was not permitted to take as its ideal that "stillness, which never existed."[3] Life had been at work on such a face. At the same time Rodin had "completely perfected his method of going through a face," expressing "every line that fate had drawn." He worked "without asking who the man was whose life was passing once more through his hands." He could not look at the human face anymore "without thinking of the days that he had been at work upon it." But there was life in every gesture. In his life-sized figures Rodin transferred the expression of the face—and its

nakedness—onto the entire body. Therein lay the revolutionary nature of his modern sculpture. It was through their passionate bodies that Rodin's people came to life: "life, which was as readable on human faces as time is upon clock faces, yet on bodies it was more diffuse, greater, more mysterious and eternal. There was no dissembling here," as happens so easily in faces. In their gestures Rodin's bodies resisted all roles that were demanded of them, but this resistance gives more space to the longing for nature and freedom than to the expression of a single person.

Rilke was still alive during the prologue to a century that was to focus unbearably on the face through events like Auschwitz—and cast doubt not only upon the face, but upon all imaginable images.[4] The fine arts have retreated

FIGURE 38 Auguste Rodin, *The Man with the Broken Nose*, 1863–64 (Munich, Neue Pinakothek)

from the face for a long time, because the avant-garde became fascinated with the machine and showed preference for "mechanical beauty" over the "sentimental" face, as Pontus Hultén once stated.[5] For the futurists a race car supplanted the famous Hellenistic statue of Nike in the Louvre. The passionate Fernand Léger[6] was a champion of the machine aesthetic. He felt that his own ideal of a nostalgic cult surrounding the smile on the face of the Mona Lisa was under threat, and he thus polemicized strenuously against faces in art, which he rejected as bourgeois clichés embodying an obsolete concept of the subject. For him, only the "plastic" object that possessed no human face had validity. He valued only form, whose meaning was simply itself without any other significance. For him the world was supposed to stop looking anthropomorphic.

In his polemical book, *Die Antiquiertheit des Menschen* (The obsolescence of man) (1956), Günther Anders suggests a scenario from which death has departed. As a consequence, the living face has lost all interest. "Iconomania" (which he had touched on earlier) becomes a substitute for a lost reality of humankind. In this book Anders refers to Evelyn Waugh's famous novel about the cemeteries of Hollywood, *The Loved One*, which in 1948 initiated a new wave of European criticism of

the culture of the United States. According to Waugh's thesis, the sugarcoating of death banishes its own reality for the sake of a sterile fiction of life. "What is buried in these cemeteries is not dead people but death itself." In the administrative offices of Whispering Glades, the California cemetery, the corpse is registered as "just another has-been," and in conversations with the clients it is referred to as "the loved one," rather than by name. Seen from this European distance, this early criticism views the United States as an adumbration of a future dystopia.

Anders, however, recognizes the first signs of the creeping loss of the human face on the European side of the Atlantic. By this he does not mean "the frequently observed standardization of contemporary physiognomies, nor the fact that even faces shaped by identical influences are today serial products that resemble one another. One face differs from another only as much as one piece of cloth from another—namely, by virtue of individual flaws in its weave." More to the point, now even the "standardized face is being lost."[7]

Among those voices of the postwar period that stand out from the debate about the endangered face, Antonin Artaud's frequently quoted text, *Le Visage Humain* (The human face), deserves our attention. Artaud published this in July 1947 when his *Portraits et Dessins* were on display in the Galerie Pierre in Paris. This explains his angry demand that his own drawings should be taken seriously as symbols of the face. After his release from the psychiatric clinics where he had spent long years, he wanted to save himself from the threatening loss of identity by producing portrait drawings. To this end his friends were supposed to participate as models and comrades. On these pages the dead appear in death masks, whereas the faces of the living are rendered with penetrating intensity, as though each had already become a real face. The intimate dialogues the draftsman carries on with all these faces are meant to force them to reveal everything they do not know themselves but have been carrying inside for so long.[8]

During the heyday of abstraction—the unassailable credo of the art world in the 1940s—Artaud's drawings were seen as anachronistic experiments done by a literary figure. But he stubbornly resisted the new trend with his determination to reproduce "the characteristics of the human face as they really are. For, in the way that they are, they have not yet found the form that they evoke. In other words, the (given) face (*visage*) has not yet found its *face*, and therefore must receive it from the painter." *Face* is another word for *Gesicht*, but the concept also carries within it the meaning of countenance and self-expression, which form a contrast to purely physiognomic similarity. "The human countenance, just as it is, is still seeking itself. It carries a kind of eternal death, from which the painter must rescue it by giving it back its true characteristics." These words also contain an affirmation of the por-

FIGURE 39 Antonin Artaud, No title, 1948, drawing (private collection). © 2016
Artists Rights Society (ARS), New York / ADAGP, Paris

trait, which ultimately took resistance to death as its goal. Artaud, however, with his
drawings, did not wish to be seen as part of a tradition he considered to have col-
lapsed. In older portraits, he found that painters had been satisfied with "mere sur-
faces" in order to let living faces speak upon them. Artaud, on the other hand, wants
to fathom the true face. The face as form has never "completely corresponded with
the body, but rather began to be something other than the body."[9]

Shortly before his early death in January 1948, Artaud made a wonderful
sketch in which he took up the struggle for the face and accelerated the search for
his own face (fig. 39).[10] In this drawing the disembodied faces move confidently with
each other, as though in a great theatrical masque of life. On the left side, theater
masks hang upon a string like obsolete props after all their roles had been canceled
by death. On the right side, faces line up randomly, as though waiting for their

entrance, but it is Artaud's face alone that makes an entrance. He seems to be glancing back at life, taking leave of it. And yet he alone, among all the other masks, seeks for his real face in life, to use Artaud's own concept for the ultimate face. He tries to wrest an expression of life from death, which at the time he felt approaching, for in life the face is still in a state of becoming. Once it has become its fate, however, its time has run out, and it becomes the blank and rigid mask that the dead on both sides of the drawing exhibit. Artaud's face seems to gently touch the hair of his friend Yvonne Allendy, whose death he still mourns after ten years. Her overly large mask, in its immobile frontality, has become frozen into an image of memory behind his head. But she is repeated several times in a downward-sloping pattern like an echo, as if Artaud wanted to suggest that, with his death, her image is also fading from memory. His own face, however, is only permitted a short time to "say what it has to say."

Artaud's apology for the face anticipates a eulogy. It flows into the thought that the face already carries the mask within itself, even when it has not yet found its form, which it must extract from the time allotted to it. The contrast with the man-made, manufactured masks lies in the life process, which takes place in the real face. In this process a face is not static. It looks backward to the path it has already traversed as well as predicting the mask that it will become in death. Artaud's drawings point beyond the concepts in his text. The drama of the face is the drama of the subject, which Artaud once again draws out of the shadow of death. From today's perspective his text seems like a valediction, which in our media society will no longer be heard.

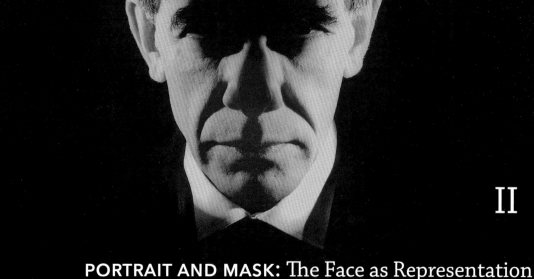

PORTRAIT AND MASK: The Face as Representation

8

THE EUROPEAN PORTRAIT AS MASK

Despite the fact that all our lives we continually snap photographs of one another, modern culture often views the portrait as passé. Artists have to go to great lengths to find new justifications for portraiture and endow it with contemporary form. The reasons for the portrait's loss of meaning are many and varied. The face, subject of all portraits, has become an inflationary commodity in the mass media of our "facial society," and thus cheapened. It has not been the focus of science for quite a while, as the example of neurology demonstrates. Neurology studies the brain directly rather than via the medium of the face. And yet the face remains relevant because, all eulogies to the contrary, we still possess faces and use them to express ourselves. The concept of the individual self, or ego—whose expression has always been sought in the face—is far from obsolete today. We prefer to identify ourselves with such a self rather than with an organ like the brain. A self (ego) strives to present itself and communicate via the face. This means that the face still holds many unsolved problems. When we view the historical (and contemporary) portrait as privileged space that stimulates contemplation of the face and its meaning, it shakes off its ancient dust.

By the time World War I had ended, and the traditional image of man made its exit and divided the various schools of thought, all battles over the portrait had

already been fought. In light of the controversy of the day, everything about the topic that emerged in the second half of the twentieth century seems like a weak aftershock. In the period between the two world wars, however, a controversy between different philosophies of the portrait photograph was ignited—a controversy that the rise of National Socialism quickly extinguished.[1] It was also a controversy about individual or collective physiognomies—about faces versus social types. From our perspective today one is struck by the dominant role given to the face as a proxy for a divisive image of man. The dispute about the face was conducted with pictures, which were judged to be right or wrong. Nowadays, given our experience of the labyrinths within virtual worlds, and the digital monopoly on our lives, the historical debate presents the impression of a stubborn belief in the reality of the face and the realism of images that depict it.

The progressive camp welcomed the demise of individual portraiture as a liberation from bourgeois conventions. But therein lies a misunderstanding, which was subsequently adopted by most theories. This misunderstanding is a belief that the portrait—as a product of bourgeois (that is, pre-1918) culture—had (like this culture itself) outgrown its purpose. The same argument was used to try to view individuality as a cliché of bourgeois culture. Polemics like this obscured the fact that the history of portraiture has much earlier roots, and that the human visage had once served as a statement of self-assertion in other societies. The portrait experienced a kind of swan song, which obscured its early history. Only by accepting this premise can we calculate the significance of a pictorial device that takes on a key role in European culture. In the period of court and church authority, the emancipation of the subject is demonstrated in the portrait. It is precisely in the portraits of the early modern era that we find the conflicts between the individual and society more clearly defined than in the texts of the same period.

Since antiquity Western culture has no longer produced masks one can identify with. The full mask of antiquity remained a rare exception even on the stage, while masks became just another attribute of folklore. The face became all the more important when it alone was the vehicle for conveying meaning and expression, laying claim to the social roles of the mask. Masks, in the old sense, were consequently devalued as a falsification of the face. The earlier distinction between face and mask disappeared. This distinction had existed with respect to masks worn by dancers or actors. No longer was it necessary to have an artifact like the man-made mask in order to represent a face. And yet such an artifact still exists if we view the portrait as a European mask. It is a mask, but not one presented by actors; rather, it is a mask that has been petrified as a bearer of memory—memory of the face.

The portrait originated as an artifact with a lifeless surface, which by its very

nature was a vehicle for the permanence of all things per se. Conversely, it became the proxy for the face, the expression of which separated it from the body and transferred it to a symbolic surface. By this means, the *mask as portrait* made its way back into European culture. But this interpretation requires us to define the relationship between face and mask differently from the way it is normally done. We like to speak of the resemblance of a painted portrait in a physiognomic sense, but the resemblance begins at the point where the portrait tries to resemble a *face*. This resemblance rests upon a fiction: how can flat wooden panels or photocopies resemble a living face? Thus an act of transference—the essence of representation—takes place. A real face is physically *present*, but a portrait takes its place in its physical absence. It is reified as representation and can be nothing else. It detaches the view of a face without combining it with facial expression or the presence of life.

Paradoxically, a portrait reduces the face to a concept of itself by creating a mask of it; while a face has an open form, the mask has a closed form. This means that only the mask can represent the essence of the face permanently, while a face can never come to rest and thus cannot be reduced to a concept. When the portrait takes the place of the absent face, it does not do so as representation in a performative sense, but rather in a mimetic sense. The representation succeeds only when it conforms to the conventions of its age and social context. This process intensifies the masklike character of the face. In a portrait an exchange takes place between a living mask (face) and an inanimate one, which does not claim to be alive, but simply captures the lineaments of life. By the sheer fact that every portrait is made, and thus presupposes a maker and a patron, it is stamped by the mask of the age that produces it.

It may seem peculiar to speak of a wooden portrait panel as an artifact, since over the course of time we have grown to admire it as a work of art. We see Renaissance portraits hanging in museums, labeled with artists' names like all other paintings. This tends to make us forget that a portable portrait panel once served different social practices that encompassed many functions—as objects to be exchanged or inherited, expressions of official status or family mementos, and as objects of display in mortuary chapels or aristocratic residences. Formal portraits are still a reminder of their former function, which was connected to a protective, and protecting, status. Official portraiture came into its own wherever the person represented was absent but nonetheless wanted to enforce his rights. It is well known that portraits also figured in inheritance claims, which involved titles and property rather than the portrait itself, which they served to validate. Anyone who has ever been allowed to hold an old Flemish portrait in his hand will agree that it transforms a *personal existence* into the *tangible existence* of a portable object. The panel was not merely a memento, but rather lent the person represented a symbolic

presence, as if still alive—on the panel if not in person. The symbolic function of such a portrait was fulfilled in the portable panel, for it could be taken to all the places where someone was to be remembered and have his rights acknowledged.

The analogy between portrait and mask is nowhere more tangibly demonstrated than on the sliding lid of a Florentine portrait box in the Uffizi Gallery that depicts a mask (fig. 40).[2] Before one could see the portrait, the sliding lid prepared the viewer for the fact that the portrait actually involved a mask. The lid lay over the portrait like a mask upon the face of its wearer, but the portrait was no face, but only a representation of a face, merely painted, just as the mask was a painted mask. Here, the analogy between mask and face goes further because, despite its empty eye sockets, the mask is painted with the pink flesh tone of a face. This enforces the resemblance between portrait and mask. When the lid was closed, one saw only the mask. Open, it revealed a face that it had already announced as a mask. But mask in what sense?

The Latin inscription above the mask gives the answer in its apodictic formulation, "to each, his role (*persona*)," "*sua cuique persona.*" For someone knowledgeable in classical literature, this wordplay conveyed the identical nature of role and mask. It was a literary topos to designate a social role as a mask. Every person played roles in life—roles that, we are meant to conclude, were transferred to his portrait and represented him in that sense. But the painter carries this argument a step further. The fresh facial color of the mask stands in intentional contrast to the inanimate fantastic beasts in the ornamentation, which hold quite different, stone-colored masks. This paradox vanishes when we connect the mask to the portrait under the lid. This, too, was also just a mask of the true face whose living color it assumed. But which portrait are we discussing here? In the nineteenth century the lid in the Uffizi was united with the portrait of an aristocratic lady, who poses in front of her country estate, holding a prayer book in her hand (fig. 41). The mask upon the lid has the same measurements as the pale face in the portrait. The lady was tentatively called "The Nun" (*Monaca*), although she does not wear a nun's habit. Today there is agreement about the attribution of lid and likeness to the painter Ridolfo, who in his Florentine period was a friend of Raphael. Perhaps the portrait represents a memento of a dead woman. But what portrait was painted without the thought of death? We do not know why this portrait was painted with the idea of a mask. Nonetheless, the emblem upon the lid is evidence that the mask stood for the whole genre. The representation of a face, with its unique conventions, could always and only be a mask anchored in its own era.

In the final analysis, the concept of the mask harks back to Cicero, whose tract *De officiis* distinguishes predetermined roles in human action. Francesco Guicciardini[3] takes up the theme in 1527 when he compares "our life with a comedy" and

·SVA·CVIQVE·
·PERSONA·

FIGURE 40 Sliding lid of a portrait, attributed to Ridolfo Ghirlandaio, ca. 1510 (Florence, Uffizi Gallery)

FIGURE 41 Portrait of an Aristocratic Lady ("Monaca"), attributed to Ridolfo del Ghirlandaio, ca. 1510 (Florence, Uffizi Gallery)

enjoins his reader to master the role that he is meant to play. "For everyone must play the role (*fare la persona*) that is assigned to him." One year later, in 1528, Baldassare Castiglione published his famous *Cortegiano*, or *The Book of the Courtier*, where he writes that, at court, one must learn to play one's desired role so effortlessly that no one may notice that one is wearing a mask. Of course all courtiers practiced this, which meant that they had to be on guard with everyone. They could trust no one and no mask (*mai di persona*), as the book says ambiguously of both person and mask, nor must they ever permit themselves to forget the game.[4] Castiglione describes the mask of the courtier, whereas Machiavelli, in his book *The Prince*, describes the mask the ruler should wear before his court. The game of masks defined interaction at court. On both sides, the mask had to be practiced so well that it had the effect of the real face.

Castiglione's work contains a further concept of the mask. In the dedicatory epistle to *The Book of the Courtier* he calls his work "a portrait of the court of Urbino,"

in which only such persons appear who have since died and can thus be only shades of memory." In an elegy, he describes his own portrait—painted by Raphael—as his proxy to represent him with his family from whom he was absent when traveling. He conceives this elegy as a letter, which his wife, Ippolita, had written to him once when he was away for a long time. "Only the painted picture by Raphael's hand keeps your face in my memory," and "I laugh and speak with it as though it were yourself." He writes that even his young son recognized his father in the portrait and would stand in front of the picture to address him.[5] The mask as a painted face is here the surrogate for an absent person and not the mask of a role demanded by social conventions.

It was possible to simplify things by calling the mask question—which was primarily one of roles—a moral one, and to see it as a choice between virtue and vice that an individual had to make in life. The poet Aretino made use of this topos when he had his portrait painted by the Venetian Sebastiano del Piombo around 1525 in a completely emblematic style. Giorgio Vasari, in his *Lives of the Artists*, recorded the description of a lost portrait in which the famous poet posed between "two masks, one beautiful, representing virtue, and one ugly, representing vice." Vasari was thus using the newly introduced Arabic concept of *maschera* in order to differentiate the mask as artifact from the classical concept of *persona*, for this word had come to embody the meaning of person, in a more general sense.[6] The duty of deciding between virtue and vice in life is no longer grounded in religion, but rather delineates a character who chooses between virtue and vice as masks of the self.

The practice of using a mask that had actually been cast from a face as a model for a portrait involved an immediate connection between portrait and mask. Such a mask guaranteed similarity through its mechanical impression, in other words through its means of production. With the use of such a replica, the face could be transferred into a one-to-one likeness. This custom continued in the practice of making death masks, which were usually translated into the image of a living portrait. One example is the death mask of Lorenzo de' Medici from the year 1492 (fig. 42), which served as the model for several casts so it could be used in place of an official portrait with a political message.[7] This mask in the Pitti Palace in Florence is mounted upon a board like a portrait and accompanied by a formal inscription that mourns the loss that had befallen the state as a result of Lorenzo's early death. The inscription also refers to the dangers, internal and external, that threaten Florence.

Casts of faces belong to a subcategory of portraiture. Since they are sculpted, their material properties lend them a superficial resemblance to masks in other cultures. But any comparison would only emphasize the differences of Western practices. In the West the masks are castings of individual faces and as "portrait masks"

FIGURE 42 Cast of the death mask of Lorenzo de' Medici, 1492 (Florence, Pitti Palace, Museo degli Argenti)

they contradict the meaning of most ritual masks, which is to provide faces for strangers and unknown people. Castings reproduce human faces as facsimiles whose authenticity is guaranteed by the actual body, with which they came into physical contact. When they are death masks they are mementos intended to capture a face for eternity. Faces have however undeniably been transformed into masks whenever they have been reproduced. In this process they have left their image but not their life behind, and by this change of medium they have thus become isolated upon the face. And yet such a practice is proof of the mimetic relationship between mask and face, which has promoted the crossover between the two.

We have become alienated from the early history of the portrait, even though we marvel at the art it represents, for the portrait acquired a key position in the modern culture from which we stem. It originated unconsciously as an alternative to the masks that are a familiar phenomenon in other cultures. But in its own way it was a mask resulting from the transformation of the face into an artifact. It was the destiny of the mask to represent social roles on the natural face of a living person. There was no contradiction here between the private intention to represent a *real face* and the collective intention to exhibit the *face of a role*, with which its wearer displayed social status. The success of a portrait lay in its ability to provide a mirror image of society, even though it displayed this only in a single individual. The more strictly a society was organized, the more mandatory the face became as role, and thus the more unequivocally it showed its social mask. Whether or not a painter represented the social class or the profession of a person, the image was always bound to conventions. These involved limits that could not be overstepped except in cases of rebellion or extravagance. The problems of the portrait were suggested by the same questions that one posed about the living face. The face of the role did not exist without an individual face, which at the same time had its own physiognomy. It could only be represented as an individual portrait; thus it took its life from the tension between norm and nature, between role and face. That is the contradiction for which every portrait has had to seek a new solution.

The masklike character of historical portraits is unintentionally displayed in a contemporary attempt to reconstruct such portraits in photographs. In one such group of works from the 1980s by the American Cindy Sherman, the artist places her own face into historical roles in the form of a mask (fig. 43). These are authentic photographs but dramatized like portraits from the history of painting.[8] For these, the artist used the term *history portraits* (a term she invented), partly in reference to her models in historical painting, but also with a backward glance at the portrait as a historical genre that today can only be revived by quotation. Her large-format photographs recall paintings, thereby denying their analogy to photographs, which is what they actually are. Cindy Sherman herself sat as a model for each image and played different roles as she changed costumes and poses. This *masque* derives from the changing role of one and the same face as it seamlessly assumes the most varied historical characters. This attempt to exchange photography for painting awakens the suspicion that the historical paintings themselves might have been photographed, for the precision in the representation (enlarged in the photograph) contrasts with the dominance of the pose held by the model in her facial expression, body language, and costume. Even though these history portraits run counter to contemporary practice, many are recognizable as portraits because their sources are

FIGURE 43 Cindy Sherman, Untitled #209, 1989 (photograph)

familiar. In them the artist detaches their memory from its archival context and unsparingly reveals historical and social affectations. The uncertain role of the face is surprising in all this. Cindy Sherman barely altered her own face to make it appear different each time, for the role she plays is dominated almost effortlessly by the person posing for it. As a result, none of these photographs can ever have the status of a self-portrait. The same face even completes a gender transformation and seems to adjust to each new context effortlessly. The only contemporary motif—Sherman's face—is thus separated from any contemporary message, but it transforms everything else into a theatrical tableau. Even the old portraits show actors, but with the difference that they were playing an identity connoted by their role.

Cindy Sherman's work crosses historical boundaries with irony and self-assurance, as for example when she poses with her own face for a photograph as an aristocratic woman of the Renaissance as the wife of Peter Paul Rubens or as a lady from nineteenth-century Parisian society. To accomplish all this, she only required a costume change. We seem to be looking at an old painting, but the face of an American artist looks back at us with a complicit expression. The historical ladies looked the same way when they were painted except that here the mask is the artist's own face grafted onto the work. One forgets the mask when Sherman looks at us in the guise of a young woman from the Renaissance, and yet we cannot forget her for a moment, because she also returns in the act of being portrayed in a contemporary "afterimage" (see fig. 43).[9] In other works by Sherman, her own face is not sufficient for the role change; she sometimes uses prostheses such as appliqué noses and cheeks to expand the boundaries of the mask. Between face and role there also develops an interplay that is not immediately understandable. The distance from historical painting seems to diminish when the artist uses mimicry to awaken the old portraits to a perfect afterlife. This, however, is only possible because in the past the pose had triumphed over the similarity to the person sitting for the portrait. The contemporary transformation is not amazing, but rather the opposite—namely, the truth about the historical examples that inspire it. Even then a portrait represented a socially constructed self. The painted staging equipped a person with the very mask that was required by society.

The portrait as historical mask was brought into play in an equally radical way by the Japanese photographer Hiroshi Sugimoto, when he created his series *Portraits* in 1999, in which he also photographed historical personalities from the Renaissance. The impossibility of this endeavor is explained by the fact that Sugimoto visited Madame Tussaud's Waxworks and took portrait photographs of the figures in it. When the subjects were personalities who had lived before the invention of photography, the wax figure was formed according to a painted portrait,

even though in this case he was taking a full-length photograph. But Sugimoto takes us back to the half-figure portrait format by repeating the excerpt of the image and its lighting, although in doing so he uses the techniques of his modern medium: large-format black-and-white photography.

This working method reveals a threefold mask. Only the wax figure wears a mask in the literal sense. Yet this is based upon a painted face—the model for a new mask, which reproduces the painted mask in the medium of photography. This double media switch is perfectly successful, because it is based upon a change of masks. An example of this is the half-figure "portrait" of Jane Seymour, one of the wives of King Henry VIII, who appears before us in real clothing but with a wax face (fig. 44).[10] The comparison with the aforementioned work of Cindy Sherman is revealing and confusing at once. In both cases we are confronted with a photograph, and in both cases a historical painting has been imitated. And yet at the same time, the process is as profoundly different as the originals that were used. Only the mask-like character, which emerges despite the difference between the living face and the wax figure, permits a comparison. This comparison reveals the masklike character of the genre of the portrait that is the basis for the very different photographs.

Both of these contemporary artists show in their own ways that the portrait has become a historical genre that summons up memory, despite the fact that in individual cases official portraits can still conform to a lost tradition. The private consumption of pictures has lost this practice; it is still honored only in passport photographs. One work from Cindy Sherman's series reenacting Caravaggio's painting of Bacchus appeared on the cover of the Parisian magazine *Artstudio* in the summer of 1991. This issue was dedicated to the contemporary portrait (fig. 45). As one thumbs through the illustrations, it becomes apparent that all conventions that once applied to the portrait have been eliminated. The *portrait* as a protected genre no longer exists, although the subject of the face still does, even though it now defies all definitions that rely on its external appearance. And with this, the development that we call the history of the portrait is complete. It is a European history that does not correlate with the visual history of the human face, which is found in almost all cultures. We find ourselves at a heuristic advantage if, instead of bemoaning a loss, we focus on questions about this history from our modern perspective. Among these is the question of the mask, which could not be asked earlier, given the self-definition of the portrait as authentic representation of an individual. There is a further aspect of the nature of art that forms a barrier to the mask question, because art is measured by the degree to which it represents a face as true to life and unmistakable.

Ever since photography began to lose its documentary character and rival painting with museum pictures in giant format, it has also become a subject of art history.

FIGURE 44 Hiroshi Sugimoto, *Jane Seymour*, 1999 (photograph)

FIGURE 45 Cover of the Journal *Artstudio*, Summer 1991, showing a photograph of Cindy Sherman as Caravaggio's Bacchus

Artstudio

Le Portrait contemporain

Frank Auerbach
Christian Boltanski
Lucian Freud
Alex Katz

Jean Le Gac
Hans Namuth
Roman Opalka

Arnulf Rainer
Cindy Sherman
William Wegman

21
Été 1991
Prix 130 F

When Walter Benjamin celebrated modern photography for its realism and defined it in opposition to the allure of art, he would never have considered this transformation possible. On these huge surfaces the natural face loses its literal contours as it takes on every imaginable format. At the very moment when they are presented as portraits, such photographs are removed from the history of the portrait. By contrast, they give the impression of competing with the medium of advertising, which numbs us in all its formats. The digital revolution has made its own contribution to this. The phenomenon has severed the dependence upon a face as the natural point of reference of the illustration and invented faces that cannot exist with bodies. The representation of the face is liberated when it no longer must—or no longer needs to—prove anything. People demand authentic or real faces only from journalism in order to bear witness to events. Specially modified photographs are even superimposed when the reporter can be reached only by telephone.

This contemporary crisis of the portrait is hardly surprising, for we live in a so-called media society that is no longer society in the traditional sense of the word. Rather, it is only present in the media it employs. These are public media that restrict private access to the viewer. In retrospect it becomes all the clearer that portraiture, despite being the representation of individuals, was the reflection of a society that originally existed only in Europe, just as the portrait panel was a European pictorial genre. As a consequence, the transformation of portraiture reflects a transformation of the society from which it developed. The portrait thus cannot be defined as a universal genre, but can only be represented within the context of the history that produced and shaped it. The following text confines itself to an overview that connects the portrait with a cultural history of the face, which is my topic.

The history of the individual portrait essentially begins with its function as document and memento after it emerged from the shadow of courtly representation and embraced the notion of death. In its further development, the social connection took precedence in the dramatized face, but gradually disappeared as a theme in the eighteenth century. The question of the self, which was absent in the face, grew more important in the self-portrait, which was constantly in revolt against the conventions of representation. Finally, photography, which was welcomed as the true document of the face, once again proved to be a mask that captured life in frozen form. People began to seek an escape from the mask in live pictures as soon as the appropriate technology permitted it. The modern era has seen new revolts against the fetters of the portrait, such as in the work of the painter Francis Bacon (see fig. 76), who sought a violent way out of the portrait tradition in order to give life to faces he considered ossified. My considerations proceed from the conviction that in the relationships between face and portrait, the

balance has always been shifting, which is why "the portrait" cannot be reduced to a single common denominator. The mask, however, was and remains the darker rival wherever and whenever people have tried to depict the face.

The mask also provides a key that helps us trace the development of the portrait in the early modern period. Rather than being limited to physiognomic similarities, portraits have always represented the conflict between social mask and mortal identity. They were the space in which the conflict is played out. The question about what a person is, or should be, has always been asked anew, because all portraits are incapable of presenting a person's definitive face for all time. The likeness that was destined to take the place of the face made a statement about the representation of a person for whom there was no eternity. Every portrait was thus a new attempt to progress toward a vivid idea of a human being in order to represent him as an image for the society of his own time. It was precisely this necessity of posing the same question each time that gave portraiture its opportunity. In contrast to the life mask or death mask, the painted portrait was neither cast from the face nor legitimized by contact with the body. It was rather an interpretation determined by social interests. It did not actually represent the face, but rather its claim to representation. To this end, the portrait created in its symbolic surface a vehicle of meaning that had been invented in Europe. This was first seen in the framed portrait panel and later in the modern era in the photographic print.

The assertion that the European portrait can be understood as a specific kind of mask does not mean that it bears any similarity to a real mask. It can always merely resemble a face without ever *being* a face. The analogy with a mask lies in the fact that the portrait exchanges a face for an image. Its difference from a mask exists insofar as the face is imagined as absent, whereas masks in other cultures have always sought to create presence, often in the context of ritual and dance. The inanimate vehicle for an image cannot embody life in the portrait in the way that a living wearer of a mask has always done. The portrait may deny the existence of the mask, which produces it through mimicry and worldview, yet it can only resemble a face by its absence, an absence that grows over time. The true destiny of the portrait did not fulfill itself until the person represented had died and remained present only in a picture that connected memory with an object. A portrait was used as a so-called *interface*, as one would say today. As such it addressed the viewer in order to show the painted face of the person depicted.[11] The portrait's painted face offered an interface to encourage the viewer to communicate with the portrait instead of with the real face.

During the first centuries of its history, the portrait represented individuals within the social context to which they belonged. It depicted not only a physiognomy that differed from others, but was also a mask with which such persons

asserted status in society: a mask that represented presence via an image—in other words, in an object. We found the counterexample in the "portraits" that Géricault painted from 1819 to 1822 of the mentally ill (*fous*) whom Dr. Georget treated in the Salpêtrière in Paris. These are clinical studies created without the participation of the patients. They focus on medical cases rather than human subjects. As one can see from an example in the Reinhart Collection in Winterthur, they document that person's loss of identity. In this case the person is a "monomaniac" (to use the term then applied to such behavior) who thought he was someone else and dressed the part (fig. 46). With his unsteady gaze he seems unable to perceive the artist and appears so lost in another world that he can no longer lay claim to representation of a "self" that forms the basis of every portrait.[12]

9
FACE AND SKULL: Two Opposing Views

As a document and memento of a face, the portrait embodies a contradiction to the age-old custom of viewing corpses. It has been a long time since we have been allowed to view the deceased or even the dying. Now, we have become accustomed to the official absence of death.[1] When important public figures die they return in the mass media in snapshots from their lives where only the commentary reveals them as having died. Yet this very denial makes death omnipresent. Death hides in the great swirl of photographic images of people around us. The mass media make it impossible to recognize whether the faces whose images the photographs now broadcast are actually still alive. Like all images, these concede a new, symbolic presence to death—a presence that is both iconic and ambiguous. We are now accustomed to seeing only pictures of the living, without being able to know whether those shown are still alive. Of course, the victims of tragedies are depicted, but they remain anonymous images. In these victims we mourn our fellow human beings whose lives were eradicated by a nameless quirk of chance.[2]

The portrait of early modernity was a mask of life that defied death and yet predicted its approach. Although the painted face has become separated from the place of burial and is displayed in living rooms, behind the invention of the portrait there stood a protest against the graveyard. At the time when individual portraits began to be painted, the greatest part of the population still met its ultimate end in ossuaries— charnel houses, or bone houses (fig. 47). The clean, shining skulls stared at the cemetery visitor from their sightless eye sockets without giving any indication of their owner's identity in life. In death the face had slipped away from them, just as masks do when they have discharged their duty. But what about what lay behind the living

FIGURE 46 Théodore Géricault, *Mental Patient with Military Megalomania*, ca. 1819–22 (Winterthur, Oskar Reinhart Collection "Am Römerholz")

FIGURE 47 Skulls in the ossuary (Charnel House, or Bone House) at the cemetery in Hallstatt (Austria)

mask? To judge by appearances, the skull alone was bearer of the face. Life had concealed death until death emerged from behind the face. Questions about the former owner of the face could not be answered from the anonymous gaze of the skull. The answers could only be sought in people's faith in an immortal soul, which was no more amenable to depiction than the self is in modernity after it disintegrates in death.

The portrait[3] thus posed the fundamental question about what visible appearance can offer for the concept of the human being. Only two conditions of the body are accessible to empirical perception: in life it is the face, and in death it is the faceless skull. In their ultimate contradiction, these views of the human being both appear like thesis and antithesis in the repertoire of early portrait painting. When the portrait originated, people wanted to remove the face temporarily, like a mask, from the depredations of death. Today we no longer get to see skulls. It has been a long time since we have fostered a philosophical cult of skulls, as Goethe still did when he paid homage to the skull of Schiller in his house in Weimar.[4] As a result we are no longer accustomed to the contrast between life and death that we notice when viewing a faceless skull. Yet it was precisely this upsetting experience that gave rise to the invention of modern portraiture. A skull does not become visible until it loses the face it wore in life. Early portraiture symbolically reversed the loss

of the face and retrieved the face in the image. On the picture panels one "retrieved" the face from the body, so to speak, as is suggested by the Italian word *ritrarre*, which is the root of *ritratto* (portrait).

The skull confronts us with our own decomposition, which is followed by bones and the visage of death. Only the saints were exempt from the anonymity of the bare skull, with its gruesome memento mori. Their skulls were enclosed in reliquaries of gold and precious stones. These lent them new and radiant faces and masked the facelessness of their real skulls. The busts of the saints boasted the presence of real skulls, but concealed behind the medium of dazzling representation, they inspired awe, not fear, in the viewer. Over time, however, the saints' faces reflected the novel taste for portraits of mortals and were thus endowed with individualized but completely fictitious facial features. In this cult such sacred faces became objects of veneration rather than inducements to memory. The cult of saints' skulls stood in absolute contrast to the fear of skulls that normal mortals felt.

The private portrait bust, which originated in the same period as the portrait panel, marked the anthropocentric shift in the history of imagery. The technique that produced it, however, was bound up with the presence of the body, for it occasionally made direct use of the life or death mask taken directly from a face in a negative-positive process. This lent it authenticity that a painter could never guarantee as credibly. And yet it was always limited to the head and shoulder area.[5] It shared its space with the viewer, whereas painting created its own space within the picture frame. In Florence the portrait bust was long considered the legacy of the saints' bust, although it represented nothing less than a saint. In the spirit of the Renaissance, a new precedent for portraiture was found in the classical ancestor bust. These "new Romans" were displayed in private living spaces of fifteenth-century palazzi where painted portraits of family members, usually male ancestors, adorned the walls. Both genres displayed the same verism by emphasizing family traits in the physiognomy.

The Pitti Palace Museum owns a rare exception, the previously mentioned death mask of Lorenzo de' Medici who died in 1492 at the age of forty-three (see fig. 42). This mask is remarkable because it was not used for a portrait of the living statesman, but rather was displayed instead of a portrait—or as a portrait—on a panel with a formal inscription. This dramatization showed the dead face, which had been taken from "this body" as an admonition and political manifesto.[6] The inscription mourns the "cruel death (*morte crudele*) that visited this body. After this death the world collapsed in disorder (*sotto zopra*), whereas this man had maintained peace for as long as he lived." The words consistently urge that the viewer look at what is being displayed: the expressionless face of a dead man whose place

was taken by political heirs who did not fulfill the promise of his legacy. Therefore, the authenticity of the face was an invocation of presence that transcended artistic representation. The death mask as an exaggeration of the individual portrait was neither a life mask nor a memento mori, but rather an appeal from the deceased that offered his heirs public legitimacy.

At the time when individual portraiture was emerging, owning one's own grave was an extraordinary privilege. Defying the loss of one's own face with a painted mask of life was a similar privilege. Today we speak metaphorically of "losing face," but in earlier times people thought about death's work quite literally. The custom of producing a portrait that would save one's face for eternity was viewed as gross presumption, despite the fact that this face was mortal and in old age had already begun to presage death. Having one's own skull painted was seen as atonement— the skull no one had ever seen before, which could be laid upon the scales of life and death. The masklessness of death, represented so vividly in the skull, questioned the mask of life that had produced the portrait. In the same medium, the skull itself lifted the mask that had concealed death. Paradoxically, the death's head thus became a second portrait, embodying an antirepresentation that negated the portrait's claim to be the vehicle of representation. Because the painted face possesses the permanence of an object, it defies the inescapable revelation of death, yet the painted skull admits that a face possesses no permanence.

Face and skull, which spar with each other in the painted portrait, held their debate in the form of the figure of death on the monument. It was common for the deceased—in this guise as the stone face that it would bear in public—to retain the status that he had acquired in life. In the late Middle Ages, however, this fiction of life was exposed when a second figure was introduced in one and the same tomb, showing bodily death as it really was. This antithesis was not confined to the skull alone, but portrayed the whole body in the early stages of decay. The key example of this practice is the magnificent unprecedented tomb that Cardinal Jean de la Grange (d. 1402) commissioned from the sculptor Pierre Morel for the monastery church of Saint Martial in Avignon (fig. 48).[7] This tomb, which represents a towering accomplishment among medieval grave monuments, depicts the cardinal twice— once as the solemn official in his episcopal vestments, whose face captures the lineaments of transitory life; and a second time as a macabre, naked corpse showing signs of decay. The cadaver tomb (*transi*) embodies a paradox as the sculpture captures the creeping process of putrefaction, whose permanence the stone emphatically contradicts. There is the further paradox that we seem to see the dead face of the cardinal dissolving before our eyes (the incorruptible tassels of the cardinal's hat grotesquely caress his face); it seems to utter a personal warning to us about the

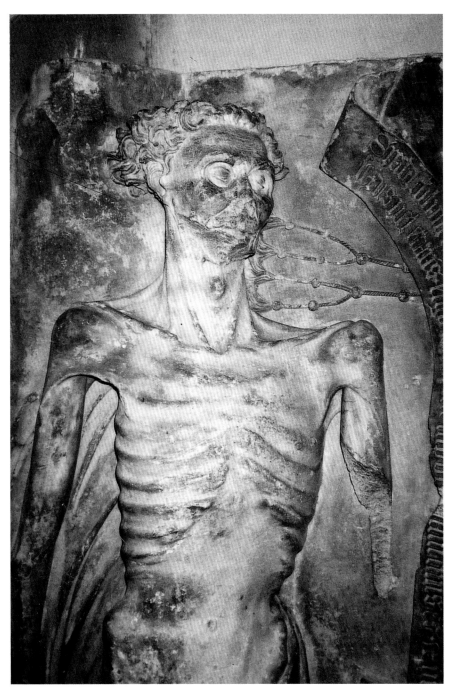

FIGURE 48 Cadaver tomb (Transı) from the grave monument of Jean de la Grange (d. 1402), detail (Avignon, Musée du Petit Palais)

illusion of life: "For dust thou art and, like me, to a stinking cadaver shalt thou return." This is how the sculptor has depicted the cardinal. The prince of the church and the naked cadaver in one and the same place hold each other in balance—or perhaps more aptly, they negate each other.

The dual portrait of face and skull—if one may speak of the skull as a rival portrait— became something of a painted discourse about portraiture as long as the portrait asserted its right to depict a person. In the same period such an assertion was legitimized by a religious function. A diptych usually served this purpose. This was held in the hands during prayer by the person who also found himself represented in the portrait for eternity, even after the person could no longer pray for himself. We encounter this dramatization in a diptych commissioned by the Burgundian courtier Jean Carondelet, a cleric who ordered it from the court painter, Jan Gossaert, in the Netherlands. The interior view shows the patron at prayer with the actual *"reprecentacion"* mentioned in the accompanying inscription (fig. 49). During his lifetime Carondelet had himself painted by the same painter three times. In the example from the Louvre, included here, his face is a memorial to life even before it has ended. The exterior view, by contrast, refers this image back to the mortality of life (fig. 50). Here the faceless skull, with its jaw forever silent as a speech organ, slips down below the margin of the painted field.[8] The skull has become just as much a lifeless, silent thing as the coat of arms on the obverse, which had represented the bishop during his lifetime.

A portrait of a man painted around 1500 by Giovanni Antonio Boltraffio presents us with a bold stroke: upon turning it over one discovers on the reverse side a skull painted with the same sophistication as the face on the obverse (fig. 51). The skull has already lost its lower jaw and stares directly at us as though peering from its niche—its pedestal seems to open up from the painted wall. The skull glows with a pale luminescence that cannot illuminate the shadow of death in this tomb. A Latin inscription names Girolamo Casio as the deceased, who can no longer speak for himself. It also presents the skull as his "coat of arms" (*Insigne sum Ieronymi Casii*).[9] A speaking skull is just as much a paradox as a talking coat of arms, yet the inscription admits in its ironically devout way that when the body has lost its face, it has become a thing as lifeless as the coat of arms was during his lifetime and has now been permanently relegated to the realm of speechless objects.

The transitory nature of the body is a thought summoned by a glance in the mirror. The passing reflection, so impermanent upon the glass, is its symbol. When glancing in the mirror, the modern subject becomes conscious of the short time left before death. Consequently, the view of a skull in the mirror was used as the metaphor to allude to our brief time on earth as the great truth behind the face. In a dou-

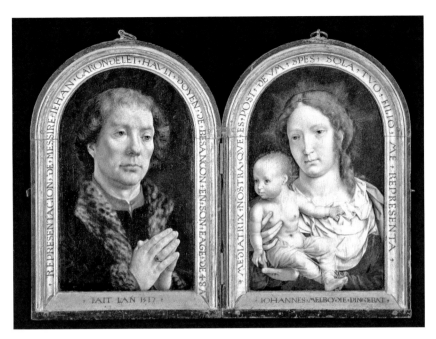

FIGURE 49 Jan Gossaert, *Diptych of Jean Carondelet, Interior*, 1517 (Paris, Musée du Louvre)

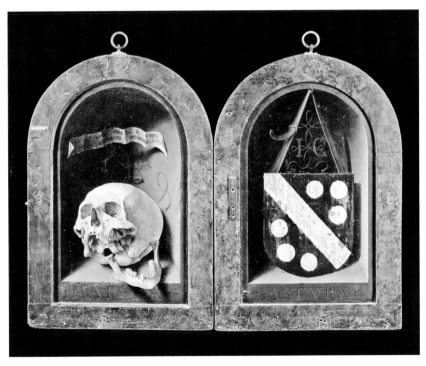

FIGURE 50 Jan Gossaert, *Diptych of Jean Carondelet, Exterior*, 1517 (Paris, Musée du Louvre)

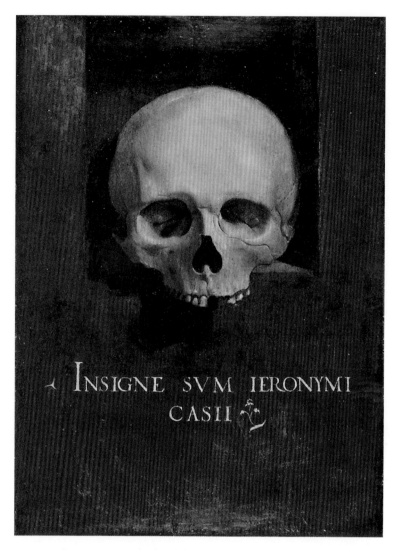

FIGURE 51 Giovanni Antonio Boltraffio, *Skull, Reverse of the Portrait of Girolamo Casio*, ca. 1500 (Chatsworth, the Devonshire Collection)

ble portrait by Lucas Furtenagel of the Augsburg painter Hans Burgkmair and his wife, both spouses are looking at themselves in a hand mirror and seeing themselves as death's heads, in anticipation of the end of their lives (fig. 52).[10] During life the mirror could not reflect the skull beneath the face. Only the allegorical mirror revealed the truth about death. The married couple speaks their elegy to us from an inscription that reads, "Of such a form we both once were." The conclusion that they "were" as one sees them in the lifelike portrait, shifts the picture into the past even

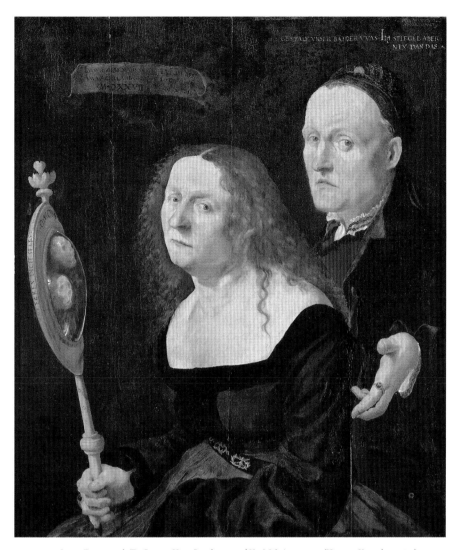

FIGURE 52 Lucas Furtenagel, *The Painter Hans Burgkmair and His Wife Anna*, 1529 (Vienna, Kunsthistorisches Museum)

while they lived. The text continues by saying that nothing remains "in the mirror but that," namely, the skull, which reveals the ultimate futility of the painted immortalization.

Religion legitimized the metaphor of the skull as a memento mori that revealed the vanity of the world. It was also a topos that legitimized portraiture of the common people, thus representing a departure from the monopoly of the court portrait of the early fifteenth century. No longer did it represent a genealogical line of inher-

itance, but rather a mortal person whose individuality also included death. Because both—aristocrats and commoners—used the same portrait panel, the class distinction was no longer obvious in the representation. The bourgeois portrait also showed a face removed from the ravages of age and death. Thus the portrait no longer served to glorify office and rank, but rather familiar and civic memory. Because it was not a skull, but rather a wooden panel that lay beneath the portrait face, it could no longer die in this disembodied state. But the skull was also placed upon the scales, as it were, in order to diminish the portrait's assertion. The portrait thus liberated new reflection about the right to representation, which supplanted corporeal presence. It captured the face in a document that permitted the heirs to honor the deceased in memory.

The question of whether a face could be exchanged for an image, and whether or not an image could outlive death, stimulated discussions and skepticism whenever an artist took his own face as a subject. Given the proximity of the actual grave, such a portrait was negated, so to speak, by the invisible presence of the corpse. The architect Giovanni Battista Gisleni alluded to this ambiguity between reality and appearance in a clever series of images that he designed for his own monument on the wall in the entrance of the basilica of Santa Maria del Popolo in Rome in 1672 (fig. 53). At the end of the wall tomb where the head lies, he looks at us in a self-portrait painted with the fresh palette of life as though peering out of a window. At the foot of the monument behind a grate he placed a marble replica of his skeleton with crossed arms, as though we could look into the dark grave cavity. The Latin inscriptions, however, warn the viewer not to trust superficial appearance and confuse Gisleni's picture with reality after death. "Neither am I here alive (*neque hic vivus*)," says the lifelike portrait, "nor am I dead there (*neque illic mortuus*)," answers the skeleton. In this impossible statement, addressed to us in the first person, both representations cancel each other out as artistic fictions. One sees neither the living nor the dead Gisleni when viewing the images. Neither the animated face nor the faceless skull is what it claims to be. Both are masks for what they show us, for life and death can only be represented as masks when one transforms them into images.[11]

The work of Jan van Eyck was influential in the development of modern portraiture. An exception among his works is the likeness of so-called Timotheus, which evokes thoughts of death by referring to the grave rather than the skull (fig. 54).[12] It depicts a young man standing behind a weathered gravestone that already shows cracks and fissures. Because the original frame is lost, we do not know the name of the subject portrayed here. It is unusual that instead of writing his signature on the frame, he has used delicate white brushstrokes to place it upon the stone, which functions as a balustrade. The wording of the signature is equally unusual, for it speaks of the fact

FIGURE 53 Two views of the deceased on the grave of Giovanni Battista Gisleni, 1672 (Rome, Santa Maria del Popolo)

NEQVE ILLIC MORTVVS

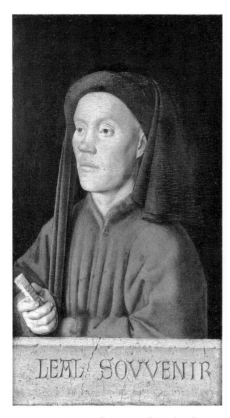

that the painter "completed" or "negotiated" (Latin, *actum*) the portrait on October 10, 1432. This allusion is picked up in a closely written piece of paper that the painted subject holds in his hand folded like a letter or contract. At the same time, the front of the inscription on the stone is somewhat archaic and gives an older impression than van Eyck's signature. It consists of two words, between which there runs a long crack, like the trace of time long past. The words are "Leal Souvenir." The painted "memento" (souvenir) is defined by the word *leal*, which, in contemporary courtly language, conveyed both "loyal" and "legal," and can be applied to portraiture as a genre.

A soft light falls upon the face as it looks into the distance with a dreamy, blank gaze. If the portrait was actually meant to represent a man who had already died, the expression chosen here would be explained. The ambiguity between life and death is essential to the imagery, between the painted life of the face and the counterpoint of death in the weathered gravestone. At the same time the pictorial form contains an internal criticism of the image; in relation to the grave and the skull, every face is a mask, for it bears and expresses life, which disappears in death. The skull is left behind as nothing more than a relic of the life it had formerly served.

10

THE "REAL FACE" OF THE ICON AND THE "SIMILAR FACE"

The image in the early modern period underwent a transformation from icon to portrait—a transformation from the sacred face to the face from which a subject engages the viewer. In Western culture the important axiom of similarity in portraiture is ultimately derived from the icon. This axiom is not tied to just any icon, but rather to a Roman icon that was the image of all images. One above all was considered the true image because it showed the authentic face that (according to legend) Christ left as an

impression on the cloth Saint Veronica handed to him along the Way of the Cross. The existence in Rome of "the Veronica Veil," or simply the "Veronica," as the cloth was called, was first reported around 1200, yet the legend also becomes attached to guarantees of authenticity of the earliest miraculous images of Christ. These also depicted a facial expression that predicted the authenticity of a photograph and was meant to provide proof of the corporeal presence of the divine man, thereby confirming his dual nature.[1] The Roman icon that was preserved in Saint Peter's satisfied the wish to view the face of God on earth whenever its replica upon the cloth, supposedly taken during Jesus's lifetime, was displayed in public. European pilgrimages to the true face turned Rome into a sort of Christian Mecca.[2] The texts from this period around 1200 even interpret the name of Saint Veronica as a reference to the *vera iconia*, in other words, the "true image." A famous hymn from the same period speaks of the "holy face" (*sancta facies*) "not painted by human hand."[3]

This icon is present in the early portrait paintings from Flanders, for example, in the work of all the pioneers of the new realism (like Robert Campin, Rogier van der Weiden, and Hans Memling) whenever they depict the legend and icon itself. In such cases the face of Christ with flowing hair and beard is isolated from the body and reproduced in flat frontality like a mask upon the cloth. When the painters departed from the legend, however, they transformed the icon into a portrait and made a portrait-like bust of the disembodied face on the cloth. A prime example of this is Jan van Eyck's series of variations of a portrait depicting the Roman icon instead of a living model (fig. 55). Because this icon was considered original and bore the seal of authenticity, van Eyck felt he had the right to make a portrait from it. In so doing he ultimately produced the portrait that the icon had always been. Similarity—which we expect from any portrait—was the purpose of the icon. Thus it became a modern portrait, but one in which the stark frontality of its gaze cannot be confused with a private portrait. The painter signed and dated the individual versions of his work, much as he did with versions of all of his portraits. Accordingly, the Berlin version was completed on January 31, 1438, whereas the version in

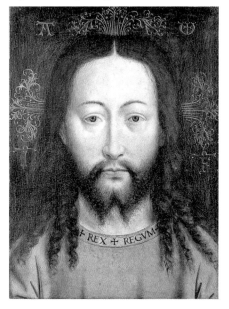

FIGURE 55 Jan van Eyck, *Portrait of a Christ Icon*, 1438 (Staatliche Museen zu Berlin, Gemäldegalerie)

Bruges (on the frame of which van Eyck identifies himself as its "inventor") is dated January 30, 1440. In both cases the painter obviously started the new year by producing an icon of Christ.[4] Identifying himself as the creator served to reclaim the icon for portraiture. He had not produced a copy, as was the custom in the painting of icons, but offered a personal analysis.

This sort of genealogy from icon to portrait sheds new light on the development of portraiture, which claimed to present a real face "from life" (au vif), meaning what the painter saw in front of his eyes in his studio. To be sure, portraits existed before this transition to individual depiction, but they were often portraits in series that were meant to document the aristocratic genealogy of a dynasty, or they played a secondary role in larger contexts, such as imagery for tombs or altarpieces. A chronicler from the period when Jan van Eyck was painting the first modern portraits remarked on the Burgundian Duke Philipp that "his exterior expressed his inner being."[5] With that he meant the true face, but the chronicler continues, noting that Philipp also wore "the face of his fathers" whose features he had inherited. Thus the duke in his physiognomy carried the dynastic mask of his legitimacy.

Such portraits were mostly represented in static profile views. As with likenesses upon coins and medals, these profiles could never gaze out of the picture frame, nor could they assert themselves within the picture itself. That did not happen until portraiture completed its transition to faciality, which released the face from the surface and turned it to the viewer—an orientation that previously had been the privilege of the icon. With the freeing of the portrait from the picture plane, the person represented claimed the space for his own presence, a presence *in imagine*. This was so suggestive that it had the effect of a presence *in corpore*. Presence is more than similarity, because it asserts the existence of a face in the picture and not merely a memory of the face.

An inscription on the frame of a work by van Eyck contrasts the origin of the portrait with the birth of the person portrayed and the rebirth of the body in the image. This person is Jan de Leeuw, a goldsmith in Bruges, identified in the inscription as one who "first glimpsed the light of the world (dat claer) on Saint Ursula's Day," in the year 1401 (fig. 56). Moreover, the inscription goes on to say that the likeness was painted by Jan van Eyck and that one should be aware "when he began it," namely, in 1436. Painters usually recorded the date of a painting's completion. When he makes an exception here and refers to when the completed work was begun, this makes sense only if he was referring to the life of the goldsmith, which began in 1401, and to the portrait, which he began in 1436. The face of the man portrayed seems to be illuminated in its dark interior by light from a window; it gives the impression that he is turning toward us precisely as we are

looking at him. From the corners of his eyes comes a captivating gaze.[6]

The new faciality—the facialization of portraiture—was only fully realized through the painted gaze, which Jean-Luc Nancy identifies in the title of his book about the portrait.[7] Not only does the person portrayed gaze, but the portrait itself also gazes. The gaze in the portrait is, like the presence, a legacy of the icon, but here it has been redefined. To the portrait, Nancy correctly attributes the reinvention of the gaze showing the inner world with which the *subject* is described and experienced as a gazing presence. The gaze becomes a medium and expression of the subject's description, which situates the subject in the

FIGURE 56 Jan van Eyck, *Portrait of Jan de Leeuw*, 1436 (Vienna, Kunsthistorisches Museum)

world. With the gaze the portrait loses its character as an object and appropriates the presence of a real face with which we—the viewers—can establish contact through our gaze. As a painted wooden panel, the portrait remains a mask bequeathing its face to us but feigning human life, which a wooden panel does not possess. Gazing is different from seeing, for the gaze contains a self-reference to the subject, an expression of the subject about himself. For this reason, the subject can enter into a direct or indirect exchange of gazes with the viewer. With the gaze the subject transcends himself, and "that is what turns him into a subject. It does not look at an object," but rather signifies "an opening to the world."[8] In the gaze an essential similarity constitutes itself between the person in the portrait and the person in front of the portrait—a similarity that transcends any physiognomic differences.

Nicholas of Cusa (Cusanus) addresses this trend toward portraiture in a famous text written in the early period of the genre's development. This text contains an oft-neglected differentiation between the inner-worldly portrait and the transcendent icon.[9] His tract, *De visione Dei*, offers instructions on how to view an icon in order to differentiate it from the gaze inherent in a private portrait. All the brothers in the monastery were supposed to take their places before the "icon of God" (*eiconam Dei*), which the author of the tract had donated to the monastery, and in doing so they were to recognize that it looked at each individual monk in the same way. For Cusanus, therein lay a metaphor for God's omnipresence embodying

an "absolute gaze" (*visus absolutus*) in contrast to the human, or "limited gaze" (*visus contractus*). The dialogic gaze between portrait and viewer does not pertain to this experience. One always stood before the icon as a being created by God who is being gazed upon by his creator. Portraiture, on the other hand, was based upon a human exchange of gazes and represented the sitter as someone who possessed the very same gaze as the viewer. Cusanus applies this differentiation both to the mirror as a real tool of similarity, as Jan van Eyck had done in his own self-portrait, and also to the mirror as metaphor. "Upon looking into a mirror . . . one recognizes the figure gazed upon as one's own, just as is the case in an actual mirror made of glass." Yet the monks were not supposed to look at the icon as into a "looking-glass of eternity" and see their own image, but rather to see a truth that they themselves embodied in that image.

The portrait presented similarity as an actual mirror, except that it portrayed another person. The Sicilian Antonello da Messina, who became acquainted with Netherlandish portraits in Naples, went a step further than his colleagues in the North and introduced lifelike facial expressions—a technique that further removed him from the passive expression of the icon. The direct exchange of gazes, in which the experience of the present is strengthened in the moment of observation, now became a constituent feature of all of his portraits as they explored individuality using a hitherto unknown range of expression. In his paintings, temperament speaks directly through the gaze, sometimes as curiosity and sometimes as its opposite, defensiveness. The gaze frees itself from the legacy of the icon and becomes dialogic to the point of brashness, and, in so doing, the facial expression supports the gaze with a spontaneity generated by the treatment of the oral musculature. A human image was born that could readily perform the drama of the gaze. The art historian Federico Zeri thought he recognized the threatening or devious smile of a Sicilian in a portrait now in Cefalù (fig. 57).

In other portraits by Antonello da Messina the artist's signature appears on a small piece of folded paper (*cartellino*) that seems to be attached in *trompe l'oeil* to a painted stone balustrade.[10] In 1465 the same staging returns with balustrade and artist's signature in the only icon of Christ that Antonello ever painted (fig. 58). This could be called a portrait of an icon and is modern in a different sense than the icon by van Eyck, which is twenty-five years older.[11] The Savior turns directly to the viewer with a gesture of blessing, placing the fingertips of his left hand on the edge of the balustrade bathed in bright daylight. The presence is thus synchronized with that of the viewer and, like it, derives completely from the gesture. The gaze, while achieved authoritatively from an unattainable distance, seems to acknowledge the viewer from the picture plane. The face with its asymmetric halves and eyes of

FIGURE 57 Antonello da Messina, *Portrait of a Man*, ca. 1465 (Cefalù Museo Mandralisca)

slightly different sizes, was sketched in the studio using a male model and distinctive lighting. Here the boundary between the monologic and the dialogic gaze is not crossed, yet it is demarcated in such a subtle way that the distance between icon and portrait shrinks.

In Dürer's famous self-portrait from 1500 the issue of "similarity" is not limited to physiognomy but plays a key role on several levels (fig. 59). Almost every interpretation of this image concludes that it is a mimesis of Christ, but there is no consensus about what this consists of or what it means. Only Joseph Koerner has scrutinized the "analogy" between Dürer's face and the "real face" of the true icon. He writes that a contemporary observer would first have noticed the resemblance to the iconic Christ image of the popular Vera Icon ("Veronica Veil")—and only then

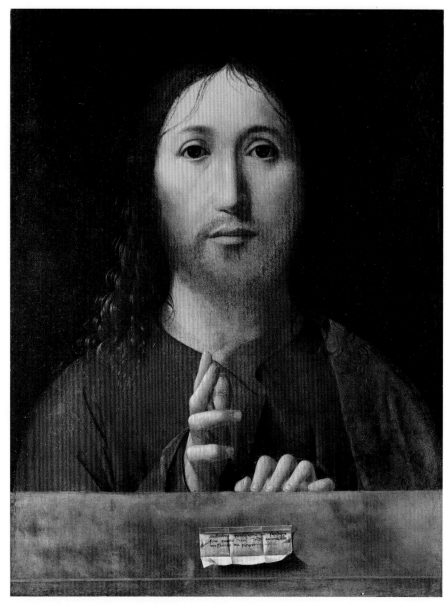

FIGURE 58 Antonello da Messina, *Salvator Mundi*, 1465 (London, National Gallery)

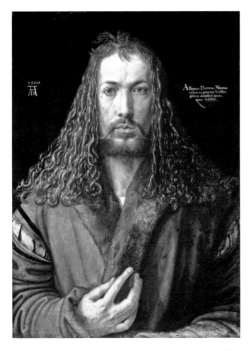 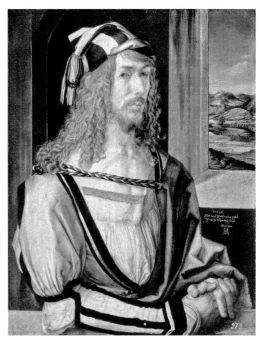

FIGURE 59 Albrecht Dürer, *Self-Portrait*, 1500 (Munich, Alte Pinakothek)

FIGURE 60 Albrecht Dürer, *Self-Portrait*, 1498 (Madrid, Prado)

recognized a portrait of Dürer in it.[12] The treatment of the hair—with its long, flow-ing locks—and the beard that still inspires viewers to think of the stereotypical image of Jesus, are not unique to this portrait but appear two years earlier, in 1498, in the dandified self-portrait of the twenty-six-year-old Dürer that hangs today in the Prado (fig. 60).[13] For a long time thereafter, the artist wore the same hairstyle and beard, as though in his physical appearance he were trying to project an image and perform a mimetic act, not limited to the painted portrait.

A comparison with the earlier self-portrait immediately reveals how unusual this self-stylization is in Dürer's later work. In the Prado portrait the painter looks at us with a sidelong gaze, wearing the same expression with which he once looked in the mirror. In doing so he enters our field of vision as though inviting us to exchange glances, and he even permits a complicit view of his surroundings, includ-ing a painted window frame upon which he rests his arm to show his elegant gloves. In the Munich picture all these moments of spontaneity and immediacy disappear. In particular, the gaze from the face in frontal view seems static, set off by the abstract black background. This frontality has been explained by a system of ideal proportions, which the artist has applied to his own facial features.[14] The idea of an

artist as a second creator, or new Apelles, was popular in humanistic circles at the time.[15] Dürer's gaze, however, demands its own interpretation. When he spoke about the Christ icon, Cusanus had used the concept of a *visus abstractus*, which also applies to Dürer's gaze. When such a gaze appears in a portrait it raises the question of divine likeness, which itself leads back to the icon. The theological formula that "man was created in God's image" ("*ad imaginem Dei*"; Genesis 1:27) is later explained in a second passage in Genesis (5:1) as man's having achieved "similarity" (*similitudinem*) to God. Dürer did not have far to reach in order to express this thought through the similarity of a portrait to the "true face" of the icon. He shows himself not merely as a likeness, but as a depiction of his creator. In the representation of the face as an icon, a presence of the ur-image is conjured up by the gaze, as if in a double exposure that justifies similarity on theological grounds.

Dürer painted numerous versions of the Vera Icon; during his trip through the Netherlands he even produced these as commissioned pieces. In his journal we can read that he painted "a good Veronica face in oil, worth twelve guilders," and later that he had done "one more (different) Veronica face in oil better than the earlier one." He even depicted such a Veronica as the theme of the central panel of a triptych for Jacob Heller, now lost.[16] For the most part, however, these versions included a crown of thorns, so that they were not the equivalents of portraiture. In the Munich self-portrait Dürer takes another tack in order to embody the beauty of the archetype in its literal sense through the human face. In order to do so, he could emphasize similarity with the icon by gazing into the mirror. In this vein, Dürer's own Netherlandish journal urges a hesitant Erasmus of Rotterdam to "be similar here below, to your master, Christ," in the struggle for the Reformation.[17]

11
THE RECORD OF MEMORY AND THE SPEECH ACT OF THE FACE

When the portrait emerged as an artistic genre, it had to find its niche in the culture of the early modern era. But verisimilitude in the likeness of a face soon became a cheap commodity offered by artists without much justification. In its formative period the portrait was a document of enduring presence, asserting a legal status similar to that of the disposition of a last will and testament. At the same time, it was tied to a new image of humanity that constituted an incursion into feudal privilege—a privilege of the social body, because it included the right of an individual to representation through an image. Every portrait placed its subject in society, be it in an actual or perhaps a desired position. Even when the portrait was meant as a negative statement about society, it could not divorce itself from that society. In por-

traiture, however, the face is not a given; it is a mask that society has always fashioned according to its own norms in rather the same way that nature produces physiognomy. In this connection, Jean-Jacques Courtine and Claudine Haroche refer to a "history of the face" in the early modern period.[1] Again and again similarity thus proves to be a wide-open field, for it has been discerned in the mask of the self, on which a painter may have only collaborated as an accomplice in order to manage his model's entrance into society.

It was only when the portrait had become mere convention that its value was measured by the lifelike quality of the moment it captured. Thus the painter's bravura, rather than the similarity to the face portrayed, was proclaimed. In art academies the portrait, as an inferior genre, was standardized by rules derived from artistic practice. In 1767 Denis Diderot saw in the Salon (the annual exhibition in Paris) "many portraits, among them few that are good, but how could it be otherwise?" In the portrait of a well-known eye doctor, Diderot viewed an ugly face, which was nonetheless a beautiful painting. "Yes, that was him, as if he were poking his head out through a little frame of black wood."[2] Even in painting the candid moment that could be captured repeatedly had a more honest appeal than the defiance of time and death. Portraiture was granted free rein to grant special wishes, even should the subject wish to be seen gliding through the picture as a skater. In this period the portrayal of slaves and exotic visitors was fashionable, conceived in order to satisfy curiosity about the colonies. Once people tired of this genre in all its variations, they finally welcomed the photograph as a breath of fresh air—at least as long as it still held novelty.

The pictures of Jan van Eyck, which inaugurate the history of portraiture, are documented by dates and something like notarized affidavits in which the ages and names of the persons represented are displayed upon the frames. The painter as witness guaranteed the authenticity of the face that his patron had borne in life, thereby fulfilling a contract with the sitter. The person portrayed in a dwelling was captured as if in a mirror hanging in the interior shown in the painting. The perspective of the scene gave the sitter the aura of living in the same dwelling as the viewer. Picture frames were originally constructed like real window frames. Within such a frame, the portrait occupied a kind of intersection point between the painted and the real world through which a viewer communicated with the person in the picture. The frame also functioned as a time window by separating the time in the picture from the time that preceded it. Thus, it logically separates the time of memory from the viewer's time. The realism that entered the portrait by analogy to the represented space and time became concentrated in the face whose authenticity the viewer could supposedly recognize and guarantee. This was no mere face or a face

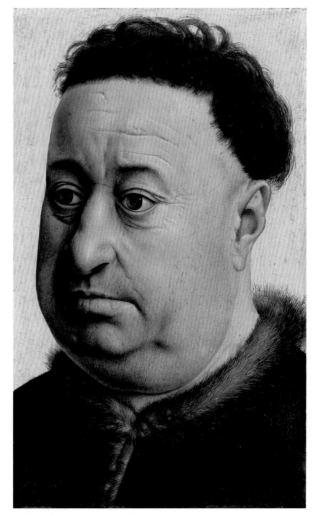

FIGURE 61 Robert Campin, *Robert de Masmines* (?) (d. 1430) (Staatliche Museen zu Berlin, Gemäldegalerie)

per se, but rather a face that had lived. It had a specific age, expression, and gaze; it was involved in one of life's moments. In portraiture the face is isolated in a timeless role that values dramatization above physiognomy.

In one of the first private portraits ever painted in the Netherlands, Robert Campin probably depicted the Burgundian courtier Robert de Masmines, who was killed in 1430 at the battle of Bouvines (fig. 61). The small format and its concentration upon the face lend this portrait an archaic character. The dramatic, almost photographically realistic, facial features speak to us all the more powerfully as they almost seem to force their way out of the frame. The portrait is all face and only

face, a document of a person for the memory of his family. This function is confirmed by the fact that it survives in two almost identical versions of equal perfection. These were meant as a legacy for his heirs and thus as documents of his person.[3] Fidelity to nature is celebrated in the portrait that Hans Holbein the Younger painted of the twenty-four-year-old humanist Bonifacius Amerbach in Basel in 1519. The inscription on a board that seems to hang from a tree says that although the face was painted (*picta facies*), it is by no means inferior to the "living face." The inscription continues, saying that here one finds "that which belongs to nature, yet is expressed through art."[4] Although the face belongs to nature, the portrait produces a painted document of that face.

In order to understand early portraits as documents, we can turn to heraldry for comparison, for here is a field with a history that predates portraiture. The coat of arms was not a picture of the body, but rather a figural sign that identified the social status of a body using heraldic abstraction. The differentiation between the coat of arms and the individual shield also applies to the portrait and to portrait panels.[5] The heraldic shield and the panel showing a human likeness were, incidentally, similar in concept. The Flemish designated both representations as *schild*, while the French used the word *tableau*. Moreover, they were made by the same painters, the so-called shield-makers. The coat of arms does not display a physiognomy but rather a dynastic face, for heraldic shield and image panel refer to each other when they represent one and the same person. In the coat of arms, representation was a right, not an achievement, but even the portrait was at first connected with the right of representation.

The panel bearing a portrait image came into its own in contrast to the heraldic shield. It thus distanced itself from the flatness of heraldic representation and expressed a dualism of interior and exterior, of soul and body through the activity of the gaze. Genealogical and personal emblems, coats of arms and devices, together created a "heraldic face."[6] The coat of arms could be inherited, while the portrait was reserved for the living holder of an office and thus for a person. A triptych by Lucas Cranach the Elder depicts three electors of the House of Wettin. It is significant that only the living bearer of the coat of arms, Johann Friedrich the Magnificent (who succeeded his father and uncle in 1532) is shown with the armorial bearings of the principality (fig. 62). When he came to power he commissioned sixty diptychs with the likenesses of his predecessors in order to emphasize his own legitimacy.[7] The physiognomic likeness is a genealogical device that has the role of depicting the subject in the historical chronicle and turns the natural face into a placeholder for the subject. Social status is represented in heraldry, but the subject is represented by a face.

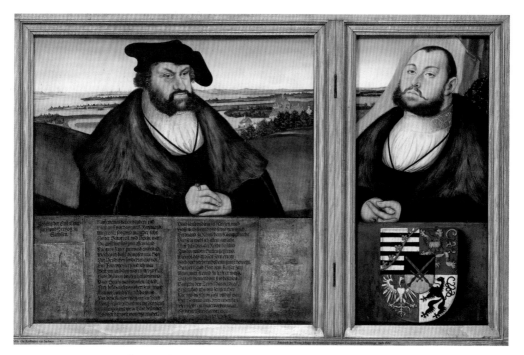

FIGURE 62 Lukas Cranach the Elder, *Triptych of the Wettin Electors*, Middle Panel and Right Wing, after 1532 (Hamburg, Kunsthalle)

In the portrait, however, the face was not only document and memento but it was also the topic of the self. With this image the boundary between visibility and physiognomic similarity was inexorably crossed. In the early modern period the self was both a philosophical problem and a question of image; the face was an image that could easily be transformed into a mask. With that, the possibility of portraying the invisible self became the core issue. The portrait could not be limited to the way one looked, but rather opened the question of how one wished to portray oneself or to be portrayed. For this it required staging as well as the depiction of a face, and the speech act became more important than similarity. This speech act, however, functioned without the help of verbal language. It had to achieve its goal using rhetorical tools like facial expression, gaze, gestures, and pose. Part of this speech act involved the fiction that the subject in the portrait was speaking to a particular conversational partner and actually making eye contact with that person.

With this gesture, the naïveté with which the early Renaissance had embraced the portrait as documentation of the face became a thing of the past. Questions of roles won the upper hand the more that staging gained control over the face and let it communicate. This communication also involved the whole body as a fellow actor.

Every expression, no matter how fleeting or theatrical, became more important than mere physiognomy. The justification for this development lies in the fact that the face was a mortal mask, whereas the self, which one tried to encounter in the face, possessed an immortal soul. Physiognomy as a domain of the body signified mortality. The task was thus to simulate life in the face—life that would not end there.

This problem was also posed in humanist circles of thinkers seeking a new public, not just with their writings but also with painted or engraved portraits. Art, they contended, showed only its face, whereas the spirit expressed itself in the word and thus in the printed text. They therefore limited the ability of portraiture to express the self by including inscriptions that they wrote themselves. Erasmus of Rotterdam is the best known example of this. In some portraits by Hans Holbein the Younger he had himself portrayed in profile as an author bending over a text in the act of writing. Instead of turning his face to the viewer, he directs attention to the text taking shape under his pen—a text destined for his reading public. The media of reproduction, such as woodcut and copper engraving, use the same techniques as the printed book to enhance public dissemination of such portraits. These images generally included commentary that directed the viewer away from the subject he was viewing to something that could only be read.[8]

In 1526 Dürer completed his copperplate engraving of the likeness of the reformer Philipp Melanchthon who was living in Nuremberg at the time. The Latin motto that accompanies the image, probably suggested by Melanchthon himself, informs the viewer that Dürer had painted "Philipp's exterior (*ora*) from the life," yet even the artist's "practiced hand was unable to paint his mind (*mens*)."[9] For the face, the rather unusual concept *ora* is used, which encompasses the meaning of both exterior and boundary, thereby bringing the body into play. The physical appearance can only lead the viewer to what lies behind it. Dürer's engraving of Erasmus from the same year (fig. 63) carries the concept of image and script even further in the inscriptions and the setting of the scholar's study. The view of Erasmus writing among his books stands in contrast to the script, which has an almost iconic presence in a framed inscription.[10] The

FIGURE 63 Albrecht Dürer, *Erasmus of Rotterdam* (1526), copperplate engraving (Nürnberg, Germanisches Nationalmuseum)

Greek inscription directs us to the works of the scholar, where one may get to know him "better." The Latin inscription speaks of the picture (*imago*) of Erasmus drawn, it was said, by Dürer "from the living effigy" (*effigies*). In fact, Dürer had drawn the famous scholar six years earlier on his journey through the Netherlands. The dual concept of image differentiates the portrait from the face that Erasmus wore in life. We thus see the image of a picture. The living face, for its part, is an external appearance presented by Erasmus with his body. Erasmus, incidentally, was not at all pleased with the engraving and found fault not only with the lack of resemblance but also with the fact that his face was not placed in the center of Dürer's plate.

The meaning of *effigies* as face is confirmed by the third plate showing Luther's likeness, which Lucas Cranach engraved in 1524. Here the inscription speaks of the "mortal effigy (*moritura effigies*)." This can be seen on the paper, whereas only Luther himself could "express the eternal (image) of his soul."[11] In an earlier engraving by Cranach, there is even an explicit reference to the face where one reads that the artist can express "only mortal faces (*vultus occiduos*) of Luther and not the eternal images of his mind (*aeterna simulacra suai mentis*)."[12] In the iconoclastic climate of hostility toward images, the Reformation had special reasons for justifying printed likenesses of Luther. Yet the iconoclastic climate aligns itself with the new consciousness of the discrepancy between face and person—a consciousness that was widespread in humanistic circles.

Such notions reflect an early crisis, which involved portraiture that aimed to capture a self in the face—a self that could not be expressed via the visible evidence of facial characteristics. The discrepancy between person and face forced the painter to refer to the invisible self and to take a position against the mere visibility of the body. If the self had access to many masks, all of which could be expressed in the same face, then a single view was insufficient, for one view had to refer simultaneously to all other masks that remained outside of the depiction and could only be surmised in the aggregate of the person behind the masks. In any case, the life of the person who had left behind only a mask of his face could not be recaptured in the image. It was never possible for a painter to guarantee the authenticity of facial characteristics as persuasively as a cast of the face, yet he did have the advantage that he could create the appearance of life. Furthermore, the painting—in contrast to the plaster or wax mask—was not limited to the face in the speech act; it could imbue the sitter with the ability to address a contemporary viewer. The role that the face played in this process changed, in that it was consistently staged by the body instead of performing the opposite function of staging the body.

This process does not mean staging by social status or office, but rather a staging of the self that came to the fore particularly in private portraiture. With no par-

ticular attributes at its disposal, the staging often consisted only of a moment captured in a dual sense: as a glance that supports a conversation between two people in words. It can also capture the interval between that which is said and that which remains unsaid. The painted gaze can be replete with memory, in other words, turn inward and thereby express the thought of an absent viewer. It can also signify a hiatus, as if a pause had entered a living conversation and thereby simulate the presence of the second person in front of the picture. The motivation was always to awaken corporeal life within the portrait, which transformed the actual absence into a fictional presence. Thus, the painter restored mimetic life to the face, life it had been denied by its transformation into a painted mask. The masklike quality was consequently no obstacle but rather an impetus that could spur the painter on to conquer the mask or to deceive it.

An example of such a staging of the self is the double portrait documenting a friendship. Such pictures could also include the painter and were often given to a friend as a memento. The Venetian poet Pietro Bembo apparently commissioned such a double portrait from the hand of Raphael. Bembo later had this painting hanging in his house in Padua. The picture was painted in Rome when the humanist Andrea Navagero (1483–1529) was called back to Venice in 1516; his friend, Agostino Bezzano, looks lost in thought. Navagero turns his back as if to leave, and he directs a determined parting glance out of the picture toward the viewer. The faces emerge in pale illumination from their dark background, as if the painter had surprised them in the space where they were taking their leave from each other.[13]

Raphael brings himself into the painted moment in an unusual double portrait depicting a lively conversation (fig. 64).[14] He is seen behind a friend on whose shoulder he places his hand while looking out of the picture, motionless and wide-eyed, as if examining his friend's finished portrait on the easel. The friend, who may have sat for the portrait in the studio, turns around to the painter with a quick swivel of the head and with an outstretched finger draws the artist's attention to his likeness, which remains outside the picture as though he were saying, "This is how I look," or "I leave this behind as a memento for you." The foreground figure that dominates the space is having his portrait painted and debating with the portraitist at his back about the work that they both have before them. Perhaps the invisible portrait, which we can only imagine, was especially successful or still needed further retouching. We thus have before us a rare example of staging. We see only the person who is having his portrait painted, but we do not see him in portrait mode but rather in a paradoxical situation: it is as if he were just as alive as the painter and the painter has become the viewer—and has thus not yet painted. The sitter suggests to us an exchange of eye contact with the painter when the portrait is still at an early

FIGURE 64 Raffael, *Painter and His Model in the Studio* (?), ca. 1518–20 (Paris, Musée du Louvre)

stage but has already been captured in the picture. With this gesture, Raphael successfully communicates a brilliant speech act that takes as its theme the work of portrait painting itself.

12

REMBRANDT'S SELF-PORTRAITURE: Revolt against the Mask

The masklike quality of portraiture evolved, predictably, in the self-portrait. In this genre the artist did not restrict his painting to his own face, but rather confronted the question of what or whom the face depicted. For artists the self-portrait engendered the painful awareness of transforming oneself into a lifeless mask in the process of self-representation. The inescapably masklike character of the portrait constantly elicited a revolt against this effort. The ultimate goal of the self-portrait was to capture the essence of one's own self through self-representation. The self-portrait, in which sitter and painter were one and the same person, emerged from the mirror gaze, yet this was more than a mere mechanical reflection. The self-portrait is simultaneously pose and analysis. The physiognomy it depicts remains opaque and inaccessible unless transformed into a speech act involving the viewer as conversational partner. This genre had to be staged in order to fulfill the requirement of entering the picture in the name of the self. Here the artists encountered the dilemma of representing a self that eluded simple depiction.

Writers also came up against the question of the self when they turned their hands to autobiography. Once they entered into the search for the self, writers like artists encountered an endless and uncertain process. Philippe Lejeune spoke of the "autobiographical pact entered into both by the narrator and his personal identity, when the one who speaks is the same person who is spoken about.[1] Andrew Small drew a parallel to the painted self-portrait, calling Montaigne and Rembrandt the first who pursued "the fiction of a coherent self," meaning that they recognized the fictionality of the individual identity that emerged as soon as they attempted to show or describe the self.[2] This question of the self exposed both the face and self-description as masks in which painters and writers could never discover an unchanging self. Their self-awareness separated them from what they encountered in the mirror.

In his *Essays* Montaigne created new alternatives of his self, similar to pages of a book that all belonged to one and the same volume. To be sure, his was a book filled with very different texts. As in a book, however, only one page was visible at a time. Rembrandt was continually painting new and different portraits as well. These took their place beside those that had already been painted and did not merely sup-

plement but also challenged them. Montaigne succinctly called the roles of his individual identity "faces" (*visages*). He understood his literary work to be his effort to "paint a portrait of himself," but one that continually generated new portraits because no single one satisfied him (II.17.653). A portrait painter usually captured but a single face when he painted his model. Yet the *Essays* struggled with the lifelong transformation and malleability of the self, just as Rembrandt had done in his self-portraits. The author states that he does not want to conceal the imperfect and unpleasant side of his person any more than "a portrait would do that a painter might have painted not from an ideal face, but from my own" (I.26.148). He patiently consults the autobiographical sketches of classical authors in his library in order to measure himself against them. In his study of ancient texts, however, he changes from reader to author and from imitator to inventor who is constantly asserting his literary self. His *Essays* are "faces" of his self. Only when taken as a whole do they prove to be essentially identical with their author (II.18.648c).[3]

For Montaigne self-consciousness is a path to self-knowledge. But he differentiates this from self-expression, which strives to play various roles and to construct various faces. Montaigne makes a principle of the dissimilarity (*dissemblance*) between the self and the faces. Rembrandt, too, is aware of the discrepancy between the self and its faces when he plays various roles standing before his easel.[4] Never for a moment do metamorphoses of the self permit the face to come to rest. The self constantly retreats from the changing images that it produces of itself in speaking. But where does it go? The traditional differentiation between interior and exterior, between subject and body, leads nowhere. For the subject must express itself in order to be perceived. And yet it cannot, or will not, surrender to the gaze of another. Therefore, when the self practices itself in the face like a role, the distinction between face and mask soon becomes dubious.

It is highly significant that when Jan van Eyck invented the modern portrait in Flemish painting, he immediately put it to the test by taking the first step toward self-portraiture (fig. 65).[5] In doing so he employed the same expensive procedure that his prominent customers were accustomed to paying for. Because he had no model, he looked to a mirror for help. Only there did his own face show itself. Otherwise, he could not view his model. The painter, however, represented not only what he saw in the mirror, but also the act of seeing, that is, his own gaze. He thus bends forward with eyes straining toward his portrait. In doing so he is practicing a role of the self—an observer of the world, whose scientific curiosity documents its observations in the face. The mirror provided the proof of his physical presence in the world, for he could show only someone who actually stood or sat before a mirror. The dialogic gaze, however, which portraits otherwise direct toward the world,

FIGURE 65 Jan van Eyck, *Self-Portrait*, 1433 (London, National Gallery)

is here a dialogue between the painter and himself—in other words, a self-examination of the face with which he lived in the world. For what was it that he really saw when he painted the portrait?

For this process he had no access to a flat looking glass, so he used the old convex mirror instead, an object he also depicts in two other works as the typical mirror of its day.[6] When we realize that van Eyck was only simulating a flat mirror, we discover something unexpected. It only *seems* as if the Flemish artist were simply copying a mirrored reflection. In reality he had to invent such a gaze by choosing it for his painting. He painted an imaginary mirror into which he gazed in order to reproduce his personal identity, or self, in the form of an image. One can speak of a painted mirror-fiction with which van Eyck put himself in the picture as its subject. But the fiction had to give the impression of documentary evidence, such as one would have expected from any portrait of the period. Van Eyck therefore recorded the exact calendrical date, an October day in the year 1433, in the inscription upon the frame. He makes it clear exactly when, at what specific age, and in what place (his studio) he was painting, and that he had seen himself there (as he claims) just as he painted himself—in the role of a chronicler of the eye, an archivist for posterity. This impression is accentuated by the concentration on the penetrating gaze with which his eyes look away from the body axis, turning toward the viewer today as they originally did to his own face. The gaze is more alive than the mirror it seeks. In reality we have here a painted *production of the gaze* in which van Eyck transcended the obstacles that the mirror technology of the day placed before him. In doing so he chose himself as a model. This raises all the implications of choosing oneself—a model who not only sees but also knows himself. The reproduction of his own face ultimately leads to the production of an individual identity. This phenomenon first appears in the works of van Eyck and, for the time being, is still obscured by the newly discovered capacity to communicate the self visually in a picture. The *description of the face*, however, is in this instance already a *description of the subject*, and thus a representation of character as self-interpretation.

This discussion has introduced a development that was to continue to determine the self-portrait as a genre. It culminates in the seventeenth century in Rembrandt's lifelong project, to be discussed later. In Rembrandt's age artists began to establish the guidelines that underlie every self-portrait. They made the work of the self-portrait, instead of the portrait itself, their subject, and they carried on a painted discourse with the viewer, in which they differentiate the portrait from the mirror that they used to make the portrait. The gaze from the picture is different from the gaze into the mirror. This development is explored around 1646 with remarkable acuity in a work of the German painter Johannes Gumpp, which earned

FIGURE 66 Johannes Gumpp, *Self-Portrait*, ca. 1646 (Florence, Galleria degli Uffizi)

him philosophical acclaim by Jean-Luc Nancy (fig. 66).[7] Gumpp presents the work method in a way that shows the painter as if he were removing a mask from the face that he had found in the mirror.

The painter appears three times in the picture: once with his back to the viewer, then in the mirror, and finally in the unfinished portrait on the easel. The painter's back represents (and simultaneously conceals) the presence of the real face, which we can never really see in a painting anyway. On one side the reflection takes his place, and on the other the portrait does so, although his upper body has not yet been painted. The painter views himself in his mirror reflection. The painted face seems to look at the viewer over the artist's shoulder. In the famous painting *Die Malkunst* (The Art of Painting, or The Allegory of Painting) by Jan Vermeer, which dates from approximately the same time, we see the painter from behind at his

easel. On the table, which protrudes into the foreground, a large mask is placed in a prominent position. This refers to the work that is currently being executed, thereby producing a paradoxical portrait of the painting as a female allegory.

Johannes Gumpp translates the fleeting and mechanical image reflected in the mirror (the image is reversed) into a picture that he himself represents by a portrait. With the help of the mirror he produces a similar mask, or a mask of similarity. In the one case he exchanges the visible mirror reflection for the gaze that is invisible to us; in the other, he lets the gaze of the portrait look out of the picture. Each gaze has a very different connotation. As a dual gaze, they are the basis of every portrait: the living gaze of the painter at the model and the painted gaze of the model at the viewer. A double barrier eliminates the illusion in Gumpp's portrait. First, we have his back in front of his own reflection; second, we have the other hand as it paints the unfinished portrait. The mirror produces a resemblance mechanically through optical reflection. Underlying the painting, however, is the painter's contemplation of the representation of resemblance. A mirror image is connected to the presence of a face, while a portrait lives through its absence.[8] Gumpp shows us the method by which resemblance is produced, the resemblance to a face from which only a mask can be the result—a mask that then loses the life of the face.

Jean-Luc Nancy describes Gumpp's work in a chapter devoted to resemblance. In his analysis he emphasizes the "dissimilarity" between two different types of resemblance—mirror and portrait. The gaze of the portrait does not view itself but is rather directed at us, and thus to an "other" who comes to the portrait as its future viewer. Beneath the portrait being painted (on which the painter has also left his signature) lies the dog, a reference to faithful similarity, whereas the cat below the untrustworthy mirror refers to the opposite quality. The mirror image (*le reflet*) is imbued with narcissism while the portrait establishes "the connection to another in itself or to itself as an other." One of the pictures thus exists *in praesentia*, while the other *in absentia* is thoroughly focused on absence. Absence, however, "is nothing more than the stipulation according to which a subject refers to and *resembles* itself. To resemble oneself, therefore, means to be one's self, or to experience one's self as a unique identity."[9] When we wear an actual mask upon our body we are absent behind the mask. Our own face has no place there; it is merely painted.

The conundrum of "presence in the picture" and "absence as body" becomes forced to the point of trompe l'oeil in an oil sketch from 1604 in which Annibale Carracci lets us participate in the production of a self-portrait in his studio as Gumpp later did (fig. 67).[10] In the half-light of this studio it seems as though the painter has just finished his work and left the room. The self-portrait still stands on the easel, its colors fresh, as we can also see on the palette that hangs below it. Research has

revealed that the artist began work on a
portrait before deciding to paint over
the face and replace it with the reproduc-
tion of a portrait. We are thus seeing the
image of a painted picture that doubles
the absence of a face. An artifact appears
in place of the face, and it is precisely at
this point, against all appearances, that
we perceive a gesture of true virtuosity,
when our gaze meets that of the artist. It
is as if he had disengaged himself from
the canvas and met our gaze through the
magic of a shaft of light. The presence of
the gaze reinforces the absence of a face.

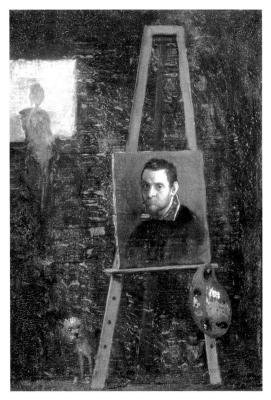

FIGURE 67 Annibale Carracci, *Self-portrait on Easel*,
ca. 1604 (Saint Petersburg, Hermitage)

The work by Caravaggio from
almost the same time clearly reveals the
theme of the disembodiment of the face
in the self-portrait. It is probably the
only self-portrait in the history of art in
which an artist portrays his own face at
the moment when life is leaving it (fig.
68). The biblical story of David and Goli-
ath provides the imagery for this narra-
tive. It was already known in the
seventeenth century that the painting in the Borghese Gallery in Rome contained a
self-portrait. The severed head of the giant, in which the eyes are closing in death as
rigor mortis sets in, is a likeness of the painter. We are clearly observing the trans-
formation of a face into a death mask. According to the Bible (I Samuel 17) David
slew the Philistine with a stone, the wound of which is also visible on the forehead
of Caravaggio's giant. Nonetheless, the painter represents the subsequent behead-
ing with the sword, that is, Goliath's execution. The painting is documented as hav-
ing been in the possession of Cardinal Scipione Borghese in 1617, a few years after
Caravaggio's death. The cardinal was one of Caravaggio's most important patrons.[11]
It is possible that the painting alludes to a murder that took place on May 31, 1606,
during a knife fight after a ball near the Villa Medici, which left the painter "badly
wounded on his head."[12] Caravaggio had to flee Rome, hoping in vain for a pardon. A
price had been placed upon his head in the so-called *bando della testa*, which offi-
cially branded him a criminal and made him an outlaw ("bandit"). If the painting

dates from the period after his flight from Rome, then the autobiographical connection lies in Caravaggio's attempt to avert the threat of execution and move his patron to pardon his most important artist.

This self-portrait also contains further meaning: Caravaggio suggests to us that through the very act of painting, he has already taken his own life. We must not ignore the tradition of the so-called identification portrait, in which the face portrayed could represent an allusion to a biblical figure.[13] In this case, however, Caravaggio does not approach us as the young David holding up the severed head with an unexpected and inexplicably pained expression. David's gaze and the position of his arm lead our eyes to the unusual self-portrait that has been separated from its own body. The fresh blood still seems to drip from the neck, and yet the painter has let it begin to flow thickly over the canvas, as if wishing to make us witnesses to the coagulation and drying of the paint. The beheading becomes a metaphor for the act of painting and thus for the withdrawal of life from the face through its transformation in painting. Beheading and disembodiment refer to each other in this self-portrait-like mirror image. In the act of being painted, a face stiffens into a mask.

A portrait suspends the flow of time, which constantly changes the expression of the face. It also brings facial expression to a standstill. Paradoxically, only when a face is freed from expressivity can it be reduced most vividly to the fundamental concept of itself. But this comes at a price: it becomes a mask and can never resemble a living face. Every portrait raises the dual challenge of reproducing an individual face while representing the face on a lifeless surface, the only thing it can offer for this task. Self-portraiture thus engenders a revolt against the mask. We all know the experience of the mask when we see ourselves stiffening in a mirrored reflection. This self-observation has the immediate consequence that we lose our spontaneous self-expression. For this reason, the mirror frequently invites us to make faces, if only to escape the mask that holds us at its mercy. This also explains why we often view photographs of ourselves with reluctance. A subject that seeks itself in a mirror finds another there. One can only identify with that other once the face in the mirror has been animated. The reflected image offers a painter not only many choices but also uncertainties, as when he must decide upon a single image. The portrait is grounded in a concept of the self that not even a painter can discover in the mirror.

Rembrandt created many self-portraits, making his own face available for studies of expression and character.[14] Scholarship has naturally been fascinated by the question of when Rembrandt actually intended a self-portrait and when he was only using his face as a mask for a role, in the way one might costume a body. In Rembrandt's lifetime, artists in the Netherlands were trained in the genre of "tronie," or "trogne" painting. This colloquial term had been borrowed from the Old

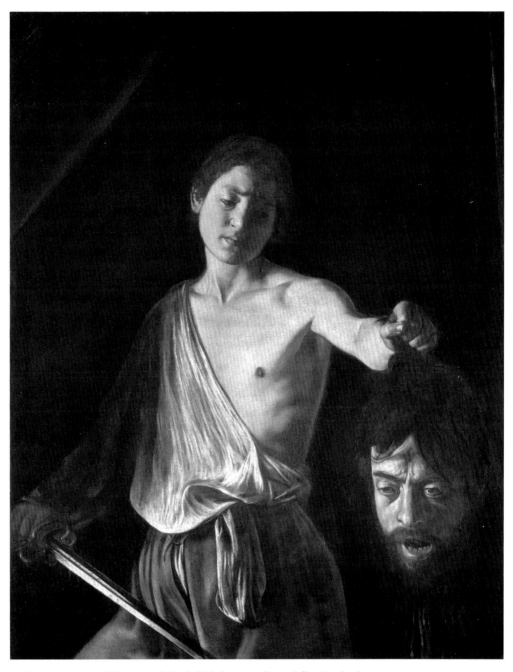

FIGURE 68 Caravaggio, *Self-Portrait as the Head of Goliath*, ca. 1607 (Rome, Galleria Borghese)

French.[15] As a pictorial genre the tronie was not a portrait of an individual but rather an expressive study of the face of a foreign race.[16] Sources sometimes mention portraits of a tronie.[17] In this vein a text from Rembrandt's era differentiates a portrait (*conterfeytsel*) from the true face (*van de tronie*), which the painter had before him.[18] A tronie could be a face as well as a mask. The choice of the unstylized face—the face more or less as raw material—gave the tronie license to represent foreign types, a *vreemde tronie*. The concept designated a physiognomy that fit many roles, like a mold for a mask. Because tronies were usually images of roles—and therefore essentially masks—facial expression was forced, or captured a moment or an expressive feature of a type. With this in mind Jan van Vliet published the groundbreaking large editions of expressive studies that young Rembrandt created using his own face (fig. 69).[19] Constantijn Huygens once remarked of the painter Jan Lievens that he had painted a Turkish prince using a Dutch model.[20] The model gave the artist only the face for his ethnic mask.

When he wanted to paint himself, Rembrandt performed roles and cloaked himself in poses before a mirror.[21] In the course of his life a certain coherence emerged among several faces and portraits in a sequence. Self-portraiture, at any rate, lives from a "rhetoric of the self. Because that self is always changing, we must also change the self-portraits."[22] Rembrandt's self-portraits never appear alone, and they depend upon differences that they present in the same face. Their relationship to the face is thus not primarily a mimetic connection but rather a means of dramatization. Rembrandt's distance from himself characterizes these images as the roles of an actor, behind which the ever-changing self can always take refuge. As early as in his etchings and oil studies from the Leiden period, the artist approaches the mirror with a strained gaze and open mouth. As he does so, his gaze is that of an observer reporting how the expression changes on one and the same face (fig. 70).[23] The etchings depict a young man laughing or with wide-open eyes, a man whose expressive mask is distinct from the wearer.[24] This gives the impression of a painter analyzing the phenomenon of laughter per se. This unusually bold gesture displaced the earlier status of self-portraiture and liberated the intangible play of expressivity in the face. When Rembrandt meant to portray himself, he not only approached "the mirror with questions, but with an agenda."[25]

This agenda consisted of performing roles before the mirror simply in order to render them as images. "Each pose denounces every other pose as inadequate. This produces a never-ending sequence of masks," which were all worn by Rembrandt, because the self could not be found, even in the mirror.[26] The mask is attached to the role it serves. Even in his own life Rembrandt also played roles, which were either oriented to public view—as when he posed in historical costume as a Renaissance

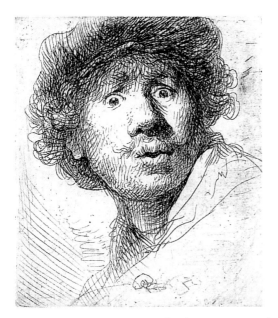

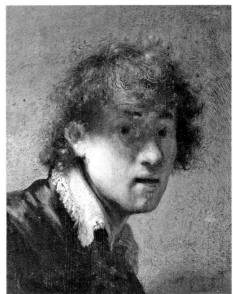

FIGURE 69 Rembrandt, *Self-Portrait with Wide-Open Eyes*, 1630, etching

FIGURE 70 Rembrandt, *Self-Portrait as Young Man*, 1629 (Munich, Alte Pinakothek)

painter in 1640 (fig. 71)—or turned their backs on the public sphere. During his last years, when Rembrandt's self-doubt increased, his self-portraits become more numerous. Many still present him in the act of painting, yet in others he rejects this role in order to concentrate on the face that is becoming ever more alien. Then his gaze, as well as his consciousness, achieves a distance from that which he sees within himself. The representation of his gaze duplicates itself in the portrayal of that which the gaze observes.

Only once in these late self-portraits does he overcome the distance and laugh in his own face. There is an ironic joke in this: Rembrandt (if one may put it this way) unmasks both himself and the portrait as a mask. The old painter is laugh-

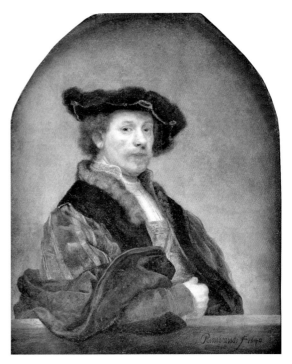

FIGURE 71 Rembrandt, *Self-Portrait at Age Thirty-Four*, 1640 (London, National Gallery)

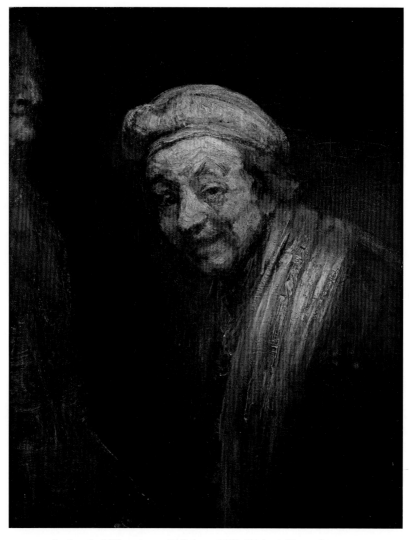

ing because he is once more painting a portrait that can never capture his true self, but that can produce only a mask. The image under consideration is the puzzling self-portrait in Cologne, which deserves its own excursus here (fig. 72).[27] After Rembrandt's death the painting was cut down to fit the usual portrait format, although it originally represented him as a "painting of an old woman," as the 1761 entry in the catalog of a private London collection reads. Even today one can still see the half-profile of an older woman wearing a pearl necklace and long decorative chain at the left margin of the picture. The artist does not rest his hand with the maulstick against

the woman's dress, but against her likeness that stands on the easel and is still visible today, set apart by the dark frame against the illuminated space even today.

It has recently been revealed that at the time a classical legend about artists was circulating in painters' studios, and that this legend lies behind Rembrandt's pictorial idea. The treatise on painting by Samuel van Hoogstraten published in 1678 twice mentions this source. He recounts the story of the painter Zeuxis, who did not wish to paint common (*gemeene*) stories, and who in his old age painted so wondrously (*zijan wonderliken aert*) that he died laughing at his own work. In another passage in the same text we read that the sculptor Myron earned great fame with his depiction of a drunken old man. This satisfaction was never granted to the painter Zeuxis. It was said of him that when painting "a silly old woman" (*bes*) from the life, he erupted into such uncontrollable laughter that he choked and died.[28] In 1685 the painter Arent de Gelder took the legend as a theme for his self-portrait (fig. 73). He had begun his training with Hoogstraten and completed it under Rembrandt. But when he finished the self-portrait he was forty years old, whereas Rembrandt painted a likeness of old age with all the "comical" wrinkles that had been mentioned in the classical text.

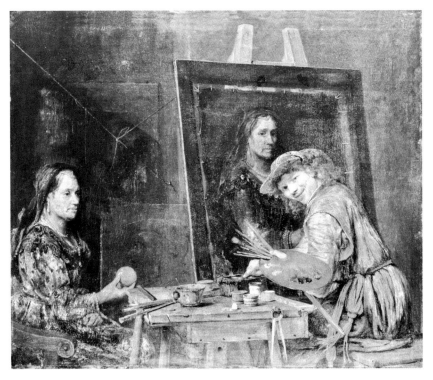

FIGURE 73 Arent de Gelder, *Self-Portrait as Zeuxis at His Easel*, 1685 (Frankfurt am Main, Städel Museum)

In the legend, old age with its vanished beauty is merely the occasion for laughter. It no longer possesses the timeless beauty of antiquity, which so often calls upon art to depict it. The implication is that painting did not need a beautiful model but was, rather, beautiful in its own right as a medium—especially in the case of unattractive subjects. Rembrandt extracts from all this more than just a plea for the beauty of art, he also casts a backward glance at the decades during which he had tried to capture the fleeting and mutable views of himself in countless portraits. Clothed in a painter's beret and a great mantle, a magnifying glass around his neck, he leans forward, toward his reflection in the studio, with shortsighted, wide-open eyes, while he interrupts his work on the female likeness. The work depicts an aged portrait painter at work on the likeness of an old woman. Behind this there lies a nuanced message against self-portraiture, which is exposed as a genre. Capturing one's unique essence, he seems to say, is ultimately a futile attempt. Rembrandt is laughing because by now he knows that his personality is anchored in his consciousness, not in his likeness. In an essay on "Rembrandt's Mirror," Jean Paris speaks of the "sequentially worn masks," with which the painter struggled against the uncertainty of his persona.[29]

This penetrating interrogation of the self, carried out in the darkness of self-doubt and coaxed from the unstable medium of paint, makes a powerful contrast to two approximately contemporaneous self-portraits by Nicolas Poussin, which are bathed in the bright daylight of work grounded securely in artistic theory.[30] For his Parisian friends, who had requested a portrait, but not a self-portrait, Poussin painted two pictures that included his *effigies*, whose resemblance the friends could then see only by comparing the pictures in the absence of the artist. They were thus meant to open a dialogue about art with their recipients. In the self-portrait in the Louvre (1650), Poussin distances his face from us by turning his head self-consciously over his shoulder. In doing so he directs a critical gaze, not upon himself, and not out of the picture plane, but upon his work—essentially at the self-portrait sent to the friends from Rome as a manifesto of his rhetorically grounded art (fig. 74). The friends are receiving not only his portrait, but also a gaze of self-distance reflected in the mirror of the painting. The artist does not capture himself at work in his studio. Rather, he depicts himself in front of stacks of canvases, painted and unpainted. His body casts a shadow upon these, as if he wished to say that each and every one of his works had been conceived of as a self-portrait using the language of art. As a person in bodily form he remained outside of art, which perhaps explains why his head is not shown framed by the canvases but instead extends above them.

In the modern period self-portraiture took a Romantic turn, as it became the arena where the myth of the artist and his insecure aspirations found expression. In

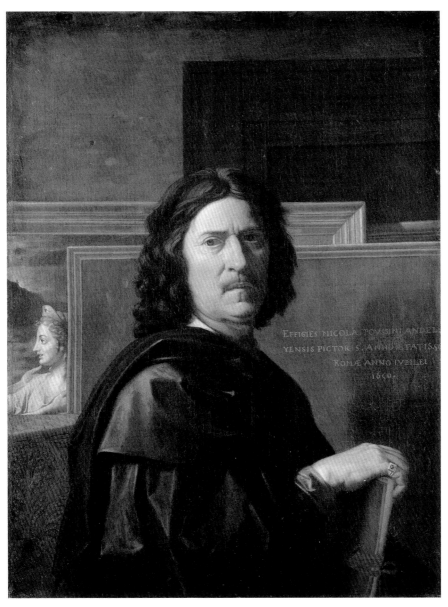

FIGURE 74 Nicolas Poussin, *Self-Portrait*, 1650 (Paris, Musée du Louvre)

the struggle for recognition, the self-portrait was chosen to represent one's personal idea of art. Since the Romantic period artists who sense their isolation from society retreat into the self-portrait as a work for which they have not yet found a public. In this way the loneliness of the prophetic artistic hero becomes the theme of a new iconography. The problem of the face, however, has become pedestrian and, with the emergence of photography, been relegated to this new medium. In the twentieth century the artist no longer competes for our attention with a single self-portrait, but with numerous ones. In the permanent state of self-observation, such as Rembrandt had expressed in his later work, there now lies the question of the stability of one's own artistic position amid the rapid changes of the artistic scene.

In the works of Arnold Böcklin, Lovis Corinth, and even more strikingly, Max Beckmann, the appearance of the artistic self betrays an emerging resistance against collective artistic fashions and the competition presented by artistic photography. In his self-portrait Max Beckmann portrays himself as a loner playing roles that separate him from others. These roles are those of the clown and acrobat, who represent a long tradition of artistic metaphors or biographical ones that conceal a personal myth. The artist's self strengthens the claim of the autonomous subject against all doubt. His own face and prominent head—which the painter consistently "models" with unflagging energy in the play of light and shadow—prevail despite all disguise and defy the mutability of life. In 1936, shortly before his emigration as a so-called degenerate artist, Beckmann had a bronze cast made of his head. He even appropriated the photographic portrait with the pose of a visionary. The pose is the vehicle for the penetrating, or fierce, gaze with which he explores his self in an exchange of gazes before the mirror. With one hand often holding a lighted cigarette, he holds the pose as if in a photographic snapshot, resisting the mask so that life may not ebb from it.[31]

13

SILENT SCREAMS IN THE GLASS CASE: The Face Set Free

In the autumn of 1950 the painter Francis Bacon exhibited a series of six portraits in the Hanover Gallery in London. Among these were three papal images (two of which were subsequently destroyed). These were unusual portraits, for these fictional images of popes—which would dominate Bacon's repertoire for years to come—deconstructed a historical portrait from the seventeenth century.[1] Bacon did not call these portraits, despite the fact that they could be nothing else, but rather referred to them as "studies for a portrait," as if to emphasize that it was the portrait as genre that he was attempting to subvert. Vividness and presence take

precedence over resemblance, which in the traditional portrait had frozen the face into a rigid mask. Bacon's portraits have elicited speculation about whether the head (and with it the body) have taken precedence over the face, which is an observation that is true for only part of his oeuvre.[2] The titles themselves differentiate between head and portrait. The faces that Bacon painted are tense and tortured— screaming faces whose cries echo silently within their glass cases. As Bacon consistently emphasized, he wanted to stimulate a new sensation in the viewer, the sensation of an animalistic life—in other words, a presence that transcends the masklike character of the portrait.[3] He created an almost paradoxical life in his pictures that we otherwise know only from the moving images of film.

It is logical that Bacon's portraits should refer clearly to a scene from Eisenstein's film *Battleship Potemkin* (1925). In it, the bloody face of a governess stares at the massacre on the steps in Odessa; her mouth is wide open, and she begins to scream—as inaudibly in the silent film as later in Bacon's paintings. In the case of Bacon's paintings, however, no event provokes this response. His figures are screaming as if they wanted to free themselves from the cage that encloses them in the picture. Simultaneously, Bacon blatantly alludes to the famous portrait of Pope Innocent X, painted by Velázquez during his visit to Rome in 1650. The artist used the papal throne again even when he was painting pictures of people from his own milieu. The stony face of the pope by Velázquez represents the greatest contrast to the violently expressive face of the governess. In all this the pope stands for the whole genre of portraiture that Bacon is subjecting to an internal criticism in the same medium in order to free it from its fetters. The 1950s saw the production of an extensive corpus of actual and fictional portraits unique in the world of postwar art.

Three more versions in large format (198 × 137 cm) belong to the papal portrait series in which Bacon attacked Velázquez's portrait in 1951 in order to vanquish it with a reaction. The painting *Pope II* (also known as *Study for Portrait II*), which hangs in the Mannheim Kunsthalle, shows the enthroned pope turning a screaming face toward us (fig. 75).[4] The scream and pince-nez are references to Eisenstein's film, while the scream is amplified by the narrow glass case enclosing the pope as if he were locked inside his own portrait. The contrast of this trembling body with the cagelike framework of throne and platform in the glass case gives the impression of helpless life. The cold geometry of the glass case inserts itself into the painting like a second frame. Bacon would later complain that he had not been successful in "painting the best painting of the human cry." He had always been interested in the mouth and its expression. "I wanted to paint the scream more than the horror." He asserted that he had always been very moved "by the movements of the mouth and the shape of the

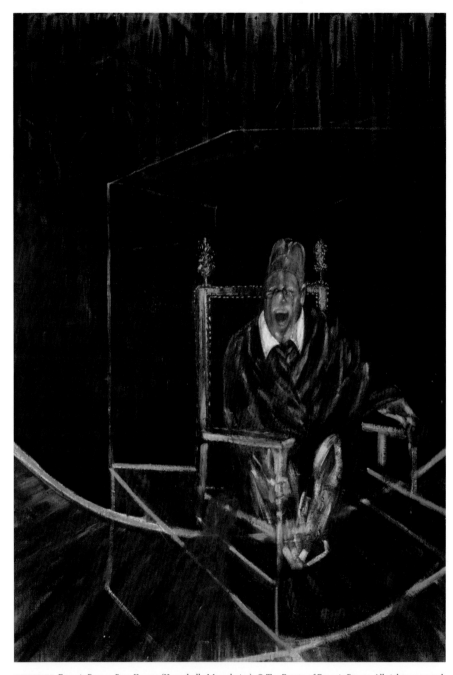

FIGURE 75 Francis Bacon, *Pope II*, 1951 (Kunsthalle Mannheim). © The Estate of Francis Bacon. All rights reserved. / DACS, London / ARS, NY 2016

mouth and the teeth."[5] Bacon justified the scream with the argument that he wanted to communicate "the feeling of life." "I think that disfigurement can sometimes give an image more power."[6] The painter obviously wished to fill the "picture" with life, which he, for the most part, missed in portraiture. He stated that, as a result, he liked to work from photographs, for they were already a picture of what they portrayed, thus permitting him to translate them into his own picture.

In Bacon's portraits a struggle with the mask is also taking place, a mask the artist wishes to tear from the face that has become a portrait. He therefore ties the face to the whole body as well as the head, for the body can give life to the face. A screaming face is an active face, whereas the mask remains passive. With ever greater rage the painter attacks the mask, which stares at him from the old papal portrait. In the summer of 1953, in fourteen days, he painted eight different papal portraits, which escalate their expressivity to the point of hysteria. The *Portrait Study VI* hanging in Minneapolis (fig. 76) belongs among these.[7] Here the pope's eyes turn away from the direction of the scream without looking at it, as if to flee. Closer inspection shows that the surface of the face has been applied with a single thin brushstroke upon the dark background, as though it were a mask that is tearing itself from the face at this very moment—from a face that sheds its painted mask through its expression. The painter's frantic brushstroke corresponds to the expression of violence that he wants to capture. Eyes and mouth push through the face as though through a splintering shell that has separated them from us.

The papal portraits leave the impression that they are not about the pope but about the image. An image can only reproduce a human being in a mask, yet Bacon wants to convey it precisely in the fragility and misery of its flesh, "as directly and honestly as possible," as he confided to his interviewer, David Sylvester.[8] For this reason it was the official face of the pope—which he wore in the old portrait like a mask of office—that provoked Bacon to unmask him. In doing so, he made it a private face. Bacon did not shrink from disfiguring the face to the point of unrecognizability in order to capture the expression of life.

Bacon's *Three Studies of the Human Head* (each 61 × 51 cm) document his method (fig. 77). They date from 1953, the same year as the papal portrait. The artist's conversations with David Sylvester reveal that he painted the third portrait as an individual picture. He created the other two after this picture had been rejected as incomprehensible.[9] Bacon, however, did not merely add two further portraits, but conceived a kind of cycle that leads directly—as in a cinematic sequence—to the disintegration of the face in the third picture. The expression intensifies in each one. In the first picture it is still distanced; in the second it culminates in the crescendo of a scream; and in its final state, it devours the face. The three "studies" thus

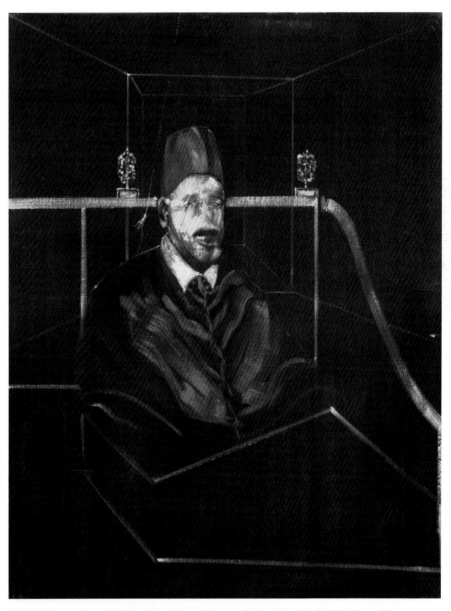

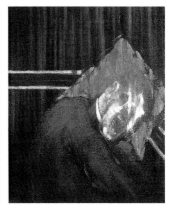

explain the process of a pictorial idea that no longer relies upon a living model and breaks through the boundaries of the picture. In doing so the picture changes from a silent object into the illusion of a subject that screams at us. The pictures had fulfilled their purpose as likenesses. Bacon decided to relinquish this function to the media of photography and film.

The philosopher Gilles Deleuze tried to capture Bacon's work in a single thought, namely, the contrast between face and head. His theme is, first and foremost, the sensation that bodies transmit and record.[10] This is triggered in the nervous system and then is conveyed further. Deleuze thus separates the face from the body and then connects the body to the head. He views the face as a system of signs distinct from the body and concludes that "Bacon the portraitist is a painter of heads and not of faces. . . . The head shakes off (*secoue*)[11] its face. Such a thesis creates doubts about the portrait as a genre. In the face Bacon awakens a new life of the flesh. When a face screams in his pictures, the whole body screams as well. Bacon returns the face to the body and emphasizes the expression of its forsaken condition, which includes the face and the head. Bacon's true theme is the image, which is only to be expected of an artist. Yet at the same time he also undertakes the never-ending experiment of crossing the boundaries between image and body with all the violence he can muster. The face, however, remains the focus of the picture, even when it is reduced to a blind scream.

While Deleuze was expounding his own thesis about Bacon's oeuvre, the surrealist writer and ethnologist Michel Leiris was interpreting Bacon through his own painting, using his own ideas. Leiris had been a friend of the artist for a long time and twice commissioned a portrait of himself from Bacon, in 1976 and 1978. In the very

title of Leiris's book on Bacon, *Full Face and in Profile*, the face becomes central to the argument.[12] His book emphasizes the ephemeral character of Bacon's portraits, "which pull us directly into the picture without erecting barriers of time and place." They collect "the rhythm of life" like a snapshot of a theatrical production that never ends. These portraits achieve their "extreme tension" through the contrast of the restless bodies with their detached geometrical settings. The directness of this pulsing painting, according to Leiris, is determined by a "thirst for presence" and by the search for "existence."[13] Leiris's interpretation proceeds from the picture itself, which is ultimately a portrait, and reflects a certain fascination with the unprecedented transgression between image and life, between mask and face. The silent scream is a contradiction per se, for it falls silent at the boundary between body and painting. At this inflection point, Bacon stubbornly tries to expose the face of flesh and blood behind the mask, as if he wanted—at any cost—to fill the mask of absence with the presence of an impossible life, a presence that only the face possesses.

In 1955 Bacon actually took for his model a mask, one representing William Blake (1757– 1827), who for subsequent English artists—and apparently for Bacon—had become a sort of idol and superego (fig. 78). Bacon chose the life mask, which Blake had cast in 1823, as a model for three "portrait studies" in small format. He produced these in rapid succession in 1955 (fig. 79).[14] This special case within Bacon's work deserves closer examination. Bacon rejects the view offered to him by the mask and seems to transform this into a wildly animated face. Yet this animation resides only in the painting, which renders the surface of the face in jagged contours, thereby adumbrating the gestural painting of the 1960s and 1970s. Bacon essentially changed little in the mask, not even the closed eyes. And yet everything is different. On this black background, the head is turned to the side to look like a relic from an execution. Nonetheless, we sense a lingering impression of life in this, which is absent in the actual mask.

There is a certain irony in the fact that Blake's life mask with its tense smile appears dead, whereas Bacon's portrait invests the same facial traits with expression. This time the defiant mouth, now without the scream, plays a major role in the expressivity. By attacking the mask in three separate instances of portraiture, Bacon has wrested life from it—life that he had found missing in the original mask. Blake's mask freezes the face into rigid memory; face and mask are one and the same. Bacon's "portrait studies," on the other hand, are paradoxically more like the "facsimile" that had inspired them. They revolt against the mask and through Bacon's primitive signature style create the appearance of life. The mask, however, had originated in Blake's authentic face when the cast was taken. In the closed cycle of these pictures there is no escape from the mask.

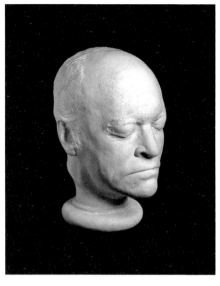

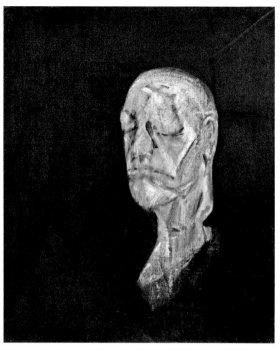

FIGURE 78 James Deville, *Life Mask of William Blake*, 1823 (London, National Portrait Gallery)

FIGURE 79 Francis Bacon, *Study for Portrait II* (after the Life Mask of William Blake), 1955 (London, Tate Modern). © The Estate of Francis Bacon. All rights reserved. / DACS, London / ARS, NY 2016

14

PHOTOGRAPHY AND MASK: Jorge Molder's Own Alien Face

Roland Barthes reduced photography to its essence when he remarked that a photograph could "only achieve significance when it shows a mask." In doing so he invoked Italo Calvino, who understood the concept of mask to mean anything "that turns the face into a product of society and its history." As an example, Barthes chose the photograph of a former slave, in which "the essence of slavery is revealed. The mask is his true significance, insofar as it is nothing more than a mask, like its function in classical theater." The great portraitists like Nadar, Barthes continues, represented French high society or, like Sander, represented the Germans of the interwar era in the sense that they depict masks of both their time and their society. For Barthes, however, the mask is "the most difficult part of photography." Society does not wish to reveal its own character realistically. The unadorned social mask created unrest because it is always controlled by a critical gaze and raises the issue of censorship.[1] The mask presupposes that it will not be seen as a mask, but rather considered to be the face.

The pressure of the mask elicited the unwanted face. As a counterpoise people quickly tore the mask from the faces of outsiders concealed under a collective mask. During the Third Reich photography was supposed to show the true face of the Jews. Aggression, however, was not only directed against Jewish photographers, whose portrait photographs abandoned the conventions of the majority. In May 1933 the Deutsches Nachrichtenbüro (German Press Agency) called for the purging of photojournalism under the title "Down with the Mask." As early as 1930 Ernst Jünger imputed that the Jews were "masters of all masks," for they had succumbed to the delusion that they could be "Germans in Germany." It seemed to be merely a question of masks that they looked like Germans. Consequently, photographers were urged to ferret out the "racial soul" behind the mask, as Alfred Rosenberg wrote.[2]

The flight from the mask occurs with the admission that ultimately the camera can produce only masks. In a photograph we wear a mask upon our body as we stiffen into an image. Despite all logic, a magical practice returns when we imbue a photograph, which captures only a shadow, with borrowed life. In the photograph we see someone who is no longer there. When we view ourselves, an unwelcome distance from our own lives arises. We encounter a mask that looks alien to us, as if it were being worn by someone else. Photographs belong to a different time as soon as we view them. The notion of "that's the way it was" is transformed into "it will never be the same again." By this token no picture can ever be repeated. Even when the production of images is repeatable, this does not apply to the pictures created by the process. These refer back to the moment when the photograph was taken and thus to a time beyond our life. The absence of a body is exchanged for the presence of an image, thus alienating us (literally) because images try to capture transitory life.

The "*thanatos* effect" that Roland Barthes has described is experienced in photography with a power as old as picture making itself. Barthes seems surprised at this insight; he devotes a long section to the argument in his well-known essay on photography. Such surprise can probably be explained by the fact that in photography we repress the death mask so adamantly. We always photograph the living without preparing ourselves for the fact that these people not only can, but some day may be, remembered in the photograph as the dead. We thus involuntarily encounter the death mask in the photographic archive of life that we are constantly expanding. The older we get, the more photography as a medium of memory brings death into focus. Barthes can thus state with a certain amount of wonder that photography has to struggle against the depiction of death, for in the photographic process, "I have become one with the image, in other words, Death personified." Photographs turn us into objects that others can control as they wish. "Death is the *Eidos* of such photography." Barthes hesitantly approaches the cult of death, which

adumbrates this experience, in the same way that theater has its roots in this phenomenon. "The photograph is like a primitive theater, like a *tableau vivant*. It is the depiction of the immobile and heavily made-up face that we see on the dead."[3]

The analogy between photography and mortality is as undesirable as it is irrefutable. It is evident in the irreversible time gap that usually separates us from pictures. Barthes thus speaks of the "*punctum*" as the catalyst that creates the temporality in the photograph, for the age of the picture is the *signum* (signifier) of past time. Many photographs conceal "a catastrophe that has already happened," even if it still lay in the future when the photograph was taken. Ultimately every photograph conceals "this catastrophe within itself, whether or not the subject is now dead." Barthes certainly chose a private view of photographs for his point of departure—a view of photographs in which the individuals activated his memory. From these he concluded that our relationship to photographs is always a private one because photography emerged at the same time as "the intrusion of the private into the public space, and thus the publicity of privacy." Amid the visual noise of the media, he consequently turned specifically to photographs that "caused him pain," because they had preserved his personal memories.[4]

Paradoxically, however, the image praxis of the mass media shows us the most striking evidence for the coincidence of the death of mask. Every newspaper and broadcasting medium stores huge archives of photographs, sound recordings, films, and videos, which stand ready for the obituary reports of public figures and make it possible to compile retrospectives of their lives. Reportage about deaths is always accompanied by photographs of the living. In the photograph taken during the lifetime of the deceased, the dead person is remembered without showing death in the picture. Only the gaze of the never-changing photograph has altered. Death is announced by the commentary of the broadcaster, whereas in the picture life has already become embalmed. If death has no place in such pictures, then this is also true for life. These pictures—so seemingly lifelike—show a mask with which the dead can also be depicted. At that moment the pseudo-life of the picture takes possession of the true life of the person.

Resemblance is a concept that has enormous problematic significance in the history of portraiture, yet it no longer concerns Barthes. In its place there appears a characteristic that he calls "*air*." It is more than just facial expression, and in its new significance it recalls the "aura" as Walter Benjamin understood it—namely, "a strange tissue of space and time, a unique appearance of distance, no matter how close."[5] Barthes differentiates "*air*" from "simple analogy such as so-called resemblance," calling it the animation and physical aura of a human being in the picture. The photographs of his mother seem to him "a bit like masks." "In the last photo-

graph, however, the mask disappeared. There remained a soul, ageless, and yet not outside of time, for in this *air*—it was she herself whom I saw." Here Barthes introduces the key theological concept for the real presence of Christ in the mass by designating the *air* in the photograph of his mother as "consubstantial with her face." In other words, he postulates an exchange of substance between the picture and the person.[6] In this way he hopes to coax life from photography—for him an eternal mask—life that had been lost in the mask. This suggests a reevaluation of portraiture. With the photographic act, Barthes is no longer interested in the representation of the face but rather in something else: marking the traces of a physical life.

As portraiture, photography has always been both evidence and obstacle. It is evidence in that it reproduces a face presented before the camera; it is an obstacle in that it can only capture a single point in time, which the face no longer resembles a moment later. A person, who is always changing faces in life, cannot be replicated by a single photo, even though the viewer might be reminded of the person's other faces, with which he is familiar. Photography as documentation has established new confidence in portraiture, confidence that painting has squandered. Photography eliminates any outside intervention—such as that of the painter, for example—because it has always been possible to take a photograph of oneself with the apparatus. But the belief in photographic objectivity as evidence of real life did not last long. Distrust entered with the pose one struck in front of the camera lens. In addition, every photograph was reproducible and replaceable with a different one, so that the assurance soon disappeared that a photograph could produce a unique image of a person. While the initial euphoria lasted, the Parisian photographer Disdéri waxed enthusiastic "about the true total character" of the person being photographed. He encouraged his clients to have themselves photographed in "as idealized a form as possible," by staging them and persuading them to take flattering poses.[7] However, he soon had to abandon this naive practice.

In Russian modernism, Alexander Rodchenko received nothing but vehement criticism for his belief in the photographic portrait. This criticism was aimed at his trust in the image in general. In a text from 1928 he opposed "the synthetic portrait" and defended the snapshot.[8] He claimed that only the snapshot was suited to the tempo of modern life and argued that photography had to take up the struggle with "fraudulent eternity," which had the characteristic of painting. He believed that the "unique, finished portrait" had lost its meaning because no human being could represent totality. He argued that we all consist of many faces—often as not, ones that contradict one other. It was at last possible, he believed, to be able to "unmask artistic synthesis, which depicted one human being as another." Rodchenko even went so far as to abandon a subject's frontally oriented position toward the world and set

up his camera in a random corner in order to photograph either from above or below so as never to view the other person as if one were standing opposite him. In doing so he focused on his subject in such a way as to emphasize the mechanical optics of the photographic apparatus.

In a tone typical of his generation Walter Benjamin stated enthusiastically that a "politically trained gaze" could liberate the portrait from all personal considerations. One simply had to bid farewell to the "representative portrait photograph" that middle-class society had believed in for so long. Yet in his rejection of traditional portraiture Benjamin does not see any "rejection of the human being." He claims that in the future, photography must concentrate on those social strata that had not yet been included in photographs meant for posterity. Then, he continues, they will be able to express human nature in "that anonymous appearance that the human visage possesses." The collective face of the new society had been made visible "for the first time" to Benjamin in Eisenstein's revolutionary films: "and suddenly the human face made an appearance with new and immeasurable significance. But it was no longer a portrait. What was it?"[9]

He sought the answer to this question in August Sander's photographic project, finding this material in no way inferior to the "powerful physiognomic gallery" in the Russian films. As mentioned earlier, Sander had published the first installment of his book of sixty photographs of Germans, *Das Antlitz der Zeit* (*The Face of Our Time*) in 1929. Despite the title, he detached the gaze from the face and depicted people as social types. Benjamin hoped to find an authentic mirror of society in Sander's work, as well as an "intensification of the physiognomic concept." No matter whether one "came from the right or the left," politically speaking, one's origins "would immediately be examined." Benjamin believed that people could learn from Sander how to interact with the classes of contemporary society.[10] Because representation of a subject was no longer the goal, the masklike character of the photograph presented no obstacle, since social classes were designated as the masks of the collective.

The critique of civilization prevalent at the time deplored the masks when they denoted modern city dwellers. This critique raised a lament about the "masklike superficiality of the photographic face," which urban dwellers seemed to exchange at will. In their eyes all that remained was the retreat to the apparently timeless face of people in the countryside. But one immediately fell into ideological traps by searching for the authentic face in the "folkish" face and inventing completely new tasks for portraiture in this search. These portraits appeared in expensive books of photographic collections.[11] In 1931 Karl Jaspers criticized the "anthropological obsession" that he observed in the common types of photographic likenesses of the

period. The apparently objective differentiation among "popular types, professional types, and physical types" was actually established according to ideological lines.[12] Was it still possible to represent a *type* or even society any longer through portraiture? August Sander chose full-length photos in which the *pose* before the camera betrayed social *position* (see figs. 35 and 36).[13] In this manner the most diverse factions imaginable worked away at the portrait in the vain hope of reinventing it as a reflection of society.

The illustrated press of the Weimar period questioned the significance of portraiture, just as the silent film was doing with its faces in huge format on the screen.[14] The mass media gave birth to stars who were no more subjects than the individual in the masses had been. There was, furthermore, an art scene that reduced the portrait to an artistic problem in order to align it with contemporary style. Whether one had rejected the autonomous subject or considered it no longer capable of being represented, the result was the same. The emergence from the traditional frontal view is a symptom of this crisis, which was a crisis of the face that had undermined every dramatization of the self. In extreme close-ups some photographers eliminated the distance from the face that is necessary for every representation of the self. The closer the camera comes to the face, the more the face becomes detached from the person to whom it belongs. It becomes pure surface or "landscape," as Karl Schnebel defined this phenomenon in 1929.[15] We see details such as nose or mouth but no longer discern the person. For Helmar Lerski the face was nothing more than a sculpture when he produced his portfolio *Transformations through Light* (*Verwandlungen durch Licht*). It was already an artifact for him well before the face was replicated as a photographic artifact. László Moholy-Nagy shows facial skin filling an entire photograph, while the eyes seem to fend off the proximity with which our gaze intrudes upon the face.[16]

A further flight from portraiture can be found in the so-called high-speed action series (*Reihenaufnahme*).[17] This technique of multiple shutter bursts per second shows a clear debt to photojournalism. The photographer portrays his model in a series in order to reintroduce the passage of time that portraiture suspends. In a series of snapshots, the single image loses the right to be considered a valid representation of a person. Every image in the series has equal value to every other image. Only their sequence simulates the movement of life, which no individual photo can capture. Josef Albers photographed the painter Paul Klee at the Bauhaus in the smoke of his cigarette, thereby underscoring the fleeting moment. He produced a similar portrait series of Marli Heimann, whose face appears in changing light and with changing expressions. A collage of twelve prints emerged, all taken "during 1 hour," as Albers noted in the margin.[18]

At the time, the photographic self-portrait presented a challenge by reintroducing the mirror used by artists. The photographers did not pose in front of the camera, but rather beside it and in front of the mirror. They gave a significance to the self-gaze that asserted itself despite the mechanism of the lens. With this even the cord of the self-timing shutter release gained symbolic meaning. The crisis of self-portraiture had reached the medium of photography. The game with the self demanded an actor, and all he had at his disposal was the mask. In a self-portrait from 1928 Werner Rohde applied thick makeup to his face, transforming it into a heavily painted mask. He looks out from behind a cardboard mask of "Renate," expanding the staging to the point of being a double mask.[19]

A key work regarding masks and portraiture is the photograph that Man Ray (the American expatriate in Paris) made of the writer Gertrude Stein in 1922 (fig. 80). When the photograph was taken Stein sat in front of the portrait of her that Picasso had painted in 1906, nearly twenty years earlier. In his autobiography, *Self-Portrait*, which he began writing in 1951, Man Ray calls the photograph of this celebrated "sibyl of Montparnasse" a "double portrait" of the painted as well as the living person.[20] It is the photograph of a portrait and thus the mask of a mask, with which Man Ray forces a comparison with Picasso in the portrait of Gertrude Stein, although the sitter had aged considerably in the meantime. In this double portrait Gertrude Stein sat in front of her painted double in the form of a younger version of herself. The resemblance to the model—to be expected from a photograph—is mirrored in the resemblance of the person to her portrait.

The allusion to the mask, however, goes even further, for the early portrait by Picasso was the subject of a legend having to do with the creation of a mask (fig. 81). Gertrude Stein played a part in this legend when she wrote in 1938 in her book on Picasso: "I posed for him all that winter, eighty times and in the end he painted out the head, he told me that he could not look at me anymore and then he left once more for Spain. It was the first time since the blue period and immediately upon his return from Spain he painted in the head without having seen me again and he gave me the picture and I was and I still am satisfied with my portrait, for me, it is I, and it is the only reproduction of me which is always I"—in other words, the self.[21] In this "funny story," as Stein calls it, she identifies herself emphatically and enigmatically with a mask. Perhaps it was for this reason that she even urged the "double portrait." In it she tries to resemble the mask, which "is always I"—an immutable self, defying age and deterioration in life: her self as writer.

By the time her modeling sessions had finished, Stein certainly knew that Picasso had been searching for a prehistoric mask for her face. He finally found one in the summer of 1906 when he encountered the pre-Roman Osuna figures of his

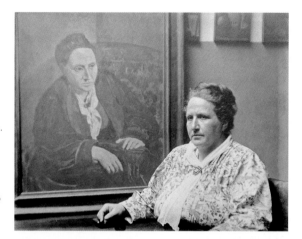

FIGURE 80 Man Ray, *Gertrude Stein*, 1922 (photograph). © Man Ray Trust / Artists Rights Society (ARS), NY / ADAGP, Paris 2016

FIGURE 81 Pablo Picasso, *Portrait of Gertrude Stein*, 1906 (New York, Metropolitan Museum of Art). © 2016 Estate of Pablo Picasso / Artists Rights Society (ARS), New York

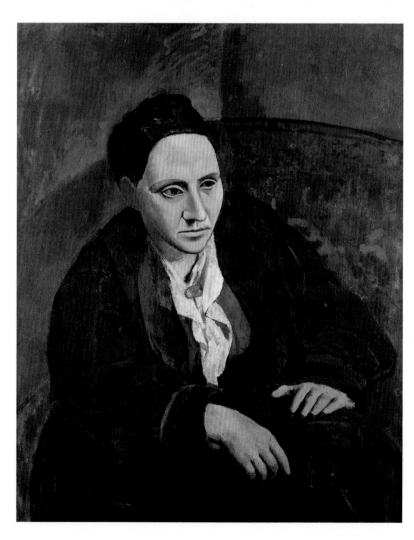

Iberian homeland, which had fascinated him long before he discovered African masks in Paris. In fact, the painter did substitute a mask for the face in the portrait that he was working on. This mask does, however, possess a certain resemblance to the face of the sitter. In this way the face disappeared from the context in which Picasso saw his model during the sittings and assumed a timeless character inherent in the essence of earlier memorial portraits. The strong lighting contributes to this impression as it isolates the face on the painting from its surroundings.

Picasso removed all incidental details from the facial characteristics and from the haunting gaze. And yet in the black-and-white photograph we immediately recognize the same expression, which preserves the difference presented by the polychrome painting. The analogy between painting and photograph is intensified by the rigid expression with which Stein gazes into the distance. Other parallels also emphasize the relationship, such as the seated position of the sitter in both portraits and her lace jabot with the brooch. In the photograph she transforms her face into a mask, as if she wished to resemble her own portrait, in which the facial expression has become frozen. One can still sense something of the conversations that took place during these sessions, for Gertrude Stein would have asked Picasso which face he wanted to paint. Picasso's response, which she quotes (and perhaps invented?) was, "all faces are as old as the world." Here again we see the equation of mask and face, which proclaims its transcendental significance only in hindsight as we look back at older cultures.

When Man Ray photographed Gertrude Stein, he was already well-versed in the game of masks. He demonstrates this in his portrait of his fellow artist Marcel Duchamp, who wears a costume, hat, and wig, with a female mask over his real face.[22] "Rrose Sélavy," whom Duchamp is playing here in 1920, is validated as a real person by having been captured in a photograph signed by Duchamp in his own hand: "lovingly, Rrose Sélavy." But this woman exists only in the photograph, not in life. Such Dadaistic mask games seek to prove that a self can only be captured in the sum of its lifelong entrances on the stage of the face.

The frame that encloses a face in a picture is not only an external frame marking the format of a photographic print but also a symbolic frame, within which we perceive someone as a picture. To demonstrate this Man Ray had the writer Jean Cocteau hold an empty picture frame in front of his face with both hands for a portrait. In doing so Cocteau made himself into a picture in front of the camera even before the shutter was released (fig. 82). With this gesture he chose in life the mask that awaited him in the photograph. The frame is the symbol for the interval of time that separates the viewer from every photo he gets to see. The subject of the photograph can never again occupy the very same space before the camera. For pictures there is

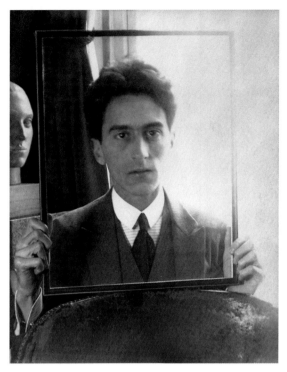

"no next time, since they all refer to the first time," as Adolfo Bioy Casares writes in his futuristic novel, *Morel's Invention*.[23]

In the digital age we already find ourselves talking about analogue photography in hindsight, but even the photographic portrait has altered its appearance so drastically that one can no longer really reduce it to a common denominator with what it once was. In recent decades, photography has become archival, an exhibition genre, and for this reason the old equation between face and image seems to have gotten lost. In exhibition galleries we encounter minutely detailed photographed faces in monumental format, which brutally abandon the human dimensions of the face and rival the faces of the mass media that await us in the public sphere. We find ourselves in an unprecedented situation: new digital technology has dissolved the connection of the image to the face that it seeks to document and placed the pictures completely at our disposal.

And yet we should not hasten to deduce all-too-simple implications from this situation. The correlation between face and photo had already been challenged and denied in analog technology, for a photograph sooner leads us to a mask than to a face. Even the self-reference of a face fixed forever in a photograph, which does not keep pace with life, often ends in an open question. Jorge Molder, the photographer from Lisbon, has been posing this question to his own face for many years. In his photographic sequence, *Series with Narrative Titles*, he appears as the actor of his own face. As though struggling in different roles and with different scripts, he has tried in vain to come to grips with this actor. The photographs that emerge from this process always reactivate the question about the presence of the person whose face they portray. It had always been the object of the self-portrait to interrogate its own genre, but Molder goes further and plays with the portrait in order to bring it into opposition to the face. Lighting and camera angle are techniques for the staging of a subject that can never be successful. Instead, such staging draws the face into a strange twilight.

In its various views and roles in each one of the photo series, the face resists the resemblance to itself. In doing so it is revealed as a kind of foreign object, in that it enters the picture as a body. According to his own words, Molder meets a character in his own photographs "that doesn't quite correspond to me. And nonetheless it cannot be anyone else but I, myself."[24] In fact, however, he encounters a body, and therefore a surface that does not exactly "correspond to himself." The experiment to try to master one's own person in a photograph is, as expected, fruitless. Photography always produces masks, no matter how often it focuses on the same face.

In conversation Molder has pointed out that, as an actor of his own face, he "can show something that I don't know anything about, [I] can show what it is— and that I am neither myself nor anything else, nor another person." There emerges "a being in between"—in that space between the self and an other. The ambiguity lies in the fact that Molder is simultaneously model and photographer, in other words an observer who approaches what he sees with objectivity. "Even when producing self-portraits," according to Molder, "one wears a mask."[25] Manuel Olveira speaks aptly of the paradoxical "monologue with the other."[26] The alterity Molder mentions is familiar to anyone who has looked in the mirror in the morning and sensed his distance from the reflection it shows. One can only show oneself as a face, but people are unwilling to surrender this function to the mirror or the photograph. This kind of distance is expressed as a mirrored situation in Molder's series *Points of No Return* (1995; fig. 83). When Molder views himself in the mirror, the photograph produces two faces, which nonetheless belong to a single person. But as a picture—or pictures—they assume very different positions. The sideways view grazes the body before the mirror, whereas the full frontal view captures the face in the mirror. Molder has photographed a face looking at itself and, in doing so, keeping its distance from itself through the gaze. Here a paradoxical directorial decision has been introduced into the picture, which contains a philosophical question about visibility and existence.[27]

The inquisitorial approach that never reaches its goal continues in a photograph from the series *Anatomy and Boxing* (1996–97, fig. 84). The image is again one of a reflection, but this time it seems that one face is looking down upon another as if challenging the face

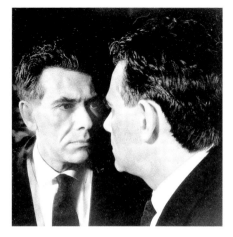

FIGURE 83 Jorge Molder, from the series *Points of No Return*, 1995 (photograph)

being viewed to a duel (boxing), or wanting to turn it into an object.[28] We see only one of the two faces, whereas the other one—the supine head—intrudes into the picture space from below. The picture has been quite literally "stood on its head." If the white dividing line between both faces is the edge of a mirror, then the face that looks down upon the head from above is the reflection, and the head is the gazing partner—in other words, Narcissus. In this way the normal situation of a reflection would reverse itself, and yet we don't abandon the mirror in either case, because even the other head has been captured by the camera. The exchange of gazes can only be represented because a third gaze—the gaze of the photographer—has staged this double visage. The pictures duplicate themselves, and in doing so, retreat from the face that is their origin. As images they remain doppelgängers and give no unequivocal answers to the questions they pose.

This is also true for the directorial vision of a work in the series *Nox* (Night) from 1999 (fig. 85).[29] Here the hand of an invisible third party (the photographer himself) intrudes into the picture space from below. It holds a photograph before the mirror, between thumb and forefinger; the photograph shows the same face from a different angle. Light creates this reflective effect as it illuminates both faces from another side than it does the hand presenting the photograph within the photograph. For a moment it seems as if Molder had separated the photograph from the mirror and cut it out, but it is not the same picture, only the same face. But what does *face* mean here? Mirror and photograph possess different materiality and a different surface than the physical face that they are intended to convey. When we want to see our face, we can only do so in pictures, and there are countless different views in these. All the same, the face itself remains eternally elusive, as does the person shown on the face. Here we enter a labyrinth of the face where there is nothing but masks.

In Molder's work the mask has played another special role. For an installation in Santiago de Compostela and Madrid in 2006 he produced a double in the form of a dummy wearing an image of his own living face as a mask. A test photo taken during the work in progress shows him once in a photograph and once as a mask. His goal was to demonstrate the pose that he would assume in the finished work (fig. 86).[30] This situation is remarkable for two reasons. On the one hand, it brings together two portrait media, which had become separated from each other in the nineteenth century: the plaster cast and the photograph as replicas of the human being. It seems even more important to me that the alien nature of one's own face (which Molder senses in every one of his photos) appears to be stylized as a theme in the mask. The photograph of a mask, the mask of a mask, thus produces distance from the face in two different ways.

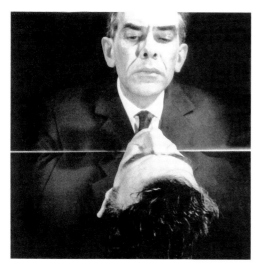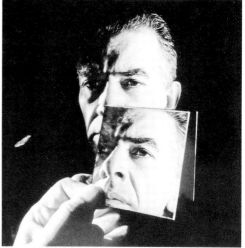

FIGURE 84 Jorge Molder, from the series *Anatomy and Boxing*, 1996–97 (photograph)

FIGURE 85 Jorge Molder, from the series *Nox*, 1999 (photograph)

FIGURE 86 Jorge Molder, working photo for the installation *Algún Tiempo Antes* 2006 (Santiago de Compostela)

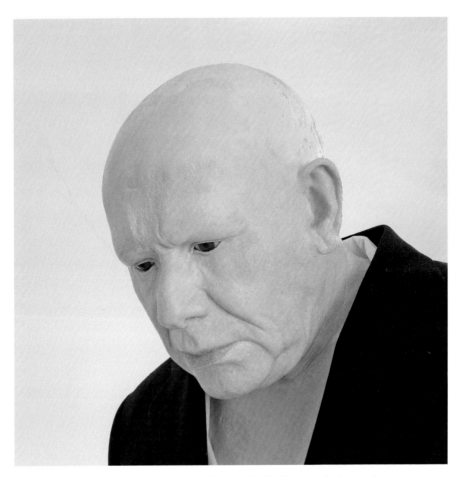

FIGURE 87 Jorge Molder, working photo for the production of his double as *Pinocchio* (2009–10)

It is not possible to provide a more detailed description of the installation *Algún Tiempo Antes* (*Some Time Before*) here. In it Molder appeared as fictional observer of the legendary defenestration that Yves Klein had simulated in a photomontage from 1960 as *Homme dans l'Espace* (Man in Space). Here Molder cast a backward glance into the abyss where his famous fellow artist found himself in freefall. Yet the secondary role that Molder played in this installation gave him the idea of playing the main role and of turning his double in the mask into the subject. For this he chose the prototypical figure of Pinocchio who tricked everybody with his antics in his double life as a wooden figure and a flesh and blood boy. Molder used a mannequin with real hair, which he constructed as a literal doppelgänger of himself. This time the whole work process was documented in a series of successive

photographs showing an astonishing transformation, the transformation of the living mask into a facsimile of the entire body. A paradoxical genre thus emerged, namely, the portrait of a mask (fig. 87). The photograph reproduced here shows a stage at which the finished modeled head is placed upon the mannequin still lacking its hair and clothing. Using photographic techniques that guide the viewer's gaze and accentuate the light source, Molder registers every pore in the skin, as well as the applied glass eye, so suggestively that at first glance one might think the head real.[31] Here the false portrait photograph intentionally crosses the boundary between face and mask thus representing a fluid border for Molder. When we look back at the series in which he appears with his own face, the ambiguity between face and mask—pushed to its limit in this photo—emerges as the artist's agenda.

Let us return to the portrait, which is the primary focus of this chapter. Here we have seen how the mask has generated bitter opposition to its inevitability. To fulfill this opposition, the face had to be distorted to the point of unrecognizability and the question of resemblance relegated to second place. The best example of this was the face liberated in Francis Bacon's work. In two photographic series from the 1990s, Molder announces in the title of his works that he had in mind the modern history of portraiture and, in particular, the example of Francis Bacon. First, we have the series *INOX* from the year 1995. The title refers to Bacon's series based on Velázquez's portrait of Pope Innocent X, the subject of his furious sequence of exaggerations and competing images. To do this Bacon worked with photographs—even refusing to view the original in Rome—in order to use these images to accomplish the dissolution of the painted mask.

Molder more or less reverses this process when he uses photography in his own series to set about liberating rigid facial form. How is this possible if the camera is constructed only to register the face objectively? Molder succeeds by outsmarting the camera with the play of light, which controls the mechanical apparatus. In the three photographs from the series *INOX*, Molder's face dissolves in a successive amplification of light, so that by the third photograph it fades out completely and can only blink helplessly (fig. 88 a–c). The same light that in the first photograph models the face against the black background (the central axis remains in shadow) destroys its form through the increased intensity of the brightness by the final photograph. Through this, the expression increasingly becomes the antagonist of physiognomy, although nothing in the picture moves. In his series Molder seems to take up a process that had earlier inspired Bacon to create a triptych. This is the *Three Studies of the Human Head* from 1953, which show the head dissolving from its solid form into pure expression, as if in cinematic sequence (see fig. 77). We are no longer talking about the papal portraits here, but still about Bacon, who presented a chal-

FIGURE 88 A–C (above and opposite) Jorge Molder, from the series *INOX*, triptych, 1995 (photograph)

lenge for Molder the photographer by provoking him to produce an answer that seems impossible using the tools of photography.

The series *T.V.* was created in 1995, at the same time that the series *INOX* appeared. This series uses a completely different method to approach the face, and yet in doing so it misses the mark more than ever.[32] The title alludes not only to TV as a medium but also to Pope Innocent X, to whom Molder attributes the utterance that Velázquez had made him look "all too lifelike" (*troppo vero*). In fact, it is said that the pope rejected the unpleasantly accurate portrait. It could also be said that Velázquez had peered more deeply beneath the official mask than the pontiff had wished him to. However, Molder sets about dissolving the boundaries of his own face by getting too close to it. At first one sees the whole head, but as light and shadow model him, he gains the upper hand over the physiognomy and subjects the face to a wild play of light and dark that leaves nothing in place. Only the eyes, which are also cloaked in shadow, gleam from the corners of their sclera, yet they do not reveal the gaze directed at us (?) or the camera (?) or at his own face, which presses right up against the picture plane (fig. 89). All one can see is a facial landscape, but not a face that one could assign to an individual. The extreme close-up goes so far that the face is out of focus and blurred. In other series Molder keeps his distance from the face, but here he subverts the distance demanded by the mechanism and loses the face again in *troppo vero*. To paraphrase Molder, this attack upon his own face does not prevent it from remaining an alien entity throughout all these approaches. When the camera deconstructs that mask, which can produce a por-

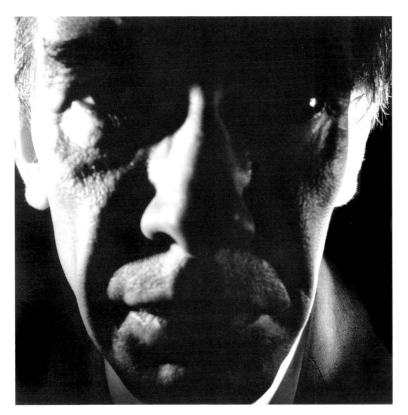

FIGURE 89 Jorge Molder, from the series *T.V.*, 1995 (photograph)

trait so easily, then it also fails to capture the face, which (we may conclude) can only be represented by the mask.

The photographs that Jorge Molder produced of his face in complete series and innovative configurations focus attention on the crises that have always been latent in portraiture. The portrait always promised to get to the core of the self but immediately created a sense of disappointment when that self eluded its grasp on the surface of the painting. Not even photography could escape the mask. Molder made this conclusion inevitable when he photographed his double with the mask of his own face.

III

MEDIA AND MASKS: The Production of Faces

15
THE CONSUMPTION OF MEDIA FACES

In this media age the history of the face evolves in a new way, for a media society incessantly consumes the faces it produces. These are artifacts that have advanced to the latest technological stage of image production and impress us with their speed. It could be said that media faces in the public realm have supplanted the natural face, which is rehearsed via the camera as a mask for its transmission to the screen. The media present the general audience with clichés of the face serving as public proxies for human beings. The digital revolution ultimately perfects the technique of replicating faces. This creates a synthetic face whose connection to a living body has been severed. The concept of the *cyberface* marks the rejection of true resemblance and likeness.

For a generation with a short memory, the pictorial history of the face seems to correspond with modern media history, which began with photography and film, continued with television and the Internet, and seems to have reached its temporary zenith with Facebook. Today's media deliver faces to consumers at a dizzying pace. The circulation of these faces in our global era crosses even cultural boundaries. Paradoxically, however, in this much-lamented flood of mass media images, nothing is more strikingly absent than the face itself. Its very overproduction guar-

antees a formulaic homogenization. French film critics have even observed the gradual disappearance of the truly human face, even in cinematic close-ups that focus on faces.

When one recounts the story of the face as a history of images, the question arises as to whether or not we are talking about the same thing nowadays, and whether this history is continuous despite ruptures. The "facial society" that Thomas Macho described compensates for the lack of authentic faces in public by providing a flood of images that substitute for, and compete with, the face. These are the *faces* that the American photo magazine *Life* heralded in 1937, the year it was founded. This boom in faces still dominates both the news and entertainment unchallenged. This boom in faces permits the consumer to be merely a passive observer because it actually produces nothing but masks. In the biological sciences as well, the individual face no longer seems to inspire questions that could restore the face's former significance. In this domain questions about the human species or human systems are directed specifically to the brain where science is not looking for clues to the individual person but to a physical organ. In the brain, however, there is very little to see that could correspond to the old conception of physiognomy and facial expression.

In a media society, faces follow the logic of politics and advertising. The mass media—a concept that states its purpose by its very label—deliver faces as commodities and weapons. By doing so this effect creates a hidden dialectic between the *prominent faces*, which are constantly being presented by the media and the *anonymous faces* of the crowd. The consumption of faces in the media feeds upon faces that have their origins in masks, in other words faces that have been "made." On the Internet, however, private consumption of faces is spreading at the same time. This involves people's posting their own faces for others to see, as though everyone were participating in an imaginary, perpetual party. In place of the old forms of public and private spheres, there has arisen a parallel world, a new version of the "society of the spectacle" (*société du spectacle*), which Guy Debord conceptualized a half century ago.

The individual face is nowadays no longer used as evidence that defies death, because death itself is taboo. While the private images of the dead still remind us of loss, the public dead continue to smile at us in the media from the moment of their deaths. Just prior to that moment, they had been raw material for the news, whose repertoire they constitute. Death did not transform them into masks, for they were already masks during life, stored in the databases of media firms and waiting to be downloaded. Once there, however, they can no longer be updated after death. They remain nothing more than archival images, from which life has departed.

This idea should be qualified. The natural face continues to be drawn from its living contours, as Roland Barthes expressed in his *Mythologies* (1957).[1] People fall too easily under the spell of discourses about the face and let themselves be guided by the dubious premise that we live in an age in which everything has changed. The belief prevails that any connection to the earlier history of the face has been severed—as though living faces had recently somehow been replaced by mere stereotypes. This argument results in the fallacy that public faces did not exist in historical times, while in truth they have most certainly always existed, ever since societies have used them to express their norms. After a period of unprecedented cultural change, fashionable discourses become entangled in contradictions to accommodate new theories and draw attention to themselves. We must remember this caveat when we view our media society as something that does not represent a complete break with the pictorial history of the face.

We can speak only about those faces circulating in the age of mass media when we speak about the media themselves. Their history may not actually have begun with the American print media of the last century; nonetheless, that is where we find the impetus for it. The pictorial magazine *Life*—which Henry R. Luce (also the publisher of *Time* magazine) brought to market on November 23, 1936—offers evidence for this. From the outset the editorial staff informed its readers that the pictures reproduced in its pages were meant to supersede the previous dominance of informative texts. To this end, on December 28, a month after the appearance of its first edition, the magazine published a column titled "Faces," which proclaimed the omnipresence of media visages. A secondary intention was to advertise the firm's own newsreels, which the publisher was preparing to launch as a new brand of cinematic journalism called "The March of Time."[2] The statement went on to say that one could see the continuous parade of old and new faces in the rhythm of each new year on the front pages of newspapers and on movie screens. These displayed "notable faces—notorious faces"—from Hitler's drooping forelock to Roosevelt's deep-set eyes. Even Mussolini and the Duke of Windsor appear in the same pictorial lineup (fig. 90). In order to reduce the essence of famous faces to a vivid metaphor, the magazine presented a faceless head onto which an infinite number of faces could be projected. This template resembles a shop window mannequin with its ever-changing costumes. It more or less embodies the faceless practice of the media, which act as a matrix for all the faces that vie for presence there. This infinitely available, but also all-devouring, media presence turns real faces into media faces. For this reason, the seemingly innocent-sounding commentary of the magazine is actually arguing for the medium's own system. The contemporary faces are all standardized—whether Roosevelt or Hitler, good or bad—as long as they stimu-

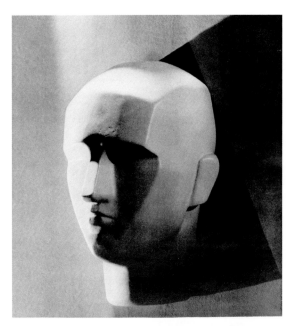

late controversy. The examples in the row below the anonymous model offer a tangible lesson demonstrating the paradox that the faces are interchangeable but also unmistakable—or at least they seem to be. The faces came and went, but the media remained.

The layout of the magazine conveys the impression that the news and its bonus of topicality are responsible when a medium (itself faceless) attracts ever-new faces to it—faces that continually displace one another as masks. One sees new faces in the same place and always in the same way. It is a remarkable coincidence that half a year later, on July 12, 1937, the cover of *Life* carried a portrait photograph of a shop window mannequin. "Grace, the Dummy" was exhibited by Saks Fifth Avenue as the first mannequin with a face (fig. 91), thus signaling the end of an era of headless forms in shop windows. The function of such dummies was to use the same face to model the newest fashions. The clothes are ever changing; the faces are not. The advertising copy for *Life*'s weekly magazine assured the reading public that in the future it would enjoy a *distinguished gallery* of political luminaries and promised that interesting new faces of emerging celebrities would be added in the new year.

In the age of Hollywood, it would be the movie stars who caught the fancy of the masses. A few months later, on November 8, 1937, *Life* paid tribute to this phenomenon when its cover showed a photograph of an actress (fig. 92). She sits enthroned before us in the pose of an idol surrounded by the aura of unapproachability. It is the "divine" Greta Garbo, the "recluse of Hollywood" who, the magazine reports, is planning to retreat from public life completely and return to Sweden. At the same time, Garbo presents herself in a starring role: she wears her historical costume as the Polish countess, Napoleon's mistress in the film *The Conquest* (1930), one of Hollywood's most expensive films. Something that might have been (and perhaps was) a single shot in the film has become a role through the change of

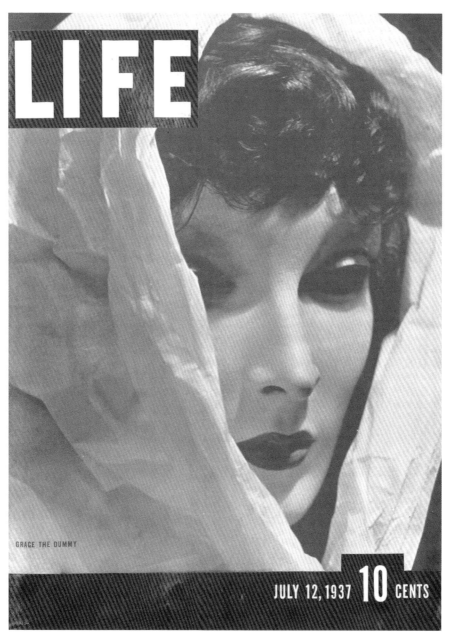

LIFE

GRACE THE DUMMY

JULY 12, 1937 10 CENTS

FIGURE 91 "The Mannequin 'Grace, the Dummy,'" cover of *Life*, July 12, 1937

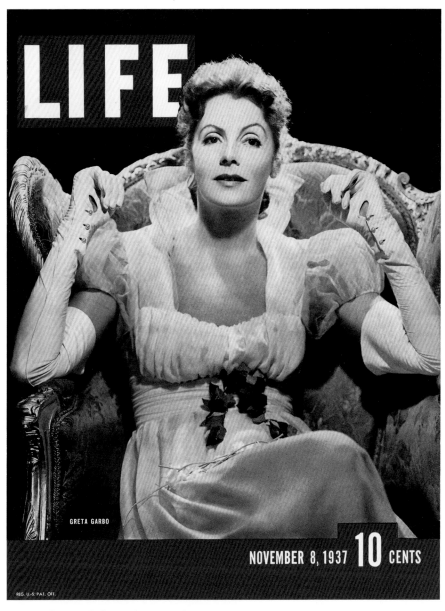

LIFE

GRETA GARBO

NOVEMBER 8, 1937 **10** CENTS

REG. U.-S. PAT. OFF.

FIGURE 92 "Greta Garbo," cover of *Life*, November 8, 1937

medium—a role in which Garbo plays herself as she displays the famous face that played different characters while she always remained herself. It is a trophy face. Even her smile is iconic. Here it is directed at nothing and no one in particular, but is simply a representation of her legendary face without any real corporeal presence.

After advertising itself with prominent faces in the column "Faces" on December 28, 1936, *Life* offered its readers a somewhat sanctimonious concession. The magazine assured them that everyday faces would be just as interesting as famous ones. They were considered an integral a part of current affairs and therefore worthy of being covered in the weekly review. The object was to rescue the faces of the masses at the other end of the scale from the darkness of their obscurity. This idealistic plan, however, was not destined to succeed. The magazine made the outwardly democratic offer to represent American society to itself and, by way of example, show workers from Fort Peck. The monopoly of the in-house photojournalists also seems to have been abandoned at this time. Thus, when the magazine invited readers to send in snapshots from their lives and to include their explanatory stories, this project failed because of the high photographic standards of the magazine. Professional quality trumped all other considerations. We can still notice a similar phenomenon today when people on the street are momentarily placed in front of the camera and asked their responses to a topical event, but only professional newscasters are actually allowed to present reports.

The topicality of the American pictorial magazine as a forum for prominent faces was soon imperiled by competition from television. In December 1972, confronted with live reporting on the Vietnam War, *Life* knew they had lost the competition and ceased publication. From the fall of 1963 on, TV news had been broadcasting images from portable movie cameras in half-hour intervals, thereby capturing the market of the weekly magazine *Life*, which up to then had enjoyed a readership of no fewer than thirty million people. *Life* tried to defend itself against the competition by invoking permanence as a strength of still photography. Television, it claimed, presented only the fleeting moment, whereas one could look at "the wonderful photographs in *Life* forever."[3] After the funeral of Winston Churchill in London in January 1965, *Life* chartered a DC 8 in order to develop the photographs for the Monday edition in a mobile darkroom on board during the eight-hour return flight to Chicago. But this effort was already a rearguard action. The digital age would make it possible to transmit pictures in any form and any condition in seconds, but that day had not yet dawned. Nonetheless, the print media—those labor-intensive archives of material—were being outstripped by faster, more up-to-date media technologies.

The production of public faces also changed as the rise of television displaced the cinema from its dominant position. Images were no longer limited to movies

and actors, but entered people's houses in all their authenticity showing public figures from the worlds of politics, economics, and glamour. They afforded access to people who would never have appeared in the movies yet were public in almost every other respect. The snapshot has since become both an opportunity and a risk of the new face consumerism, a phenomenon served by an infinite number of photojournalists who rush around the globe besieging every celebrity who has a well-known face. Live transmissions of speeches or gala parties are part of this phenomenon, yet communication with prominent faces on television remains a simulation and, in its transmission, is invisibly controlled by the techniques and rules of the media. When reporters stalk the studied façade of a prominent face in order to capture the real face behind it, they can only capture the stereotypical "smile for the camera." They constantly have to be on the lookout for that furtive surprise moment when the mask is lifted to reveal something new that the consumers of such images crave.

Prominent faces in the mass media no longer connect directly to the anonymous faces of the crowd that consumes them, at least they lack the kind of contact that we are used to with living actors in the theater who perform before our eyes. The face gains an abstract power through the image that replaces it. Rather than returning the gaze of the public on which it is calculated to have an effect, it remains unattainably self-referential and anonymous, just like the broadcast into the living room that constantly simulates a face-to-face encounter. The mimetic impulse thus encounters a void in the masses. It is projected solely onto public masks behind which their wearers disappear. The media presence is always the product of representation. As such, it replaces the ritual presence of the past in which a representative appeared in public physically. Faces now remain in their "distant presence," blind to their public, as Thomas Macho has written.[4] It is essential to the nature of an icon that it draws all gazes to itself and yet returns none of them. The icon has always functioned in an asymmetrical relationship that has made it unattainable to its viewer. Technical advances in television broadcasting produced a new kind of asymmetry. In the media a face lacks fixed defining criteria, just like the faces of the masses, onto whose television screens it is broadcast.

The faces of those in power in authoritarian regimes appear in gigantic formats made possible by modern printing techniques. These can be seen everywhere on the walls of public spaces. Political authority is exerted through the power of images that no one on the streets can avoid. All the faces of the crowd submit to a single face as they pass it. The authoritarian presence is expressed symbolically through the presence of the image. A face that pedestrians experience every day in the print or television media reappears in a public place, on the street, as a colossal mask.

FIGURE 93 Demonstrator in front of a poster of Hosni Mubarak, Cairo, January 2011

Such enormous posters are often the first target to be attacked when people revolt and proclaim a regime change. Iconoclastic acts like this were formerly directed at cult images in churches or at the statues of a leader. Even today they reveal their powerlessness when the pictures that demonstrated supreme authority are destroyed. As a case in point, in January 2011, demonstrators tore down pictures of the tyrant Hosni Mubarak during the Egyptian Revolution—pictures that were suddenly revealed as nothing more than printed paper that could be peeled from walls (fig. 93). A newspaper photograph taken at the time vividly exemplifies the fiction as well as the huge format of the public face; although the image resembles a face, it is really no longer a face.[5]

When we look back on the history of media faces, the significance of modern reproduction media becomes obvious. The public prevalence of faces had its fore-runner in photography, the medium that satisfied the universal desire and the universal capacity to see oneself in pictures. The production of pictures of the face was made possible by the availability of this technology to all. Since then "no one will ever again live pictureless and no one will live faceless," as Ulrich Raulff writes.[6] By this means, however, the masses do not receive a face, but rather resort to the private snapshot capturing a random moment and an arbitrary view. In the nineteenth century, by contrast, official photography held its ground as a new medium of self-

representation in civil life. It distanced itself from the masses and represented one's social position with its attendant standards. Photographers were needed, professionals who could build special stages and scenery in their studios for their clients in order to create the socially appropriate setting. Other photographers did not come to the fore until later when it was possible to take one's own picture in the Kodak era. In the early days of photography, however, there were arguments about the photographic "authenticity" of a face that only awakens to life through its innate expressivity, while this aspect is frozen in reproduction.

For a long time, the production of prominent faces relied on varieties of print media that lacked the printing technology appropriate for photography. In the 1840s in New York and Washington, DC, Mathew B. Brady, a pioneer of American photography, established a "gallery of illustrious Americans" meant to be displayed in an exhibition. The publication of these photos in *Harper's Weekly* was not possible until the development of wood engraving, as photomechanical printing was not invented until much later. In November 1860, the title page of the magazine carried the portrait of Abraham Lincoln that was engraved after the Brady photograph from the exhibition (fig. 94).[7] In its role of popularizing official photographs, the magazine had a complementary relationship to Brady's exhibition. To be photographed by Brady represented a stamp of approval for prominent people in the young republic. The "distinguished Americans" achieved public presence through the medium in which their faces were published, and American society was meant to see itself reflected in the faces of its "most eminent citizens." Their presentation as moral examples ensured their prominence in the democratic ferment of these years.[8] Nowadays prominence is played out exclusively in the media and created outside the value system of social hierarchies.

After World War I spelled the end of traditional social structures, August Sander developed an innovative project in which he showed human beings as representatives of their professions and class. As we noted earlier, he depicted them as social types in full-length views that showed their social or professional activities—at their desks and on construction sites. In this project all social classes, even those formerly excluded, were presented in official photographs, each according to its own norm. In Sander's famous collection we can clearly see the contradictions in society that had long been denied. The project was conceived as a protest against bourgeois portraiture. In his introduction to Sander's album, Alfred Döblin criticized the "homogenization of faces by human society" expressed in the photographs.[9] He saw this as a cultural shift toward a "second anonymity" in which the individual face and the character study of the previous bourgeois era had played themselves out. Walter Benjamin was excited by the fact that the human face was

HARPER'S WEEKLY.

A JOURNAL OF CIVILIZATION

VOL. IV.—No. 202.] NEW YORK, SATURDAY, NOVEMBER 10, 1860. [PRICE FIVE CENTS.

Entered according to Act of Congress, in the Year 1860, by Harper & Brothers, in the Clerk's Office of the District Court for the Southern District of New York.

HON. ABRAHAM LINCOLN, BORN IN KENTUCKY, FEBRUARY 12, 1860.—[PHOTOGRAPHED BY BRADY.]

FIGURE 94 Mathew B. Brady, *Portrait of Abraham Lincoln*, cover of *Harper's Weekly*, November 10, 1860

185

no longer defined by the traditional portrait but instead only "reflected the existing social order." With this in mind he commended Sander's book as a kind of pictorial atlas that allowed people of the modern democratic world to practice recognizing themselves. He also tried to understand the role of film in the same way and thought the image of Soviet society in Eisenstein's films exemplary.[10]

Little was said of other mass media—specifically, magazine culture—in this modern period. Magazines compensated for the loss of face in the portrait by offering a cult of the face of contemporary idols. As Hollywood imports to Europe, these were either welcomed or criticized. These idols appeared as a sign of a new public sphere made up of media like print or film. Regardless of national or political boundaries, such prominent faces now came into circulation exclusively via the media. They transported a society that was no longer sure of its own identity into the intoxication of an imaginary world where, significantly, actors dominated—actors who created a general type with their own faces, a type that seemed to promise the illusion of a society without barriers. The media that supplied these fantasies produced icons that were pervasively abstract, in which everyone could recognize himself and be someone who knew the people everybody else knew.

For a long time, film set the pioneering standard among these media. In film a single face on the movie screen in close-up can represent the anonymous public, which disappears into the darkness with its many faces. The close-up dangled face-to-face contact before the viewer and initially threw "the masses into great confusion" because, according to Roland Barthes, they experienced the "total mask" simultaneously with a feeling of deepest intimacy.[11] Gilles Deleuze called these "affection-images" because, as simple bearers of expression, they separate pure expression from a face. A close-up "is the face"[12]—and yet it is simultaneously the absolute contradiction of the face, which in the cinematic medium remains locked in illusion by the fact that it cannot come "close" to us. Prominent faces in film are as imaginary as the medium they serve. These are movie actors who have lost their luster today in the era of television.

Nowadays politicians and pop stars have robbed such icons of their status, for they appear physically before the public and not in movies. These new stars are concerned about an image that no longer has a script. In the breathless struggle for attention they all need consultants to help them control their image. The American pop star Michael Jackson went beyond mere media presence by repeatedly having his own face operated on to transform it into the desired media face for his performances in front of mostly white audiences. He surrendered his face to surgeons because, when performing before his public, he wanted to wear a life mask. The mourning at his death in 2009 was directed primarily at the farewell to a face that

had been internalized and remained omnipresent, even though Jackson's appearance kept changing during his life.

The politicians and musical celebrities we can encounter live at public events play very different roles from those created by public images. The "mimetic impulse" is also similarly structured. The masses are hungry for idealized projections of images originally embodied by divas and rock stars but today are claimed by other idols. This means that they seek contact with faces as though these were people like themselves. American fan mail, which in the 1950s used to inundate television studios, had a modest start in the early days of television. But even then it was motivated by the urge to elicit a response from the empty gaze, which people vainly wished to direct toward themselves. After this naive desire had been disappointed, there arose—in place of the anonymous and unrequited homage—the desire for a physical embodiment that could walk around as a living double. Consequently, cosmetic surgery became the radical fulfillment of the mimetic impulse formerly served by fan mail. By having one's own features operated on, one aspires to possess a celebrity face. In the United States, television popularizes these desirable faces, ultimately turning the cameras around to film the facial victimization of the fans. In 2004 a program was broadcast called "I Want a Famous Face," which brought the viewing public so close to the surgery that it was like having one's own wishes fulfilled in the process.[13] Those who undergo the operation want to do more than just emulate their role models; they also want to adopt a celebrity face because they no longer value their own. Only a resemblance to their idol holds the promise that their face will be noticed in the crowd. Because people identify only with a media face and not with a real person, the exchange of faces (in contrast to an exchange of gazes) is a natural consequence in this ritual consumption of the face. We find here a grotesque extension of the former custom of wearing a man-made mask. Nowadays people prefer to wear a mask their whole lives rather than make do with the face they were born with when that loses its appeal.

The mimetic impulse is not just a matter of the modern age. The tyranny of the face exerted by the mass media produces a new inevitability. The cult of faces, which both dominates and unites the masses, becomes so powerful through this attraction that we are no longer talking about the real faces of the bearers, but of masks that they wear in the media. Real faces stand no chance against the power of such masks. This is shown by the fact that they cannot return a gaze, for they are not truly gazed at. In earlier times society was divided into those who wore a ritual face and the others before whom they appeared when they wore this face. But such ritual was played out in real space, such as a municipal square or a hall where both sides—the prominent face and the many faces of the public—were physically present. Today we are

dealing with a symbolic presence instead, which is relegated to the screen where it creates a pseudo-proximity that is actually an anonymous experience. The whole question of the image has changed radically thanks to this perception via machine.

Living viewers and their technological images are incommensurate by definition. They are also incommensurate in a different way than the relations of ancient masks were to their public with their rigid power of expression and ceremonial authority. Nowadays a media mask is not merely the photograph of a face, but rather a cinematic picture from the stream of life that records the voice and ever-changing facial expressions. It thus presents an experience of immediacy, although it comes to us from a mediated distance. This was once the privilege of the close-up in the movie theater. In the age of television, however, it has become a common model in which a face always dominates, as it expresses everything we expect while also expanding language with its expression. The success of faces lies in the fact that, although we know them only as images, we understand them as faces. As with a real face, the expression in one of these media faces changes with apparent spontaneity, and yet this is quite calculated, because expressions are premeditated for effect. Of course we know that these masks/faces are staged by the mass media, yet we have become so accustomed to this orchestration that we no longer perceive the medium. We believe that because we know the media face so well, we also know the person. It is only for this reason that a media face seems so alive, because it can no longer be separated from the person we perceive as a face.

The face of the movie star Marilyn Monroe is recognized by people who have never seen her on film. Her face deserves closer attention because it is still considered the essence of eroticism today. In the meantime, it has been impersonated by living actresses who play the myth of Marilyn as a movie role as they copy her example. Hers is a ubiquitous face that has long since been transported into the aura of collective memory and become abstracted from the woman who bore the face in life. It also recalls memories of the past age of the great film stars when Marilyn won her unprecedented fame. Her face is enveloped by the cult of an immutable icon unlike other modern faces in the media. In our context it has a special place because it has provided artists with subject matter they have used to analyze not only media faces but the media per se.

Andy Warhol took the lead when he not only exposed Marilyn's pop star essence but simultaneously put the commercial art gallery scene into competition with the mass media by using a pop idol who met the criteria of commercial advertising. When Marilyn was found dead in her house in Los Angeles in August 1962, Warhol responded to the shock the public showed in the same way that the news did. The whole world mourned a face that no longer belonged to a living person but was now

FIGURE 95 Andy Warhol's preparation of a publicity still of Marilyn Monroe for the film *Niagara* (1953), 1962 (Pittsburgh, Archives of the Andy Warhol Museum). © 2016 The Andy Warhol Foundation for the Visual Arts, Inc. / Artists Rights Society (ARS), New York

relegated to our memory. The death of the movie star seemed to transform her face into a death mask, but that cannot exist in the media any more than real life can. A media face cannot die, because death can only belong to the reality of a body.

Warhol's *Marilyn* series does not really recall a living Marilyn because Marilyn herself had portrayed Marilyn while she was alive. Each example in the series shows a different number of faces in order to demonstrate the arbitrarily extendable character of the series itself. A work could be purchased from the artist as a sheet of images or as an individual canvas. One could buy a double face, a so-called six pack, or a series of twenty. It is interesting to note which version Warhol chose when he began his mass production of Marilyn faces. It was the seductive black-and-white publicity still used to advertise the 1953 film *Niagara*, which was Marilyn's breakthrough (fig. 95). The actress's torso was trimmed from the picture so that only the face remained, letting its character emerge as an eye-catching mask.[14] We cannot see the disembodied face without perceiving the media mask that Warhol has constructed: a mask outside of space and time as only the media can produce. The silkscreen technique lends itself to the use of a preexisting stereotype in order to transfer it to another stereotype. Warhol described the process as follows: "You pick a photograph, blow it up, transfer it in glue onto silk, and then roll ink across it so the ink goes through the silk but not through the glue. That way you get the same image, slightly different each time."[15] This mechanical method of mass production, with reference to print media, now found its way into the world of art exhibitions.

FIGURE 96 Andy Warhol, *Two Marilyns*, 1962 (private collection). © 2016 The Andy Warhol Foundation for the Visual Arts, Inc. / Artists Rights Society (ARS), New York

Two Marilyns (1962), a silk screen with pencil on canvas, is an example of one of the many serial portraits Warhol made of Marilyn that used the studio still instead of her real face as a model (fig. 96).[16] Both heads, which overlap each other at the seam (emphasizing the serial character of the work) are signed by the artist, and the whole piece carries a dedication to the buyer. The vertical arrangement is reminiscent of the individual frames of a strip of film, which are set into motion when they run through a projector. Like the other silk screens by Warhol these "Marilyns" are not differentiated by the person they represent, if one can still speak of such a person, but rather by their means of production, which leave visible traces. The smudged contours and bright colors of other works by Warhol show surfaces that could only have been produced by the medium. This strategy exposes the properties of those surfaces we are so willing to mistake for faces in the media. "If you want to know all about Andy Warhol, just look at the surface: of my paintings, my films, and me, and there I am. There is nothing behind it."[17] The media produce surfaces on which faces come and go, isolated from any kind of physicality. Warhol's plan to compete with the media was successful. The exhibition at the Stable Gallery in New York, where the new "Marilyns" were shown in 1962 for the first time, was an instant hit. Even the Museum of Modern Art purchased one of the "Marilyns" in order to keep up with the new pace of art.

About ten years later Warhol began his Mao series, which was also produced in different numbers, sizes, and colors. As Victor Stoichita notes about Warhol's approach to Marilyn, "The star is both being and appearance, a living person and a phantom. She is never 'herself'; she is never 'one,' but can only be experienced as a replica, which eradicates difference between original and copy."[18] Even in the media the public presence of a face is created by the frequency with which it is seen. The prominent face is faceless in a different way than faces are in a crowd, for since the mask conceals nothing, it is a mask behind which one no longer looks for a real face. Instead, it shows us what we already know.

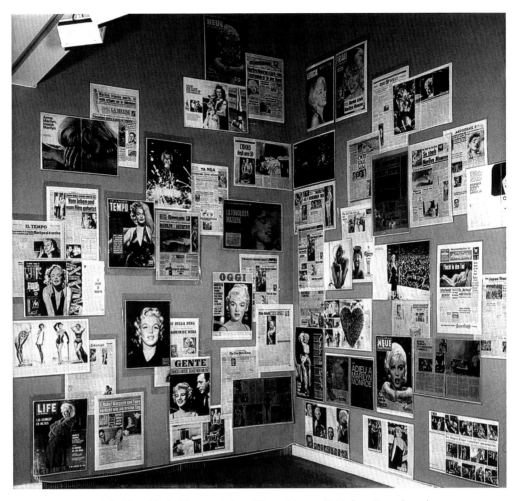

FIGURE 97 Nam June Paik, *Adieu à Marilyn Monroe*, 1962/1999 (Vienna, Museum für Moderne Kunst, formerly Sammlung Hahn)

In the year of Marilyn's death, 1962, the video artist Nam June Paik dedicated a work to the movie star that has been neglected. Paik's installation is, by its very ephemeral character, fundamentally different from Warhol's printed editions (we shall apply this term to them in general). What we can generally expect from an installation is an assemblage of material subordinated to an overarching idea, which then reveals the content in a new light. That was precisely what Paik did when he collected all available front pages from newspapers and magazines that announced the film star's death. He titled the piece *Adieu à Marilyn Monroe* (fig. 97).[19] Topical products of the mass media were used here. These had made headlines with reproductions of one and

the same face but each time with quite a different view and a completely different situation, from movie still to snapshot or photojournalistic coverage of Marilyn's death.

This approach raised completely new questions. With Paik we are not dealing with the same image, and certainly not with a rigid face isolated from context as in Warhol's work. Rather we are dealing with such different, intimate, or scandalous pictures that the identity of the face is no longer immediately apparent. On the one hand, a laughing, seductive diva gazes at us, and on the other, she is conversing with Arthur Miller or attending a formal event. In addition to movie stills, there are snapshots from Monroe's life whose past has become an absolute barrier in death. All the texts are written in the past tense, through which they contradict the present captured in the images (if we wish to distinguish these from the continuous present of the images themselves). We thus read words such as: "That was Marilyn Monroe," or "She Died Alone." As several of the comments explain, the laughing face concealed an escape into death.

An updated version of Paik's work, titled *Recollection of the Twentieth Century* (1999), includes a cabinet containing old records and a record player. Essentially, visitors to the exhibition are intended to give in to the temptation to play the records since they no longer own a record player at home. This shifts the entire message. The images in the print media prove to be obsolete relics of the twentieth century. They preserve the face just as records preserve the voice. But they were already preserved when they were published a few days after Marilyn's death. Most of the images, if not taken from contemporary journalism, come from the archives of each magazine. The question that was asked by the first version of Paik's installation thus crops up again. In each case it is not the same image that is shown several times, yet we recognize the same face in each picture, despite its difference. Countless images of the movie star circulated throughout the media, capturing the famous face again in the same way that it had inscribed itself into collective memory—although the individual images were very different from one another. What we have is an image in our imagination, a picture that has become stamped upon our memories; it cannot be reproduced, but it can be projected onto the reproductions of the movie star's image by the viewer. During Marilyn's lifetime these pictures were as changeable as the media through which the *face* drifted. But it had long since entered the collective imagination.

16
ARCHIVES: Controlling the Faces of the Crowd

So-called archives for the collection and registration of faces by bureaucracies have existed since the nineteenth century and in a way offset the faces of prominent citizens. These archives were established to gather statistical information about the

anonymous masses. In them photography was forced upon faces that feared this technology and preferred to escape the eyes of the authorities. Government agencies wanted to protect themselves from the faceless threat of criminals, over whom they had lost control in the big cities. This helps explain the feverish activity devoted to developing methods to monitor the face. To this end an archive of faces was established, and bureaucrats used it to analyze individual examples statistically. It fell to photography to secure an inventory of faces.[1] The goal of this kind of surveillance was to register all those anonymous faces that disappear so easily into the crowd. It was also meant to prevent criminals from eluding the police by changing their appearance. It was hoped that a pictorial archive would offer the authorities reliable access to criminals and their activity. Such archives were not created to bring new insights about individuality. On the contrary, this statistical method was aimed solely at those characteristics that made a body available for official purposes.

The masses first appear as a phenomenon during the French Revolution. In Paris the chronicler of this phenomenon was Louis-Sébastien Mercier, who profoundly wished he possessed the physiognomic skills of a Lavater, to "read in faces that which they conceal in the depths of their hearts."[2] He strove, albeit in vain, to detect faces that remained identifiable "in the midst of such an immense crowd."[3] He concluded with resignation that physiognomy was no longer determined by an individual but by a person's class. Mercier's contemporary, Diderot, was also fascinated by the adversarial relationship of classes in a society that seemed impenetrable at the time. He held contradictory feelings about "the people," whose faces he considered more authentic than the masks at court. And despite—or perhaps because of—this, he feared the ungoverned and ungovernable populace that could stir up dangers still latent in the masses.[4] The anonymity of the masses intensified in the urban centers of the nineteenth century, and the threat increased for the authorities. Edgar Allan Poe first described these fears in his tale "The Man in the Crowd," a predecessor of detective fiction. Here the protagonist disappears into the crowd where his face becomes unreadable. It was not possible to connect a face with a specific person unless one could stalk a shadowy figure through the alleys where he would try to change his appearance and become unrecognizable. Painters, not photographers, had taken the French capital as their subject from the 1860s onward. Édouard Manet, who wandered through the city like a reporter, embodied Baudelaire's type of the flaneur and depicted modern Paris in crowd scenes that submerge individual faces. This could happen in the garden cafés, at the horse races, or at the Opera Ball. This urban scene also repeats itself in Boulogne on the beach at the Folkestone Ferry landing (fig. 98).[5] In each case the paintings leave a general impression when the gaze skims the anonymous heads of the crowd and registers only the clothing of the Parisians.

FIGURE 98 Recognizing a person's character in his face. Édouard Manet, *The Departure of the Folkestone Steamer,* *1868* (Winterthur, Sammlung Oskar Reinhart "Am Römerholz")

Adolphe Quetelet, a founder of the discipline of sociology, wrote about the populace of the big city in his major work, *Sur l'Homme* (1835), where he noted "individual traits disappear, whether they relate to the physical or character type." He found instead that "general facts, which make up a society, come to the fore."[6] Social statistics were meant to help him make statements about the new types emerging in society. With such quantifiable data he hoped to gain insight into a social identity that supplanted personal identity. The *homme moyen*—as Quetelet called the "normal" citizen—was the new ideal, for it was his role to provide moral stability for society.[7] In the nineteenth century the pressure for normalcy had increased to such an extent that the elimination of the *criminal body* was seen as the key task to keep society pure. For a while physiognomic interest concentrated on the faces of criminals, in which people thought they could detect the degeneration of civic ideals. But this argument produced new and unwelcome problems. The discussion culminated in the question of whether individuals were born with criminal tendencies. If that were true, it would mean that they would have to be apprehended before they first committed a crime. The congenitally criminal face as the object of the search soon proved to be an illusion, and with this realization the last hope of ever reliably attributing character to the face disappeared.

Although faces of future media celebrities would be later disembodied in order to become ubiquitous, authorities began their hunt for hidden faces among the

masses in order to expose them as bodies.[8] The anonymous faces of the masses seemed to call for the creation of an archive in which everyone was registered with a number and an official stamp. Outside the context of the archive, faces had already become masks that embodied types. Yet within the archive they were again reduced to masks, because there they existed solely as standards of measurement. This new archival material soon created the temptation to read variations in cranial dimensions and facial characteristics as deviations from moral and ethical norms. Society sought evidence of degeneracy in these measurements.

It is well known that the personal identity card has a longer history than the passport photograph. Its origins lie in the late Middle Ages, yet for a long time it was based on nothing more than unreliable descriptions of a person identified as little more than belonging to a general type.[9] It was not until the nineteenth century and its new techniques of mass-produced images that pictures became the standard. In 1882 Alphonse Bertillon founded a section within the Paris Police Prefecture to introduce photography into the archive. Here he inaugurated the *Signalement*, calling it the "description of a person for the purpose of recognition."[10] This description relied on body measurements and fixed characteristics. Bertillon also contrasted profiles with frontal images. The profile view was intended to eliminate changeability of expression as well as those alterations produced by the aging process. A catalog of images was accompanied by explanatory terminology to describe the "general form of the head or profile." The various forms of ears were cataloged with equal meticulousness.[11] The uniform format of this documentation made it possible to compare relevant personal files. Details mattered in registering and describing a person, because these revealed the deviations from the norm upon which the system was based.

The *photographie signalétique* was a standardized image used as part of a standardized description. By the same token the *portrait parlé* was not a "speaking portrait" (if one can even speak of such portraits) but rather an image that fit a personal description. By using *inscription*, physical attributes such as bone structure (the correlation of chin, nose, and forehead) could be expressed in words. This simplified the identification of an individual in the deluge of archival data. As Bertillon worked out his system of taxonomy to make a person identifiable, he struggled for years to get financial backing for his project. He argued, "It takes only two pairs of policemen every morning between 9:00 and 12:00 to measure up to 150 men who were arrested the night before."[12] In ten years Bertillon collected 100,000 photographs, yet what use are they when a hundred new people are arrested every day? The opaque masses could not be duplicated in the archive if it was to be of any use. To help the police, officers were equipped with pages of data when they began their duties each morning. The identification data they carried with them on their beat

when they did their profiling consisted of photos and measurements that complemented the images; these were adjusted where necessary (fig. 99).[13] The page included body measurements, descriptions of the profile (such as "flat occiput") and facial forms (such as prominent cheekbones), in addition to details of clothing and general health and body type. When folded, this standardized sheet with its photograph could easily be carried in the pocket. This process was no longer an "anthropometry" in the old sense of ideal measurements of the human body, but rather a collection of data based on scientific principles for use in the archive. By this process the face that appeared in the crowd became merely a statistic.

Even when photographs of faces are archived they still prove to be untrustworthy as legal evidence. This explains the curve that graphs the rise and fall of photography as an archival tool in the nineteenth century. As early as 1877 French authorities decided that photography could no longer be relied upon in court as evidence to identify individuals. The same regulation states that new methods must be found that are "cheaper and more reliable." The "indexicality" or validity of clues revealed in photography in the archive was a failure because it could not fulfill its promise of the archive. Faces did not conclusively reveal the identity of a person who was capable of changing his facial expression. Pictures were deceptive because they could not record this transformation. They could only capture differences in a person's looks. Alphonse Bertillon had to admit that the similarity of the images among the photographs that the police were using often allowed no conclusions about the identity of individuals (fig. 100). There was such a thing as a "national resemblance (Gypsies)" or a "family resemblance (twin brothers)." On the other hand images sometimes represented one and the same person "despite significant dissimilarity" between them, especially when that person had intentionally changed his appearance, for example, with or without a beard, or unintentionally due to a longer passage of time (see fig. 101).[14] Photography was certainly

FIGURE 100 Alphonse Bertillon, *Nonidentity of Persons Despite the Resemblance of Their Photographs*, from *Das Anthropometrische Signalement*, 1895

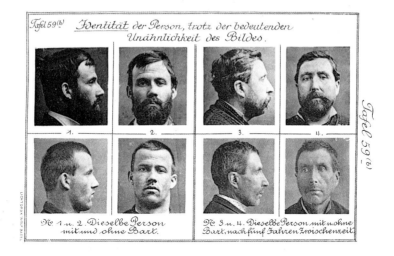

FIGURE 101 Alphonse Bertillon, *Identity of the Person Despite Significant Lack of Resemblance in the Photograph*, from *Das Anthropometrische Signalement*, 1895

more reliable than other images had been. For that reason, the actual or apparent resemblance no longer seemed to be a problem with the images. The problem began with the face. Images could not be any more reliable than the faces themselves when it was so difficult to assign them to a specific person. In the field of statistics, photography was gradually devalued. That decline reached its logical end with Francis Galton's breakthrough in the science of fingerprinting in 1893. In the colonies of the Far East, William J. Herschel had become familiar with Chinese precursors of this technique in the form of the art of "finger examination," which was easily adopted in Paris as an official tool. In Great Britain, however, the procedure provoked general outrage, because it threatened a traditional view of man that had always been associated with the face.[15] Identity was now perceived via patterns in the skin of the finger, rather than in the face. A nondescript detail of the body robbed the face of its representational power. In his *Composite Portraiture*, Francis Galton originally wanted to trace the constant features of a face by means of multiple exposures, but he gave up the project in disappointment in view of the ordinariness of the faces.[16] Bertillon's system no longer made it possible to maintain the old belief in the truth and expressivity of the face. In the process of taking inventory of a face to be assigned to an individual, the face proved to be a barely penetrable mask.

Fingerprinting has now been supplanted by procedures like iris scans, which have made passports forgery-proof since 2010. A beam of light reads the pattern of the iris and compares the result with an archive containing almost infinite data. The body part in question has gone from the fingertip back to the face, but without recourse to individual expression. The face, moreover, has once again become the locus for useful data, albeit concealed microdata, and its surface can be accessed electronically. The face as the only mirror of identity has become abstract and numerical, even when it serves merely as a storehouse of information. The self-evidence of a portrait has furthermore diminished since we have learned to control and manipulate faces on a screen. Our visual perception of a face is no longer relevant for the official recognition of a person's identity.

By now the science of biometrics exerts total control over the face in a way similar to video surveillance, as that technology records the comings and goings of the masses in public as images.[17] The procedure of automatic facial recognition (AFR) assesses the significance of individual facial features (lips, nose, and eyes) to achieve an accurate identification. To accomplish this, the face must be transferred to a flat plane to reveal the desired information. Furthermore, it is necessary to normalize the facial surface. In addition, mapping must be added to the procedure for automatic facial recognition. Here the system decides with a *yes* or *no* answer whether or not a face belongs to the name that has been entered. This requires the system to

examine a face for the best match, confirming the name of the bearer (fig. 102).[18] Basically, the system can only answer whether or not a certain face is stored in the database and coupled with a particular name. Its function proves useful only when it subverts the pictorial character of the face and stores only those inconspicuous but informative details that cannot be changed except by surgery—a process whose growing significance threatens the system.

Under these conditions face and mask enter into a new relationship. Faces that are saved in the archive only as statistical quantities are inevitably transformed into masks in such isolation. They reveal their absent bearers only with the help of an electronic pro-

FIGURE 102 Diagram of facial identification, from Montonori Doi et al., *Lock-Control System Using Face Identification*, 1997

cess that runs the whole system. This process focuses on tiny exterior details with no expressive value. It is those details that we would never notice in a person that receive the greatest emphasis in the data collection. As a bearer of data, then, the face has become just as abstract as the data the system downloads. This tallies with a reevaluation of the images, which serve only to visualize those data of a face that have been stored in memory. In this process the face loses the central significance it possessed as an image or an image carrier in the past.

In times of crisis the mass media register signs of resistance to the archive, with its statistical indifference to the fate of individuals. Nothing triggers criticism like numerical reporting about death. On June 27, 1969, *Life* magazine made a statement of resistance against the US government's Vietnam policy in light of the many deaths the war had claimed every week (fig. 103). On Memorial Day the magazine published the names and photographs of 242 Americans who had fallen in a single week. On the cover a young face looks out at the passive public with an expression of questioning and challenge, as if finally demanding an explanation for its death. "The Faces of the American Dead in Vietnam: One Week's Toll," as the headline read, was a general call to protest. The magazine contained 242 passport photographs that for the most part had come from the families of the dead soldiers. These were accompanied by the challenge not to view these dead as statistics. "We must pause

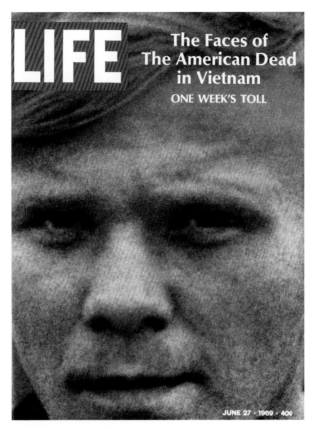

FIGURE 103 "The Faces of the Dead in Vietnam: One Week's Toll." Cover of
Life, June 27, 1969

to look into the faces. More than we must know *how many*, we must know *who*. The
faces of one week's dead, unknown but to families and friends, are suddenly identi-
fiable in this gallery of young American eyes."[19] Every individual face in this gallery,
which ostensibly uses the format of an archive, carries an accusation against the
politicians responsible. Although the faces in the grid seem uniform, in this context
they are powerfully expressive.

At the time, the archive under discussion also found resonance in the art scene.
Since the 1970s the archive as a topic has taken center stage in the work of the French
artist Christian Boltanski. In his case one can speak of a veritable counterarchive,
with which Boltanski's installations simulate archives as images of the dead whose
anonymous faces resist identification.[20] The project completely reverses the concept
of the archive. An archive usually functions to aid in profiling the living, but with
memories of Auschwitz kindled by Boltanski's photographs of Jewish schoolchildren,
or the collection of articles of used clothing, our view is altered. We cast a glance of

remembrance at the pictures of the dead, a glance that is not documentary but personal in nature. In this case completely different traditions of the image emerge. In some countries cemeteries are places of remembrance filled with images of faces on the gravestones. The connection with the grave imbues these pictures with their ultimate finality and connects them to a name and a place. Although they show snapshots of the dead taken in life, these memorial photos continue the tradition of the death mask. An archive of nameless pictures lacking both graves and identification points to the terrible anonymity that befell the victims of mass extermination.

Boltanski expands his subject matter through a general reflection about images that are already used or have faded. They show an indistinct face that has been separated from its bearer, thereby changing the viewer's perception. Because the images no longer serve to recall individuals, the people represented have begun their retreat into lost time—the timelessness of death. The faces have been transported into an absence that bestows upon them their own aura and alien existence. The photographs, which Boltanski repeats in ever-changing formats, seem to refer to masks, yet they also gives the impression that unmistakable faces exist in these masses, even though we know nothing about them and cannot differentiate them among the blurry images. Although society honors only its prominent dead, Boltanski restores a certain melancholy presence to the anonymous faces, a presence that is intensified by the lamps that hang above the photographs and in the narrow, darkened rooms where we view them.

An example for the staging of a death ritual is the installation with photographs of faces of a class of Jewish children from the Lycée Chase in Vienna, which Boltanski exhibited in Düsseldorf in 1987 (fig. 104). In the installation, oversized photographs are placed on two stacks of cookie tins that remind the viewer of small coffins or urns. It is as though the artist wanted give the children back that place that has been denied them. In the photographs they seem to smile into the void of oblivion.[21] The borders between loss and presence are always shifting in his artistic project. Each image is ultimately futile and yet meaningful. The work of time removes the faces from any statistical grasp. Boltanski consistently reminds us of the archive, which the dead have already escaped. It is not control that determines this antiarchive, but rather the privilege of a common place of memory. Boltanski sometimes mixes such images with pictures of living persons, though the difference is not discernable. But the day may come when "only the photograph or the name remains."[22] To the collection of photographs of children from Dijon, Boltanski has added commentary stating that they are all "alive in the photographs, and yet one gets the feeling that they are dead children. But that is not so. They are simply no longer there. The way they are in the photographs is not the way they exist anymore."[23]

FIGURE 104 Christian Boltanski, *Children from the Lycée Chase, Vienna*, 1987, (Installation Düsseldorf Kunstverein). © 2016 Artists Rights Society (ARS), New York / ADAGP, Paris

In Boltanski's oeuvre there is special significance in the inventory of the *Suisse Morts* (a pseudo-archive of more than one thousand Swiss dead).[24] This comprises pictures of dead people cut out of regional newspapers throughout the year 1990. The artist once said in an interview that the Swiss embody the "cliché of being orderly and happy people. I chose the Swiss because they are least suited to an image of death. Incidentally, the people in these photos are not dead. The point is that these photographs are of clean, healthy people, who are doing well."[25] In other words these were snapshots from life that were used in the newspapers and, in the case of this collection, it turns out that the newspapers had become an archive for the dead.

In a second installation called *La Réserve des Suisses Morts* (*Storeroom of the Dead Swiss*), Boltanski has attached similar photographs of Swiss people to tin boxes that contain their newspaper obituaries, thereby severing the connection between photograph and name, visibility and identity (fig. 105).[26] Visitors to the gallery space wandered among these stacks of reliquaries, which gave the impression that all these dead had found a common cemetery. An image of each of them remained that had become anonymous and lost all connection to a person. More than any portrait, these pictures remind us of the power of death, which portraiture was created to resist. They testify to the existence of faces that were once alive and are now no more. In an interview Boltanski insisted "that they are all similar and yet different. So, what is nature, species, the individual? One talks about thousands of people, but what is a single person except an individual who has a different face, a different essence each time?"

The reference to the archive is immediately apparent in the title of the work, *Archives*, which could be seen in 1987 in the contemporary art exhibition *Documenta*,

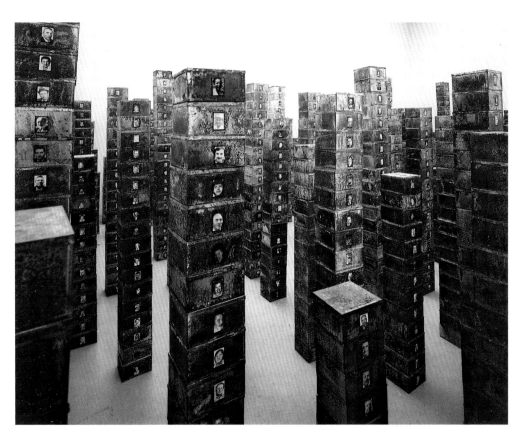

FIGURE 105 Christian Boltanski, *Storeroom of the Dead Swiss*, 1991, installation (Paris, Gallerie Hussenot). © 2016 Artists Rights Society (ARS), New York / ADAGP, Paris

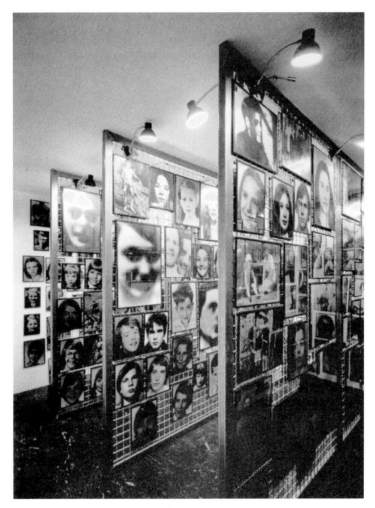

FIGURE 106 Christian Boltanski, *Archives*, 1987, installation (Kassel, *Documenta*). © 2016 Artists Rights Society (ARS), New York / ADAGP, Paris

which is held every five years in Kassel, Germany (fig. 106). Boltanski collected 350 black-and-white photographs of faces of unidentified people. These were attached to display grids illuminated by desk lamps, as though suggesting that they belonged to some official agency.[27] All these photographs had been used elsewhere in Boltanski's other works, but here they were displayed in different sizes, each one showing different details of the face. It is precisely the removal of their "civilian status" (as the Parisian Police Prefect Bertillon would have called it in the nineteenth century) that gives such faces of different ages, sex, and expressivity an identity superior to that of any official authentication. Faces of this type lived in a time and were victims of that time, victims whose work is achieved in death. As death masks they are,

paradoxically, "anonymous portraits," as Alessandro Nova has called them, and because they do not address any individual viewer, they speak to all visitors to the exhibition, who personally share the collective fate of a transitory life.[28]

17

VIDEO AND LIVE IMAGE: The Flight from the Mask

As chapter 14 of this book described, photography eventually led to an insight about modern technology. Instead of creating faces that are reproducible in the photograph with an immediacy and mechanical precision never before achieved (apparently without the intervention of the human eye), modern technology was ultimately just creating masks. As a result, the nearly obsessive invention of new image media (beginning with film) from the turn of the twentieth century on was triggered by a flight from the mask. The hope was to banish the inert mask from the moving picture. Photography had shown something that was no longer a face, but in the next moment had already become a memory in life. The so-called live image (the concept is deceptive) competed with life in the gap that photography had left behind. The live image attempted to cross, if not eliminate, the boundary between life and picture. Despite the superabundance of pictures, these always remained a substitute and simulacrum of life. Even though in the public sphere images gradually supplanted the faces they represented, their lifelessness (a topic in image theory since Plato) encouraged their use to imitate a life that they did not possess.

Film has outstripped photography, for it consists of rapidly accelerated frames that lose their individuality in projection. For a long time, film was a public medium that could be seen only in movie theaters, whereas private pictures were always the purview of the photograph. Films can always be viewed again, and when they are, they create the semblance of life that gets lost in still photography. At the dawn of the age of film, still photographers like Étienne-Jules Marey were obsessed with producing the impression of "flowing pictures" in their images of natural human movements. Yet they could not anticipate film.[1] The cinematic image was greeted with the same enthusiasm photography had enjoyed two generations earlier. This technology imitates the stream of life by using tracking shots and cuts to suggest the experience of time, which is solely the province of film as it unspools. As Gilles Deleuze has demonstrated in his classic work, *L'Image Mouvement*, although film can manipulate time, it is the moving image that began the flight from the photographic mask, its most important time form.

In the middle of the last century the version of real time offered by television quickly became the next success. But most "live pictures" fall victim to the trap of

time when they are revealed as recorded images. Anyone may see this on television on the eve of an election when there is inadequate pictorial material to fill a program and, as a result, the same film clips have to be rebroadcast repeatedly. Each repetition mars the impression that one is present as an observer of the event. The images reveal themselves as recorded material that insinuates itself into the here and now of the observer. All at once they no longer have the same effect as the events themselves, which at first glance they had seemed to embody when the interval between the recording and broadcast was almost instantaneous. Because they are broadcast at the speed of the present moment, the observer initially forgets that one is seeing nothing but recordings, no matter how incalculably brief the time interval may be. In this way we project our own presence before the screen into the people we view in the picture.

The digital image, which predates the modern camera, has cleared the way for a completely different escape route from the photograph. Its virtual worlds no longer represent what exists in the real world and thus free themselves from the trap of time into which those images from the real world draw us. In keeping with its technology and intention, the freely manipulated digital image eludes the photographic analogy with the real face, an analogy that constituted the essence of portraiture.[2] Nor does it have an expiration date, which had been the fate of live images recorded by film photography.

But even before the shift to the digital age, technology existed that revolutionized the photograph. In the 1960s video technology entered the market, and it offered a new camera to compete with the movie camera. Video cameras for private use were soon widely affordable, replacing the earlier technology of photography. Videotapes soon replaced photo albums. Audiotapes had preceded them as live recordings of private events. Now the moving picture joined the voice and offered the possibility of capturing human gestures instead of freezing them in photographs and sending them into that time trap between image and event. In the continuous flow with which video images follow one another, they could be played as often as one liked and then edited to taste. Each time, the moment returned so convincingly that viewers felt like eyewitnesses. Our personal memory had long been trained by photographs that had recorded our lives. Video recordings, on the other hand, reminded people of the living movements familiar from the mirror, thereby transcending the format of the individual photograph. Video technology functioned as a private mirror to capture life as it rushed by—the difference being that life lacks a replay function.

The video camera, which promised to be an inexpensive rival to photography, as well as competitor to the movie camera, was welcomed by artists around the

world as an instrument for image production (and image control). But it also stimulated critical reflection about how to behave without a film script, as if one were studying one's own face on the video screen. Of course, the difference from the mirror is that with a camera one could record this study of the face. The 1960s saw the rise of the "happening" and performance raised to artistic forms in which artists employed their own bodies. Only the video, however, offered the possibility of documenting one's own entrance and capturing one's self-representation as an image.

As Rosalind Krauss first pointed out in 1976 in the journal *October*, this turned out to be crucial. She declared that narcissism was so endemic in video works that it could serve as the governing concept for the whole genre. She accused the artists of indulging in uncritical self-reflection made available to them by this filmic technique. By means of the manipulation of the gaze in the moving picture, the video image was spontaneous in a way that resembled the mirror image—hence her criticism that artists had lost all distance from themselves and were using the new medium shamelessly for the purpose of self-promotion. Video, she argued, had fostered the narcissistic urge for self-projection.[3] In her analysis, however, the author left little room for the equally possible practice of critical self-*reflection*, which challenged artists to seek their place in a world created by video.

The large anthology *Video Art*, from 1976 (the same year as Krauss's essay), shows the euphoria triggered by the discovery that art had now arrived in the here and now, the "present tense." As in life, the "live phenomena on the screen" stimulated curiosity about the next image that would appear.[4] In the case of the face, one had certainly escaped the discarded mask of the photograph but at the same time been tempted to create new masks that possessed the novelty that one could film them as they changed. Self-representation in the video is also a confrontation with a face that always remains exterior to the self and produces unknown masks of the self when people try to penetrate it. One could state the case using Samuel Beckett's words for *Avigdor Arikha* (1965): "Siege laid again to the impregnable without. Eye and hand fevering after the unself."[5] For Bruce Nauman, who likes to refer to Beckett, the blurred distinction between face and mask is the theme for some of his works. In a drawing from 1981, he takes the relation between face and mask almost literally when he depicts a face and a mask confronting each other and writes the word "face" over the word "mask" in mirror writing. Here the mask is another word for the face, which appears when one calls up the mask. The mask is connected to the face, as the face is connected to the mask.

In the text for an installation from 1975 bearing the cryptic title *Consummate Mask of Rock*, Nauman engages in wordplay in the form of old children's songs. These ambiguously reduce one's own mode of existence to the concept of the mask.[6]

The assertion, "this is my mask of fidelity to truth and life" is countered with the confession, "this is the mask to cover my infidelity to truth (this is my cover)." In the hologram series *Making Faces (A–K)* from 1968, Nauman uses his hands to form sounds that transform a face into speech masks, thereby straining his physiognomy in order to create expression. In his videos the mask also stands as a permanent question mark like a shadow behind his own face with which he poses. In the work *Art Make-Up* (1967–68), which was recorded on 16 mm film, Bruce Nauman painted his face and naked torso four times with different colors. In this way he simultaneously opened up an enigmatic game on four screens. Face and mask detach from each other by this intensifying "make-up," although the face always remains the same (fig. 107). The "art" of coloring serves the mask, which is defined purely by make-up. The progressive transformation of a face into a living mask that Nauman produced in his studio almost seems to take shape before our eyes in the exhibition space. A stranger emerges to the degree to which the artist has colored his face. This stranger loses his resemblance to the face that was filmed initially. We suddenly no longer know whether we are dealing with the same face, for Nauman retreats ever further from it through the progressive applications of make-up that we saw at first.[7] The flight from the mask (which the face might have become in a photograph) ends in an animated ballet of different masks, which have since become standard in the repertoire of the self-portrait.

In the world of the visual arts, video also laid the groundwork for a permanent stage. This had already happened by the time video was introduced on the theatrical stage for the purpose of magnifying actors' images on oversized screens. Nauman even used this function in a generic way in a video that broadcasts a situation in a studio where no works (in the traditional sense) are being produced anymore. Instead, "art as action" takes place and is broadcast into the exhibition space. A short film with the banal title *Playing a Note on the Violin while I Walk around the Studio*, shows a performance in which Nauman does nothing other than produce a note on his violin while walking around the studio with it.[8] In his studio he acts as a soloist using pantomime and dance to transform the real space into an imaginary stage with gesture. In the exhibition he showed what he had actually done in his studio.

Such a theatrical situation is conceptualized in 1968 in Nauman's video *Beckett's Walk*. The title alludes to Samuel Beckett's late stage works in which an actor, taking steps in a geometric pattern, expressed the expansion of time in a void that no longer needs to be filled with plot.[9] In Beckett's work the actor remained alone without his roles, just as the artist in his studio remained alone with his physical presence. In the period we are examining, which follows portraiture, there develops a presence without reference. Even in historical self-portraiture, chronological suc-

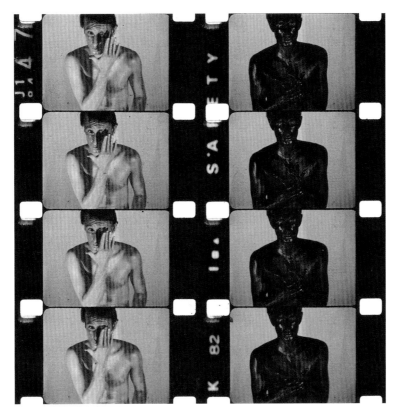

FIGURE 107 Bruce Nauman, *Art Make-Up 1–4*, 1967–68, 16 mm film, frames (Amsterdam, Stedelijk Museum). © 2016 Bruce Nauman / Artists Rights Society (ARS), New York

cession had always been the rule. People could view a portrait for the first time in an exhibition and not in the studio where it originated. In Nauman's case, however, a staged performance supplanted the old representation with the face.

At the beginning of his career, Nam June Paik, who became a key figure in the development of video into an art form, found a new expression for the play of masks in his own face. This began when he had himself photographed by Wolfgang Ramsbott in 1961 for the performance of Stockhausen's work *Originale*.[10] To do this he placed both hands over his face and opened and closed them to create a temporally animated mask (fig. 108). For the production of this mask, all that he needed were his own two hands. When they opened, his eyes squinted through the mask, and in the next moment the hands placed the mask over the face again. In doing so the old double meaning of the mask—both to show and to conceal—was created by timing, which made either the face or the mask visible. The face countered this

rhythm of visibility and invisibility with nothing more than its own presence, but it was the role of the mask either to reveal or conceal the face.

About twenty years later, in 1982, Paik reprised this youthful cinematic memory in an installation in which a bronze *Self-Portrait* (now at age fifty) shows him in front of the screen as an ironic and also blind viewer of the film. For the bronze cast of a face, he paradoxically revisited the filmic game of using both hands on his face, with the result that very little of the portrait is visible (fig. 109). This gesture produces a kind of tautological act, for now the hands do not conceal the real face, but rather mask a mask, which is essentially not a face, but either represents or conceals the face. In this play with the hands, a portrait head in the traditional manner becomes intelligible only via the film it stands in front of. It imitates movement that is belied by the genre. But Paik also took the game a step further when he posed for a photograph in which he grasps the bronze mask with his real hands (concealing the sculptured hands applied on the mask) as if he were trying to (or even could) place this head on his body (fig. 110). This time we get to see Paik's real face, which he used as a cast for the bronze head. Yet the artist smiles conspiratorially at us because he knows that all we are ever going to get to see of any of this is the photograph. Thus the three faces of the same person—two invisible and one visible—refer to one another in a circular manner without ever finding an escape from this play with the masks and without ever even seeking such an escape. Not even the real face can strip away the masks that it reproduces in the film or in bronze. In this work the artist-philosopher reduces the whole history of portraiture—which has gone through so many artistic media, from bronze and photography to film and video—to a metaphor. He performs the role of Narcissus who knows that of all people, he is the least able to see himself. In Nam June Paik's performance, the flight from the mask, which had led to the invention of live images in film and video, is answered by an escape into the mask when the artist repeats the filmic image with a bronze face and then performs this again with his own presence.

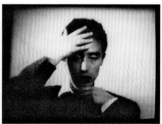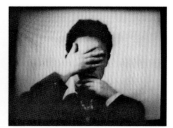

FIGURE 108 Wolfgang Ramsbott, *Nam June Paik*, 1961 (film stills)

FIGURE 109 Nam June Paik, *Self-Portrait/Head with Two Hands*, 1982

FIGURE 110 Nam June Paik with *Self-Portrait/Head with Two Hands*, 1982, beside a screen showing the film by Wolfgang Ramsbott, 1982

18

INGMAR BERGMAN AND THE FACE IN FILM

Nowadays it is hard to imagine the extent to which the face on film dominated all other media in the first half of the twentieth century until television displaced the movies from their quasi-monopoly. That said, no particular cinematic viewpoint is intended in the following discussion. The fact is that nowhere else but in the movies could one see faces that assaulted viewers with such movement and expressivity of life and then suddenly disappeared. Nowhere else could such power of suggestion be experienced than on the movie screen in the darkened cinema where the feeling of place seems suspended and one sits alone under the onslaught of images. This experience, which became ever more prevalent both in feature films and the news with its documentary features, initially fueled spirited discussions about the limits of the permissible and about protecting the face from overexposure. The face suffered as the camera moved in ever closer. Gradually, stylistic conventions of the montage technique emerged, which we can now differentiate as directorial styles. Given this situation, it is neither possible nor desirable to focus on all aspects of the film face. This subject nowadays fills whole bookshelves and can only be touched upon here.

It was not just any faces that appeared in the movies, but rather the faces of actors who played a variety of roles and used their faces differently than on the stage. In live theater the distance between stage and audience prevented an emancipation

of the face from the body as a whole; in the era of the silent film, emancipation from the voice was also impossible. The fame of movie actors who made their way into every small town cinema across the world seemingly overnight, equaled the fame of the medium of film. These faces were recognized everywhere and reached a mass audience that had never entered a traditional theater and was no longer separated by language barriers. A series of monographs devoted to individual film stars brought out by a Munich publisher in the 1920s bore the title *Das Filmgesicht* (The film face). The issue devoted to Douglas Fairbanks (fig. 111) does not include medium or extreme close-ups of his face, but rather illustrates all the roles the actor had played up to this point—naturally with his versatile and yet uniquely identifiable face. His face was recognized in any film. And the reason "the divine Greta Garbo" made it to the cover of *Life* was that everyone adored her face and wished to contemplate a photograph of it in peace and quiet, even when the star presented herself to the public full-length on a throne (see fig. 92). Such a cult of movie stars triggered a countermovement to democratize the face in Soviet film. In the 1920s Eisenstein discovered authentic expressivity in the anonymous faces of peasants and industrial workers and made this his subject. In *Battleship Potemkin* the face of the screaming governess has so deeply etched itself upon our collective memory that thirty years later the painter Francis Bacon could refer to it directly in his papal portraits. The Russian director brought a "powerful gallery of physiognomy" to the cinema, as Walter Benjamin rhapsodized at the time. Yet these are rather a gallery of types from the "new" social classes, which were meant to reflect the birth of the new age. The close-ups of Eisenstein's faces, which distanced themselves from the theatrical and melodramatic, depended on two cinematic conditions that the director reformulated for himself. They relied on detaching the face from the reflection of any mere cinematic plot and also upon the "steely rhythm" of a montage in which the faces were "combined like words in a sentence."[1]

The close-up has always been a controversial topic in film and has often been an issue that has separated European film—where it has a long, varied, and conflicted history—from American film where it was less established.[2] The extreme form of the close-up is one that the viewer cannot encompass with his own gaze. The outsized film face so thoroughly overpowers the gaze that we lose our sense of proportion between the fictional proximity of the film and the factual distance of the screen. For the first time film made possible the representation of an "animated mask" (if one may call it that). In silent film especially, the old mask returned when a close-up froze the face in the camera's view, transforming it into an icon that remained untouchable in the memory. Perhaps that was why a crisis of the face emerged in the talkies as soon as the medium tried to find the cinematic expression

FIGURE 111 Douglas Fairbanks, cover of *Das Filmgesicht*, ed. Wolfgang Martini, 1928

for a "speaking mask." Although film produced the virtual epitome of a face, over-sized projection turned the face into a mask upon which we lavish a more intimate gaze than we usually do upon any other face. It seemed that the difference between mask and face had become obsolete and that the face in the picture had finally come into its own. Yet the production of faces on film could only come at the price of transforming faces into masks furnished by the medium of film.

The early film theorist Béla Balázs delightedly acclaimed "the close-up as the poetry of film." "Close-ups are the most distinctive province of film," especially with regard to physiognomy and facial expressivity.[3] Yet one could easily object that both

of these depend on completely different types of perception. The closer we approach a face and its play of expressions, the less we can observe its physiognomy as a whole. The filmic mask soon prevailed over the physiognomic face, from which it produced the mask. Balázs, however, was celebrating the revolution in this new pictorial medium. For him the human being first became "visible" on film (as one of his titles claims), and the "invisible countenance" emerged, revealed in the physical face of the film.[4] Because Balázs included everyday objects and landscapes as motifs of the close-up, he was able to attribute to film a previously impossible view of the world.

The play of expression in the film face was not able to offer any more certainty of message than physiognomy had done, which is what Balázs had predicted. In the early 1920s the Russian painter and film theoretician Lev Kuleshov undertook a well-known experiment with the film face that created a controversy in the world of cinema. In 1929 his colleague Vsevolod Pudovkin at the Film Society of London made the public aware of the so-called Kuleshov effect.[5] From its inception it was celebrated as a triumph of cinematic magic because it proved that one could produce facial expression with montage alone. In the experiment, one and the same face—of the czarist matinee idol Ivan Mosjoukine—was incorporated into a montage with many different images (from children playing, to a plate of soup, or a corpse), producing differing responses. As the film was projected the audience was carried away by the theatrical achievement of finding the same facial expression in very different contexts and interpreted the effect as a face displaying different emotions when close up. We have here the primal scene of the theory of montage. The Russian inventors were proud of having discovered the raw materials that could be composed into a cinematic context in the cutting room, regardless of how heterogeneous the individual elements were.

The close-up always remained independent of other elements (like the plot of the film) and was judged according to its narrative expression. Eisenstein came at it from a different direction when he applied montage as a didactic and ideological process. In so doing, every face became its own context and could be introduced as a building block in an argument; in other words, it could be recontextualized. He no longer wanted to write "novels in pictures," as he had accused another director of doing. Rather, by using montage as pointed contrast he wanted to construct cinematically didactic material.[6] He offered a vivid example of this process that emerged spontaneously in 1930 when he was presenting a new film at the Sorbonne in Paris. The film under discussion was La Ligne Générale, which he had made in 1929 to depict the collectivization of agriculture. When the Paris police prohibited the screening, Eisenstein explained the basic ideas of his film in a lecture (fig. 112). He produced two plates of pictures with newly ordered film stills for publication in the journal Documents. These make montage blatantly obvious.[7]

FIGURE 112 Sergei Eisenstein, collage of faces from *La Ligne Générale*, 1929
(*Documents* 4, 1930)

Laughing young faces and faces of old peasants bearing the traces of another, difficult time are juxtaposed to form a gallery like the building blocks of film. The fat faces of a kulak and his wife form a powerful contrast to the proud face of a Komsomol youth. In addition to the faces, one finds close-ups in the most literal sense of a bull identified in the picture caption as Fomka, as well as other shots of nature in spring—all meant to symbolize the awakening of a new social order. Each face is raw material for the film and consequently is objectified like the other things near it. The film depicts a village that is transforming into a collective farm and also a collective identity. The collective rules the individual; the present rules the past. The new wind that blew across the land hit the viewers in the face, as the surrealist Robert Desnos recalled. Eisenstein turned his back on narrative film that told its story using famous faces. The concept of the face is determined by the context, which the film itself provides; the contrast with the version of movie star cinema could not be greater.

Gilles Deleuze looked back on a half century of film history when he published his two-volume book covering a wide-ranging examination of the face in film, which he understood to be the "affection-image."[8] "The affection-image is the close-up and the close-up is the face," when it is detached from context by a film plot. The close-up "has the power to show the pure affect in its expression . . . in other words, it is not an enlargement," but rather represents an "absolute alteration" of the film. This leads to different consequences. As an independent and isolated motif, a face can pull the film together or suggest a new meaning instead of only reflecting a plot through a simple detail. In Eisenstein's work the close-up brings about a qualitative leap that reveals things that we would otherwise not apprehend. The affection-image is liberated expression per se. "The affect appears as . . . feeling or even desire in a person, and the face, as its character or its mask." In contrast to the action-image, the "affection-image is detached from all coordinates of time and space that could possibly bind it to any particular circumstance. In itself, it releases the face of the person" to whom it belongs.[9]

In his discussion of the affection-image, Deleuze describes a particular role of the close-up supported by the film theory of Balázs. Yet the way in which the film face relates to the face itself remains an open question. Is film theory just a variation or continuation of the way in which we speak about those faces we use to exchange gazes in life? Deleuze speaks of different conditions of the face in which expressivity can rise to such a degree that "the facial expressions liberate themselves [s'échappent] from the outline and become independent." In other words, when expressive intensity dominates the face, it will erase the unity of its physiognomy. From this, Deleuze distinguishes the "reflexive or reflecting face" in which the features compose themselves until they no longer betray what a person is thinking.[10] The film must show, either beforehand or afterward, that which is represented in such a face, whereas the expression of the affect represents itself. This applies in the same degree to the living face in which facial expression dominates and can be transformed into pure expression, while the work of the face remains at rest in a condition of reflection, as if behind a mask. Media theory must start with the face itself when the medium of film is being discussed. In the face it finds a technique we use to carry out or block all communication.

By contrast, the filmmaker Pascal Bonitzer chose a different path when he analyzed the close-up as an image form in film, with its temptations and terrors in the context of other modern image-media.[11] He sees it in both a terrorist and a revolutionary role: revolutionary in the sense that it toppled the hierarchy of images and spaces, events and bodies, "made that which was small large and that which was large, small"; and terrorist in the sense that it discarded all proper bourgeois habits

of seeing and attacked the audience with the "severed heads" of faces without bodies or context. It was used as provocation in order to throw bloody details in the viewer's face, as seen specifically in the case of early Buñuel, where he does so with the razor slicing an eye. The extreme close-up presents a surface rather than an image in space "presented . . . as a place of ambiguity between attraction and repulsion, seduction and terror." In doing so it prefigured entire cinematic genres such as suspense, horror, and erotica. It opened up a treatment of faces that signaled the end of any authoritative representation of the face for all time. By purporting to democratize the face, it also expanded the terrain of masks exponentially. Jacques Aumont described it in his history of the film face as a partial victory on the long path of hopes and illusions on which the human being had always been the object of the search but always gotten lost.[12]

In Ingmar Bergman's masterpiece *Persona* (1966), the face is central to the plot in a double configuration.[13] The extreme close-ups of the principal actresses create a stage that fills the entire screen, upon which both the women enact a conflict with each other, and soon with themselves. One face remains silent during the entire film, while the other speaks with ever growing intensity. And yet there develops between the silent and the speaking face an unequal dialogue in which the power of words and the plea for an answer ultimately succumb to the superior expressivity of the silent face. On a Swedish island a drama of the soul is played out, which slowly drives both women to a crisis of identity. The women are the actress Elisabet Vogler (Liv Ullmann) and her nurse, Alma (Bibi Andersson). Face and mask alternate with each other in each new shot, revealing the ambiguity of person (face) and role (mask). The title of the film refers to the ancient concept of the mask, the *persona*. The psychologist C. G. Jung recognized in this concept the "role-ego" that one presents visually to the world, whereas he understood "alma" as the invisible soul-picture. Are both women then simultaneously two sides of one and the same woman? Bergman used two actresses in whose faces he noticed great similarity, but in the film resemblance threatens identity and provokes conflict.

During the film's opening credits, one glimpses a flashback with Elisabet's face as it was during her stage career. With its heavy makeup, rolling eyes, and the harsh glare of the spotlight, it has the effect of a mask—the very mask that she has tried to discard in all the roles she subsequently played (fig. 113). Consequently, she falls into complete silence after a performance of *Elektra*. We meet her again with a defiantly incommunicative face in a clinic where she has been mute for three months, despite showing all the other attributes of a healthy person (fig. 114). Before she is consigned to the care of Alma, whose task is to make her speak again, the doctor accuses her of the "hopeless urge to find a truth" that is impossible in life. She is

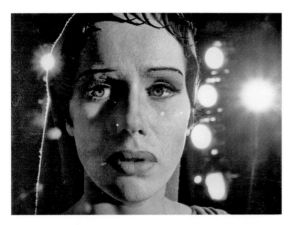

FIGURE 113 Ingmar Bergman, *Persona*: Liv Ullmann as Elisabet Vogler (in stage makeup), 1966 (film still)

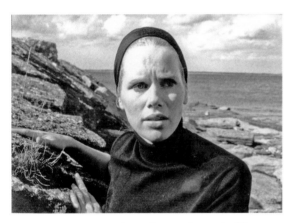

FIGURE 114 Ingmar Bergman, *Persona*: Liv Ullmann as Elisabet Vogler (as silent patient on the island), 1966 (film still)

told that even now she is playing a role, one that she will tire of in time. The patient listens attentively without letting on whether she will take this warning to heart.

In the doctor's summer house on the island, the lopsided dialogue between the actress and her caregiver begins and even continues in both women's dreams. Alma admires her patient, who embodies for her the power of art over life, and she tells her of the small, sad roles that her own life has scripted for her up to this point. She "would like to be" like the other woman and would prefer to "transform herself into her," considering that their faces are so similar. Thus begins the confusion between face and identity. Alma sees her trust in Elisabet cruelly betrayed when she reads in her letter to the doctor that Elisabet finds her merely amusing but naive. She now regrets the "betrayal" of the mute face whose expressions have so deeply disappointed her, and she demands her own identity back: "No, I am not like you. I shall never be like you." When she receives no answer she demands a confession from Elisabet, even if it is nothing more than a single word. Later it remains unclear whether Elisabet ever spoke that single word, or whether this happened only in a dream. The word is "nothing."

The film never answers the question of whether the women's dialogues take place in their daily life or continue in their dreams. In the real world a letter arrives from Elisabet's husband, which Alma reads to her patient. Enclosed is a photograph of their little son, which Elisabet tears to shreds in front of the horrified Alma. The son, her unwanted child, points to a second cause behind Elisabet's silence. During the film's credits we see the boy using the five fingers of his hand, which is in shadow, to wistfully caress his mother's distant, rigid face—which is not really her face, but

rather one that seems inaccessible, projected on a screen behind a glass wall (see frontispiece). Bergman has chosen dimensions that throw the physical proximity of the boy and the filmed absence of the mother into an unbridgeable contrast. The large face is only an image, which for the son takes the place of the unreachable mother. The theme of guilt toward one's own child has until now been concealed in Elisabet's life but is brought to the fore by the letter that really does arrive.

The visit from Elisabet's husband, by contrast, does not seem to belong to the real world. Alma takes over the wife's role when the husband does not recognize her face; she replies, in Elisabet's place, to the conversation that the husband demands (for she is both pressured and simultaneously restrained by Elisabet). Similarly, in the dream where the barriers of everyday reality collapse there emerges the "dual monologue," as Bergman called it, in which Alma speaks the same lines twice. It is a confession of Elisabet's guilt as a mother, which she does not make herself (she still does not wish to speak) but which Alma says "to her face" instead. At times the camera lingers for a long time on Elisabet's face, which alternates between terror and rejection, and at other times it lingers exclusively on Alma's face as she struggles to make Elisabet speak and force a confession from her. This means that she wishes to make her experience everything again on her "inner screen."[14] "In this dream situation Alma's aggression grows to such a degree that she becomes irrational and all expression drains from her."[15]

This sequence inspired Bergman to conduct an experiment by sending "that bit in—the bit where the dark side of one face is complemented by the light side of the other—to be printed. When the scene came back from the lab . . . I asked the girls to come and see something amusing—a surprise": the dual face in which both actresses were present and inseparably united (fig. 115). Neither actress was at first able to recognize her own face," but instead, saw only "the ugly side of the other face."[16] One could say that by now each one had projected her own face onto the other to such an extent that she no longer recognized the difference in their physiognomies and thus in their persons. And yet in the process each woman was very focused on her own identity. Liv Ullmann wrote in retrospect that she had wanted "to show a completely naked face" and to start "a voyage of discovery into my own self," which meant "throwing off the mask and showing what was behind it."[17]

In the departure scene Alma looks into a large wall mirror and discovers that her face suddenly appears alone, forsaken by the other face. At that moment she strokes the side of her head in a spontaneous gesture that she has picked up from Elisabet. The entire film is based on the principle of the reflection of one face in another without the two ever actually merging (that was not even possible in the lab, where both halves of different faces were simply superimposed). Each of the

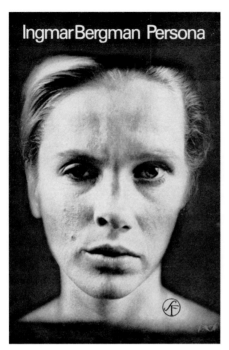

FIGURE 115 Ingmar Bergman, *Persona: Collage of Two Faces*, 1966 (film still and poster)

two faces always appears in the other's mirror when it is held in front of the other woman. These mirrors depict both approach and distance, openness and resistance. The face does not even know itself but rather seeks itself, as if in a living mirror in the exchange of gazes with another face where it experiences its own effect.[18]

With his film *Persona*, Bergman, who was then artistic director of the *Dramaten* theater in Stockholm and in a time of personal crisis, deliberately turned from the stage to the medium of film. He chose a representation of the face that can only be realized in film over the language of the stage.[19] He could avoid repartee, for there was only one person speaking while the other remained silent. Consequently, to shoot the gaze of one face toward another—or the intimate gaze of the viewer as an accomplice of both faces—he needed only one camera placement. The camera changes so frequently from the full screen to the extreme close-up that the hard cuts no longer penetrate the consciousness, and one starts to wait for the next extreme close-up. In collaboration with his cameraman, Bergman did not use any lighting to illuminate the face evenly, but instead always left one half of the face in complete darkness in order to open the sharp outline of the face and dissolve its surface in expressivity (see fig. 114).

Even before he started filming *Persona*, Bergman stated his conviction in the *Cahiers du cinéma* that "our work begins with the human countenance. . . . The original and essential uniqueness of film lies in its ability to get close to the human face."[20] In this process, the almost paradoxical task of the extreme close-up is to promote this "approach" and render the face beyond manipulation by the cinematic media, and thus beyond mere image production, thereby returning it to itself. This opinion put Bergman in an almost solitary position within the controversies about the pros and cons of film techniques—techniques that could be easily misused to sacrifice the face to the media effect. Yet even in Bergman's work we always find the mask present. It appears all by itself as a cinematic form that has to be wrested from

the face—yet this also resembles life. Bergman writes about the mask in his autobiography when he describes his failed marriage with the pianist Käbi Laretei: "two people hunting for identity and security assign each other roles to please one another. The masks soon shatter. Nobody has the patience to observe the face of the other. Each one calls with averted gaze: look at me . . . but no one looks."[21]

19
OVERPAINTING AND REPLICATING THE FACE: Signs of Crisis

In contemporary art the face has already passed through the filter of image media technology. Since the advent of the mechanical production of faces in the form of readily available images, painters have lost their traditional function of reducing the face to a concept, which was expected of them before the modern era. That function was meant to serve the purpose of representation. It is thus logical that instead of taking the face for their subject, they concentrated on its representation as well as its ability to be represented. In doing so they expressed the crises that have befallen the face in our media society since every reliable meaning and the individuality of the face seems to be devalued. It has been forgotten that these painters' predecessors produced masks against their will when they contemplated a unique face. Now the primary task is literally to strip the masks of the face from the readily available, industrially produced image media, even if this iconoclastic gesture is directed against itself. In hindsight the portraits of earlier ages, whose stereotypical nature has been forgotten beneath the guise of art, seem maskless and authentic as well as spontaneous. The portrait as a genre is now being dissected and analyzed by painters who either refuse to engage in representation or otherwise raise this to a new cult, which is placed in opposition to the mass media. The artists attack stereotypes and with them contemporary masks, which they filter out of the fashions of technology in order to focus on the face again. This process seldom produces portraits anymore, but rather critical paraphrases of the portrait as acts of rebellion and self-assertion.

The artist Arnulf Rainer was an early forerunner of this movement when he began to paint over pictures with violent brushstrokes. He was no longer painting faces, but rather attacking pictures in order to reclaim the face from them for his own self-expression. On this path to the face, pictures were destroyed or transformed. These interventions proclaim Rainer's handling of the face as image-criticism.[1] In the 1950s he began to paint over his own works so that they retreat from our gaze and exert their effect on us in their absence. The overpaintings and accretions of paint lock the picture away from us like a mute face that does not communicate. Behind this there lies a criticism, not of the face, but of pictures of the

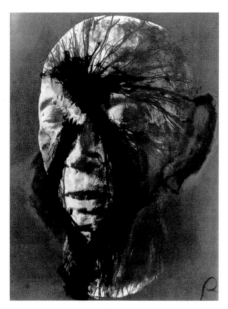

face in current circulation. At the start it was sometimes only the titles of the work that betrayed the fact that a head was concealed underneath the layer of black paint.[2] The technique changed with Rainer's images of heads penciled over, works that presented a double presence—that of photograph and painting—in the original underlying image as well as the new one. This series of works shows the face emerging anew when we see the traces of emotion and aggression in the gestural signature of the artist.

Paradoxically, through the veiled glimpse of the faces there emerges a new presence, which Rainer has reclaimed from the "face inflation" of the mass media. In one furious dialogue he destroyed inexpensive mass-produced pictures in order to increase the value of the faces vis-à-vis the cheap currency of the readily obtainable reproductions. He thus restaged the old drama of face and image with new techniques. In this process Rainer's intention to "forsake" painting and attempt a "post-painting painting" leads to counterdesigns for the portrait, which has lost its market value as painting. The spontaneous act of painting gains the upper hand over the image; the violent gesture trumps representation, which comes across only as reproduction.[3]

The fascination with the face intensified as Rainer produced a series of physiognomy studies in the 1960s. He posed for these himself and then painted over his photograph so that it came to life in an almost splenetic way. *Face Farces* show the artist grimacing in these head shots in an act of defiance against the rigidity of expression in photography and losing himself in the act of slashing away with the paintbrush. The act of painting thus conquers the photographic image.[4] The next step then came unexpectedly between 1977 and 1979, when Rainer turned to the death mask as his sole subject (fig. 116). In this group of works the artist again approaches the face in order to lay bare the ossification of its visage and the conventions of its representation. Death and life create an open boundary at the moment that a face closes and finds absolute expression before it disintegrates.[5] In this vein Ernst Benkhard called the death mask "the final image of man."[6]

FIGURE 117 Arnulf Rainer, *Totenübermahlung* (Overpainted Corpse), 1981–83

When Rainer painted over photographs of death masks, he questioned the pictorial character of a face that is paradoxically only revealed when it becomes a mask. As soon as it abandons every fleeting expression, its pictorial character emerges as never before. Maurice Blanchot got right to the heart of it when he called the corpse "his own image."[7] Rainer's violent intervention eliminated the distance from which we view a mask and forced it back into life. From the very beginning his dual strategy was to devalue the self-representation of the dead as well as any other portrayal, so that at the next stage, life was again captured with the gestural power of his paintbrush. The face still radiates life, even if it does so through an iconoclastic act that seems to do violence to the dead face (fig. 117).

We may assume that Rainer wasn't the least interested in the mask per se, but was instead trying to observe the face in the process of dying, thereby approaching it in a way that touches a taboo in our society. This assumption is supported by the fact that he took pictures of the faces of dead people with his camera as often as possible and then included these in his series beside the death masks as if he wanted to show the same thing. His detailed commentary, written for a Viennese exhibition of death masks in 1978, supports this. "After ten years of crabbed self-depiction, I was touched by the expressive, physiognomic language of the faces in death more than anything else." Their self-depiction enters the realm of "immediacy, of facelessness," and acquires an aura of indifference, "as if it were formal validity, finality." It is the "visage of the absent one," which makes it "almost impossible to reach the true face of death," where physiognomy no longer exists.[8]

The argument is that there is an image that does not reveal "the true face of death." Through the absence of that which it shows, however, it reveals the distance in the face and to the face. The concept of the image in Rainer's work is inseparable from the face. This means, for example, that we have only images of the face, and yet we know that they remain images and are never faces. We want to see more than pictures can show. This concept of the image conveys the division between representation and unrepresentability, which is repeated in the division between visibility and presence. The visibility of something in a picture by no means signifies its presence. The image represents a face that is unrepresentable and quickly dissolves into a mask as soon as we want to pin it down. Consequently, Rainer works on photographs of death masks, which are (as it were) masks of masks; he remains mindful of the limits encountered in each image. Those brushstrokes that are his own gestures contain more life than a photograph could ever capture. At the same time, they are acts of violence against the flat surface, which has locked the face down on the photograph.

The American artist Chuck Close (b. 1940) has made the face the subject of his life even more than Rainer has. In doing so he presents the greatest imaginable contrast to Rainer. This begins at the outset with the photograph, which each artist takes as the point of departure for his work. Rainer intrudes into the photograph and paints over it so that it is barely recognizable any longer. In his meticulously followed ritual, Close produces Polaroids as templates for his paintings. It looks as though he is translating a photograph into a painting, or even as though he is copying a photograph. In a photograph from 1970 (fig. 118), depicting him working on a portrait of his friend Keith, he grids the "maquette" with the original small photo in order to transfer it point by point onto the large-format canvas, which towers over him.[9] The black-and-white character of the photograph is meanwhile retained in the painting, thereby producing a hybrid that is no longer a photograph and yet resembles one. The

painting is large (273.1 × 212.1 cm), which was not possible in photography until the 1970s. Yet Close strenuously denies that he is a copyist of photographs. The photograph, he explains, is merely his orientation for a work method, during which he does not want to have the living face around. The photograph plays the role of the subject, whereas the picture is gradually filled with the painter's own view of the person.

Instead of concealing the face behind the masks of his painting, as Rainer does, Close exposes the masks of his figure. The oversized canvases rob the faces of their normal scale, which historically has always been typical for portraiture. In their enormous formats, which challenge any gallery space, these faces recall cinematic close-ups, now frozen in their frames. On the colossal mask, the camera's snapshot has now

FIGURE 118 Chuck Close, *Artist at Work on the Portrait Keith*, 1970 (Saint Louis Art Museum)

ossified in an incongruous way. The life of the face, as interpreted by Close, becomes vivid for only a moment and in the next becomes something quite different. He has said, "I am interested in the way someone looks at a hundredth of a second." His subject never again needs to look the way he did in the moment when the photograph captures life. Close has commented that he considers similarity nothing more than a by-product of his work.[10] Similarity (or resemblance) was an old belief in the permanent expression of physiognomy that Close refutes by always producing a series of portrait photographs and then choosing only one of these for his painting.

In his first self-portrait (from 1968), Close painted the archetype of all of his subsequent faces. Such hyperrealistic details as the pores of the skin had never been seen before on canvas. During this enlargement process the image undergoes no coarsening of the grain, as is familiar from photographic reproductions.[11] For the first and last time one can sense the anecdotal nature of Close's work. Bevan Davies, his photographer at the time, reported that beginning in 1970 the artist had banished expressive activity. From that point on the subjects were photographed in neutral views in order to reveal their differences in the same format.[12] In 1971 Close used paint to distance

himself consciously from any resemblance to the photograph. His first experiments were in watercolor, pastels, and print, where he employs the grid as a colored stylistic element to dissolve the picture plane and give the face its own life through the processes of painting. Work on the face is always work on the image and thus on the mask. A further experiment led to the composite self-portrait of 1979, which is made up of nine color Polaroids, arranged against one another so that only the viewer can assemble the partial views to form a complete face.

Although the artist painted pictures of well-known people and colleagues in his early years, after the late 1980s he moved to the other end of the spectrum and chose prominent private faces from the New York art scene. The grid in which the mechanical transference of the photographs remained invisible was now shown clearly as the painting of a technical surface arranged in a network of individual modules. The facial expressions are formed "behind" the painted gridlines. This discrepancy between face and data carrier is intentional. The appearance of a face had etched itself into the presence of the painted surface—a face that becomes separate from the actual painted surface and takes on its own life during the compositional process.

The grid assumed a different character in 1989 when Close, who was then in a wheelchair after a year of crisis following a stroke (the "event"), began working again. The individual grid elements now became building blocks of his subject. These "marks," as Close calls them, all consist of small paintings when viewed up close (fig. 119). Viewed from a certain distance, they become, to the viewer's eye, united into an animated surface of a face. The modules construct the picture in a sequence from top to bottom and from left to right, like lines of text. Here Close uses the term "image," which means something other than the actual work. As he has stated, "My paintings are more about language than they are about abstraction. Their pictorial syntax is made up of clusters of marks that are like words. . . . They tell you a story. They bring you an image," instead of merely decorating a surface.[13]

This downright anachronistically labor-intensive work process, whose uniqueness declares war on image-consumption in the mass media, leaves a trace of the face despite the outsized format of the canvas. In 1973, when his grids had a very different look, Close rejected the idea that he was painting pixels. On the way to an exhibition of his works he discovered a copy of *Scientific American* at a magazine stand. The cover showed a famous portrait of George Washington dissolved into a pixilated surface (fig. 120). He then opened the exhibition with the warning that one should not compare his painting with digital technology. He emphasized that he never used machines to create his pictures, and that he "wasn't interested in having the machine do the work for me, or in having any kind of artificial layer between the image and me."[14] The faces of Chuck Close can be understood as media criticism,

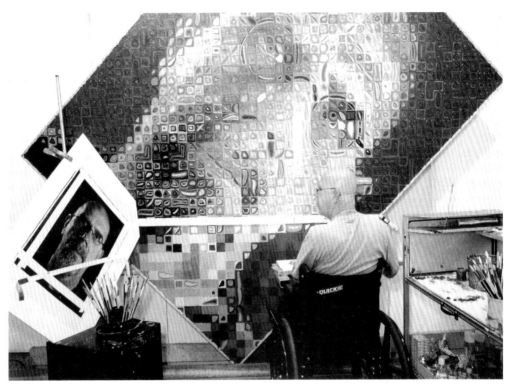

FIGURE 119 Chuck Close, *At Work on a Self-Portrait from the Year 2000–2001* (photograph, property of the artist)

even though they primarily deconstruct the concept of the image, which had led to the crisis about the ability of the face to be portrayed.

The ritual that Close staged with his subjects is best described by the writer and director John Guare after he sat for his portrait with the painter in December 1994.[15] This painted portrait was more or less an answer to the literary portrait, which John Guare produced in his book about the painter's paralysis in 1988. For five hours the writer posed for oversized Polaroid prints while Close made sure that his eyes and mouth were on the same plane. Even the placement of the eyebrow was determined in the last photograph. In his book about his sessions as a sitter, Guare wrote that the photographs had constituted a "human floor plan," and transformed the face into a describable landscape. The correct lighting constantly played the decisive role during this long sitting. Close regulated this like a director, as though he were filming a movie. Guare had the impression that he was participating in the "performance of a lifetime." After it was over the twenty Polaroids were finally displayed and discussed with the subject before Close made his final choice, thus determining the facial expression himself.

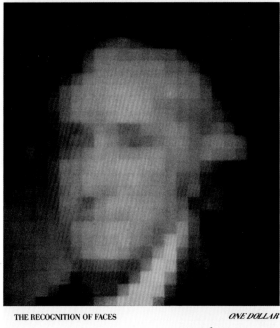

SCIENTIFIC AMERICAN

THE RECOGNITION OF FACES *ONE DOLLAR*

November 1973

FIGURE 120 *Pixilated Portrait of George Washington*, cover of *Scientific American*, November 1973

Close's typical work method, which Robert Rauschenberg and Richard Serra also reported on after posing for him, is testimony to the crisis of the image, which for its own part was triggered by the crisis of the face. The "similar" depiction of a face in traditional portraiture seems to have played itself out. In Close's work, similarity is, on the one hand, forced, and on the other, produced by a technical process involving steps that can be followed as precisely as though they were directions for operating a machine. Close carries out the reconstruction of the face with the help of formulaic elements, the "marks." Marion Cajori filmed the work method behind Chuck Close's self-portrait for three months. She reports that (to use the artist's own words) he wanted to make "a beautiful, powerful image out of stupid marks."[16]

But this image is not yet the face; instead, it has its own life, which must assert itself against the moribund context of mechanical acts of painting and against the oversized dimensions of the work. The crisis of the face consists of the fact that one can no longer reproduce it 1:1 because, in the age of technological media, painting repudiates the expertise required to do this. The former gaze of the painter upon a face has been replaced by a neutral technological process whose result stands in for the image of the face. And yet even here the face still remains an inaccessible quantity, and it reconstitutes itself beyond the reach of all techniques of reproduction when we gaze at it and thus—as viewers—are "in the picture."

20
MAO'S FACE: State Icon and Pop Idol

After 1949 the monumentalized face of the "great Chairman Mao Tse-tung" became the public face par excellence. It was truly a face for everyone. As such it determined the production of political faces in the mass media in the political sphere. By virtue of its omnipresence, its superhuman, oversized format, its mass production in numbers that ran into the millions, and the depersonalization of facial features, it achieved sacrosanct status controlled by the Party. This face culminated in the monumental portrait—if it can still be called portraiture—on the gate above the Square of Heavenly Peace (Tiananmen Square) in Beijing. Here it was acclaimed as a state icon and also an original work of which there could only be copies (fig. 121). When staged like this the image appeared as the permanent proxy for Mao, whom the masses looked up to when they gathered by the hundreds of thousands in the huge square. The face of the first chairman also embodied the people, who sought a collective physiognomy in their anonymity. China's state icon became known worldwide thanks to American art in the 1970s when Andy Warhol turned Mao's face into a pop idol. In sharp contrast to its original, it became an interchangeable cliché of celebrity culture. This same face was colored using the printing techniques of the mass media and became a commodity fetish of a so-called popular yet high-priced art scene in America.

These two faces of Mao—one from Beijing and one by Warhol—epitomize two radically different social systems. Yet the relationship between the two involved timing and content, which makes it all the more necessary that we reconstruct their mutual history. In doing so we can appreciate how the role of the media (or in Warhol's case, the role of art) may differ in the production of the face. Since 1949 the state icon has been hanging beneath the rostrum from which Mao proclaimed the foundation of the People's Republic of China in that year. Yet it has been altered several

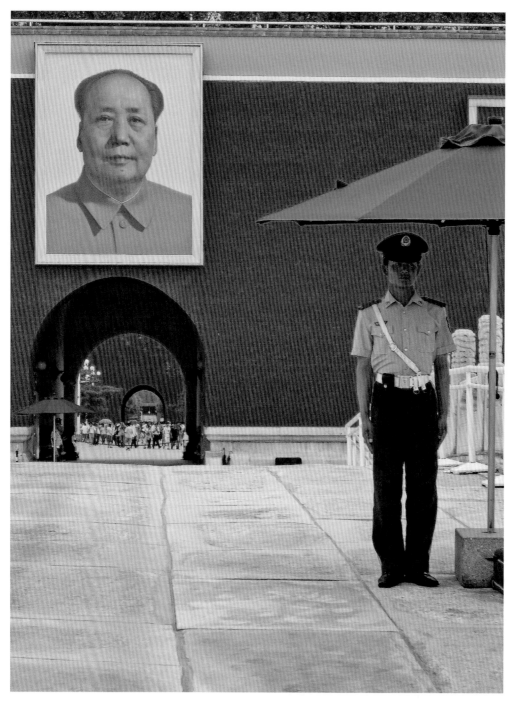

FIGURE 121 State portrait of Mao Tse-tung, version of 2009 (Peking, Tiananmen Square)

times since then, and in significant ways, so that each time it has appeared timeless, even though it is not.[1] The Party leadership controlled the ideological meaning of the image down to its minutest detail. In the earliest period Mao had looked toward the heavens with a visionary gaze, peering into the distant future. But the future soon became the present in the form of revolutionary masses. It was decided that they should get the impression of being gazed at and thus acknowledged by their Chairman, which meant that they could interpret him as an advocate and partner. Over the course of his life, the portrait was subtly changed in accordance with Mao's advancing years; it seemed to age with him imperceptibly. Despite all criticism of the cult of the individual, the image achieved a solemn timelessness after his death in 1976. It was a process otherwise known only from the tradition of the death mask, and it continues to embody the unity of Party and people in the person of Mao.

The reproduction process and the format have remained the same. In contrast to the reproduction methods of the mass media, the image was traditionally produced in oil as a gigantic painting (6 × 4.6 m). The so-called authenticity of this image lies in the fact that it originally reproduced a real photograph, which could never have been enlarged to this size. Only the medium of painting could enlarge it on this scale. This painted face was exposed to inclement weather, which meant that the paint had to be renewed annually. For many years, this offered an opportunity to change the picture's expression to meet the Party's current ideal. Most viewers took little notice of this, for the picture was always meant to look the same. It had been conceived as a unique object that functioned as the original for the production of images throughout the whole country, as though it were Mao in person.

For decades a state functionary—the official Tiananmen portrait painter—was responsible for the production of this state icon. The entire process was veiled in secrecy.[2] In 1964 Wang Guodong was hired to do the job, and he most likely designed the famous portrait that was circulated worldwide with the *Little Red Book* in 1967 (fig. 122). This was the image that Warhol incorrectly took to be the timeless official portrait, a portrait that had recently been updated according to Party wishes and that would subsequently be altered again. The basis for the image was a photograph from 1963 from the Xinhua Agency in which Mao is seen with a gentle smile upon his lips as he gazes past the camera out into the world. The state icon even included the wart on his chin from the photograph.[3] This revision of the face was undertaken during the years of the Cultural Revolution, a period when Mao dismissed all of his adversaries among the Party leadership so as to rule his people "directly." Now the image cult surrounding his person reached its absolute zenith. At least 100 million copies were printed, reaching every household. At the same time, it was disseminated internationally in the "Mao Bible" (Little Red Book), published by the People's Republic of

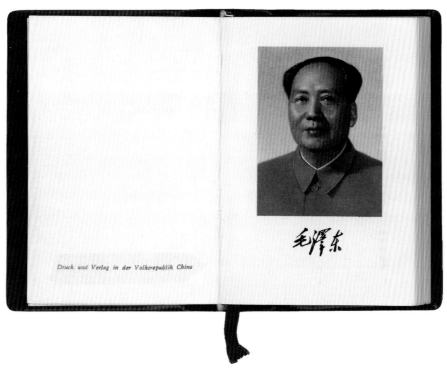

FIGURE 122 Frontispiece of Mao Tse-tung, *The Words of Chairman Mao Tse-tung* (The Little Red Book), 1972

China Printing Office. Here the image served as the frontispiece for the "words of Chairman Mao Tse-tung, which could be memorized like proverbs and had the same function as the authority of the portrait (see fig. 122). The crowds in the enforced conformity of their uniform clothing on the enormous Tiananmen Square could now carry the words of the one upon whose image they gazed in the distance—silent and superhumanly large, like their own collective image.

In 1967 the state icon again received a final revision of the face originally commissioned from Wang Guodong (see fig. 121). In this version the face is expanded on the picture plane in a larger format and has abandoned its pose for the camera. It looks out upon the square, unapproachable and sublime, without any facial expression. Wu Hung understood this as intensifying the face's masklike character.[4] By turning the head to a completely frontal view, thereby imperceptibly negating the majestic low-angle shot, it became possible for the first time to show both ears in the picture. The gesture is usually interpreted as meaning that Mao is now listening to his people with both ears.

This interpretation of the monumental state icon remains in place today, even after Wang Guodong's pupil Ge Xiaoguang took over as official Tiananmen portrait

painter in 1976 and produced the same image every year thereafter. It was not until the 1990s that the current Tiananmen portrait painter was allowed to speak about his position publicly. When he did so he made it clear that he had "done his best to represent the broad mind and deep thoughts of Chairman Mao through carefully depicting his gaze." To him, Mao's gaze served to unite a leader with the people and to link the past with the present and future. This overload of meaning, along with the depersonalization of facial expression, has intensified the masklike character of Mao's image. Here the mask no longer ties the face to a single body, but rather draws the gaze of the masses to it and reflects them. The effect is closely tied to the ritual of mass rallies when participants assemble in military formation in columns and rows. But the masses were also capable of rejecting the surrogacy of the face looking down upon them and of turning against the dictatorship embodied in the authority of this image. The rebellion occurred during the dramatic days of the student revolts that ended with the massacre of June 4, 1989. During those days, students pelted Mao's portrait with eggs and defaced it with paint, acts that were punished with immediate imprisonment. At the same time students from the Central Art Academy created a statue of the "goddess of democracy" (a variation on the Statue of Liberty) and carried this in triumph in front of the state icon in order to denounce its empty and violent authority.[5] Don DeLillo, who followed the events on television, wrote about what happened in the square in his novel *Mao II*, which is told through the eyes of the photographer Brita. These were crowd scenes in which "she sees people with hands calmly folded over knees. She sees in the deep distance a portrait of Mao Zedong. Then rain comes on. They're marching in the rain, a million Chinese. . . . Then the portrait of Mao in the daylit square with paint spattered on his head." Corpses come into view and "the crowd [was] dispersed by jogging troops who move into the great space. . . . They show the portrait of Mao up close, a clean new picture, and he has those little mounds of hair that bulge out of his head and the great wart below his mouth."[6]

But Brita is suddenly distracted by her doubt as to whether the portrait on Tiananmen Square that she sees on television really corresponds to the Mao image by Andy Warhol that she knows, but which lacks the wart on its chin. This begins a completely new story, as DeLillo's novel now turns to the role that the Mao portrait played in pop art. The point of view changes completely and readers find themselves transported to New York in 1972. At the time Andy Warhol was already marketing the glamour of celebrities from Marilyn Monroe to Jackie Kennedy with his silk screens. But after doing this for ten years he was looking for a new inspiration. The following narrative has entered the Warhol legend. Bruno Bischofberger, Warhol's agent in Zurich, had advised the artist to choose "the most important figure" of the

century, with the exception of Hitler, in order to make a new start in this genre. He was thinking at the time of Albert Einstein, but Warhol chose Mao after *Life* magazine (March 3, 1972) devoted its cover story to Richard Nixon's visit to "Mao's country." This was the first state visit of an American president to the People's Republic of China, and if Mao "was okay for Nixon," then in Warhol's opinion, he would be okay for his own collectors as well.[7]

For his model Warhol chose the Mao portrait from the *Little Red Book*, which had been circulating for five years and had become a cult classic for Maoists around the world as it propagandized the Cultural Revolution in China. He enlarged his source image in various formats and in garish tones, thus leaving the cliché suspended in an endless closed loop (fig. 123). In doing so he gave new meaning to the serial production method that had served political propaganda in China. Warhol gives it a contradictory meaning by shifting the emphasis from the face to the means of artistic reproduction and focusing on the bold, eye-catching techniques of the mass media. The face was depleted of meaning as a surface that duplicated another surface. It had become the reproduction of a reproduction in which the individual was lost.

The skin coloration—different from sheet to sheet or canvas to canvas—was not applied to the face but rather to the print. In places where one could detect a personal touch to the brushstroke, there emerged those gestures of the painter or draftsman that were the signature style of the star artist: Warhol himself. He put his own stamp on the famous face and reinvented the Mao portrait for Western art collectors as his trademark. In his own culture there was no political star like Mao, whom everyone recognized without having to believe in him. In the same way that tabloid celebrities were owned by the mass media who had created them and kept them alive, Warhol took ownership of Mao's face. That act made the question of the subject superfluous and shifted attention completely to the unmistakable yet derivative vocabulary of Warhol's images.

In the fall of the same year, 1972, the first exhibition of the new group of works was mounted in the Basel Art Museum under the title *Warhol Maos, Ten Images of Mao Tse-tung*. The choice of the plural made unmistakably clear what the viewer could expect from this exhibition: people were not going to see a portrait of Mao in various copies, but rather a series of different Maos, all signed by Andy Warhol. They differed from one another in their color palettes and final touches, even though they all had the uniformity of pop art and even the same format—similar to that of the "Marilyns" familiar from Warhol's other series. Furthermore, each one was individually signed; in other words, it could be purchased separately. Each silk screen, whether it showed a single Mao or six Maos at a time, was an individual work, and therefore of equal worth to the other silk screens. By purchasing a print

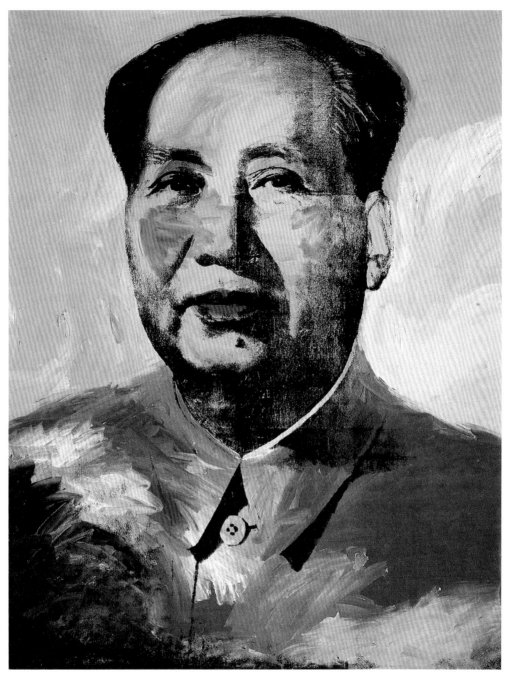

FIGURE 123 Andy Warhol, *Mao*, 1973 (Chicago: The Art Institute). © 2016 The Andy Warhol Foundation for the Visual Arts, Inc. / Artists Rights Society (ARS), New York

of Mao's face, one was buying a Warhol. The infinitely reproducible series was an idiom of the mass media, as was the mechanical printing process, which was a reproduction even before it was transferred to a new, larger surface. Yet Warhol put his own stamp as a brand on this idiom of the mass media. The faces of his Mao attracted Western buyers; in China Mao's face impressed the people.

In 1973 Mao production continued unabated in Warhol's "Factory" and employed ever-larger formats. The silk screens in acrylic on canvas were usually 208.3 × 155 cm, but individual examples like the canvas print in the Art Institute of Chicago reached the impressive size of 444.3 × 346.7 cm (see fig. 123). This oversized format seemed suspiciously close to a public propaganda image in a public space with which Warhol was competing. Yet it remained confined to the circle of exhibitions and collectors even as it shattered the conventions of its categories. Warhol used the large surfaces of Mao's clothing to develop a free play of color with the brush—subjective artistic gestures in the style of action painting. But the face, like the clothing, remained an empty surface to illustrate the printing process and its matrix, as well as the fine-tuning that went on in the Factory. By 1972 Warhol had supplemented his Mao collection with a folio of ten silk screen prints in a square format. These were conceived for other collectors and expanded the choice of genre, which repeated itself in all formats.

The extent of Warhol's Mao production became apparent when he collected their variations in the Musée Galliera, the fashion museum of Paris. For this event, however, he added a further genre. This was the "Mao wallpaper" mounted as background on all the walls of the exhibition, replacing the usual wall covering (fig. 124).[8] The Mao portraits were displayed as individual works in three quite different formats in rows in front of his Mao wallpaper. This wallpaper was most visible behind the smallest pictures, while the largest of them obscured it almost completely. These consisted of printed redrawings of the Mao face, which by virtue of color alone, stood out like an egg on the white field—an egg of intense violet color that made it jump out of its context. The exhibition gave the impression of a boutique where one could purchase a company brand in various formats at different prices. The contradictory nature between the serial production and the originality of a brand, for which normally only one designer is responsible, was here presented in the sphere of consumerism in the most blatant fashion. In all this the face played no real role. It was a pattern on the surface and "nothing was behind it," as Warhol once said of his own face.

The Mao wallpaper directs one's attention to the fact that in Warhol's work, drawing had been added to the production of Mao faces as its own genre (fig. 125). The artist signed his own drawing on paper, but on the wallpaper the signature was part of the template reproduced by the printing process. This made it infinitely

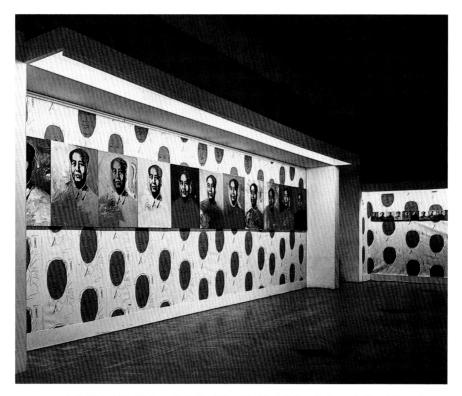

repeatable. It thus incorporated an inherent contradiction: the difference between original and copy. Warhol offered pencil drawings as original works, but when he did so, it was in the format of the large prints. These thus created a contradiction and simulated spontaneity where everything was formulaic. They were quite obviously copied from the stereotypical Mao image, Warhol's own product, and thus not drawn from the face. Apparently Warhol wanted to find out just how minimal he could make his technique and still produce a recognizable face from its almost complete disintegration and reproduce it anew in an almost hallucinatory way.

The drawing *Mao* from 1973 measures 206.4 × 107.3 cm; the drawing *Mao II* from the same year measures 92.7 × 82.6 cm (see fig. 125).[9] The title of this second drawing (essentially nothing other than "Mao Number 2") was what Don DeLillo chose as the title of his novel. The book critically exposes the role of images in the formation of the crowd. The images are empty and therefore exert power, for they are possessed collectively. They can be used to establish presence. But they can also function in the opposite way. The protagonist of the novel, a writer, will never publish his last novel, but

he has himself photographed in order to disappear in public behind his image. At an exhibition of Warhol's silk screen prints in New York, his assistant, Scott, stands before a piece called *Crowd*, from which he moves to a room filled with images of Chairman Mao—photocopy Mao, silk screen Mao, and wallpaper Mao. A multitude of copies of Mao's face stares at him from the walls. He finds the images, free of their photographic source and "unwitting of history," liberating.[10]

He thus decides to bring his friend, Karen, a reproduction of a Mao drawing, namely *Mao II*. This is her reaction to the present: "It was strange how a few lines with a pencil and there he is, some shading in, a scribbled neck and brows. It was by a famous painter whose name she could never remember but he was famous, he was dead, he had a white mask of a face and glowing white hair. Or maybe he was just supposed to be dead. Scott said he didn't seem dead because he never seemed real. Andy. That was it."[11] The anecdote about the present in the novel derives from a kernel of truth. In 1973 Warhol had published an edition of three hundred Xeroxed copies, all of the same drawing, but in every case always revealing a bit less of the original because every copy was a copy of the previous one and no longer a copy of the original drawing itself. As Dieter Koepplin remarked, "the imperfections of the copy machine created an alienated semblance of the indomitable Mao, whom everyone thought they knew."[12]

The state-sanctioned icon of Mao offers a glimpse into the cult of the face in a system that produced faceless masses. Similarly, the pop idol proclaims the consumption of faces in a society that is enslaved to consumerism and advertising. Oddly enough, Warhol's Mao production triggered a rush of portrait commissions for the artist in the same year. In some years there were more than a hundred requests, which had him traveling around the world for years with a Polaroid camera. This is remarkable since Mao's face by no means fulfills the traditional expectations of an individual portrait, but apparently every one of Warhol's private subjects wanted to become as famous, or at least to appear as famous, as those colorful silk screen prints by the artist. In the meantime, the world has changed, and the story surrounding the Mao face simply serves to remind us of the division of the globe during the era of the Cold War.

There was a remarkable epilogue to this in Warhol's own life when, in November 1982, he traveled to Beijing with the photographer Christopher Makos. There he was photographed and filmed in front of the state icon on Tiananmen Square. Chinese artists see this visit as a symbol of a period of change, which in those years gradually included even contemporary Chinese art.[13] Since then a new nostalgic Mao production by Chinese artists has thrived and attained prices in the art market as high as those commanded by Warhol's Mao images. One of these new artistic stars, Zeng Fanzhi, set a record price at an auction at Sotheby's on October 4, 2008, for his large-format painting titled *After the Long March Andy Warhol Arrived in China*.

21
CYBERFACES: Masks without Faces

The following section is not a summary, but rather an attempt to draft an epilogue to include current Internet culture. This is not an epilogue to the face, for such epilogues have become downright fashionable in the modern age (we need only remember Rilke's eulogy or the facial cult of the death mask). This can, rather, only be an epilogue to the foregoing cultural history of the face, which seems to have arrived at a watershed. Radical changes in media culture have opened a new debate about the face, as if everything we knew about the face were suddenly passé, and in cyberspace (and only there) the face had already disintegrated into a mirage. And yet the new debate about the face only shows how central it has always been in the image world of the media and in our gaze—and so it remains. As we understand them today, cyberfaces are not faces but rather digital masks with which the production of faces has reached a turning point in the modern media.

This cybernetic revolution challenges the distinction between what is artistic and what is natural, for now we can program hybrid realities that occupy a gray area and only admit nature as a quotation. Manfred Fassler describes this experience using the metaphor "living without a mirror." This means no longer communicating with the face that we know only from the mirror, because we have always sought it there—in other words, with one's own face. The mirror was and is the space for a "gesture of absence," which, even in childhood, is an act of self-assertion. The mirror is still there, but in the meantime we have invented mirrors with a different function and different symbolism, mirrors that are no longer designed to serve faciality. In the world of tele-presence, according to Fassler, the "future of the face is uncertain."[1] One could counter by saying that we may only be letting ourselves be blinded by techno-semantics, which uses digital technology to entice us into a futuristic world where we feel liberated from the representation of the natural world. Many

artists have used the digital techniques of "post-photography," with all its freedom, to stand up to techno-fiction on its own ground. They invite us—sometimes playfully and sometimes satirically—to examine a culture that they unmask as a culture of surfaces rather than a culture of bodies.[2]

The debate as it now stands since the digital revolution can be quickly summarized. Wherever a face can be compiled from multiple facial quotations, a digital face is the result. This face defies any reference to an actual bearer or to any particular face. The digital revolution may have seemed like liberation when it released images from illustration. But they have been released into an eternal present, whereas analog images always carry with them the traces of past time (as well as the traces of death in a representation of life). Nowadays faces can be produced that no longer correspond to the physical world and cannot be described by the contrast between life and death. They replace the memory of presence with a passage of time without any past or future. One could also say: faces can be produced that belong to no one but exist only as images. With this development, images have established their own imaginary world.

The mask, which was the inevitable result of the conversion of the face into an artifact without anyone ever intending that this should happen, becomes an end in itself. It is no longer a double, but rather evokes an infinite number of faces instead of a single one. The total mask is basically no longer a mask, because nothing and no one is there anymore whom it represents or conceals. As an image, a digital face is a paradox per se because it rejects the old task of illustration, and by analogy to a real face, loses its historical connection. Cyberfaces exist in fundamental contradiction to the history of portraiture; they no longer represent *faces*, but only *interfaces* among an infinite number of potential images, whose closed loop separates them from the outside without the interposition of any physical bodies. The world of science fiction has also reached the face. Here images use the dream to realize a synthetic face. Just as in biotechnical morphing, they annul the origins of an inherited and lived face.

Yet this can be countered with a different argument. The impulse to change the face or create a fiction of the face instead of an illustration of the face is as old as human culture. These are the traditions of the play of masks that have been reborn in the virtual world. Digital masks no longer need physical bearers and have become disembodied or, to put it differently, they circulate in a virtual dimension, which can evolve from cyberspace into cyber-Utopia. Here the interplay of face and mask— defined as opposites in the history of the face—is nullified. This is shown by the fact that superficially (in the most literal sense) cyberfaces look like real, normal faces, though they lack any actual relationship to an individual face. One could say

that they temporarily block the path from face to artifact. One cannot carry on a dialogue with an anonymous artifact of the face the way one can with a familiar or recalled human being via a picture. Digital techniques are producing masks that have power over the simulation of life without the need for a living bearer of a mask or the existence of an original from the world of the living. By the same token, in a quasi-revolutionary way, they serve the old impulse to leave the empirical world in order to construct an imaginary world beyond physical space and the boundaries set by our bodies.[3]

A reaction against the fictive face can be seen in the Internet in the form of a digital masquerade. Here partners communicate verbally with one another without faces, using false names that would reveal aspects of their identity such as their sex.[4] "Within electronic networks identity does not depend on visual features." Even when images are in play, "digitized images can be easily changed. Deception can absolutely be programmed in."[5] Whereas virtual faces remain anonymous from the outset, a different kind of anonymity can emerge when real people are acting but nonetheless acting under the cover of a mask offered by the medium. The expression *terminal identity* has been coined for this phenomenon to point to the identity on the computer screen (*terminal*), while at the same time suggesting the end of identity and the retreat of the subject into a new, artificial role.[6]

The *cyberface* can also take over a role that one cannot play oneself—in place of the face as a proxy for the viewer. It comes into play where the old games of science fiction serve new utopian wishes. Yet in the face of the utopian mindset of digital technology, we often overlook the ideological use to which it is put in the mass media to program a collective world of conformity. A vivid example of this phenom-enon can be found in the cover story of *Time* magazine from 1993, which proclaimed "the new face of America" as seen in the multiethnic ideal face of American society. The subject was a young woman who gazed joyfully into the future. In actuality she was a construct (and a compromise) created from many different and contradictory faces, all transformed into a collective ideal. The editors found in this "mix of several races" a shorthand vision of the new America. Even the publishers claimed to have fallen for the charm of these aspirational standards as the image was transformed into an apparently real person. The editorial mentioned the "image of our new Eve," and reported that the male component of the staff had immediately fallen in love with this woman who was only a digital mask. The publishers ingratiated them-selves with their public by reporting that one male colleague had sighed, "it breaks my heart that she doesn't exist."[7]

Several artists have recently critically analyzed the ideological subtext in the use of digital media, or claimed new identities for themselves within the landscape

FIGURE 126 Irene Andessner, Self-portrait from the cycle *Cyberface/Nexus 7*, 1988

of virtual space. In her cycle titled *Cyberface* (1998), Irene Andessner tried to find a template in the "portrait of an artificial human being" (a contradiction in itself). It was her idiosyncratic and subversive goal to use this to program her self-portrait (fig. 126), making that a template for self-expression of a new kind. The artist's choice first fell upon the character of the replicant Rachel in Ridley Scott's film *Blade Runner*, an artificial life-form who possessed no face, but rather only a mask with nothing behind it. She did not receive a face until the artist slipped into her mask in a referential "portrait" and postulated her own presence in the nightmarish light of a virtual world.[8] In doing so she staged "notions of the human image using myself as actress," with the result that the "alien images are superimposed over my self-portrait." When boundaries are transgressed like this they indicate a renewed search for the face in order to give it a space beyond the limits of the physical world.

In the art world as well we sometimes encounter trite idealizations and fashionable nods to the zeitgeist. In the texts the artists published in the catalog for the exhibition *Photography after Photography* (1995), polemics prevail over timeworn photography. In the "digital aura"—Vilém Flusser's term—the face has disengaged itself from any question of identity and become available for arbitrary experiments of *morphing*. The alternative was a sort of digital mask, which presented itself to topple the face from its privileged pedestal. Even here there were, of course, reactions in protest like the *News from Dystopia* in which Anthony Aziz and Sammy Cucher settled a score with current utopias.[9] But the play instinct won out so that no straight course

was ever followed in this game. The artists who took part in this incidentally expressed the secret wish to discover the freedom of new gender roles in the digital arena.

Lynn Hershman surrendered to the hope of "artificial personalities," since the "masked version of one's own personality" no longer matters in an electronic community. She believes that the mask has always served to conceal "one's own fragility." In the choice of "contemporary masks" one can encounter a true mirror of modern society, for here the current problems of humanity are reflected.[10] In contrast to this reflexive seriousness the texts of the young artist Keith Cottingham in the same catalog bristle with naive clichés. He created a furor in the exhibition with his *Fictitious Portraits*, in which he produced seemingly cloned serial portraits of a

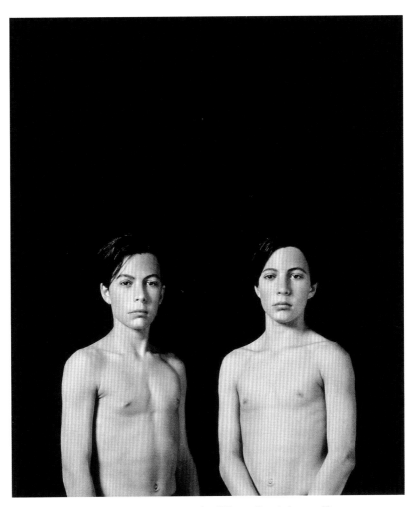

FIGURE 127 Keith Cottingham, *Fictitious Portrait (Double)*, 1993 (digital photograph)

boy in the twilight between childhood and sexual maturity (fig. 127). In the doubling and tripling of *cyberfaces* Cottingham used real faces and clay masks indiscriminately as photographic models for his work on the computer. Although the artist cited the techniques of traditional portraiture like lighting and dark backgrounds as his authority, his intention was quite different.[11]

This also shows up in his hope to be able to use digital painting and montage to design individual generalized beings. To this end he used "figures of clay, anatomical drawings, and images of people of different races, sexes, and age groups." This produced, in his words, a "collage of reality" that could no longer point to any antecedent. In portraiture, which he describes as "the most important invention of modernity," his goal was to deconstruct the subject. To this end he conceived of a "portrait as a multiple personality," which means, in more straightforward terms, the "portrait of a multiple personality." But when Cottingham declares the multiple personality as a great innovation in the art of portraiture, he is tilting at windmills. This also applies to his goal of using cyberfaces to "unmask the belief in the scientific objectivity of representation," for such a naive understanding of representation never predominated in art. Such texts betray an inclination to cyber-Utopias, to use an expression of Margaret Wertheim's.[12]

A surprising example of a new kind of cyber-Utopia can be found in a digitally produced work of art that reflects the world of the icon in Russian orthodoxy (fig. 128) and with it, the world of religion. A huge iconostasis (wall of icons) was erected in Moscow in the fall of 2004. On this wall twenty-three portraits of Christ and the saints were assembled—all the results of digitally processed photo-collages and overpainting. The artist Konstantin Khudyakof exhibited his so-called digital icons in their larger-than-life format (160 × 110 cm) in the Tretyakov Gallery (Moscow), the world's most important icon museum. These icons offered the public the impression of a vision, as though one could look directly at the faces of the saints as they had been in life—as if the viewer had been transported to another sphere.[13] The project, *Deisis* (Supplication), took several years and was financed by the art collector Viktor Bondarenko. It is unique in the digital media as well as in the art world. For this reason, it evoked violent reactions pro and con. The raw material for the icon series was 60,000 photographs of 350 real faces, which even include philosophers and, provocatively, the last czar (a ruler of the Orthodox faith). The facial features of each of these was saved and then manipulated in order to compose the new icons. Each of the monumental faces is constructed with different lighting and its own perspective, which is never the perspective of the public. Using a network of numerous points of light, the faces create the impression of hovering in front of a dark background in the glow of celestial illumination.

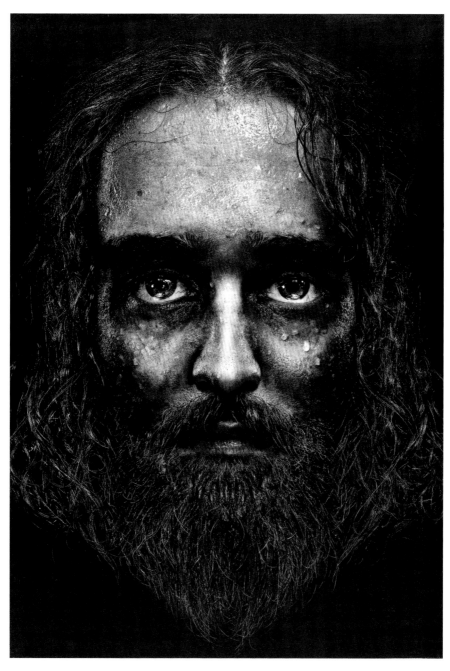

FIGURE 128 Konstantin Khudyakof, *Deisis Icon of Christ*, 2004 (digital photo-collage with overpainting, property of the artist)

The synthetic faces in this installation more or less step into the light out of a sort of black box, representing digital masks that bathe the face in a virtual aura. They offer an experience similar to that of the panels by icon painters of earlier times whose works were viewed in the flickering candlelight of darkened spaces. The cult image returns here in the unexpected guise of a virtual "epiphany," which has changed only in its technology and medium and controls an ancient gaze. But it justifies itself as art by its production process. It makes a transcendental claim in that it shows a face that we have never seen and that we nonetheless believe in. Both of those expectations can be summed up with the concepts of the ideal and the real face. In the case of the "real face" of a famous icon, which the digital portrait of Christ in Moscow recalled with its expansive composition of curling hair and beard, the desire to know how its bearer really looked during his earthly existence predominates. Even the ancient image of Christ was a hybrid, in the sense that, like a mask, it had supposedly been taken from a real, living face. And yet it looked at the faithful with living eyes, which would have been technically impossible in the case of a mechanical copy.[14] Margaret Wertheim, in her cultural history of space, has described the Utopian wish for a return to "spiritual space" in "virtual space."[15] The *Deisis* in Moscow provides a graphic example of this. Old archetypes return in the digital world as artifacts that live in the same interval between dream and empirical reality. When we see the "real image" we never see the true face, but always a proxy for it—or, if you will, a mask.

ACKNOWLEDGMENTS

The work on this book encompassed more than ten years and was frequently interrupted by other projects as well as by doubts about whether it was possible to do justice to an infinite subject like the face in a single text. After my pleasant experience at the graduate seminar "Bild—Körper—Medium" at the Institute of Design in Karlsruhe, for whose fellows my "Bild—Anthropologie" was initially intended, the phase of collecting materials began during a semester as visiting scholar at Northwestern University (Evanston, Illinois). I resumed work on the project during my years at the International Research Center for Cultural Studies in Vienna, where I benefited from valuable suggestions from Lutz Musner and the then-current fellows Sergius Kodera, Thomas Hauschild, and Erhard Schüttpelz. At the same time Sylvia Ferino-Pagden was preparing her magnificent exhibition on the mask at the Kunsthistorisches Museum in Vienna. My time in residence at Williams College, which owes much to conversations with Michael Ann Holly, led me to begin writing. During a conference at the Herzog August Bibliothek in Wolfenbüttel organized and hosted by Christiane Kruse, I was able to propose the subject of theater and mask for discussion. Richard Weihe was also present at this conference, and has been an important conversational partner since my time in Vienna. The question of the face and theater was the topic of my inaugural lecture at the annual meeting of the Bavarian Academy of Fine Arts in 2010. During these years Sigrid Weigel started an extraordinarily fruitful project on the face as artifact at the Center for Literature and Cultural Research in Berlin. This project has been a source of inspiration. It was here that I had the opportunity to publish individual "views" of the face, and here that I enjoyed the collegial support of Dirk Naguschewski and Franziska Thun-Hohenstein. The research on the face by Thomas Macho and Sigrid Weigel, also including Jacques Aumont, Françoise Frontisi-Ducroux, and Claudia Schmölders, to name but a few, is reflected in my text. At the same time that we were working with Peter Weibel to finish a volume about global art for the MIT Press, Andrea Buddensieg offered unflagging patience and advice. I owe a special debt of gratitude to Stefanie Hölscher and the entire C. H. Beck publishing house, for it was their dedication to my subject that kept me on course during those periods of doubt. The title emerged in a cordial conversation with Detlef Felken, the esteemed editor in chief of C. H. Beck. Stefanie Hölscher, Jörg Alt, and Beate Sander were never discouraged by the grueling spadework involved when they took it upon themselves to conduct the crucial picture research and bring it to a happy conclusion.

NOTES

Introduction

1. For a comprehensive treatment of this topic see Thomas Macho's *Analysis of the Power of Images* (2011).

2. Interview with Hanns Zischler about the process of casting. See Loyen and Neumann (2006).

3. "Facial Fashions" (*Gesichtermoden*) is the title of a brochure by "Tumult." See Loyen and Neumann (2006).

4. Sander (1976).

5. Cole (1999), 98. On *Darwin* (1872), see my remarks in chapters 1, 5.

6. Cole (1999), 265.

7. Weigel (2012a), 6ff.

8. Courtine and Haroche (1988), 15ff.

9. Courtine and Haroche (1988), 276ff.

10. Jacques Le Goff, "Conclusions," in *Objet et méthods de l'histoire de la culture*, ed. Jacques Le Goff (Paris: Éditions du CNRS, 1982), 247.

11. Schmitt (2012), 7.

12. Schmitt (2012), 12.

13. Didi-Huberman (1992), 23.

14. Didi-Huberman (1992), 16.

15. Weihe (2004), 13.

16. Weihe (2004), 349.

17. Schüttpelz (2006), 54f.

18. My thanks to Thomas Hauschild for his suggestions for this excursus, and for referring me to Fritz Kramer's study, *Der Rote Fes: Über Besessenheit und Kunst in Afrika* (Frankfurt am Main: Athenäum, 1987), which examines the complementary roles of masquerade and possession.

19. Lucien Clergue, *Jean Cocteau and the Testament of Orpheus: The Photographs* (New York: Viking Studio, 2001), plates 107 and 120.

20. Beyer (2002).

21. Didi-Huberman (2012b).

22. For details, see Didi-Huberman (2012b), 35-47 with illustrations.

23. Macho (2011).

24. I shall mention here only Gilles Deleuze, "Das Bewegungs-Bild," in *Kino*, vol. 1 (Frankfurt am Main, 1989), and Aumont (1992).

25. I refer here to my approach in *Florenz und Bagdad: Eine west-östliche Geschichte des Blicks* (Munich: Beck, 2008).

26. Leila Ahmed, "The Discourse of the Veil," in Bailey and Tawadros (2003), 42ff.

27. Hamid Naficy, "Poetics and Politics of the Veil," in Bailey and Tawadros (2003), 138ff.

28. Jemima Montagu, *East-West Divan: Contemporary Art from Afghanistan, Iran, and Pakistan* (Venice, 2009), 11 and 34f. (with a bio-bibliography); Evelyne Astner, "Nusra Latif Qureshi," in *The Global Contemporary and the Rise of New Art Worlds*, ed. Hans Belting, Andrea Buddensieg, and Peter Weibel (Cambridge, Mass.: MIT Press, 2013), 386ff.

29. The size of this canvas is 76.2 by 63.5 cm. It was purchased by the museum directors in Doha, Qatar; export permission was made possible by an agreement with the National Portrait Gallery in London, which has permission to display the picture in English collections for five years. See Martin Bailey, "Bought by Qatar but Staying in Britain," *Art Newspaper* 222 (2011): 13.

30. Thomas Bluett, *Some Memoirs of the Life of Job, the Son of Solomon* (London, 1734), 63 pages, the source of the following information. See also "Gentleman's Magazine" XX (1750): 270–72. Most recently, Charles T. Davis and Henry Louis Gates, Jr., eds., *The Slave's Narrative* (Oxford: Oxford University Press, 1985), 4.

31. Bluett, *Some Memoirs*, 50.

1. Facial Expression, Masks of the Self, and Roles of the Face

On this topic of the face and the mask, see the important book by Weihe (2004), which draws on the immense literature about individual types of masks, and also Olschanski (2001). On the face, see Simmel (1995); Emmanuel Levinas, *Ethik un Unendliches: Gespräche mit Philippe Nemo*, ed. Peter Engelmann (Vienna, 1996); Sartre (1970); Agamben (2002); Gombrich (1972); Macho (1996; 1999). See also Courtine and Haroche (1988); Macho and Treusch-Dieter (1996); Wysocki (1995); Hindry (1991); Loisy (1992); Landau (1993); Aumont (1992); Blümlinger and Sierek (2002); Schmidt (2003); Löffler and Scholz (2004).

1. Weihe (2004), 52ff. and 179ff.

2. Belting (2001), 34ff.

3. Jacob and Wilhelm Grimm, *Deutsches Wörterbuch*, vol. 4, 1, col. 4087ff., see headword "Gesicht."

4. Friedrich Nietzsche, *Jenseits von Gut und Böse* (Beyond Good and Evil), no. 40, in Nietzsche, *Werke*, ed. Karl Schlechta (Munich, 1955), 2: 604.

5. Gombrich (1977), 17, 20, 22, 42.

6. Argyle and Cook (1976), 67ff.

7. Cf. *Frankfurter Allgemeine Zeitung* (June 22, 2011), 34.

8. Charles Baudelaire, *Oeuvres Complètes* (*Bibliothèque de la Pléiade*), vol. 1 (Paris, 2006), 98 and 830.

9. See the works by Olschansky (2001) and Wysocki (1995).

10. Richard Sennett, *Verfall und Ende des öffentlichen Lebens: Die Tyrannei der Intimität* (Frankfurt am Main: Fischer Taschenbuch, 1983); Goffman (1986).

11. Plessner (1982a), 272.

12. Plessner (1982b), 410f.

13. Plessner (1982a), 240f.

14. See Ulrich Fülleborn and Manfred Engel, eds. *Das Neuzeitliche Ich in der Literatur des 18. und 20. Jahrhunderts. Zur Dialektik der Moderne* (Munich: W. Fink, 1988).

15. Melchior-Bonnet (1994), 146ff. and 162ff.

16. William Shakespeare, *Richard II*, I: 1.

17. Courtine and Haroche (1988), 238f., with quotations from "Discours sur les Sciences et les Arts" (1754) and "Discours sur l'Origine . . . de l'Inegalité parmi les Hommes" (1754).

18. Louis-Sébastien Mercier, "Tableau de Paris," vol. 9 (1782–83), reprint (Paris, 1995), 2: 513–17.

19. See Grimm, *Deutsches Wörterbuch*, op. cit., 2: col. 612.

20. Wolfgang Fritz Haug, "Charaktermaske," in *Historisch-kritisches Wörterbuch des Marxismus*, ed. Haug (Hamburg, 1995), vol. 2, col. 439. My thanks to Gregor Schneider for the citation.

21. Haug (1995), col. 442f.

22. Haug (1995), col. 440.

23. Weihe (2004), 345.

24. Joan Riviere, "Womanliness as a Masquerade" (1929) in Victor Burgin et al., eds., *Formations of Fantasy* (London, 1989), 35–44. Cf. Stephen Heath, *Joan Riviere and the Masquerade*, in ibid., 45–61; Emily Apter, "Demaskierung der Maskerade: Fetischismus und Weiblichkeit von den Brüdern Goncourt bis Joan Riviere," in Weisberg (1994), 177ff.; Julika Funk, *Die schillernde Schönheit der Maskerade: Einleitende Überlegungen zu einer Debatte*, in Bettinger and Funk (1995), 15–28; Inge Kleine, *Der Mann, die Frau, ihre Maske, und Seine Wahrheit: Zur Maske bei Jean-Jacques Rousseau*, in ibid., 154–68.

25. Riviere (1989), *Formations of Fantasy*.

26. Judith Butler, "Subjection, Resistance, Resignification: Between Freud and Foucault," in *The Identity in Question*, ed. John Rajchman (New York: Routledge, 1995), 232.

27. Ina Schabert, "Geschlechtermaskerade," in Schabert (2002), 53ff.

28. On the subject of voice, see Reinhart Meyer-Kalkus, *Stimme und Sprechkünste im 20. Jahrhundert* (Berlin: Akademie Verlag, 2001); Michael Wimmer, "Verstimmte Ohren und unerhörte Stimmen," in *Das Schwinden der Sinne*, ed. Dietmar Kampe and Christoph Wulf (Frankfurt am Main: Suhrkamp, 1984), 115–39.

29. Goffman (1986), 5ff. and 12.

30. Roland Kuhn, *Maskendeutungen im Rorschachschen Versuch* (1944) (Basel, 1954, 2nd ed.), 46, 60f., and 125. My thanks to Lutz Musner for this reference.

31. René Descartes, *Méditations Métaphysiques*, ed. Florence Khodoss, Latin and French (Paris, 1956), 36ff. See also Hans Ebeling, *Die Maske des Cartesius* (Würzburg, 2002).

32. My thanks to Iris Därmann for the reference to this text. Cf. Iris Därmann, "Die Maske des Staates zum Begriff der Person und zur Theorie des Bildes in Thomas Hobbes' *Leviathan*," in *Die Machbarkeit der Welt*, ed. Mihran Dabag and Kristin Pratt (Munich: W. Fink, 2006), 72–92. For the text of Hobbes's *Leviathan* (1651), London, 1962 (chap. 16).

33. Horst Bredekamp, *Thomas Hobbes Visuelle Strategien: Der Leviathan* (Berlin: Akademie Verlag, 1999), 13ff.

34. Macho (1999).

35. Macho (1996), 25. For greater detail see 214ff.

36. *Frankfurter Allgemeine Zeitung* (April 13, 2002), 9.

37. *Der Spiegel* (July 19, 2004), 145.

38. Cole (1999).

39. Macho (1996), 27.

40. Simmel (1995), 39; Levinas, *Ethik und Unendliches*, 65.

41. Deleuze and Guattari (1992), 160. See also the commentary by Nicola Suthor in Preimesberger, Baader, and Suthor (1999), 464ff.

42. Deleuze and Guattari (1992), 233.

43. Deleuze and Guattari (1992), 230ff. ("The Year Zero: The Creation of the Face," especially 248ff. and 258f.).

44. Gilles Deleuze, *Francis Bacon: Logik der Sensation* (Munich: Taschenbuch, 1995), 19ff.

45. Cf. Belting (2005), 84f.

46. Didi Huberman (1992).

2. The Cult Origin of the Mask

1. Belting (2001), 153f., with reference to Neolithic masks from the Near East.

2. For a more complete discussion, see Belting (2001), chap. "Image and Death."

3. Beate Salje, "Die Statuen aus Ain Ghazal," in *10,000 Jahre Kunst und Kultur aus Jordanien: Gesichter des Orients*, ed. Beate Salje (Bonn: Austellungskatalog Vorderasiatisches Museum [Berlin], Kunst- und Ausstellungshalle der Bundesrepublik Deutschland, 2004), 31ff.; cf. Belting (2001), 150ff.

4. Belting (2001), cf. chap. "Bild und Tod."

5. Ferino-Pagden (2009), 68f.

6. Salje, "Die Statuen aus Ain Ghazal," 134.

7. Belting (2001), 152 with illustrations 6 and 7.

8. Klaus Schmidt, *Sie bauten die ersten Tempel: Das Rätselhafte Heiligtum der Steinzeitjäger; Die archäologische Entdeckung im Göbekli Tepi* (Munich: Beck, 2006), 42.

9. See Leo Frobenius, *Monumenta Africana: Der Geist eines Erdteiles*, vol. 6 (Berlin, 1929), 457, with evidence from Africa.

10. Ferino-Pagden (2009), no. I.3.

11. Belting (2001), 160ff.

12. Concerning this portrait, cf. Hans Belting, *Bild und Kult* (Munich: Beck, 1990), 44 and illustration 25.

13. Ferino-Pagden (2009), 59.

14. See the scholarship cited in the headnote to chapter 1.

15. Lévi-Strauss (1979), 144.

16. Claude Lévi-Strauss, *Masques*, in *L'œil* 62, 1960, 29–35 (interview with Jean Pouillon).

17. On this topic, see Fritz Kramer, *Der Rote Fes: Über Bessenheit und Kunst in Afrika* (Frankfurt am Main: Athenäum, 1987), 160.

18. Kramer, *Der Rote Fes*, 138ff.

19. Kramer, *Der Rote Fes*, 140 and 158–60.

20. Jutta Frings, ed., *James Cook und die Entdeckung der Südsee* (Bonn: Kunst und Ausstellungshalle der Bundesrepublik Deutschland; Museum für Völkerkunde, 2009), 233, with illustrations at 422–24.

21. Michel Leiris, "Masques dogon," in *Minotaure Sonderausgabe*, 1933, 45ff. On Leiris and his fascination with the "secret language" of the Dogon, see Irene Albers, "Passion Dogon," in *Black Paris: Kunst und Geschichte einer schwarzen Diaspora*, ed. Tobias Wendl (Wuppertal: Peter Hammer Verlag, 2006), 160ff.

3. Masks in Colonial Museums

1. Angelika Friederici, ed., *Castan's Panopticum: Ein Medium wird besichtigt*, no. 6 (Berlin, 2009), with documentation and illustrations.

2. Exceptions can be found in works like those of Jean Guiart and others in Loisy (1992), 112ff.

3. W.J.T. Mitchell, *Iconology: Image, Text, Ideology* (Chicago, 1986), 160 ff.; Mitchell, *What Do Pictures Want? The Lives and Loves of Images* (Chicago: University of Chicago Press, 2005), 160ff.

4. Cf. Mitchell, *Iconology*, 186.

5. Karl Einstein, *Bebuquin oder die Dilettanten des Wunders: Prosa und Schriften, 1906–1929* (Leipzig, 1989), 172.

6. Gail Levin, "Primitivism in American Art: Some Literary Parallels of the 1910s and 1920s," *Arts Magazine* 59 (1984): 101–5.

7. James Clifford, *The Predicament of Culture: Twentieth-Century Ethnography, Literature, and Art* (Cambridge, Mass.: Harvard University Press, 1988), 117ff.

8. Whitney Chadwick, "Fetishizing Fashion/Fetishizing Culture," *Oxford Art Journal* 18 (1995): 3–17.

9. Isabelle Monod-Fontaine, "Le Tour des objets," in *André Breton: La beauté convulsive*, ed. Agnès Angliviel du la Beau-melle (Paris: Musée Nationale d'Art Moderne, Centre Georges Pompidou, 1991), 64–83.

10. André Breton, "Phénix du Masque," *XXe Siècle*, new series 15 (1960): 57–63, reprinted in Breton, *Perspective Cavalière* (Paris: Gallimard, 1970), 182ff.

4. Face and Mask in the Theater

1. Ferino-Pagden (2009), 144ff. (on antiquity) and 158ff. (on Commedia dell'Arte). On the transition from mask to person on the stage, see also Claudio Bernardi, "Dalla maschera all volto," in *Storia del teatro moderno e contemporaneo*, ed. Roberto Alonge and Guido Davico Bonino (Turin, 2000), 1: 1163–83.

2. Plessner (1982b), 405.

3. Roger Caillois, *Les Jeux et les Hommes* (Paris, 1967), 205.

4. Plessner (1982b), 410ff.

5. Torquato Accetto, *Della dissimulazione onesta* (Naples, 1641).

6. Remo Bodei, "Die Maske auf dem Fleisch," in Schabert (2002), 44.

7. Justus Lipsius, *Politicorum*, Libri VI (Rome, 1604), 145f.

8. Frontisi-Ducroux, 1995, 14ff., 22f., and 40. Cf. also Bettini (1991); Ghiron-Bistagne (1986); Jean-Thierry Mertens, *Le Masque et le Miroir* (Paris, 1978).

9. Frontisi-Ducroux (1995), 55.

10. Hall (2000), 4f. (about the Greeks).

11. Hall (2000), 34.

12. Hall (2000), 81.

13. Christopher Schmidt, *Süddeutsche Zeitung* (July 7, 2010), 16.

14. Erika Simon, "Stumme Masken und Sprechende Gesichter," in Schabert (2002), 20f.

15. Vernant (1990), 216ff. and 226f.

16. Frontisi-Ducroux (1995), illustrations 1 and 5f.

17. Hall (2000), 28.

18. Florence Dupont, *L'Orateur sans visage. Essai sur l'Acteur Roman et son Masque* (Paris, 2000), 123.

19. Dupont, *L'orateur sans visage*, 124ff., derives *vultus* from the meaning "to want," "to want to express," and the word *facies* from the meaning "to make, create." This differentiation between expression and physiognomy lasted until the Middle Ages before being abandoned.

20. Frontisi-Ducroux (1995), 44 and illustration 12, which refers to Cicero's text "De Oratore," where one reads that "the eyes of the actor gleam from out of the mask" (*ex persona ardent oculi histrionis*), II.193.

21. Frontisi-Ducroux (1995), 130, with references to Cicero, *De Oratore*, III.221: "Ut imago est animi vultus, sic indices oculi." Cf. also Dupont, *L'orateur sans visage*, 156, for the following remarks.

22. Harriet I. Flower, *Ancestor Masks and Aristocratic Power in Roman Culture* (Oxford: Clarendon Press, 1996). See also Christa Belting-Ihm, *Imagines Maiorum*, in *Reallexikon für Antike und Christentum* 17, col. 995ff.; Belting (2001), 177ff.

23. Belting (2005), 47ff.; Weihe (2004), 28f. and 181ff.

24. Belting (2005), 76f.

25. Cf. Weihe (2004), 190ff. under the rubric "Verinnerlichung der Maske" (Internalization of the Mask).

26. Weihe (2004), 26f.

27. On the word *Larve*, cf. Eckhard Leuschner, *Persona, Larva, Maske: Ikonologische Studien zum 16. bis frühen 18. Jahrhundert* (Frankfurt am Main: P. Lang, 1997).

28. Stephen Greenblatt, *Renaissance Self-Fashioning: From More to Shakespeare* (Chicago: University of Chicago Press, 1980), cf. also Ernst Rebel, *Die Modellierung der Person, Studien zu Dürers Bildnis des Hans Kleberger* (Stuttgart: F. Steiner, 1991).

29. Erasmus of Rotterdam, *Morias enkomion seu laus stultitiae* (1511), *Ausgewählte Schriften des Erasmus* (2: 2), ed. Wendelin, Schmidt-Dengler (Darmstadt, 1975), and *Erasmus von Rotterdam, Das Lob der Narrheit (In Praise of Folly)*, afterword by Stefan Zweig (Munich, 1987), 57ff.; cf. Hans Belting, *Hieronymus Bosch: Garten der Lüste* (Munich: Prestel, 2002), 96f.

30. Barbara Ravelhofer, *The Early Stuart Masque: Dance, Costume, and Music* (Oxford: Oxford University Press, 2006), 4 (with documentation).

31. The concept *personage* comes up in a contemporary description, cf. Allardyce Nicoll, *Stuart Masques and the Renaissance Stage* (London: G. G. Harrap, 1937), which contains extensive documentation of the genre.

32. Nicoll (1937), illustrations 174 and 175.

33. William Shakespeare, *The Tempest* (The Oxford Shakespeare), ed. Stephen Orgel (Oxford: Oxford University Press, 1987), 43ff., in the commentary.

34. Weihe (2004), 169ff. and 173 for the following. The Diderot quotations come from the "Paradoxe sur le Comédien," in Denis Diderot, *Œuvres Complètes*, vol. 20, ed. Jane Marsh Dieckmann et al. (Paris, 1995), 36 and 88.

35. Sennett, *Verfall und Ende des öffentlichen Lebens*, 33.

36. François-Hédelin d'Aubignac, *La Pratique du Théâtre*, ed. Hélène Baby (Paris: H. Champion, 2001), 77ff.; Jean Rousset, *L'intérieur et l'extérieur* (Paris, 1968), 169ff.

37. Translations taken from Jean Racine, *Phädra*, ed. and newly translated by Wolf Steinsieck (Stuttgart: Reclam, 1995), 26, 30, 38f.

38. Hall (2000), 38, 41.

39. Hall (2000), 59.

40. Examples in Annette Drew-Bear, *Painted Faces on the Renaissance Stage* (London: Associated University Presses, 1994), 94f. and 99f.

41. My thanks to Frank-Patrick Steckel for this reference.

42. Bernardi, "Dalla maschera all volto," 1169f.

43. Marco Baschera, *Téâtralité dans l'œuvre de Molière* (Tübingen: Gunter Narr Verlag, 1998), 79, note 149, and 144ff. My thanks to Martin Zenck for this reference.

44. Eckhard Leuschner, in Ferino-Pagdan (2009), no. VI.12.

45. Eckhard Leuschner, in Ferino-Pagdan (2009), no. VI.10; Weihe (2004), 11f. Cf. also Diane de Grazia Bohlin, ed., *Prints and Related Drawings by the Carracci Family: A Catalogue Raisonné* (Washington, D.C.: National Gallery of Art, 1979), no. 212; Diane de Grazia Bohlin, ed., *Le stampé dei Carraci: Con i desgni le incisioni, le copie e i dipinti connessi; Catologo critico* (Bologna, 1984), no. 239, cat. 212. On the trial strike, cf. Christiane Kruse, "Zur Kunst des Kunstverbergens im Barock," in *Animazioni/Transgressionen*, ed. Ulrich Pfisterer (Berlin: Akademie Verlag, 2005), 102f.

46. Giovanni Antonio Massani, see Kruse (2003), 102.

47. Peter Schatborn and Marieke de Vinkel, "Rembrandts portraits van de acteur Willem Ruyter," *Bulletin van het Rijksmuseum* 44 (1996): 382ff.

48. George W. Brandt and Wiebe Hogendoorn, eds., *German and Dutch Theater, 1600–1848* (Cambridge: Cambridge University Press, 1992), 349ff. and 385f.

49. Walter Liedtke and Michiel C. Plomp, eds., *Vermeer and the Delft School*, Metropolitan Museum of Art, New York, and National Gallery, London (New Haven, Conn.: Yale University Press, 2001), 56ff.; Sotheby's, *Important Old Master Drawings* (New York, January 27, 2001), 120ff., Lot No. 141, with extensive documentation.

50. Aristotle, *Poetics*, ed. Stephen Halliwell, Loeb Classical Library 199 (Cambridge, Mass.: Harvard University Press, 1995), 44.

51. Brandt and Hogendoorn, *German and Dutch Theater*, 396f.

52. Samuel van Hoogstraten, *Inleiding tot de hooge schoole der Schilderkonst* (Rotterdam, 1678), 109f.; cf. Ernst van de Wetering, "The Multiple Functions of Rembrandt's Self-Portraits," in White and Buvelot (1999), 20.

53. Dedication to Madame de Comballet, cf. Pierre Corneille, *Der Cid*, ed. Hartmut Köhler (Stuttgart, 1997), 8.

54. Courtine and Haroche (1988), 237ff.

55. Caillois, *Les Jeux et les Hommes*, 254ff.

56. Andreas Beyer, "Masken für höfische Feste und Turniere," and Lina Urban Padovan, "Feste, Spiele und Masken im Venezianischen Settecento," in Ferino-Pagdan (2009), 241 and 242–45.

57. Christopher Schmidt, *Süddeutsche Zeitung* (July 17, 2010), 16.

5. From the Study of the Face to Brain Research

1. Hagner (2004), 264ff.

2. Magli (1989). Cf. Olschanski (2001), 14ff.; Schmölders

(1995 and 1996); Borrmann (1994); Tom Gunning, "In Deinem Antlitz: Dir zum Bilde. Physiognomik, Photographie und die gnostische Mission des frühen Films," in Blümlinger and Sierek (2002), 22ff.; Schmidt (2003), 19ff. On Lichtenberg's famous controversy with Lavater, see Georg Christoph Lichtenberg, "Über Physiognomik," in Lichtenberg, *Schriften und Briefe*, ed. Wolfgang Promis, vol. 3 (Munich, 1994), 252ff.

3. Lichtenberg, *Schriften und Briefe*, 295, as in previous note.

4. Cole (1999).

5. Marin Cureau de la Chambre, *L'art de connaître les hommes* (Paris, 1659), 6f. Cf. also Bodei in Schabert (2002), 45.

6. Immanuel Kant, *Anthropologie in Pragmatischer Hinsicht* (1798/1800), in Gesammelte Schriften I.1.3. and II.A., 273.

7. Giuliani (1986), 49ff.

8. Giambattista della Porta, *Teatro*, vol. 3: *Commedia*, ed. Raffaele Sirri (Naples, 2002), 346f. The reference here is to a scene in the second act of *Astrologo*.

9. My thanks to Sergius Kodera for his valuable suggestions. Cf. Kodera, "Meretricious Arts," *Zeitsprünge* 9 (2005): 101ff. on Della Porta; cf. also William Eamon, *Science and the Secrets of Nature* (Princeton, N.J.: Princeton University Press, 1994), 195ff.

10. Giambattista della Porta, *Coelestis Physiognomia*, ed. Alfonso Paolella (1996), Bk. I.1 and p. 1of. as well as 18f. (Latin) and 197ff. (Italian). Cf. Davide Stimilli, *The Face of Immortality: Physiognomy and Criticism* (Albany: State University of New York Press, 2005), 66f., with a discussion of the concept (aria) for the face that Della Porta employs.

11. Gombrich (1972), 13 and 42.

12. Charles Lebrun, *Conférence sur l'expression générale et particulière* (1688). Cf. Thomas Kirchner, *L'expression des passions: Ausdruck als Darstellungsproblem in der französischen Kunst und Kunsttheorie des 17. und 18. Jahhunderts* (Mainz, 1981); Gunning, "In Deinem Antlitz," see note 138, 26f.; Schmidt (2003), 21ff. on Hogarth; cf. William Hogarth, *Analyse der Schönheit* (1753), ed. Jörg Heininger (Dresden, 1995), 176.

13. Lavater (2002), 1: 14 and 122. For Lavater cf. Shookman (1993).

14. Lavater (2002), 1: 196 and 2: 146.

15. Lavater (2002), 3: 81.

16. Lavater (2002), 2: 75.

17. Lavater (2002), 2: 99.

18. Lavater 2002, 2: 299.

19. Lavater (2002), 2: 154.

20. Lavater (2002), 1: 131.

21. Schmölders (1995), 31; then Graeme Tytler, *Physiognomy in the European Novel* (Princeton, N.J.: Princeton University Press, 1982), 102.

22. Lavater (2002), 1: 131.

23. Wilhelm von Humboldt, *Werke*, vol. 5 (Stuttgart, 1981), 25f.

24. Georg Christoph Lichtenberg, *Aphorismen: Schriften. Briefe*, ed. Wolfgang Promis (Munich, 1974), 268–307, esp. 299.

25. Lichtenberg, *Aphorismen*, 276 and 290.

26. Lichtenberg, *Aphorismen*, 291.

27. Hagner (1997), 89ff. Cf. also Michael Hagner, *Der Geist bei der Arbeit: Zur visuellen Repräsentation cerebraler Prozesse*, in *Anatomien medizinischen Wissens*, ed. Cornelius Borck (Frankfurt am Main: Fischer Taschenbuch Verlag, 1996), 259–86; Hagner (2004).

28. The concept appears in Carl Gustav Carus, *Symbolik der menschlichen Gestalt* (Dresden, 1858; 1938), 156; cf. Hagner (2004), 17.

29. Lichtenberg, *Aphorismen*, 279f.

30. Hagner (2004), 76ff.

31. Carl Gustav Carus, *Atlas der Cranioskopie oder Abbildungen der Schädel- und Antlitzformen berühmter oder sonst merkwürdiger Personen* (Leipzig, 1843), plate I. Cf. Hagner (2004), 88 and illustration 17. Cf. also Albrecht Schöne, *Schillers Schädel* (Munich: Beck, 2002).

32. Carus, *Atlas der Cranioskopie*, 206 and 209.

33. Georg Wilhelm Friedrich Hegel, *Phänomenologie des Geistes*, ed. Johannes Schulze (Stuttgart, 1932), 248 and 150f.

34. Hegel, *Phänomenologie des Geistes*, 261f.

35. Hagner (2004), 119ff.

36. Hagner (2004), 205.

37. *News from Philosophical Hall* 11 (2007), no. 1, illustrations 15–20.

38. Hagner (2004), 303.

39. Hagner (2004), 309.

40. Darwin (1989), 1. Cf. Schmidt (2003), 48ff.; Gunning (2002), 37ff.

41. Darwin (1989), illustration 1.

42. Guillaume-Benjamin Duchenne de Boulogne, *Mécanisme de la physionomie humaine, ou Analyse électrophysiologique de l'expression des passions applicable à la pratique des arts plastiques* (Paris, 1862); cf. Schmölders (1995); Schmidt (2003), 59ff.; Gunning (2002), 31ff.

43. Darwin (1989), 285.

6. Nostalgia for the Face and the Death Mask in Modernity

1. Schmölders (1995), 190; cf. citations in footnote 138 as well as Michael Davidis and Ingeborg Dessoff-Hahn, eds., *Archiv der Gesichter: Toten- und Lebendmasken aus dem Schiller-Nationalmuseum*, Museum Schloss Moyland and Alexanderkirche (Marbach am Neckar: Museum für Sepulchralkultur Kassel, 1999).

2. Durs Grünbein, in Davidis and Dessoff-Hahn, *Archiv der Gesichter*, 12 and 16.

3. Benkard (1926), 35.

4. Belting (2005).

5. Lavater (2002), 4: 154.

6. Rainer Maria Rilke, *Die Aufzeichnungen des Malte Laurids Brigge* (The Notebooks of Malte Laurids Brigge) (1910; Leipzig, 1933), 94.

7. Maurice Blanchot, "L'Arrête de morte" (Paris, 1948), 19–22. Cf. the analysis by Didi-Huberman (2003), 157ff. My thanks to Georges Didi-Huberman for sending me his text.

8. Benkard (1926), xxvii, xxxvi, and xxxvii; Friedell (1929).

9. Grünbein, in Davidis and Dessoff-Hahn, *Archiv der Gesichter*, 12.

10. Karl Jaspers, *Die geistige Situation der Zeit* (1931); (Berlin, 1971), 144.

11. On Jünger's and Döblin's texts from 1929, see the seminal remarks (with citations) in Wolfgang Brückle, "Kein Portrait mehr? Physiognomik in der Deutschen Bildnisphotographie um 1920," in Schmölders and Gilman (2000), 131ff., esp. 136.

12. Brückle, "Kein Portrait mehr?" 144f.

13. Brückle, "Kein Portrait mehr?" 150f. Cf. August Sander, *Menschen des 21. Jahrhunderts*, vol. 2, ed. Suzanne Lange (Munich, 2000), plates II: 8.1, and II: 9.3.

14. On Lendvai-Dircksen and her circle, cf. Falk Blask and Thomas Friedrich, eds., *Menschenbild und Volksgesicht: Positionen zur Porträtfotografie* (Münster, 2005), as well as the essay by Ulrich Hägele, "Erna Lendvai-Dircksen und die Ikonographie der völkischen Fotografie," 78ff.; further, Janos Frecot, "Das Volksgesicht," in Faber and Frecot (2005), 80ff.

15. Cf. the image *Fischertochter von der Kurischen Nehrung* (Fisherman's Daughter from the Curonian Peninsula [Lithuania]).

7. Eulogy for the Face: Rilke and Artaud

1. Rainer Maria Rilke, *Die Aufzeichnungen des Malte Laurids Brigge* (The Notebooks of Malte Laurids Brigge), ed. Hangeorg Schmidt-Bergman (Frankfurt am Main: Suhrkamp, 2000), 13.

2. Rilke, *Die Aufzeichnungen*, 11f.

3. Rainer Maria Rilke, *Auguste Rodin* (Leipzig, 1913), 25, cf. also 18, 23, 49; John L. Tancock, *The Sculpture of Auguste Rodin: The Collection of the Rodin Museum Philadelphia* (Boston, 1976), 473ff., no. 79; Rainer Maria Rilke, *Auguste Rodin: Erster Teil*, in Rilke, *Sämtliche Werke*, vol. 5 (Frankfurt am Main, 1965), 157.

4. On images of the Holocaust, cf. Georges Didi-Huberman, *Images malgré tout* (Paris: Minuit, 2003).

5. For the cult of the machine, cf. Pontus Hultén, *The Machine, as Seen at the End of the Mechanical Age* (New York: Museum of Modern Art, 1968).

6. Fernand Léger, *Fonctions du la peinture* (Paris, 1965), 53ff.

7. Günther Anders, *Die Antiquiertheit des Menschen* (Munich: Beck, 1992), 1: 85 and 280.

8. On the drawings, cf. Paule Thévenin and Jacques Derrida, eds., *Antonin Artaud: Dessins et portraits* (Paris: Gallimard, 1986), where Derrida published the text, "Forcener le subjectile"; and Margit Rowell, ed., *Antonin Artaud: Works on Paper* (New York: Museum of Modern Art, 1996), where Artaud's text appears with English translation, 94ff., with commentary by Agnès de la Beaumelle, 89ff.

9. For the text, see preceding footnote.

10. The drawing measures 64 x 49 cm. Cf. Thévenin and Derrida, *Antonin Artaud: Dessins et portraits*, no. 111.

8. The European Portrait as Mask

1. See Faber and Frecot (2005).

2. Antonio Natali, *La Piscina di Betsaida: Movimenti nell'arte fiorentina del Cinquecento* (Florence: Maschietto and Musolino, 1995), 116ff.; Hannah Baader, "Anonym: 'Sua cuique persona'; Maske, Rolle, Porträt (um 1520)," in Preimesberger, Baader, and Suthor (1999), 239–46; Leuschner, *Persona, Larva, Maske*, 328ff.; Hans Belting, "Repräsentation und Anti-repräsentation: Grab und Porträt in der frühen Neuzeit," in Hans Belting, Dietmar Kamper, and Martin Schulz, *Quel Corps? Eine Frage der Repräsentation* (Munich: W. Fink, 2002), 35; Ferino-Pagden (2009), 82f., no. 1, 6.

3. "Consolatoria," in Francesco Guiccardini, *Opere*, ed. Emanuella Lugnini Scarano (Turin, 1983), 1: 508.

4. Weihe (2004), 81.

5. Édouard Pommier, *Théorie du portrait: De la Renaissance aux Lumières* (Paris: Gallimard, 1998), 62.

6. Giorgio Vasari, *Le Vite di più eccelente pittori scultori ed architettori*, ed. Gaetano Milanesi (Florence, 1906; 2nd ed. 1973), 5: 576. See also Leuschner, *Persona, Larva, Maske*, 323ff.

7. Ferino-Pagden (2009), 85f., I.18.

8. Arthur Danto, "Cindy Sherman: History Portraits," in Danto, *Past Masters and Postmoderns* (New York, 1991); Christa Schneider, *Cindy Sherman, History Portraits: Die Wiedergeburt des Gemäldes nach dem Ende der Malerei* (Munich, 1995).

9. Rosalind E. Krauss and Norman Bryson, *Cindy Sherman: Arbeiten von 1975 bis 1993* (Munich, 1993), 169; Thomas Kellein, ed., *Cindy Sherman, Ausstellungkatalog, Kunsthalle Basel, etc.* (Munich, 1991), 57.

10. Marga Taylor, ed., *Sugimoto: Portraits* (Berlin: German Guggenheim; Ostfildern-Ruit, 2000), 85.

11. For this concept of interface see Belting (2002), 34, and Belting and Kruse (1994), 39ff.

12. Régius Michel, "Portraits de fous," in Sylvain Laveis-sière, *Géricault* (Paris: Galleries Nationales du Grand Palais, 1991), 244 and illustration 381.

9. Face and Skull: Two Opposing Views

1. On the subject of this amnesia that surrounds death, see Constantin von Barloewen, ed., *Der Tod in den Weltkulturen und Welreligionen* (Munich, 1966), especially the editor's intro-duction and the essay by Jean Ziegler, "Die Herren des Todes," 433ff. See also Jan Assmann and Rolf Trauzettel, eds., *Tod, Jenseits und Identität: Perspektiven einer Kulturwissenschaftli-chen Thanatologie* (Freiburg and Munich: K. Alber, 2002).

2. On the topic of sensational deaths, see John Taylor, *Body Horror: Photojournalism, Catastrophe, and War* (New York: New York University Press, 1998).

3. On this topic, see Belting (2001), 115ff.; Belting and Kruse (1994), 39f. and 45f. See also Boehm (1985); Dülberg (1990); Koerner (1993); Pommier, *Théorie du portrait*; Preimesberger, Baader, and Suthor (1999); Beyer (2002); Belting (2005).

4. Schöne, *Schillers Schädel*. On the skull in the Renais-sance, see Belting (2002), 42f.

5. Irving Lavin, "On the Sources and Meaning of the Renaissance Portrait Bust," *Arts Quarterly* 33 (1970): 207–26; Kohl and Müller (2007); Jeanette Kohl, "Gesichter Machen: Büste und Maske im Florentiner Quattrocento," *Marburger Jahrbuch für Kunstwissenschaft* 34 (2007): 77–99.

6. Ferino-Pagden (2009), 85f., I.18.

7. Julian Gardner, *The Tomb and the Tiara: Curial Tomb Sculpture in Rome and Avignon* (Oxford: Clarendon Press, 1992), 157f. with illustrations 5 and 12.

8. Belting (2002), see note, esp. 39f. and illustration 5; the diptych of Jan Gossaert has been thoroughly examined by Ariane Mensger, *Jan Gossaert: Die niederländische Kunst zu Beginn der Neuzeit* (Berlin: Reimer, 2002), 45f.

9. Dülberg (1990), 236 and no. 208; Ferigno-Pagden (2009), 22, illustration I.a.

10. Koerner (1993), 2368 and illustration 139.

11. Joseph Connors, "The Baroque Architect's Tomb," in *An Architectural Progress in the Renaissance and Baroque*, ed. Henry Millon and Susan S. Munschowers (University Park: Pennsylvania State University, 1992), 391f.

12. Belting and Kruse (1994), plate 36; Belting (2010), 66f., with an explanation of the inscription.

10. The "Real Face" of the Icon and the "Similar Face"

1. See Belting (2005), 39f.

2. Belting (2005), 126f.; Ewa Kuryluk, *Veronica and Her Cloth* (Cambridge: Blackwell, 1991).

3. See sources in Belting, *Bild und Kult*, 602, no. 37.

4. Belting and Kruse (1994), 54f., with illustration 26f.

5. Georges Chastellain, *Oeuvres*, ed. Karvyn de Letten-hove, 7 (Brussels, 1865), 219f. ("Il avoit une identité de son dedans à son dehors").

6. Belting and Kruse (1994), 50 and plate 41.

7. Jean-Luc Nancy, *Le regard du portrait* (Paris: Galilée, 2000).

8. Nancy, *Le regard du portrait*, passim.

9. Belting, *Bild und Kult*, 605, no. 38; Belting, *Florenz und Bagdad*, 243f.

10. Gioacchino Barbera, *Antonello da Messina* (Paris, 1998), 42 with illustrations. In 1529 Marcantonio Michiel saw a picture by Antonello—the London St. Jerome—in the collection of Antonio Pasqualino in Venice, and said of it that many considered it a Netherlandish work. But the face was deemed "*finite alla italiana*," in other words, in the Itali-anate manner; see Theodor Frimmel, ed., *Der Anonimo Morelliano* (Vienna, 1888), 98.

11. Barbera, *Antonello da Messina*, 100.

12. Koerner (1993), 72f. On this image, see Belting (2005), 114f.

13. Fedja Anzelewsky, *Albrecht Dürer: Das malerische Werk* (Berlin, 1971), no. 49.

14. Anzelewsky, *Albrecht Dürer*, 165.

15. See Gabriele Kopp-Schmidt, "Mit den Farben des Apelles: Antikes Künstlerlob in Dürers Selbstbildnis von 1500," *Wolfenbüttler-Mitteilungen* 28 (2004): 1f.

16. Koerner (1993), 92 and illustration 46, with a late copy.

17. Albrecht Dürer, *Tagebücher und Briefe* (Munich, 1927), 86.

11. The Record of Memory and the Speech Act of the Face

1. Courtine and Haroche (1988).

2. Denis Diderot, *Ästhetische Schriften*, ed. Friedrich Bes-senge (Berlin, 1984), 123f.

3. Belting and Kruse (1994), 172 and plate 78.

4. Christian Müller and Stefan Kemperdick, *Hans Holbein d. J. Die Jahre in Basel 1515–1532, Ausstellungskatalog, Kunst-museum Basel* (Munich, 2006), 194f.

5. For complete discussion, see Belting (2000), 117f., which I draw upon in this section.

6. See Michel Pastoureau, *Traité d'Héraldique* (Paris, 1997), 91f. (écu), 170f. (heraldic face), and 201f. (*badges, devises, imprese, emblèms*).

7. See Belting (2001), 123 and illustration 5.1.

8. Belting (2001), 138f.

9. Preimesberger, Baader, and Suthor (1999), 220f.

10. Preimesberger, Baader, and Suthor (1999), 230f.

11. Belting (2005), 190f.

12. Martin Warnke, *Cranachs Luther: Entwürfe für ein Image* (Frankfurt am Main: Fischer, 1984), 36f.

13. Rome, Galleria Doria Pamphili; see Stephanie Buck and Peter Hohenstatt, *Raffaello Santi, Known as Raphael, 1483–1520* (Cologne: Könemann, 1998), 97f. and illustration 124.

14. Buck and Hohenstatt, *Raffaello Santi, Known as Raphael, 1483–1520*, 99.

12. Rembrandt's Self-Portraiture: Revolt against the Mask

1. Philippe Lejeune, *Le Pacte autobiographique* (Paris, 1972).

2. Andrew Small, *Essays in Self-Portraiture: A Comparison of Technique in the Self-Portraits of Montaigne and Rembrandt* (New York: P. Lang, 1996), 3f. and 9f.

3. Small, *Essays in Self-Portraiture*, 11 and 13ff.

4. Small, *Essays in Self-Portraiture*, 115f. The metaphor of the egg figures here, for the exterior view of eggs (which always look the same) conceals the fact that every egg "when it has hatched, produces a unique creature" (p. 121, with reference to Montaigne's chapter about experience).

5. For more complete discussion of this topic, see Belting and Kruse (1994), 39f.

6. See Belting (2010) for a more complete discussion, 39f.

7. Nancy, *Le regard du portrait*, 41f. See also Stoichita (1998), 276f., and especially Raupp (1984), 302f.

8. Nancy, *Le regard du portrait*, 47.

9. Nancy, *Le regard du portrait*, 41f. and 47.

10. Beyer (2002), 190; Stoichita (1998), 241f.

11. Most recently Sibylle Ebert-Schifferer, *Caravaggio: Sehen, Staunen, Glauben; Der Maler und sein Werk* (Munich: Beck, 2009), 2011f. See also Howard Hibbard, *Caravaggio* (New York: Harper and Row, 1983), 262f; Sylvia Cassani, ed., *Caravaggio: L'ultimo Tempo, 1606–1610* (Naples: Museo di Capo di Monte, 2004), 101f. and no. 16.

12. See Sergio Samek Ludovici, ed., *Vita del Caravaggio dalle testimonianze del suo tempo* (Milan, 1956), 111.

13. Friedrich Polleross, "Between Typology and Psychology: The Role of the Identification Portrait in Updating Old Testament Representations," *Artibus et Historiae* 24 (1991): 75–117.

14. Raupp (1984), 17f. (generally on self-portraiture), and 166f (on Rembrandt's age); Lyckle de Vries, "Tronies and Other Single-Figured Netherlandish Paintings," *Leids Kunsthistorisch Jahrbeek* 8 (1989): 185–202; Japp van der Veen, "Faces from Life, Tronies and Portraits in Rembrandt's Painted Oeuvre," in Blankert (1997), 69f; Ernst van de Wettering, "The Multiple Functions of Rembrandt's Self-Portraits," in White and Buvelot (1990), 10f.; Marieke de Winkel, "Costume in Rembrandt's Self-Portraits," in White and Buvelot (1990), 6of.

15. *Trésor de la langue française*, vol. 16 (Paris, 1994), col. 633; *Dictionaire historique de la langue française*, ed. Alain Rei (Paris, 1992), col. 2173; *Woordenboek der Nederlandse Taal*, vol. 172, ed. N. Bakker (The Hague and Leiden, 1949), col. 3217–20.

16. Nina Trauth, *Maske und Person: Orientalismus im Porträt des Barock* (Munich, 2009).

17. See *Woordenboek der Nederlandse Taal*, vol. 172, col. 3217.

18. "Het Konterveytsel van de Tronie van Symon den Dansaert," in Jean Denucé, *Antwerphens Konstkammers*, 110, 1642.

19. White and Buvelot (1999), 131, no. 25.

20. Cited in Van der Veen, "Faces from Life," 69f.

21. Raupp (1984), 303.

22. Small, *Essays in Self-Portraiture*, 5, 7, 12.

23. White and Buvelot (1999), 99, and no. 7.

24. White and Buvelot (1999), no. 20, 22 (monogrammed and dated RHL 1631), and 23.

25. Raupp (1984), 303.

26. Paris (1973), 33f.

27. Raupp (1984), 179. On the question of the meaning, which Albert Blankert has touched upon, see Ekkehard Mai, "Zeuxis, Rembrandt und De Gelder," in *Arent de Gelder (1645–1727). Rembrandts Meisterschüler und Nachfolger*, Ausstellungskatalog, Dordrechts Museum und Wallraf-Richartz-Museum, Köln (Cologne, 1990), 99f., as well as no. 22A and 22B on the painting by de Gelder in the Frankfurt Städel Museum dated 1685, in other words, more than twenty years after Rembrandt's painting.

28. Samuel van Hoogstraten, *Inleyding tot de Hooge Schoole der Schilderkonst* (Rotterdam, 1678, facsimile ed. Utrecht, 1969), 78 and 110. See also Albert Blankert, "Rembrandt, Zeuxis, and Ideal Beauty," in *Album amicorium J. G. van Gelder*, ed. Josua Bruyn and Jan Ameling Emmens (The Hague, 1973), 32f.

29. Paris (1973), 33f. and 43f.

30. Exhibition catalog. Paris: Musée du Louvre; Berlin: Staatliche Museen zu Berlin, Gemäldegalerie; see Elizabeth Cropper and Charles Dempsey, *Nicolas Poussin: Friendship and the Love of Painting* (Princeton, N.J.: Princeton University Press, 1996), 145f. and 185f.; Stoichita (1998), 235f.

31. Hans Belting, *Max Beckmann: Die Tradition als Problem in der Kunst der Moderne* (Munich, 1984), 45f.; Hildegarde Zenzer, *Max Beckmann: Selbstbildnisse* (Munich, 1984), 18f.

13. Silent Screams in the Glass Case: The Face Set Free

1. Selection of literature: Joachim Heusinger von Waldegg, *Francis Bacon, Schreiender Pabst, 1951* (Mannheim:

Städtische Kunsthalle Mannheim, 1980); Hugh M. Davies, *Francis Bacon: The Papal Portraits of 1953* (San Diego: Museum of Contemporary Art, 2001); Dennis Farr and Massimo Martino, eds., *Francis Bacon: A Retrospective* (New Haven, Conn.: Yale Center for British Art, 1999); Michael Peppiatt, *Francis Bacon in the 1950s*, Sainsbury Centre for Visual Arts (New Haven, Conn.: Yale University Press, 2006); Martin Harrison, ed., *Francis Bacon: Caged, Uncaged* (Porto: Museu Serralves, 2003); Wilfried Seipel and Barbara Steffen, eds., *Francis Bacon und die Bildtradition* (Vienna: Kunsthistorisches Museum Vienna / Fondation Beyler, Riehen; Milan, 2003).

2. Gilles Deleuze, *Francis Bacon: Logique de la Sensation* (Paris: Éditions de la différence, 1981), 42.

3. Deleuze, *Francis Bacon: Logique de la Sensation*, 27.

4. Heusinger von Waldegg, *Francis Bacon, Schreiender Pabst, 1951.*

5. David Sylvester, *Interviews with Francis Bacon* (London: Thames and Hudson, 1975), 48–50, passim.

6. Sylvester, *Interviews with Francis Bacon*, 43–50, passim.

7. Farr and Martino, *Francis Bacon: A Retrospective*, no. 16; Harrison, *Francis Bacon: Caged, Uncaged*, 56.

8. Sylvester, *Interviews with Francis Bacon*, 48.

9. Sylvester, *Interviews with Francis Bacon*. See also Farr and Martino, *Francis Bacon: A Retrospective*, no. 22.

10. Deleuze, *Francis Bacon: Logique de la Sensation*, 27.

11. Deleuze, *Francis Bacon: Logique de la Sensation*, 41.

12. Michel Leiris, *Francis Bacon: Full Face and in Profile* (Oxford: Phaidon, 1983).

13. Leiris, *Francis Bacon: Full Face and in Profile*, 248.

14. Each of these is 61 x 51 cm (London, Tate Gallery, and private collection); see Achille Bonito Oliva, ed., *Figurabile: Francis Bacon*, Museo Correr, Venice (Milan, 1993), 42f. and nos. 11, 12, 14.

14. Photography and Mask: Jorge Molder's Own Alien Face

1. Barthes (1980) 61, with a reference to Italo Calvino's "The Adventure of a Photographer" (1958).

2. Hanno Loewi, "Ohne Masken: Juden im Visier der deutschen Photografie 1933–1934," in *Deutsche Photografie: Macht eines Mediums, 1870–1970*, ed. Klaus Honnef, Rolf Sachsse, and Karin Thomas (Bonn: Kunst- und Austellungshalle der Bundesrepublik Deutschland, 1997), 142f.

3. Barthes (1980), 30f. and 56.

4. Barthes (1980), 148f.

5. Walter Benjamin, "Kleine Geschichte der Photographie," in Benjamin, *Das Kunstwerk im Zeitalter seiner technischen Reproduzierbarkeit: Drei Stufen zur Kunstsoziologie* (Frankfurt am Main, 1963), 83.

6. Barthes (1980), 168f.

7. André Adolphe-Eugène Disdéri, *L'Art de la photographie* (Pars, 1862); see the excerpt "Praxis und Ästhetik der Porträtphotographie," German version in Wilfried Wiegand, ed., *Die Wahrheit der Photographie: Klassische Erkenntnisse zu einer neuen Kunst* (Frankfurt am Main, 1981), 107f.

8. First published in *Novyi lef* 4 (1928): 14f. See English translation in Christopher Phillips, ed., *Photography in the Modern Era: European Documents and Critical Writings, 1930 to 1940* (New York: Metropolitan Museum of Art, 1989), 238f. On the amateur photograph as snapshot, which opens a new topic, see Timm Starl, ed., *Knipser: Die Bildgeschichte der privaten Photographie in Deutschland und Österreich von 1880 bis 1980.* (Munich: Photomuseum München, 1995).

9. Benjamin, "Kleine Geschichte der Photographie," 84f.

10. Benjamin, "Kleine Geschichte der Photographie," 86.

11. Monika Faber, "Der Individuelle und der typische Ausdruck," in Faber and Frecot (2005), 46. On the *Volksgesicht*, see Janos Frecot in Faber and Frecot (2005), 80f.; Falk Blask and Thomas Friedrich, eds., *Menschenbild und Volksgesicht: Positionen zur Porträtphotographie im Nationalsozialismus* (Münster: Lit, 2005).

12. "Volkstypen, Berufstypen, und Körperbautypen." Karl Jaspers, *Die geistige Situation der Zeit* (1931) (Berlin, 1971), 144.

13. Wolfgang Brücke, "Kein Portrait mehr? Physiognomik in der deutschen Bildnisphotographie um 1930," in Schmölders and Gilman (2000), 131f., 148.

14. Monika Faber, "Nahblicke, Grossaufnahmen," in Faber and Frecot (2005), 126f., with examples in the illustrations.

15. Karl Schnebel, "Das Gesicht als Landschaft," *Uhu* 5 (1925): 42ff.

16. Faber and Frecot (2005), illustrations 118 and 125.

17. *Reihenaufnahme* is a formulation of Monika Faber, see Faber and Frecot (2005), 47.

18. Faber and Frecot (2005), illustrations p. 46.

19. Janos Frecot, "Selbst Portraits," in Faber and Frecot (2005), 142f. and illustration 150.

20. Man Ray, *Self-Portrait* (1963) (New York, 1988), see p. 147 on the "double portrait." See also Merry Foresta, ed., *Perpetual Motif: The Art of Man Ray* (Washington, D.C.: National Museum of American Art, 1989), 143f., with illustration 15. On Picasso's portrait in the Metropolitan Museum of Art (New York), see William Stanley Rubin, ed., *Picasso and Portraiture: Representation and Transformation*, Museum of Modern Art (New York and Paris: Galleries Nationales d'Exposition du Grand Palais, 1996), 266f.

21. Gertrude Stein, *Picasso* (1938) (New York, 1984), 8 (on the portrait) and 13 (quotation about the face).

22. On the Rrose Sélavy, see Hans Belting, *Der Blick hinter Duchamps Tür* (Cologne: König, 2009), 54f.

23. Adolfo Bioy Casares, *Morel's Invention* (1940) (Frankfurt am Main, 2003), 108.

24. Quoted in Ian Hunt, "The Confidence Man," in Barbara Bergmann, ed., *Jorge Molder, Anatomy and Boxing* (Witten: Interval, Raum für Zeitgenössische Kunst and Kultur; Witten: Ludwig-Forum für Internationale Kunst, Aachen, 1999), 51. On Molder, see also Delfim Sardo, ed., *Luxury Bound: Photographs by Jorge Molder* (Milan, 1999); Delfim Sardo, *Jorge Molder: Condições de Posibilidade* (Coimbra, 2005); M. Lammert, ed., *Die Entstehung der Arten* (Berlin, 2012).

25. "Jorge Molder im Gespräch mit Doris von Drathen," in Jorge Molder, *Kritisches Lexikon der Gegenwartskunst* 57 (2002): 6: 14.

26. Manuel Olveira, in Jorge Molder and Maria do Céu Baptista, *Jorge Molder: Algún Tiempo Antes (Some Time Before)*, CGAC Centro Gallego de Arte Contemporánea, Santiago de Compostela (Madrid, 2006), 18.

27. Molder and Baptista, *Jorge Molder: Algún Tiempo Antes*, 16.

28. Molder and Baptista, *Jorge Molder: Algún Tiempo Antes*, 63.

29. Jorge Molder, *Kritisches Lexikon der Gegenwartskunst*, 12.

30. Molder and Baptista, *Jorge Molder: Algún Tiempo Antes*, 161 and 169, with an explanation by the artist.

31. Jorge Molder, *Pinocchio* (Lisbon, 2009), 41.

32. Bergmann, *Jorge Molder, Anatomy and Boxing*, 59; Sardo, *Jorge Molder: Condições de Posibilidade*, 258–63 with six illustrations.

15. The Consumption of Media Faces

1. Roland Barthes, *Mythologies*, trans. Richard Howard and Annette Lavers (New York: Hill and Wang, 2002). See chapter "Garbo's Face," 73–75.

2. *Life*, December 28, 1936, 6f. On the newsreels distributed by RKO Pictures and on Henry R. Luce's magazine *Life*, see Robert T. Elson, *Time Inc.: The Intimate History of a Publishing Enterprise, 1923–1941*, vol. 1 (New York, 1968); John K. Jessup, *The Ideas of H. Luce* (New York, 1969); Sylvia Jukes Morris, *Rage for Fame: The Ascent of Clare Booth Luce* (New York, 1997). On the Magnum photographers, see William Manchester, *In Our Time: The World as Seen by Magnum Photographers* (New York, 1989).

3. Curtis Prendergast with Geoffrey Colvin, *The World of Time Inc., The Intimate History of a Changing Enterprise*, vol. 3, 1960–1980 (New York, 1986), see pp. 280ff. and 62 for individual citations.

4. Macho (1999), 121ff.

5. Published in *Süddeutsche Zeitung* (January 27, 2011): 1.

6. Ulrich Raulff, "Image oder das öffentliche Gesicht," in *Das Schwinden der Sinne*, ed. Dietmar Kamper and Christoph Wulfs (Frankfurt am Main: Suhrkamp, 1984).

7. *Harper's Weekly* V (1860), no. 202 (November 10, 1860).

8. Alan Trachtenberg, "Brady's Portraits," *Yale Review* 73 (1984): 230–53.

9. Alfred Döblin, "Von Gesichtern, Bildern, und ihrer Wahrheit," in Sander (1979), 15. See also Raulff, "Image oder das öffentliche Gesicht," 54.

10. Walter Benjamin, "Kleine Geschichte der Photographie," in Benjamin, *Das Kunstwerk im Zeitalter seiner technischen Reproduzierbarkeit: Drei Stufen zur Kunstsoziologie* (Frankfurt am Main, 1963), 84f.

11. Barthes (1957), in Barthes, *Mythologies*, see chapter "Garbo's Face," 73–75.

12. Deleuze, "Das Bewegungsbild," 123 and 139.

13. See report on TV programs: "Blut, Fett, und Tränen," in *Der Spiegel* (July 19, 2004): 144ff.

14. Christoph Heinrich, *Andy Warhol Photography* (Hamburg: Hamburger Kunsthalle; Pittsburgh: Andy Warhol Museum, 1999), no. 54. On this topic see also John Coplans, *Andy Warhol* (New York: New York Graphic Society, 1971), 68ff.; Cécile Whiting, "Andy Warhol, the Public Star and the Private Self," *Oxford Art Journal* 10 (1987): 58ff. See also *Christie's Auction Catalogue: Post-War and Contemporary Art, Evening Sale* (December 19, 2008), 108ff., for an extensive discussion of "Double Marilyn." On the technique, see the penetrating analysis by Christiane Kruse, "Tote und Künstliche Haut: Die Maske des Stars zwischen Kunst und Massenmedien," in *Weder Haut noch Fleisch: Das Inkarnat in der Kunstgeschichte*, ed. Daniela Bohde and Mechthild Fends (Berlin: Mann, 2007), 181–98.

15. Germano Celant, *SuperWarhol* (Milan: Grimaldi Forum, Monaco, 2003), 62.

16. The size is 66 x 35.5 cm. See *Christie's Auction Catalogue: Post-War and Contemporary Art*, no. 28 and p. 108. See also Georg Frei and Neil Printz, eds., *The Andy Warhol Catalogue Raisonné*, vol. 1: *Paintings and Sculptures, 1961 to 1963* (New York, 2002), no. 278.

17. David Bourdon, *Warhol* (New York, 1989), 10.

18. Victor I. Stoichita, *The Pygmalion Effect: From Ovid to Hitchcock* (Chicago: University of Chicago Press, 2006), 190.

19. Wulf Herzogenrath, ed., *Nam June Paik: Fluxus-Video* (Bremen: Kunsthalle Bremen, 2000), 44f., with an old view. Christoph Brockhaus, ed., *Nam June Paik: Fluxus und Videoskulptur* (Duisburg: Lehmbruck Museum, 2002), 72; Drechsler (2004), 86f.

16. Archives: Controlling the Faces of the Crowd

1. The following is based on Sekula (1989), 343ff., esp. 373.

2. Louis-Sébastien Mercier, "Tableau de Paris," vol. 4 (1788), 102. See Courtine and Haroche (1988), 7.

3. Mercier, "Tableau de Paris," vol. 4, 143.

4. Denis Diderot, *Essais sur la Peinture* (Paris: Hermann, 1984), 173.

5. The size is 62 x 100.5 cm. See Theodore Reff, ed., *Manet and Modern Paris* (Washington, D.C.: National Gallery of Art, 1982), 151ff. (*Outside Paris: The Beach*).

6. Adolphe Quetelet, *Sur l'Homme et le développement de ses facultés* (1835), quoted in Sekula (1989), 343ff. and 354ff; also Quetelet, *Lettres sur la théorie des probabilités* (Brussels, 1846); Quetelet, *Anthropométrie ou mesures des différentes facultés de l'Homme* (Brussels, 1871).

7. Sekula (1989), 354, with citations.

8. Vec (2002).

9. Valentin Groebner, "Der Schein der Person: Bescheinigung und Evidenz," in Belting, Kamper, and Schulz, *Quel Corps?*, 309ff.

10. Alphone Bertillon, *L'Identification anthropométrique I* (Paris, 1893); and *Das anthropometrische Signalement*, ed. Dr. V. Sury (Bern and Leipzig, 1895), LXXII. On Bertillon, cf. also Martine Kaluszynski, "Republican Identity: Bertillonage as Government Technique," in *Documenting Individual Identity*, ed. Jane Caplan and John C. Torpey (Princeton, N.J.: Princeton University Press, 2010), 123ff; Vec (2002).

11. Bertillon, *L'Identification anthropométrique I*, plates 41 and 46.

12. "Alphonse Bertillon," *Forum* 113 (1891): 335.

13. Bertillon, *L'Identification anthropométrique I*, plate 80.

14. Bertillon, *L'Identification anthropométrique I*, plate 59 (b) and 60 (b).

15. Vec (2002), 47ff.; Simon A. Cole, *Suspect Identities: A History of Fingerprinting and Criminal Identification* (Cambridge, Mass.: Harvard University Press, 2001), 32ff.

16. Karl Pearson, *The Life, Letters, and Labours of Francis Galton* (Cambridge, 1924).

17. Thomas Y. Levin et al., eds., *Rhetorics of Surveillance from Bentham to Big Brother* (Cambridge, Mass., and Karlsruhe: Zentrum für Kunst und Medientechnologie, 2002).

18. Motonori Doi et al., "Lock Control System Using Face Identification," in *Audio-and Video-Based Biometric Person Authentication*, ed. Josef Bigün et al. (Berlin: Springer, 1997), 361ff.

19. *Life*, June 27, 1969, 20.

20. On Boltanski, see Lynn Gumpert, ed., *Christian Boltanski* (Paris, 1992); Danilo Eccher, ed., *Christian Boltanski* (Milan, 1997); Uwe M. Schneede, ed., *Christian Boltanski: Inventory* (Hamburg: Hamburger Kunsthalle, 1991); Bernhard Jussen, ed., *Signal: Christian Boltanski* (Göttingen, 2004), see text by Monika Steinhauser, *Christian Boltanski*, 103ff.

21. Gumpert, *Christian Boltanski*, 104.

22. Quoted in Schneede, *Signal: Christian Boltanski*, 69, and Jörg Zutter, ed., *Christian Boltanski*: "Les Suisses Mortes" (Vevey, 1993), 96f.

23. Quoted in Schneede, *Signal: Christian Boltanski*, 73.

24. Zutter, *Christian Boltanski*: "Les Suisses Mortes."

25. Quoted in Schneede, *Signal: Christian Boltanski*, 60.

26. Gumpert, *Christian Boltanski*, 138.

27. See Steinhauser, *Christian Boltanski*, 127f.

28. Eccher, *Christian Boltanski*, 43.

17. Video and Live Image: The Flight from the Mask

1. Georges Didi-Huberman in Georges Didi-Huberman and Laurent Mannoni, *Mouvements de l'air: Étienne-Jules Marey, photographe des fluids* (Paris, 2004), 177.

2. Belting (2001), 38ff., on the digital image.

3. Rosalind Krauss, "Video: The Aesthetics of Narcissism" (1976), reprint in John G. Hanhardt, ed., *Video Culture: A Critical Investigation* (Rochester, N.Y., 1990), 179ff.

4. Bruce Kurtz, "The Present Tense," in *Video Art: An Anthology*, ed. Ira Schneider and Beryl Korot (New York: Harcourt Brace Jovanovich, 1976), 234.

5. *Avigdor Arikha: Drawings 1965/66* (Jerusalem and Tel Aviv: Tarshish Books and Dvir, 1967 (epigraph by Samuel Beckett), 1967.

6. Kathy Halbreich and Neal Benezra, eds., *Bruce Nauman* (Minneapolis: Walker Art Center, 1994), 55ff., no. 44.

7. Halbreich and Benezra, *Bruce Nauman*, no. 20f. See also Götz Adriani, ed., *Bruce Nauman: Werke aus den Sammlungen Froehlich und F.E.R.* (Karlsruhe: Museum für Neue Kunst ZKM, 1999), 84ff.

8. For more detail, see Hans Belting, *Das Unsichtbare Meisterwerk* (Munich, 1998), 463f., with sources.

9. Kathryn Chiong, "Nauman's Beckett Gang," in *Samuel Beckett—Bruce Nauman*, ed. Michael Glasmeier (Vienna: Kunsthalle Wien, 2000), 89ff.

10. Herzogenrath, *Nam June Paik: Fluxus-Video*, 38f. and 257. See also especially Herzogenrath, "Paik-Porträts," in Brockhaus, *Nam June Paik: Fluxus und Videoskulptur*, 22ff. See also the following section.

18. Ingmar Bergman and the Face in Film

1. Lisa Gotto, ed., *Eisenstein-Reader: Die wichtigsten Schriften zum Film* (Leipzig, 2011), 132f.

2. Aumont (1992), 92.

3. Béla Balázs, *Schriften zum Film*, ed. Helmut H. Diederichs and others, vol. 1 (Munich, 1984), 82f. and 86.

4. See the interpretation by Aumont (1992), 85ff.

5. See the work of Jacques Aumont, Dominique Chateau, and Martine Jolie in *Iris* 4 (1986): no. 1, as well as Stephen Prince and Wayne Hensley, "The Kuleshov Effect," *Cinema Journal* 31, no. 2 (1992): 5–75.

6. Gotto, *Eisenstein-Reader*, 116.

7. Georges-Henri Rivière and Robert Desnos, *Documents* 4 (1930): 218–21. My thanks to Georges Didi-Huberman, who included this example in his exhibition *Atlas*.

8. Gilles Deleuze, *Cinema 1: The Movement-Image* (1986), 123ff.

9. Deleuze, *Cinema 1: The Movement-Image*.

10. Deleuze, "Das Bewegungsbild," 135.

11. Bonitzer (1987), 87–90 (La Métamorphose).

12. Aumont (1992), 77ff. (the extreme close-up).

13. Ingmar Bergman, *Bilder* (Cologne, 1990), 43ff; Robert E. Long, *Ingmar Bergman: Film and Stage* (New York, 1994), 112ff; Francis Vanoye, "Le Spectateur Capturé sur le Visage d'Ingmar Bergman," *Iris* 17 (1994): 109ff.; Paul Duncan and Bengt Wanselius, eds., *The Ingmar Bergman Archives* (Cologne, 2008), 115ff., with texts and interviews with Ingmar Bergman and his actors.

14. Duncan and Wanselius, *Ingmar Bergman Archives*, 118.

15. Duncan and Wanselius, *Ingmar Bergman Archives*, in conversation with Stig Björkman.

16. Duncan and Wanselius, *Ingmar Bergman Archives*, in conversation with Torsten Manns.

17. Duncan and Wanselius, *Ingmar Bergman Archives*, 322.

18. The question then arises whether Deleuze is correct when he finds in Ingmar Bergman's extreme close-ups the obliteration of the face and simultaneously the suspension of individuation—in other words, out and out nihilism. Deleuze, *Cinema 1: The Movement-Image*, 142.

19. Bergman, *Bilder*, 57f.

20. *Cahiers du cinéma* (October 1959), quoted in Deleuze, *Cinema 1: The Movement-Image*, 141.

21. Ingmar Bergman, *Mein Leben* (Hamburg, 1987), 223.

19. Overpainting and Replicating the Face: Signs of Crisis

1. *Arnulf Rainer* (Eindhoven: Stedelijk van Abbe-Museum Eindhoven and Whitechapel Art Gallery, London, 1980); Dieter Honisch, ed., *Arnulf Rainer* (Berlin: Nationalgallerie Berlin, 1980); Rudi Fuchs, ed., *Arnulf Rainer: Noch vor der Sprache* (Rotterdam: Stedelijk Museum, Amsterdam, 2001), 22f.; Nicole Tuffelli, "Arnulf Rainer: La mise en abyme du portrait," in Hindry (1991), 86ff. On the texts by Rainer, see *Arnulf Rainer, Hirndrang: Selbstkommentare und andere Texte zu Werk und Person*, ed. Otto Breicha (Salzburg, 1980). On the technique of overpainting pictures, see Birgit Mersmann, *Bilderstreit und Büchersturm: Medienkritische Überlegungung zu Übermahlung und Überschreibung im 20. Jahrhundert* (Würzburg, 1999).

2. *Arnulf Rainer*, illustrations 25–44; Honisch, *Arnulf Rainer*, 99ff.

3. Text from 1952, printed as introduction in *Arnulf Rainer*.

4. *Arnulf Rainer*, illustration 59ff.

5. *Arnulf Rainer*, illustrations 105–29; Honisch, *Arnulf Rainer*, 169ff.; Claude Schweisguth, ed., *Arnulf Rainer: Mort et sacrifice*, Centre Georges Pompidou (Paris, 1984).

6. "Das letzte Bild des Menschen," in Benkard (1926), xxxvii.

7. Maurice Blanchot, *L'Espace littéraire* (Paris, 1955), 2nd ed. 1993 (347).

8. Arnulf Rainer, *Totenmasken, Exhibition Catalogue*, Österreichische Gallerie des 19. und 20. Jahrhunderts, Vienna (Vienna, 1978). See quotation in Honisch, *Arnulf Rainer*, 170.

9. Martin Friedman, ed., *Close Reading: Chuck Close and the Art of the Self-Portrait* (New York: Harry N. Abrams, 2005), 44; Robert Storr, ed., *Chuck Close, Museum of Modern Art, New York* (New York, 1998), 113. The portrait *Keith* hangs in the Saint Louis Art Museum.

10. Quoted in Wolfgang Drechsler, ed., *Porträts aus der Sammlung*, Museum Moderner Kunst Stifting Ludwig, Vienna (Vienna, 2004), 55. On Close, see the texts by Robert Storr and Kirk Varnedoe, in Storr, *Chuck Close, Museum of Modern Art*, 61ff. See also Barbara Naumann, "Gesicht und Defiguration: Bemerkungen zu Don DeLillo, Andy Warhol, und Chuck Close," in *Bilder-Denken: Bildlichkeit und Argumentation*, ed. Barbara Naumann and Edgar Pankow (Munich, 2004), 267ff.; Siri Engberg and others, *Chuck Close: Self-Portraits, 1967–2005* (San Francisco: San Francisco Museum of Art, 2005).

11. Minneapolis, Walker Art Center; Storr, *Chuck Close, Museum of Modern Art*, plate p. 107.

12. Friedman, *Close Reading: Chuck Close and the Art of the Self-Portrait*, 47 and 56; Drechsler, *Porträts aus der Sammlung*, 55.

13. Quoted in Friedman, *Close Reading: Chuck Close and the Art of the Self-Portrait*, 83.

14. Quoted in Friedman, *Close Reading: Chuck Close and the Art of the Self-Portrait*, 99.

15. John Guare, *Chuck Close: Life and Work, 1988–1995* (London, 1995). See also the conversations between Close and his subjects, in Joanne Kesten, ed., *The Portraits Speak: Chuck Close in Conversation with 27 of His Subjects* (New York, 1997).

16. *Chuck Close*. A Film by Marion Cajori.

20. Mao's Face: State Icon and Pop Idol

1. My remarks are based on the detailed analysis of the portrait of Mao, in Wu Hung, *Remaking Beijing: Tiananmen Square and the Creation of a Political Space* (Chicago, 2005), 68–86.

2. Wu Hung, *Remaking Beijing*, 78.

3. In 2011 the Gallery Gary Edwards in Washington, DC, offered several copies of the photograph. See *Art Newspaper* 221 (2011): 62.

4. Wu Hung, *Remaking Beijing*, 81f.

5. Wu Hung, *Remaking Beijing*, illustration 23f.

6. Don DeLillo, *Mao II* (New York, 1991), 176–77.

7. Bob Colacello, *Holy Terror: Andy Warhol Close Up* (New York, 1990), 110f. See also Dieter Koepplin, in Marc Francis and Dieter Koepplin, *Andy Warhol: Zeichnungen* (Munich, 1998), 43f.

8. Kynaston McShine, ed., *Andy Warhol: Retrospective*, Museum Ludwig, Köln (Munich, 1989), no. 347.

9. McShine, *Andy Warhol: Retrospective*, no. 363.

10. DeLillo, *Mao II*, 21.

11. DeLillo, *Mao II*, 62.

12. Koepplin, *Andy Warhol: Zeichnungen*, 44.

13. Ai Wei Wei in the publication specifically commemorating this visit, Peter Weise, ed., *Andy Warhol China 1982* (Hong Kong, 2007).

21. Cyberfaces: Masks without Faces

1. Manfred Fassler, "Im künstlichen Gegenüber/ohne Spiegel Leben," in Faßler (2000), 11–120, see esp. 19 and 97ff.

2. See William A. Ewing, ed., *About Face: Photograph and the Death of the Portrait*, Hayward Gallery, London (London, 2004).

3. On this topic see Margaret Wertheim, *The Pearly Gates of Cyberspace: A History of Space from Dante to the Internet* (New York, 1999), 253ff.

4. Ruth Nestvold, "Die Digitale Maskerade: Das Unbehagan am Unbestimmten Geschlecht," in Elfi Bettinger and Julika Funk, eds., *Maskeraden: Geschlechterdifferenz in der literarischen Inszenierung* (Berlin, 1995), 292ff.

5. Nestvold, "Die Digitale Maskerade."

6. Scott Bukatman, *Terminal Identity: The Virtual Subject in Post-Modern Science Fiction* (Durham, N.C.: Duke University Press, 1993).

7. James R. Gaines, "From the Managing Editor," *Time*, special issue, November 18, 1993; see also Victor Burgin, "Das Bild in Teilen," in Amelunxen, Iglhaut, and Rötzer (1996), 32.

8. Irene Andessner, "Arbeitskonzept Cyberface," and Andreas Leo Findeisen and Irene Andessner, "Cyberface— Gesicht ohne Gegenüber," in Fassler (2000), 191ff.

9. Amelunxen, Iglhaut, and Rötzer (1996), 126ff.

10. Amelunxen, Iglhaut, and Rötzer (1996), 201.

11. Amelunxen, Iglhaut, and Rötzer (1996), 160ff. On Cottingham, see Annette Hüsch, "Schrecklich schön: Zum Verhältnis von Körper, Material und Bild in der Post-Photographie," in *Beiträge zur Kunst und Medientheorie: Projekte und Forschungen an der Hochschule für Gestaltung in Karlsruhe*, ed. Hans Belting and Ulrich Schulze (Stuttgart, 2000), 33ff.

12. Wertheim, *Pearly Gates of Cyberspace*, 290ff.

13. See the report with photographs in the *Frankfurter Allgemeine Zeitung* (October 26, 2004). See also the texts under "Deisis" on the artist's home page, as well as *Predstojnie. Deisis* (Moscow, 2004). My thanks to Franziska Thun-Hohenstein (Berlin) for this citation.

14. Belting (2005).

15. Wertheim, *Pearly Gates of Cyberspace*, 31 and 40.

LITERATURE CITED

Agamben, Giorgio. "Il Volto." In Blümlinger and Sierek, 2002, 219ff.

Amelunxen, Hubertus von, Stefan Iglhaut, and Florian Rötzer, eds. *Fotografie nach der Fotografie*. Dresden: Verlag der Kunst, 1996.

Argyle Michael, and Mark Cook. *Gaze and Mutual Gaze*. Cambridge: Cambridge University Press, 1976.

Aumont, Jacques. "Der porträtierte Mensch." In Barck and Beilenhoff, 2004, 12–49.

———. *Du visage au cinéma*. Paris: Cahiers du cinéma, 1992.

Bailey, David A., and Gilane Tawadros, eds. *Veil: Veiling, Representation, and Contemporary Art*. Cambridge, Mass.: MIT Press, 2003.

Barck, Joanna, and Wolfgang Beilenhoff, eds. *Das Gesicht im Film*. Marburg, 2004.

Barck, Joanna, and Petra Löffler, eds. *Gesichter des Films*. Bielefeld, 2005.

Barthes, Roland. *La chambre claire: Note sur la photographie*. Paris: Cahiers du cinéma, 1980.

Belting, Hans. *Bild-Anthropologie: Entwürfe für eine Bildwissenschaft*. Munich: W. Fink, 2001.

———. *Das echte Bild: Bildfragen als Glaubensfragen*. Munich: Beck, 2005.

———. "Face oder Trace? Anthropologische Fragen zu den frühen Christus-Porträts." In Weigel, 2013.

———. *Le Portrait médiéval et le portrait autonome: Une question*. In Olariu, 2009, 123–36.

———. *Spiegel der Welt: Die Erfindung des Gemäldes in den Niederlanden*. Munich: Beck, 2010.

Belting, Hans, and Christiane Kruse. *Die Erfindung des Gemäldes: Das erste Jahrhundert der niederländischen Malerei*. Munich: Hirmer, 1994.

Benkard, Ernst. *Das ewige Antlitz: Eine Sammlung von Totenmasken*. Berlin, 1926.

Bettinger, Elfi, and Julika Funk, eds. *Maskeraden: Geschlechterdifferenz in der literarischen Inszenierung*. Berlin: Erich Schmidt, 1995.

Bettini, Maurizio. *La maschera, il doppio e il ritratto*. Rome: Laterza, 1991.

Beyer, Andreas. *Das Porträt in der Malerei*. Munich: Hirmer, 2002.

Blankert, Albert. *Rembrandt: A Genius and His Impact*. Melbourne: National Gallery of Victoria, 1997.

Blümlinger, Christa, and Karl Sierek, eds. *Das Gesicht im Zeitalter des bewegten Bildes*. Vienna: Sonderzahl, 2002.

Boehm, Gottfried. *Bildnis und Individuum: Über den Ursprung der Porträtmalerei in der italienischen Renaissance*. Munich: Prestel-Verlag, 1985.

Bonitzer, Pascal. *Décadrages: Peinture et cinéma*, 1987; Paris: Editions de l'Etoile, 1995.

Borrmann, Norbert. *Kunst und Physiognomik: Menschendeutung und Menschendarstellung im Abendland*. Cologne: DuMont, 1994.

Christians, Heiko. *Sehnsüchte der Physiognomik*. In Van Loyen and Neumann, 2006, 4–12.

Cole, Jonathan. "Facial Function Revealed through Loss." In Kohl and Olariu, 2012, pp. 83–94.

———. *Über das Gesicht: Naturgeschichte des Gesichts und unnatürliche Geschichte derer, die es verloren haben*. Munich: Antje Kunstmann, 1999.

Courtine, Jean-Jacques, and Claudine Haroche. 1988. *Histoire du visage: Exprimer et taire ses émotions. XVIe–début XIXe siècle*. Paris: Payot and Rivages.

Darwin, Charles. *The Expression of the Emotions in Man and Animals* (1872), edited by Francis Darwin. New York: New York University Press, 1989. In *The Works of Charles Darwin*, vol. 23.

Deleuze, Gilles, and Félix Guattari. *Tausend Plateaus: Kapitalismus und Schizophrenie*. Berlin: Merve, 1992.

Didi-Huberman, Georges. *Ähnlichkeit und Berührung: Archäologie, Anachronismus und Modernität des Abdrucks*. Cologne: DuMont, 1999.

———. *La Grammaire, le chahut, le silence: Pour une anthropologie du visage*. In de Loisy, 1992, 15–55.

———. "Near and Distant: The Face, Its Imprint, and Its Place of Appearance." In Kohl and Olariu, 2012, 54–69. Cited in text as Didi-Huberman, 2012a.

———. *Peuples exposés, peuples figurants*. Paris: Minuit, 2012. (*L'oeil de l'histoire*, vol. 4.) Cited in text as Didi-Huberman, 2012b.

———. "De Ressemblance à ressemblance." In *Maurice Blanchot: Récits critiques*, edited by Christophe Bident, 143–67. Paris: Scheer, 2003.

Drechsler, Wolfgang, ed. *Porträts: Aus der Sammlung*. Museum Moderner Kunst. Vienna: Christian Brandstätter, 2004.

Dülberg, Angelica. *Privatporträts: Geschichte und Ikonologie einer Gattung*. Berlin: Gebrüder Mann Verlag, 1990.

Eisenstein, Sergei. *Expressivität der Hieroglyphe: Prinzipien der Typage* (pub. 1971 as fragment). Translated by Oksana Bulgakowa. In Van Loyen and Neumann, 2006, 42–48.

Eisermann, Gottfried. *Rolle und Maske*. Tübingen: Mohr Siebeck, 1991.

Ekma, Paul, and Wallace V. Friesen. *Unmasking the Face: A Guide to Recognizing Emotions from Facial Clues*. Englewood Cliffs, N.J.: Prentice-Hall, 1975.

Faber, Monika, and Janos Frecot, eds. *Portrait im Aufbruch: Photographie in Deutschland und Österreich, 1900–1938*. Neue Galerie, New York, and Graphische Sammlung Albertina, Vienna. Ostfildern-Ruit: Hatje Cantz, 2005.

Faßler, Manfred, ed. *Alle möglichen Welten: Virtuelle Realität, Wahrnehmung, Ethik der Kommunikation*. Munich: W. Fink, 1999.

———. *Ohne Spiegel leben: Sichtbarkeiten und posthumane Menschenbilder*. Munich: W. Fink, 2000.

Feher, Michel, ed. *Fragments for a History of the Human Body*. Vol. 2. New York: Zone, 1989.

Ferino-Pagden, Sylvia, ed. *Wir sind Maske*. Kunsthistorisches Museum und Museum für Völkerkunde Vienna. Vienna: Kunsthistorisches Museum, 2009.

Fischer, Rotraut, Gerd Schrader, and Gabriele Stumpp, eds. 1989. *Natur nach Maß: Physiognomik zwischen Wissenschaft und Ästhetik*. Marburg: Soznat.

Friedell, Egon. *Das letzte Gesicht*. Edited by Emil Schaeffer. Zurich: O. Füssli, 1929.

Frontisi-Ducroux, Françoise. *Le dieu-masque: Une figure du Dionysos d'Athènes*. Paris: Éditions la découverte, 1991.

———. *Du masque au visage: Aspects de l´identité en Grèce ancienne*. Paris: Flammarion, 1995.

Ghiron-Bistagne, Paulette. *Le masque du théâtre dans l'antiquité classique*. Arles: Conservation des musées 1986.

Giuliani, Luca. *Bildnis und Botschaft: Hermeneutische Untersuchungen zur Bildniskunst der römischen Republik*. Frankfurt am Main: Suhrkamp, 1986.

Goffman, Erving. *Interaktionsrituale: Über Verhalten in direkter Kommunikation*. Frankfurt am Main: Suhrkamp, 1986.

Gombrich, Ernst H. *Maske und Gesicht* (1972). German translation in Ernst H. Gombrich, Julian Hochberg, and Max Black, *Kunst, Wahrnehmung, Wirklichkeit*. Frankfurt am Main: Suhrkamp, 1977, 10–60.

Gray, Richard T. *About Face: German Physiognomic Thought from Lavater to Auschwitz*. Detroit: Wayne State University Press, 2004.

Hagner, Michael. *Geniale Gehirne: Zur Geschichte der Elitegehirnforschung*. Göttingen: Wallstein, 2004.

———. *Homo cerebralis: Der Wandel vom Seelenorgan zum Gehirn*. Berlin: Berlin Verlag 1997.

Hall, Peter. *Exposed by the Mask: Form and Language in Drama*. New York: Theatre Communications Group, 2000.

Hellpach, Willy. *Deutsche Physiognomik: Grundlegung einer Naturgeschichte der Nationalgesichter*. Berlin: Walter de Gruyter, 1942.

Hensel, Thomas, Klaus Krüger, and Tanja Michalsky, eds. *Das bewegte Bild: Film und Kunst*. Paderborn: W. Fink, 2006.

Hindry, Ann, ed. *Le portrait contemporain*. Artstudio 21. Paris: Artstudio, 1991.

Kirchner, Thomas. *L'expression des passions: Ausdruck als Darstellungsproblem in der französischen Kunst und Kunsttheorie des 17. und 18. Jahrhunderts* (Mainz: P. von Zabern, 1991).

Koerner, Joseph Leo. *The Moment of Self-Portraiture in German Renaissance Art*. Chicago: University of Chicago Press, 1993.

Kohl, Jeanette, and Rebecca Müller, eds. *Kopf/Bild: Die Büste in Mittelalter und früher Neuzeit*. Munich: Deutscher Kunstverlag, 2007.

Kohl, Jeanette, and Dominic Olariu, eds. *En Face: Seven Essays on the Human Face (Kritische Berichte 1 and 40, 2012)*. Marburg: Jonas, 2012.

Kruse, Christiane. *Wozu Menschen malen: Historische Begründungen eines Mediums*. Munich: W. Fink, 2003.

Landau, Terry. *Von Angesicht zu Angesicht: Was Gesichter verraten und was sie verbergen*. Heidelberg: Spektrum Akademischer, 1993.

Lange, Fritz. *Die Sprache des menschlichen Antlitzes: Eine wissenschaftliche Physiognomik und ihre praktische Verwertung im Leben und in der Kunst*. Munich: J. F. Lehmanns, 1937.

Lavater, Johann Caspar. *Physiognomische Fragmente zur Beförderung der Menschenkenntnis und Menschenliebe*. Versuch I–IV. Leipzig, 1775–78; reprint Hildesheim, 2002.

Leuschner, Eckhard. *Persona, Larva, Maske: Ikonologische Studien zum 16. bis frühen 18. Jahrhundert*. Frankfurt am Main: P. Lang, 1997.

Lévi-Strauss, Claude. *La voie des masques*. Paris: Plon, 1979.

Löffler, Petra, and Leander Scholz, eds. *Das Gesicht ist eine starke Organisation*. Cologne: DuMont, 2004.

Loisy, Jean de, ed. *À visage découvert*. Fondation Cartier pour l'Art Contemporain, Jouy-en-Josas. Paris: Flammarion, 1992.

Loyen, Ulrich van, and Michael Neumann, eds. 2006. *Gesichtermoden*. Tumult 31. Berlin: Alpheus.

Macho, Thomas. "Das prominente Gesicht: Vom Face-to-Face zum Interface." In Faßler, 1999, 121–36.

———. "Vision und Visage: Überlegungen zur Faszinationsgeschichte der Medien." In Müller-Funk and Reck, 1996, 87–108.

———. *Vorbilder*. Munich: W. Fink, 2011.

Macho, Thomas, and Gerburg Treusch-Dieter. *Medium Gesicht: Die faciale Gesellschaft*. Berlin: Elefanten Press, 1996. Ästhetik und Kommunikation, 94–95.

Magli, Patrizia. "The Face and the Soul." In Feher, 1989, 86ff.

Matt, Peter von. . . . *fertig ist das Angesicht: Zur Literaturge-schichte des menschlichen Gesichts*. Munich: Hanser, 1983.

Melchior-Bonnet, Sabine. *Histoire du Miroir*. Paris: Imago, 1994.

Meuter, Norbert. *Anthropologie des Ausdrucks: Die Expres-sivität des Menschen zwischen Natur und Kultur*. Munich: W. FInk, 2006.

Mraz, Gerda, and Uwe Schögl, eds. *Das Kunstkabinett des Johann Caspar Lavater*. Vienna: Böhlau, 1999.

Müller-Funk, Wolfgang, and Hans Ulrich Reck, eds. *Inszeni-erte Imagination: Beiträge zu einer historischen Anthropolo-gie der Medien*. Vienna: Springer, 1996.

Münch, Birgit U., Markwart Herzog, and Andreas Tacke, eds. *Künstlergrabmäler: Genese, Typologie, Intention, Meta-morphosen*. Petersburg: Michael Imhof, 2011.

Nancy, Jean-Luc. *Le regard du portrait*. Paris: Galilée, 2000.

Olariu, Dominic, ed. *Le portrait individuel: Réflexions autour d'une forme de représentation, XIIIe–XVe siècles*. Bern: P. Lang, 2009.

Olschanski, Reinhard. *Maske und Person: Zur Wirklichkeit des Darstellens und Verhüllens*. Göttingen: Vandenhoeck and Ruprecht, 2001.

Paris, Jean. *Miroirs de Rembrandt: Le Sommeil de Vermeer, Le Soleil de Van Gogh, Espaces de Cézannes*. Paris: Galilée, 1973.

Picard, Max. *Die Grenzen der Physiognomik*. Leipzig: E. Rent-sch, 1937.

Plessner, Helmuth. *Ästhesiologie des Gesichts* In Plessner, *Gesammelte Schriften*, edited by Günter Dux and others, vol. 3: *Anthropologie der Sinne*. Frankfurt am Main: Suhrkamp, 1980, 248ff.

———. "Das Lächeln" (1950). In *Gesammelte Schriften*, edited by Günter Dux and others, vol. 7: *Ausdruck und menschliche Natur*. Frankfurt am Main: Suhrkamp, 1982, 419ff. Cited in text as Plessner, 1982c.

———. "Lachen und Weinen" (1941). In Plessner, *Gesam-melte Schriften*, edited by Günter Dux and others, vol. 7: *Ausdruck und menschliche Natur*. Frankfurt am Main: Suhrkamp, 1982, 201ff. Cited in text as Plessner, 1982a.

———. *Zur Anthropologie des Schauspielers* (1948). In Pless-ner, *Gesammelte Schriften*, edited by Günter Dux and others, vol. 7: *Ausdruck und menschliche Natur*. Frankfurt am Main: Suhrkamp, 1982, 399ff. Cited in text as Pless-ner, 1982b.

Preimesberger, Rudolf, Hannah Baader, and Nicola Suthor, eds. *Porträt: Geschichte der klassischen Bildgattungen in Quellentexten und Kommentaren*, vol. 2. Berlin: Dietrich Reimer, 1999.

Raupp, Hans-Joachim. *Untersuchungen zu Künstlerbildnis und Künstlerdarstellung in den Niederlanden im 17. Jahrhun-dert* (Hildesheim: Georg Olms, 1984).

Sander, August. *Antlitz der Zeit. 60 Aufnahmen deutscher Menschen des 20. Jahrhunderts*. Introduction by Alfred Döblin. Munich: Schirmer-Mosel, 1976.

Sartre, Jean-Paul. "Visages." In *Les écrits de Sartre: Chronolo-gie, bibliographie commentée*, edited by Michel Contat and Michel Rybalka, 560–64. Paris: Gallimard, 1970.

Sauerländer, Willibald. *Ein Versuch über die Gesichter Houdons*. Munich: Deutscher Kunstverlag, 2002.

Sauvagnargues, Anne. "Gesichtlichkeit." In van Loyen and Neumann, 2006, 13–18.

Schabert, Tilo, ed. *Die Sprache der Masken*. Würzburg: Königshausen and Neumann, 2002.

Schmidt, Gunnar. *Das Gesicht: Eine Mediengeschichte*. Munich: W. Fink, 2003.

Schmitt, Jean-Claude. "For a History of the Face: Physiog-nomy, Pathognomy, Theory of Expression." In Kohl and Olariu, 2012, 7–20.

Schmölders, Claudia. *Hitlers Gesicht: Eine physiognomische Biographie*. Munich: Beck, 2000.

———. *Das Vorurteil im Leibe: Eine Einführung in die Physi-ognomik*. Berlin: Akademie Verlag, 1995.

Schmölders, Claudia, ed. *Der exzentrische Blick: Gespräch über Physiognomik*. Berlin: Akademie Verlag, 1996. See esp. Martin Blankenburg, 133–62, and Peter Becker, 163–86.

Schmölders, Claudia, and Sander Gilman, eds. *Gesichter der Weimarer Republik: Eine Physiognomische Kulturgeschichte*. Cologne: DuMont, 2000.

Schulz, Martin. "Spur des Lebens und Anblick des Todes." *Zeitschrift für Kunstgeschichte* 64 (2001): 381–96.

Schüttpelz, Erhard. "Medium Maske: Ein Kommentar zu Claude Lévi-Strauss." In Van Loyen and Neumann, 2006, 54–56.

Schwarz, Hans Peter, ed. *Mienenspiele: About Faces* (Karl-sruhe: ZKM, 1994).

Sekula. Allan. "The Body and the Archive." In *The Contest of Meaning: Critical Histories of Photography*, edited by Rich-ard Bolton, 343–89. Cambridge, Mass.: MIT Press, 1989.

Shookman, Ellis, ed. *The Faces of Physiognomy: Interdisciplin-ary Approaches to Johann Caspar Lavater*. Columbia, SC: Camden House, 1993.

Simmel, Georg. "Die ästhetische Bedeutung des Gesichts" (1901). In Simmel, *Aufsätze und Abhandlungen, 1901–1908*. Vol. 1, edited by Rüdiger Kramme. Frankfurt am Main: Suhrkamp, 1995.

Small, Andrew. *Essays in Self-Portraiture: A Comparison of Technique in the Self-Portraits of Montaigne and Rembrandt*. New York: P. Lang, 1996.

Stoichita, Victor. *Das selbstbewußte Bild: Der Ursprung der Metamalerei*. Munich: W. Fink, 1998.

Vec, Miloš. *Die Spur des Täters: Methoden der Identifikation in der Kriminalistik (1879–1933)*. Baden-Baden: Nomos, 2002.

Vernant, Jean-Pierre. *Figures, idoles, masques*. Paris: Julliard, 1990.

Weigel, Sigrid. "Das Gesicht als Artefakt." *Trajekte* 25 (2012): 5–12. Cited in text as Weigel, 2012a.

———. "Phantom Images: Face and Feeling in the Age of Brain Imaging." In Kohl and Olariu, 2012, 33–53. Cited in text as Weigel, 2012b.

———. "Phantombilder zwischen Messen und Deuten." In *Repräsentationen: Medizin und Ethik in Literatur und Kunst der Moderne*, edited by Bettina von Jagow and Florian Steger, 159–98. Heidelberg: Winter, 2004.

Weigel, Sigrid, ed. *Gesichter: Kulturgeschichtliche Szenen aus der Arbeit am Bildnis des Menschen*. Munich: W. Fink, 2013.

Weihe, Richard. *Die Paradoxie der Maske: Geschichte einer Form*. Munich: W. Fink, 2004.

Weiss, Judith, ed. *Gesicht im Porträt / Porträt ohne Gesicht*. Ruppichteroth: Kunstforum, 2012.

Weissberg, Liliane, ed. *Weiblichkeit als Maskerade*. Frankfurt am Main: Fischer Taschenbuch, 1994.

White, Christopher, and Quentin Buvelot, eds. *Rembrandt by Himself*. National Gallery, London, and Koninklijk Kabinet van Schilderijen, 's-Gravenhage. London: National Gallery Publications, 1999.

Wolf, Gerhard. *Schleier und Spiegel: Traditionen des Christusbildes und die Bildkonzepte der Renaissance*. Munich: W. Fink, 2002.

Wysocki, Gisela von. *Fremde Bühnen: Mitteilungen über das menschliche Gesicht*. Hamburg: Europäische Verlagsanstalt, 1995.

Zanker, Paul. *Die Maske des Sokrates: Das Bild des Intellektuellen in der antiken Kunst*. Munich: Beck, 1995.

Zebrowitz, Leslie A. *Reading Faces: Window to the Soul?* Boulder, Colo.: Westview Press, 1997.

INDEX OF NAMES